THE MUNICH
ART HOARD

THE MUNICH ART HOARD

Hitler's dealer and his secret legacy

CATHERINE HICKLEY

With 40 illustrations

 Thames & Hudson

For Paul, Anthea, Giles and Ginia Hickley

First published in the United Kingdom in 2015 by
Thames & Hudson Ltd, 181A High Holborn,
London WC1V 7QX

*The Munich Art Hoard: Hitler's dealer and his
secret legacy* © 2015 Catherine Hickley

British Library Cataloguing-in-Publication Data
A catalogue record for this book is available from
the British Library

ISBN 978-0-500-25215-4

Printed and bound in India by
Replika Press Pvt. Ltd.

To find out about all our publications, please visit
www.thamesandhudson.com. There you can subscribe
to our e-newsletter, browse or download our current
catalogue, and buy any titles that are in print.

Contents

Prologue

Cornelius Gurlitt, a white-haired, frail old man with a ghostly pallor and watery faraway eyes, sat in a corner of his Munich apartment. It was February 2012.

Teams of officials were combing through his reclusive life, invading his private sphere and packing his most treasured possessions into cardboard boxes to take them away.

They stayed four days. The Max Liebermann painting of two riders on a beach was unhooked from the wall, the Chagall vanished from the cupboard, the Matisse in the drawer disappeared into a box.

Gone, too, were the reams of drawings and prints, his favourites that he kept in a small suitcase. He had spent many evenings poring over those images by Pablo Picasso, Edgar Degas, Paul Cézanne, Auguste Rodin, Edvard Munch, Franz Marc and Otto Dix, the yellowed paper recalling a glittering era of creativity and inspiration, of danger and decadence.

They were more than just possessions. He talked to them. They were a substitute for family, friends, lovers. Gurlitt had only his artworks, and they were the only company he needed in his waning years. His parents had died half a century ago. His sister, the only person left to whom he was close, was dying of cancer.

Now the pictures were gone, too, and he felt more bereft than after the death of his parents. He wished his sister could help. Benita would have known how to stop these strangers from packing their father's precious legacy into boxes and carting it off.

Couldn't they have waited until Cornelius was dead too?

He blamed himself, a little. His father had rescued the pictures from the Nazis, the bombs, the fire, the Red Army. And now he, Cornelius, had failed to defend them against these strangers who were swarming through his apartment.

His property! How dare they? What did they want from him? He was no criminal. They told him the art was stolen by the Nazis. What nonsense! It was saved from the Nazis.

He was determined to get his pictures back, as many of them as he could. He would not give them up.

<hr />

This strange and lonely old man only ever spoke to the public once, in an interview with Germany's *Der Spiegel* magazine. All he wanted was to live in peace and quiet with his art. But it was not to be: he and his collection captured the world's imagination and provoked a debate about a Nazi crime that has yet to be redressed. Some of the artworks hidden for decades in his apartment were stolen from Jews who lost everything under Adolf Hitler – their livelihoods, their identities, their homes, their families and, in some cases, their lives.

The last years of Cornelius's reclusive life were to prove anything but peaceful. The prosecutor opened a criminal investigation against him, journalists besieged his home, and he was inundated with claims from the heirs of Jewish collectors who were persecuted and expropriated more than seventy years ago.

He became a polarizing figure in a complex legal debate, sparked disbelief, outrage and sympathy, and hammered home to Germany the ongoing national responsibility to address the darkest era of its history. Most importantly, he raised awareness of the thousands of artworks lurking in both private and public collections worldwide that have never been returned to their rightful owners – what Ronald Lauder, president of the World Jewish Congress, has termed 'the last prisoners of World War II'. As awareness grew that Cornelius would probably get to keep the artworks in a German court of law, the deficiencies of the legal framework to right this historic wrong became apparent to all.

Considering he rarely left his flat, Cornelius made quite an impact.

From his hospital sickbed in the last weeks of his life, under an enormous amount of public pressure, Cornelius set a moral benchmark that

many museum directors, art dealers and private collectors would do well to follow. He pledged to apply the international Washington Principles in addressing the heirs' claims. These non-binding guidelines on handling Nazi-looted art in public collections were endorsed in 1998 by forty-four governments. All too often, they are ignored or bypassed by museums and politicians. Private collectors, with the notable exception of Cornelius Gurlitt, are not bound by them at all.

For the families who were robbed, failure to address the crimes of the Nazis perpetuates the injustice they suffered. No one can bring back the millions who died in the Holocaust. Looted art, though, can and should still be returned to the families it was stolen from.

1 Two Riders on the Beach

November 2013

Lothar Fremy, a tall, unflappable north German lawyer who moved to Berlin thirty years ago and stayed, watched live on television as the Augsburg state prosecutor Reinhard Nemetz presented his spectacular find to the world. Cornelius Gurlitt's cache of 1,280 paintings, drawings, lithographs and prints included some previously unknown works, among them a Marc Chagall gouache and an Otto Dix self-portrait. The list reads like an art 'Who's Who': Pablo Picasso, Paul Cézanne, Edgar Degas, Henri Matisse, Franz Marc, Henri de Toulouse-Lautrec, Oskar Kokoschka, Gustave Courbet, Paul Klee, Ernst Ludwig Kirchner, Albrecht Dürer, Canaletto, Jean-Auguste-Dominique Ingres – all found among jam jars, fruit-juice cartons, boxes of pasta and tins of food, some of which had a best-before date in the last century.

Despite the debris in Gurlitt's apartment, the artworks were stored correctly according to Meike Hoffmann, the Berlin art historian investigating the treasure trove. They were dirty, many were frameless, but they were undamaged. 'To stand in front of pictures that were long believed lost or destroyed of course gives one an incredible feeling of joy,' Hoffmann said at the Augsburg news conference.

Every one of these pictures had a story to tell; a story of ownership that had yet to be pieced together. The strands of history to be woven into each narrative would need to be painstakingly extricated from dozens of archives: from official inventories, old catalogues, business accounts and personal letters. Some of the artworks were known to have been seized by the Nazis from German museums in a rampage against what Adolf Hitler and Joseph Goebbels vilified as 'degenerate' modern art. Others, perhaps hundreds, were looted from Jewish collectors or sold by Jews who had lost their livelihoods because of Nazi race policies.

As Fremy watched, Hoffmann projected photographs of a handful of the long-lost pictures onto a screen. The ornately framed Max Liebermann oil painting that hung in Gurlitt's apartment flashed up. On a sandy northern European beach, two men on horseback ride along the shoreline, the nearer one leaning back and turning as if to shout to his companion above the roar of the ocean. Behind them is a choppy, frothy sea and the sky is an unsettled mix of grey, white and a patch of blue.

Fremy was startled. 'I thought – "I recognize that,"' he said. 'We've been looking for it for years.'[1]

For seventy-five years, Fremy's client, David Toren, had not known where the painting was. Toren is a retired patent lawyer and lives with his wife on the twenty-third floor of an apartment building on Madison Avenue in New York. His roots are way across the Atlantic, in a land called Silesia that was once part of Germany and is now in Poland.[2]

Born Klaus-Günther Tarnowski on 30 April 1925, David Toren grew up in a well-to-do Jewish family in the chic south of Breslau, now Wrocław. The city had blossomed during the industrial revolution to become the fifth-largest metropolis in Germany. Yet despite its economic success, at the end of the 19th century, Breslau was still a cultural backwater. The public art collections were sparse, in part because there was no royal heritage to put on show. The Silesian Museum of Fine Arts, which had only opened in 1880, was reliant on the gifts and bequests of wealthy citizens. Until the end of the 19th century, these were largely members of the nobility, industrialists and scholars. By the early decades of the 20th century, the patrons were predominantly Jewish.[3]

At the time of Toren's birth, Breslau had a flourishing Jewish population of about 23,000, the third largest in Germany after Berlin and Frankfurt.[4] Jews were merchants, businessmen, lawyers, academics, local politicians and craftsmen. They enriched Breslau's cultural life enormously by exhibiting their impressive collections at the museums, making generous donations of modern art and creating the conditions

for a thriving art trade.[5] The Jews played a key role in the city's arts scene, ensuring the survival of the opera, the orchestra and the theatre through their patronage. Toren remembers being taken to *The Magic Flute* as a child.

Despite their separate religious traditions, most Breslau Jews, including Toren's father, Dr Georg Martin Tarnowski, saw themselves as patriotic Germans, committed to German culture and integrated into the city's public life. Relations between Jews and Gentiles were cordial, even if social interaction was limited.[6] Tarnowski senior, like many Breslau Jews, had served in World War I. He was proud to lead the Breslau chapter of the *Reichsbund Jüdischer Frontsoldaten* (Association of Jewish War Veterans). Efforts to win him for the Zionist cause were rebuffed.

Together with his elder brother, Hans Hermann Alfred Eberhard Tarnowski, Toren grew up in a luxurious apartment whose walls were adorned with more than a dozen paintings by the Jewish Impressionist artist Lesser Ury. The family home was above a liquor store on a grand boulevard that Toren describes as the 'Champs-Elysées of Breslau', the Kaiser Wilhelm Strasse. It would later be renamed by Adolf Hitler as the Strasse der SA in honour of the *Sturmabteilung* (SA), the Nazis' vicious paramilitary unit.

Tarnowski senior, a successful lawyer, was a religious liberal and the family attended the Neue Synagoge, the largest in Germany after the Berlin synagogue and considered the second most beautiful after Berlin. It served a Reform congregation. When Toren's father married his mother, her dowry included a pew in the second row in the centre, a sign of status in which he took great pride.

For his primary education, Toren attended a progressive private school called the Weinholdschule, which counted only a handful of other Jewish pupils. Among them was Anita Lasker, a talented young cellist who was Toren's first love. They held hands secretly under the desk and walked part of the way home from school together.[7] Anita Lasker-Wallfisch, as she later became, survived Auschwitz because she was selected to play for the women's orchestra at the camp. After the war she fled to Britain

to become a founder member of the English Chamber Orchestra.[8] She remembers Toren as an unruly little boy with blond locks and a fringe.[9]

Another of Toren's closest childhood friends was his classmate Bolko von Eichborn, a sturdy child from an aristocratic German banking family who protected Toren from bullying by threatening to beat up anyone who laid a finger on him. At ten, Toren followed in his father's footsteps by going to the Zwinger Gymnasium, the best secondary school in Breslau. Eichborn went there, too, and their friendship continued.

Toren's great-uncle David Friedmann was a wealthy sugar industrialist who built up a business empire in Breslau. He had also run a brick-manufacturing company in partnership with Toren's grandfather, Siegmund Friedmann, who died when Toren was young. Mild-mannered Uncle David was much admired in the family because, Toren said, 'he was very rich and very nice'. Already in his sixties when Toren was a boy, Friedmann had a bald patch to which he applied a dusting of white powder. When Toren was very small, he believed it was a topping of the sugar his great-uncle produced. He remembered Uncle David giving him 100 Reichsmarks – a lot of money at that time – at his bar mitzvah on 7 May 1938.

Friedmann primarily made his fortune as a landowner. He owned four country estates about an hour from Breslau and leased land to farmers to grow sugar beet. His properties, about 10,000 acres in all, included Grossburg, where he operated a sugar refiner and a distillery, and where he kept horses. The stable master there taught Toren to ride on one of the ponies. At Michelwitz and Schweinebraten, Friedmann grew beet; the fourth estate, Haltauf, was not agricultural but comprised a hunting lodge and extensive forest.

In Breslau, Friedmann lived in a palatial villa furnished with porcelain, Persian rugs, antiques and paintings – at number 27 on leafy Ahornallee, now Aleja Jaworawa – in a residential district in the south of the city inhabited by many wealthy Jews. A few blocks away was the home of Max Silberberg, its walls adorned with his magnificent collection of paintings by Cézanne, Monet, Manet, Renoir and Van Gogh. Its

fame had spread far beyond the region of Breslau. Nearby lived Carl Sachs, who produced and sold haberdashery items and accumulated precious prints by Edvard Munch, Toulouse-Lautrec, Francisco Goya and Honoré Daumier. He regularly loaned works to museums as far away as Berlin and Zurich. Another neighbour, the textiles merchant Leo Lewin, supplemented his fine array of French Impressionists with more modern works by Munch and Picasso. Liebermann, the best-known German Impressionist, and the artist Max Slevogt were guests at Lewin's home and painted portraits of his family.[10] As the art critic Karl Scheffler put it in 1923, these collections 'are important to the city in a way that cannot be expressed in sums of money, but because they generate intellectual energy and thereby become custodians of a resource that should be more important to us today than anything else'.[11]

Friedmann's villa housed works by the French Jewish Impressionist Camille Pissarro and by Gustave Courbet, as well as a trove of precious faience pottery – Dutch, Italian and German. The Liebermann painting of the two horsemen by the sea hung in a dark anteroom leading into the winter garden, illuminated by a lamp on the wall opposite. His Dutch beach scenes are among Liebermann's best-known paintings: a Jewish Berliner, he spent many summers in the Netherlands, inspired by the subtlety and variety of the light. He wrote to an art critic in 1900 saying he had entered a new creative period: 'In the three months that I just spent in the Netherlands I shed my skin once more and am painting horses and naked women (the women are not on horseback.)'[12] Friedmann may have bought the picture in 1902 at an exhibition in the Lichtenberg gallery in Breslau. He loaned it on several occasions, including to a 1905 exhibition at Paul Cassirer's Berlin gallery and for a 1927 retrospective to commemorate Liebermann's eightieth birthday.

Friedmann entertained in style at his home and every two weeks he hosted a session of Skat, a three-person card game popular in Silesia. The composer Richard Strauss was a regular guest, and Toren's father often made up the threesome. A family story is that Strauss stayed late to play cards on an evening when he was scheduled to conduct at the Breslau

opera house. Suddenly noticing it was already nearly 8 p.m., one of the guests turned to him in consternation. 'Herr Strauss, shouldn't you be at the opera by now?' he asked. 'They can't start without me,' the composer is said to have replied calmly.

Despite its liberal reputation, Breslau became one of the earliest and most ardent centres of Nazi fanaticism. Even in 1930, three years before the Nazis took power, as many as 25,000 people crammed into the city's Centennial Hall to hear Hitler speak, while another 5,000 or more thronged outside to listen to him on loudspeakers.[13] The Nazis won a higher percentage of votes in Breslau than in any other large city in 1933. Top city officials often took the lead nationwide in introducing anti-Jewish measures and the thuggish chief of police, Edmund Heines, was also an *Obergruppenführer* in the SA. He orchestrated a raid on the courthouse to expel Jewish lawyers in 1933, and initiated a book-burning ceremony of works by Jewish authors on the palace courtyard in 1934. Jewish members were expelled from the boards of the city museums and their friends' associations in 1933.

From the year the Nazis took power, Jews were excluded from the professions and their businesses were subject to boycotts. From 1935, their properties were seized. Toren's nanny was compelled to leave the household that year. As a non-Jewish woman under the age of forty-five she was banned from working for Jews under the Nuremberg Laws (see pages 85–86) because of fears of *Rassenschande* (racial pollution).

Toren recalled Adolf Hitler visiting Breslau in 1936. Minutes before he was scheduled to ride along the Strasse der SA in an open-topped Mercedes, officials with megaphones warned residents to close their windows and told Jews not to look out onto the street. Toren disobeyed and peered out. 'I saw him,' he says.

As a schoolboy, Toren experienced anti-Semitism from Nazi teachers, who used any excuse to slap him. He had a history teacher who told his pupils that the British Foreign Minister Anthony Eden, an opponent of the policy of appeasement Britain adopted towards Hitler and the Nazi Party, had a sister who was married to Stalin, and the two men were

planning to conquer the world. Toren piped up to say he didn't think it was correct that Stalin and Eden were related by marriage, so the teacher beat him. Toren's Jewish classmate Franz Loeser, who later became a Marxist professor of philosophy in East Berlin, recalled the constant bullying in his memoirs. 'Klaus and I were banished to the back row, right in the corner – the classroom ghetto,' Loeser wrote. He remembered fellow pupils pushing him and Toren downstairs after a Latin lesson, shouting racist taunts as they beat the two boys up until they were bleeding and their clothes were ripped.[14] Toren doesn't remember this particular anti-Semitic incident: 'There were so many.'

By the age of thirteen, Toren was denied many of his school friends' pleasures. Cinemas and ice-cream parlours posted signs saying 'Jews Not Welcome' on their doors. His extracurricular activities by necessity revolved around Jewish groups, including the Association of Jewish War Veterans, which his father led. The association offered members' children clubs and classes, and Toren signed up for karate and ping-pong.

The turning point in David Toren's young life and in the lives of many other German Jews came on 9 November 1938, a night of pogroms that became known as *Kristallnacht* (the Night of Broken Glass) because of the shards of glass that littered the streets the following day. Nazi mobs rampaged through cities across the German Reich, destroying Jewish businesses and institutions, and attacking Jews on the streets.

That evening, Toren left home for his karate lesson, a regular fixture from 7 p.m. to 9 p.m. But his teacher, a Korean who was studying at the University of Breslau and had a black belt in karate, sent the boys home straight away, with strict instructions to avoid street corners. He warned them that members of the SA were planning terrible attacks on the Jewish community. He asked whether any of the boys had a shop in their building. Toren answered that his family lived above a store selling liquor, tobacco and sweets.

The karate teacher telephoned Toren's father to warn him that shops would be smashed up and advised him to go and stay with a single female relative, somewhere where no men were registered as residents. He

told Tarnowski that the Gestapo was planning to arrest all Jewish men aged between seventeen and seventy-five the next morning. Tarnowski thanked him for the advice, but said he had an important appointment the following day and needed to be at home. He asked how the Korean knew of these secret plans. He replied that he had himself joined the SA to ease his integration into Breslau society, and would shortly be putting on his own Brownshirt uniform and making his way to the street corner assigned to him, ready for a night of plunder and terror.

Toren walked home with a friend, avoiding street corners, where they already spotted huddles of four or five SA men poring over city maps to identify their Jewish targets. The boys' efforts to be inconspicuous proved unsuccessful and they were waylaid by a gang of SA thugs. The Brownshirts quizzed them about where they were going and why they weren't wearing the Hitler Youth uniform. Toren gave them his Uncle David's address and said his father couldn't afford the uniform. The SA men were puzzled. 'You live there, and you can't afford the uniform?' they asked. Still, they let the boys go on their way.

But in his confusion, Toren's friend had dropped some leaflets he had picked up at the Association of Jewish War Veterans. One of the thugs saw them. 'They're lying, they're Jews, let's get them!' he cried out. The boys pelted.

Toren's friend was a good runner, but Toren was not. He heard one of the Brownshirts behind him, panting as he caught up. Toren stopped, swivelled 180 degrees and delivered a karate kick to his genitals. 'You pig!' the man shrieked, doubled over in pain. Toren escaped and ran home, unscathed apart from a broken toe.

Later that evening, Toren's elder brother rushed to the Neue Synagoge with a group of friends to try to save the Torah scrolls. He didn't succeed. The building was surrounded by SA men and they couldn't get close. He stayed overnight at a female friend's house to avoid arrest.

The night of anti-Jewish terror wreaked devastation in Breslau. The magnificent Neue Synagoge was burned down – only its outer walls were left standing so that the fire wouldn't spread to neighbouring,

non-Jewish buildings. Two other Breslau synagogues were demolished overnight, the orthodox Storch Synagogue was vandalized, a community centre and ten Jewish inns were destroyed, and at least five hundred Jewish shops were pillaged and laid to waste.[15]

Back at his apartment, Toren watched unseen from the balcony with his parents as the liquor store was plundered and bottles smashed against the walls and consumed. He remembers that the building reeked of alcohol for days afterwards. His bicycle was stolen.

The next morning at about 7 a.m., Toren's father was being shaved by an elderly man who came to the house every day when two Gestapo officers arrived at the door demanding that he accompany them. Tarnowski told them he had an important meeting with General Ewald von Kleist at 11 a.m. and couldn't leave Breslau. The officers were undeterred, and he was forced to go with them – one of 2,471 Jewish men aged between 17 and 75 who were arrested that day in Breslau for deportation to the concentration camp at Buchenwald, near Weimar.

His meeting at David Friedmann's villa was to complete the sale of one of Friedmann's estates. Tarnowski was no longer permitted to practise as a lawyer but he could still advise Jews on their legal affairs. Friedmann knew the Nazis would confiscate all his land sooner or later. Acquainted with Kleist, he had approached the general to suggest a sale knowing that he was seeking to acquire a hunting lodge and grounds. Toren thinks Kleist – who would later lead Hitler's Panzer division in the invasion of Poland – was 'a gentleman' who had offered a fair price for Friedmann's Haltauf estate despite the context of the sale.

In a state of panic, Toren's mother Maria telephoned the general at his hotel to tell him her husband had been hauled off to Buchenwald. Kleist pulled rank to have Tarnowski released – but only for the day. Tarnowski was driven to his meeting from the Gestapo headquarters in a Mercedes by two *Schutzstaffel* (SS) men so that he could attend the contract signing.

Armed with underwear and warm clothes for his father, Toren and his mother took the No. 12 tram to Uncle David's villa. The signing took

place in the winter garden. Toren sat waiting in the anteroom that held the Liebermann painting, *Two Riders on the Beach*. It was the last time he saw it.

After the signing, Toren went to play with his friend Bolko von Eichborn at his family villa. Bolko's mother had suggested the arrangement to keep Toren out of harm's way during the dreadful events that day. In the evening, the two SS officers escorted his father to Buchenwald, where he would remain for three weeks.

The conditions at Buchenwald were horrific. Sadistic guards revelled in humiliating and whipping their prisoners, who were housed in five hastily built wooden shacks. Water was scarce and as many as thirty prisoners a day died. Others were driven to insanity and killed themselves by running against the electric wire that surrounded the camp.[16]

Though physically strong, Tarnowski returned a changed man, gaunt with terrible diarrhoea and a shaved head. The night he came home, his first action was to check the bed where his elder son slept. His hair was still intact. Tarnowski knew that Hermann had been saved from arrest and the horrors of Buchenwald – at least for the time being.

Jewish children were no longer permitted to attend state schools, and Toren moved to one of two Jewish schools. Close to his home, on Rehdigerstrasse, it was gradually bleeding pupils in part because of emigration, in part because parents no longer had the means to earn a living to pay the fees.[17] Yet the academic standards were high.

Two days after *Kristallnacht*, the Nazis announced that they would levy 1 billion Reichsmarks from the Jews as 'atonement' for the damages (the *Judenbusse*), placing the blame for the pogroms squarely on their victims. Living conditions for Jews across Germany became increasingly grim. Toren's non-Jewish friends stopped calling. The family was forced to relinquish its silver and jewelry – his elder brother cleverly embedded his in pieces of nougat, which he posted to friends in Sweden and England, who saved them for him. Jews were also banned from keeping pets, and Toren was heartbroken at having to give away his two parakeets, Habakkuk and Zephaniah.

On his release from Buchenwald, Tarnowski had been forced by the Gestapo to sign a document swearing that he would do everything he could to emigrate. Yet by now, options were limited. Toren remembers that the Dominican Republic, Cuba and Shanghai were among the few places open to Jews. As a lawyer, Tarnowski was only qualified to work in Germany. He didn't want to leave and used to say, 'I am not going to Shanghai to sell shoelaces.'

Yet their parents hatched plans for Toren and his brother to escape. Tarnowski registered his younger son for an American philanthropy project, set out in a parliamentary bill backed by First Lady Eleanor Roosevelt, under which a number of unaccompanied Jewish children from Germany and Austria were to be evacuated to the United States. This programme would supplement the official immigration quotas, which were tightly restricted and had spawned long waiting lists for German and Austrian Jews desperate to escape the Nazis. The documents from the US arrived and Toren's father obtained a visa for him, but they heard nothing more.

The background to this silence was that the State Department opposed the bill and so, polls showed, did a majority of Americans. Anti-Semitism at that time was not limited to Germany. President Franklin Roosevelt, who didn't always see eye to eye with his politically active wife, failed to give her his support and dodged the issue of the child immigrants, and the programme never materialized.[18]

Finally, Toren's father managed to squeeze him on what would prove to be the last *Kindertransport* evacuation to Sweden before World War II broke out, securing him a place reserved for a child who had already left for the Dominican Republic. The Swedish government agreed that Jewish groups could rescue five hundred children from Germany, Austria and Czechoslovakia and place them in Swedish homes. Toren, now fourteen years old, left on 23 August 1939, a week before Germany invaded Poland. He was permitted to take a small suitcase with clothes and one set of silver cutlery. He remembers about fifteen children gathering at the station in Berlin for tearful farewells to parents most of them would never see again.

From Sassnitz on the Baltic Coast, Toren's group of children crossed on the ferry to Trelleborg. In Stockholm many of them had foster parents waiting for them, but Toren did not. Instead he was placed with a foot doctor, a bachelor living in the city of Norrköping. The man turned out to be a crook who was plotting to use the boy to get money out of his parents. Toren's adventures were far from over.

He was put up in a guest house about an hour north of Norrköping, in a bunk bed in the garage, which he shared with an Austrian business-man. The Austrian told him how he had himself been defrauded by the Swedish foot doctor. A woman staying in the guest house advised Toren to leave as soon as he could and suggested he accompany her to her home in the north of Sweden. After a long train journey, he arrived in a village called Undrom in the remote, picturesque Angermanland, a region of fjords, swamps and forest. Safe but somewhat stranded, he attended the local school with much younger children to learn Swedish, picked blue-berries and lingonberries, and wondered how he was going to study and make a start in life.

A place was eventually found for him at a home for Jewish refugees from Nazi-occupied Europe near Uppsala. It was a primitive exist-ence, but Toren liked it. Whenever adults asked him what he wanted to do professionally and suggested he train to be a baker or a printer, he would answer, 'I want to go to school.' Yet there was no one to pay for the schooling.

Finally, from Breslau his father managed to track down a distant relative in an upmarket suburb of Stockholm, a wealthy old lady called Mrs Spitzer. Toren visited her and she agreed to finance his tuition: 'She was my salvation.' Even after her death, her estate continued to pay. Toren passed his school-leaving exams and went on to study chemistry in Stockholm.

In 1948, he was one of seven Jewish boys recruited in Sweden by Haganah, the predecessor of the Israeli Defense Forces, and he left for Israel. Soon after his arrival, he was discharged from the army because his eyesight was not good enough. He began working as a chemist, first

in a cosmetics factory, then in a pharmaceutical company. He found both jobs dull, and applied for a position in Tel Aviv as an assistant to a patent attorney.

It was in Israel that he met his wife, an American social worker. After their wedding, the couple went to London for a year, but Toren struggled to find his feet there because only British citizens were accepted to work for patent attorneys in the years after the war. In 1955, they moved to New York, where Toren studied law. The boy who had insisted on going to school as a penniless refugee in Sweden became one of America's best-known German-speaking patent attorneys. Clients for whom he won cases included the Swiss Cheese Union, the aviation company Messerschmitt-Bölkow-Blohm, and Arnold & Richter Cine Technik in Munich, a maker of movie cameras.

Toren and his parents corresponded by post for his first years in Sweden. The mail was censored, and the Tarnowskis didn't want to cause their son anxiety or grief. The letters, which he still possesses, recount 'only nice things', Toren says. His brother Hermann had escaped a week later on a similar *Kindertransport* rescue mission to the Netherlands, then on to Britain. Toren managed to communicate to his parents in code that Hermann was studying chemistry at Leicester University.

By the time Toren left for Sweden, about half of Breslau's Jews had emigrated. Nearly all those who remained, unable to get a visa and escape, were killed.[19] To this day, Toren doesn't understand why his father made no attempt to leave. It still troubles him. As the lawyer representing the German branch of the Swedish match-manufacturing empire founded by Ivar Kreuger, Tarnowski had good contacts in Sweden whom he had used to help others and who could have dropped him a lifeline out of Germany. His father-in-law Siegmund Friedmann had imported timber from Venezuela and served as consul general for the country in Germany, so Tarnowski could also have pulled strings with Venezuelan diplomats to get visas.

The plunder of the Jews that Toren had witnessed – he had taken a trip with his father to hand over the family jewelry and silver – continued

apace after his departure. The Silesian Museum of Fine Arts had been placed in the hands of Cornelius Müller-Hofstede, an art historian sympathetic to the Nazis, in 1934. Müller-Hofstede saw the plight of the Jews as an opportunity to enrich his museum. The collectors who had previously shown such largesse to the Silesian Museum of Fine Arts would now be robbed by it. Their generosity was forgotten, hushed up and denied.[20]

The rapacious Müller-Hofstede cooperated with Sigfried Asche, the director of the art museum in Görlitz, in valuing, stealing, bartering and selling or dividing the spoils. After viewing Carl Sachs's collection, Asche compiled a wish list, although Müller-Hofstede took first pick. 'We no longer need to confine ourselves to non-existent budgets,' Asche wrote to his fellow museum director triumphantly. To cover up the crime, government officials invented tax debts and justified the seizure of the collections as payment. The Silesian Museum of Fine Arts experienced the biggest expansion of its collection in its fifty-year history, consuming the collections of Sachs and Silberberg, among others.[21]

The details of the seizure of Friedmann's collection are not known in full. On 5 December 1939, a Dr Westram of the Lower Silesian governing board wrote a letter to Walther Funk, Hitler's Minister of Economics, in which he complained that the rules on seizures of Jewish assets were not far-reaching enough and hadn't given him the authority he needed to confiscate art collections belonging to Breslau's Jews. Even so, he reassured the minister, he had taken the precaution of inventorying some of the collections, and needed his guidance on how to prevent them from being taken out of the country by emigrating Jews.

Two inventories had been taken of Friedmann's collection, Westram wrote. The first had put a value of 10,785 Reichsmarks on it, but members of his own team had later estimated it to be worth ten to fifteen times that. He said the Liebermann painting of the riders alone could fetch between 10,000 and 15,000 Reichsmarks if sold abroad: 'I have forbidden the Jewish owner to sell any of the works or to dispose of it otherwise without permission.'[22] In September the following year, Westram sent a

memo to mayors and heads of administration justifying the seizure of Jewish art collections by saying they were 'enemy assets'.[23]

Life for the Jews deteriorated further after the outbreak of World War II. Emigrating became increasingly difficult, especially after the United States entered the war. In July 1941, the month that Reichsmarschall Hermann Göring asked the SS to submit a plan for the 'final solution' of the Jewish question, Breslau began deporting Jews to concentration camps. A Jewish old people's home was evacuated so that it could be used as a military hospital; its residents were sent to camps. In November that year, one thousand Breslau Jews were arrested and sent to Kaunas in Lithuania, where they were forced to dig graves and undress before being shot.[24]

David Friedmann was evicted from his villa in 1941. He died of natural causes on 15 February 1942. The house was sold at auction and the proceeds 'forfeited to the Reich'.[25] The warehouse record of the Silesian Museum of Fine Arts notes that *Two Riders on the Beach* and a second Liebermann painting owned by Friedmann, *Basket Weavers*, entered the museum collection in July 1942, having been acquired at auction in Breslau. Friedmann was by then dead; his daughter Charlotte, Toren's cousin, had been deported to Ravensbrück concentration camp, from where she was sent to Auschwitz and murdered in October 1942.[26] Apart from his brother and an aunt, an art historian who survived Theresienstadt and later joined him in Sweden, Toren lost all his extended family in the Holocaust.

Toren knows little about the horrors his parents must have endured in their last years in Breslau. His mother was employed as a slave labourer in a factory, and in their last weeks his parents lived in a Jewish residence after being evicted from their home. He found documentation showing that the landlady of the residence complained to the Gestapo that the Tarnowskis had been insolent enough not to pay the rent for the last month they were there – the month they died. On the day before their deaths, Toren received a postcard from his parents saying that they were going to be 'resettled in the east', a Nazi euphemism that he didn't know how to interpret.

A girlfriend of Toren's brother was a nurse at the Jewish hospital in Breslau. She was deported to Auschwitz on 5 March 1943, on the same train as Toren's parents. In the selection process at the camp, she was chosen to work and survived. She saw the Tarnowskis walking towards the gas chambers, the last known sighting of them alive.

More than 1,400 of Breslau's Jews were deported to Auschwitz and 809 of them were gassed. Nearly 3,000 went to Theresienstadt – only 24 survived. In Breslau city, only 160 Jews were alive when the war ended.[27]

Toren returned to Wrocław in 2003 to revisit old haunts. He found Friedmann's villa intact, and was informed by a local that it now served as the city headquarters of the Polish secret service. He received some money in compensation for the loss of Friedmann's house.

Yet none of the art collection has been recovered. For Toren, that grainy projected image of *Two Riders on the Beach* on TV in November 2013 – seventy-five years after he had last seen the painting – was the first evidence that at least part of Friedmann's collection had survived intact. It was his favourite painting at Uncle David's house. 'I always liked that painting because I liked horses,' he says. Toren is not one to give up easily: 'I will get it back.'

As Friedmann's heir, Toren views it as his duty to recover the family's lost artwork, for the sake of his son Peter, his grandson and his brother's three daughters. His brother anglicized his name to Herman Peter Tarnesby, became a psychiatrist on London's Harley Street and lived in England for the rest of his life. He died in 2014 at the age of ninety-three.

Toren will never be able to see his favourite Liebermann painting again. He is blind. He was born with a degenerative eye condition known as retinitis pigmentosa, which didn't prevent him from reading, writing and finding his way around New York. Then in 2007, he contracted shingles. A devastating side effect of the disease was the complete loss of his eyesight within three days.

On the living-room wall in his Madison Avenue apartment is a copy of the Liebermann painting by a South Carolina artist called Christian Thee. The artist wanted to enable Toren to enjoy his painting again in a different form, and created his copy as a three-dimensional relief so that Toren can feel the contours of the horses and riders against the backdrop of the foamy waves.

Fremy and Toren filed a claim for Liebermann's *Two Riders on the Beach* with the state prosecutor in Augsburg immediately after it was shown on television. They believe the Munich cache may contain other works from Friedmann's valuable collection. Gurlitt's hoard included works by Courbet and Pissarro, both artists whose works hung in Friedmann's home. But it may be difficult to identify them with any certainty as Toren has no list of his great-uncle's artworks.

Impatient with the German government for taking so long to resolve his claim for the horsemen on the beach, Toren filed suit against the Republic of Germany and the Free State of Bavaria at the United States District Court for the District of Columbia on 5 March 2014. For Toren, approaching his nineties, time is of the essence. Justice delayed could be justice denied in his lifetime.

Friedmann is listed as the second-to-last owner of *Two Riders on the Beach* in Liebermann's catalogue raisonné, a register of the artist's works with details of ownership history. The last known owner is Hildebrand Gurlitt, Cornelius's father, an art dealer who worked for the Nazis.

It was Hildebrand who amassed the Munich hoard. To find its origins we have to retrace his steps and go further back in time to another eastern German city, home to some of the nation's finest art treasures.

2 This Barbaric Art

Hildebrand Gurlitt first encountered the art that was to shape his life in a shop selling lamps on a bleak Dresden street in 1912. His mother Marie took him as a schoolboy aged about sixteen to see an exhibition of the founders of the wild young Die Brücke (The Bridge) group of artists – Ernst Ludwig Kirchner, Karl Schmidt-Rottluff and Erich Heckel.

The pictures shocked him. Though he had seen some Vincent Van Gogh and Edvard Munch works, this was something newer and brasher. 'These barbaric, passionate, powerful colours, this coarseness, all framed in the cheapest wood – this art wanted to give the bourgeoisie a slap in the face and it succeeded,' he wrote later. His mother was impressed, and purchased one of the extraordinary woodblock prints.[1]

Kirchner, Schmidt-Rottluff, Heckel and Fritz Bleyl, pioneers of German Expressionism, founded the Brücke group in a disused shoe-maker's shop in 1905 while studying architecture at the Dresden Technical School, where Hildebrand's father Cornelius was chancellor. They swapped their studies for art and a bohemian lifestyle that entailed much naked bathing with young female models in the lakes around Dresden. Their nude portrayals were often sexually loaded. Wooden figures of naked women served as furniture and sculptures in Kirchner's studio and his tiles, curtains and wall hangings featured copulating couples. In Germany's prim pre-World War I society, they aimed to provoke with their liberal ways as well as their art. The group's revolutionary manifesto, as proclaimed in wood by Kirchner, was to 'call on all youth to unite, and as the standard-bearers for the future, assert our creative freedom and freedom of lifestyle in a stand against cosily entrenched older forces'.

Cornelius Gurlitt senior, whose fields of expertise encompassed architecture, art history, heritage protection and city planning, was the embodiment of those 'entrenched older forces'. He taught Kirchner,

Heckel and Schmidt-Rottluff. Though he could never tune to the wavelength of the Brücke members and didn't connect with their art, he could see that they were more than rebellious university dropouts. By then in his sixties, Cornelius predicted to his son that these radical young artists, with their bold colours, angular figures and highly sexed vigour, could play as big a role in Hildebrand's life as 19th-century artists like Hans Thoma, Max Liebermann and Arnold Böcklin had in his own.[2] Time was to prove him right.

Hildebrand grew up in an elegant white villa designed by his father on Kaitzer Strasse in Dresden. At that time, Dresden was the cultural jewel in Germany's crown, often described as the Florence of the north. His family was steeped in the arts. His father, a patriarch of Dresden and trusted adviser to the king of Saxony, devoted much of his illustrious career to preserving and reviving interest in the city's magnificent Baroque buildings. The extension of Kaitzer Strasse is to this day called Cornelius Gurlitt Strasse. Cornelius, prone to self-importance, would probably have heartily approved. Though intimidating to strangers[3] and old-fashioned in some of his ideas, he was a kind and loving father to his three children and welcomed their friends into his comfortable but unostentatious home.

Cornelius's mother was a descendant of the Lewalds of Königsberg, a prominent Jewish family, and her sister Fanny Lewald was a famous feminist novelist. Hildebrand's grandfather Louis Gurlitt was a landscape painter and his cousin Manfred was a composer. One of his uncles, Ludwig Gurlitt, taught art history at Munich University. Another, Fritz Gurlitt, ran an avant-garde Berlin art gallery; an exhibition of the Brücke artists was staged at the gallery in 1912, the same year as the show Hildebrand saw with his mother. In the 1890s, Fritz had been among the first dealers to exhibit the French Impressionists, long before they had become the rage in Paris. He also represented Böcklin, Liebermann and Thoma, the popular artists of the 19th-century German-speaking world.

Hildebrand completed his schooling and registered to study art history at the Dresden Technical School in 1914. World War I intervened,

putting his plans on hold for four disruptive years. Both he and his elder brother Wilibald volunteered. Their father, an ardent patriot who had himself fought in 1870 in the Franco-Prussian War, expected nothing less. Hildebrand described the boredom and horror of life in the trenches on the Western Front in letters and postcards to Wilibald. 'These hours where we are sitting in the dug-out listening to grenades whistling over our heads or above our cover are exhausting,' he wrote in January 1915. 'The absolute defencelessness of our position brings us to despair sometimes. We are constantly hoping to advance, even if in our section there is no prospect of that.'[4]

With his lively intellect and abundant energy, Hildebrand seemed to suffer more from frustration than fear. He complained of the 'big, contagious war sickness: stultification of the mind' and described to his brother how he tried to use every free minute to learn and read.

He was wounded at least twice, at the Somme and in Champagne, where he served as an officer in the machine-gun division. Many of Hildebrand's friends lost their lives in the bloody, muddy battlefields of the Somme, where tens of thousands were massacred. He later said it was the 'chance of a ten-thousandth of a second' that he was not among them and was instead sent home with injuries.[5] At the front in France he formed a lasting friendship with Arnold Friedrich Vieth von Golssenau, who later became a well-known communist writer and changed his name to Ludwig Renn, the hero of his novel *War*. Renn described Hildebrand as 'lively and talkative', and said he argued with more traditionally minded peers and quoted frequently from an avant-garde magazine called *Aktion*, which he somehow managed to get delivered past the censors to the front. Together they pored over its pages, Renn startled by the anti-war sentiment and baffled by the Expressionist poetry.[6]

Hildebrand's correspondence during the war betrays a close and affectionate relationship with his family, particularly with Wilibald and his sister Cornelia, six and five years older. That intimacy sustained him through the tedium and terror of the trenches and the long periods away from home. 'I have no greater wish than to be together with my

two siblings,' Hildebrand wrote to Wilibald in 1916. Cornelia, an artist known by the family as Eitl, volunteered as a nurse for the Red Cross. Hildebrand described to his brother a birthday at home in Dresden during his leave, when Wilibald was a prisoner of war in France. His brother's card was delivered to him under burning candles, in a wreath made by Eitl.[7]

Hildebrand's later war service was much less gruelling, working as an army press officer and discovering what he described as the 'mysterious Polish, Lithuanian and Yiddish Baroque cities of the winter and the night, Vilnius and Kaunas, where we thought we recognized images from Chagall's paintings'.[8] There he became friends with the Brücke painter Schmidt-Rottluff and the Jewish writer Arnold Zweig, with whom he worked together on the *Wilnaer Zeitung*, a newspaper for the German troops on the Eastern Front. Ludwig Renn recalled Hildebrand enthusiastically regaling him with stories about his work, especially the editorial team's subversive attempts to sneak anti-war articles and cartoons into the newspaper. Once, when they were both on leave in Dresden, Hildebrand showed him a satirical graphic by Magnus Zeller, mocking Kaiser Wilhelm II and the militaristic General Ludendorff. It had been discovered just before deadline and quickly spiked.[9]

Eitl was serving a short train ride away, working nightshifts at the hospital and painting during the day. Hildebrand spent weekends with his elder sister and a pretty, vivacious nurse called Hedwig Schloesser. Together they 'spoil me much more than I deserve and we go canoeing and lie in the woods', he reported back to Wilibald, who had been taken prisoner of war after being wounded in the Battle of the Marne in 1914 and was only released, to neutral Switzerland, in summer 1918. Hildebrand remained in Kaunas until January 1919, long after others had demobilized. It may have been Hedwig who persuaded him to stay – it seems they set up house together there. Hildebrand described the summer of 1918 as the happiest of his life.

The Germany he returned to was not the one he had left behind. The scarred and mutilated war wounded, grotesquely portrayed by

Otto Dix, Max Beckmann and George Grosz, begged in public places to survive. Food and coal were scarce and people were hungry and cold. Paramilitary groups fought armed battles on the streets and hatched terrorist plots to murder their opponents. Demonstrations, strikes and riots raged through the cities. Yet revolution brought a new creativity as it ripped apart the rigid pre-war structures. In the constitution drafted in Weimar in 1919, the freedom of the arts was anchored in law for the first time. Order and tradition gave way both to chaos and to a new social, intellectual, artistic and sexual freedom that was to usher in a tragically short-lived era of flourishing creativity.

Like the millions of other soldiers who returned to this fractious, un-German tumult, Hildebrand was also changed forever, no longer the schoolboy who had volunteered to fight with enthusiasm. His war service, an experience he shared with many of the artists whose work he later collected, earned him Saxony's highest military honours. It also left him sceptical about politics and determined to focus on art alone. He tried to keep his distance from the turmoil of the streets and the violent political exchanges. He lamented the 'hate preached by every party and every newspaper, the hatred of everyone for everyone else'. He wrote to Wilibald in 1918 that 'my political position is non-existent', adding that he would vote for no party to the left of the moderate Social Democrats. Yet he spurned the nationalists, too, chiding himself for taking up their cause so readily when he volunteered to serve in 1914. 'I believed all that stupid talk in the newspapers and everywhere about honour, bravery, patriotism and so on,' he wrote.

Imagining that art could provide an escape route from politics in the era in which Hildebrand lived was a grave miscalculation. Art was to prove no refuge from a devastatingly destructive political movement led by an embittered, failed artist called Adolf Hitler; instead it became a target for hate and intolerance. Perhaps more political engagement would have led Hildebrand to make fewer ideological compromises later in his life.

He studied art history in Frankfurt, choosing the city because it was less politically fraught and prone to rioting than either Munich or Berlin

and boasted one of the richest German art collections. He wore his old military coat dyed black. His family's wealth had evaporated in the inflation of the time and he was afraid his good woollen overcoat would be stolen – along with the twenty or so others filched from the university each day. His letters home suggest he was happy despite the hardships of the era and his young man's appetite. His parents posted him potatoes and cabbage. 'I won't suffer too much in all this poverty and the bad things that our defeat will bring Germany,' he wrote to them in February 1919. 'It's no great pleasure, but I am capable of eating at the soup kitchen with all the refugees from Alsace without having to overcome too much disgust, and it tastes better to me than it does to them.' He described being invited to the home of a rich Jewish doctor and wondered whether he would be asked again. 'There were good cakes and stuff,' he wrote.

Tragedy struck the Gurlitts later that year. Eitl had sunk into a deep despair after World War I, becoming inaccessible even to her younger brother. A talented artist, she took after her father in appearance and was tall and fair-haired. She was his favourite child and he had built her a studio in the courtyard of their Dresden villa.[10]

She revelled in the freedom she experienced serving as a nurse in Lithuania and had fallen in love with a married man – the art and theatre critic Paul Fechter, whom she met when he was working for the *Wilnaer Zeitung*. In 1917, she wrote to Wilibald describing her new friend as a person 'who immediately understands what I think and mean when I am talking about art'. Cornelia became pregnant by him and lost the child, either through an abortion or miscarriage, according to the story Wilibald's wife, Gertrud, told her son.

Miserable and lonely, Cornelia could not adjust to life in chaotic Berlin. 'She is crying for a happy time in Vilnius when everything seemed complete to her, and the wonder of that time has destroyed all her hope for the future,' Hildebrand wrote to their brother. As Marie put it in a letter to her eldest son, Fechter had made Eitl 'happy, then very happy, then very unhappy'. Hildebrand tried to warn Wilibald, then living in Switzerland, about Cornelia's despair. 'Eitl is in a much worse state than

you can imagine,' he wrote from Dresden. His attempts to get her to come home were to no avail as she wouldn't answer his letters.

Cornelia killed herself by taking poison. She went into a Berlin bakery for breakfast at 10 a.m. one morning, then fell asleep and never woke again. By 4 a.m. the following day, 5 August 1919, her heart had stopped. She left no letters apart from an old one addressed to her younger brother. 'But my mother said she found a small strip of paper with your name on it without an address,' Hildebrand wrote to Fechter three days after her death.[11]

Fechter, who remained friends with Hildebrand for decades after these sad events, wrote about Cornelia Gurlitt in his 1949 book *An der Wende der Zeit* (In a Time of Change), a compilation of essays about his encounters with female artists. He evoked a restless, passionate young woman who loved Chagall and Dostoevsky and scorned sleep to paint and to live life to the full. It may have been partly his conscience speaking when he described her as 'perhaps the most gifted of the younger generation of Expressionists' and rhapsodized about her Lithuanian landscapes and images of beggars and soldiers in Vilnius. Surviving pictures, many of them lithographs, show Cornelia's melancholy, emotional work bore similarities with that of the Brücke artists, though her lines are more delicate and precise, and there is a fantasy element that recalls Chagall.

Wilibald and Gertrud were expecting their first child when Eitl died, so it was Hildebrand who kept his distraught parents company in Dresden, sorted through her possessions and posted her paintings, drawings and lithographs to family members as mementoes. She was, he wrote to his mother Marie later, 'the person who was closest to me'. He kept some of her artworks for himself.[12]

Dietrich Gurlitt, the son born to Wilibald and Gertrud in Switzerland days after Eitl's death, is now in his nineties. Though he walks with the aid of crutches, his mind is alert. He says Marie regarded the suicide as a great disgrace and burned the rest of Eitl's artworks after Cornelius's death.[13] Ironically, given his own Jewish mother, Cornelius blamed the

Jews of Vilnius for his daughter's ruin. He lived in denial about her suicide, telling people she had died in the war.[14]

Hildebrand's grieving mother was frantically worried about him after Cornelia's death. 'He is so pale and thin,' Marie wrote to Wilibald. 'He misses Eitl and says he has no one he can confide in.' He had also fallen in love with Hedwig Schloesser, the nurse with whom he had set up house in Lithuania. Hedwig had been married briefly during the war and may have been older than Hildebrand. His parents disapproved, hurting Hildebrand's feelings. He wrote to them saying he couldn't bear their contempt and disgust for her, and asked them not to speak of her again with him.

Instead, they tried to recruit Wilibald's help in dissuading Hildebrand from the liaison, which was to last four years. Marie wrote to Wilibald that Hildebrand 'is still so young and has so much to learn' and 'is too easily influenced by others'. Much later, in 1922, Cornelius wrote in a startlingly frank letter to his elder son (with a request to Wilibald not to show it to his wife Gertrud) that Hedwig had divorced her husband because he had infected her with syphilis, and that she in turn had passed it on to Hildebrand. That may explain the wan complexion that so worried Marie in 1919, as well as Hildebrand's complaints of pain from a swollen liver over a period lasting several years.

Hildebrand picked up his studies in Berlin after Eitl's death. In the 1920s, it was the second-largest city in Europe, bustling with more inhabitants than it has now. It was a magnet for the young, poets and artists as well as for thieves, prostitutes, beggars and the homeless. A hub of economic activity, political strife, culture and nightlife, it provided a cosmopolitan haven for thousands of Russians fleeing the Revolution and had the biggest Jewish community in Germany. This was the Berlin of Christopher Isherwood, Alfred Döblin and Kurt Weill, a place of endless entertainment with its cabarets, jazz bars, crowded cafés, lavish new department stores, avant-garde theatres and seedy dance clubs.

On discovering that Hedwig was caring for Hildebrand when he contracted the flu there, his mother tried to persuade him to spend the

next semester away from his lover, in cosy Freiburg, where Wilibald was now teaching. Instead, Hildebrand used his university contacts to get a position as an assistant to the art history professor Georg Voss, helping to inventory the art collections of the state of Brandenburg, of which Voss was custodian. Hildebrand needed to remain nearby, and stayed in neighbouring Berlin. His parents couldn't object to the decision as he was gaining valuable work experience and earning money, reducing the strain on the ever-tighter family budget.

He returned to Frankfurt to study in May 1921. That summer he visited Hedwig Schloesser in Zofingen in Switzerland, writing to Wilibald that his stay with her 'is of no concern to society, the state or the family, as there will be no engagement or wedding'. Hedwig's name disappears from the family correspondence in 1922.

The following year Hildebrand got engaged to Helene Hanke, a dancer with the stage name Bambulla (which loosely translates as 'trouble'), and moved into his family's villa in Dresden with her because they couldn't afford their own home. This was the peak of hyper-inflation, and money, though abundant, was valueless. 'The soul suffers from the constant calculations, the huge sums, the enormous packets of money,' wrote Marie. She told Wilibald of a trip Helene and Hildebrand made to visit an artist in Loschwitz, a few kilometres away from Dresden, at about the time the Reichsbank began printing 100-trillion-mark notes: 'The smallest excursion has to be carefully considered because the train costs 35 billion marks.'

It's possible this was a business trip for Hildebrand, who had already begun dealing art by the time of his engagement. Before their wedding, he sent Helene to Berlin with a picture he wanted evaluated, and gave her a letter for Fechter asking whether he could take her out for lunch because she had few acquaintances in the city.[15] He had previously written to Fechter asking him to value an Erich Heckel painting that he planned to sell to a Dresden museum on behalf of a lady he didn't name.

Marie described Hildebrand and Helene's modest wedding celebration at home in Kaitzer Strasse 26 in a letter to Wilibald, who was unable

to attend: 'Everything was charming and harmonious, our home looked good, the table looked nice with the old Meissen etc. and father looked handsome in his medals. Most weddings are jollier, this one was quiet. Father found it hard – we missed Eitl, and you and Gertrud too, because the fact that you couldn't come reminded us of the difficult times we are living through.'

Helene seems to have met with the Gurlitt parents' approval, though Marie had to conquer her initial horror about her profession. Cornelius described her as 'a calm, quiet creature who is trying to support the household by teaching dance'. Hildebrand wrote in a letter to Wilibald, she 'is the only person I can sit in a room with and not be distracted. I am getting more and more work done.' Her family, he said, are 'very nice people, even if abstract academia is a long way away from their world'.

Hildebrand won his doctorate in 1924 with a thesis about the Gothic architecture of St Catherine's Church in Oppenheim. That year he also began working as an architecture professor's assistant at the Dresden Technical School, his father's academy. Since 1921 he had been writing for newspapers about art, thanks in part to Fechter's connections.[16] He continued doing so after he finished his studies, contributing reports and reviews on art and architecture to newspapers including the *Deutsche Allgemeine Zeitung*, *Dresdner Neueste Nachrichten*, *Vossische Zeitung* and the *Frankfurter Zeitung*. His reviews were knowledgeable, opinionated and lucidly written.

On assignment for the *Frankfurter Zeitung*, he travelled to New York to cover a city planning congress that his father also attended as head of the German delegation. Cornelius, who himself had written art reviews for magazines in the 1890s, thought Hildebrand's journalism was a 'useful way to oil the writer's wrist' but 'not a job for a serious person'.

In April 1925, aged just twenty-nine, Hildebrand took up his first real job when he was appointed the director of the cash-strapped King Albert Museum in Zwickau, a small industrial town southwest of Dresden. Though the museum was first opened in 1914, no full-time director had so far been appointed. The city council decided a director

could do much to encourage the patronage needed to compensate for the lack of public funds for the museum.[17]

In this sleepy provincial mining town, 'full of coalmines, industry, unemployment and rust'[18] as he put it, Hildebrand briefly opened a remarkable window on avant-garde creativity and intellectual exchange. For him, it was the fulfilment of a long-held dream. Even before he began his studies, Hildebrand had confided to Wilibald that he wanted to work as a museum director in a modern industrial city, using art to attract thinkers in all fields. He later wrote that he saw it as his role to 'eradicate some of the general awfulness' of Zwickau and that 'the uglier and grimmer life is in a town, the more agreeable the task' of running its museum and establishing a forum where creative minds could meet.[19]

He commissioned friends at the Bauhaus in Dessau, the cutting-edge architecture school, with the interior decor. He turned the main hall of the museum into an exhibition of medieval sculpture. Brought up to date with modern colours and the latest furniture, the revamped museum opened in October 1926.[20] Hildebrand's efforts made a profound impression on one young visitor, a schoolboy called Christoph Lenz, who decades later remembered the newly opened museum with its fresh modern colours – 'the beautiful grey, the mild blue' – and the stylish new Bauhaus armchairs as one of the highlights of his youth. Lenz tried to go to every event at the museum and worshipped Hildebrand from afar.[21]

Not everyone was as appreciative. The *Sächsische Volksblatt* newspaper reported on the official opening with a smirk at the incongruity of some of the guests and exhibits: 'It was a special pleasure to see distinguished gentlemen arrayed with medals and wearing steel helmets shake their heads in horror in front of the George Grosz, Dix, Kokoschka, Pechstein etc.'[22]

Hildebrand's first exhibition was devoted to Max Pechstein, a Zwickau artist who joined the Brücke group in Dresden soon after it was founded. Hildebrand staged the show with assistance from the artist and from his cousin Wolfgang Gurlitt, who took over the Berlin dealership of his father Fritz Gurlitt after World War I. The cousins later fell

out, but at this point Wolfgang was willing to loan Hildebrand some Pechstein works for the exhibition, as did a Dresden gallery. Hildebrand purchased five graphic works from the exhibition for the museum.

The composer Paul Hindemith gave regular recitals in the museum and Hildebrand also put on exhibitions of Schmidt-Rottluff, Heckel, Emil Nolde, Max Slevogt and Käthe Kollwitz.[23] He persuaded his Berlin art critic friend Fechter to venture out to the provinces to lecture and to write about the museum, raising its profile.[24] Among his most popular exhibitions were a 1927 show called 'Kitsch and Art' and a 1928 exploration of sexually transmitted diseases, which drew 7,500 visitors.[25] Hildebrand worked hard to push the buttons that would bring Zwickau's working-class citizens into the museum.

With virtually no budget, Hildebrand acquired mainly works on paper and sold some 19th-century works to buy the art of his day. This he did carefully, as he saw safeguarding the old collections as an important part of his role 'so that nothing historical – as indifferent as it may seem to us now – is lost or damaged, because it may be needed at a later time for a purpose that we can't even guess at today'.[26]

His primary interest, though, was contemporary art and his bold ambition for this industrial backwater was to build a collection 'unparalleled in Germany'. He found private sponsors, including the department-store magnate and publisher Salman Schocken (who was to emigrate in 1933 to Israel, where he became owner of *Haaretz* newspaper). Hildebrand showed amazing foresight, buying art by Paul Klee, Wassily Kandinsky, Oskar Kokoschka, Kollwitz, Kirchner, Heckel, Schmidt-Rottluff, Franz Marc, Emil Nolde, Edvard Munch, Otto Dix and more.[27]

These are artists whose works today can fetch millions at auction and delight visitors at museums around the world. Yet at that time, they were groundbreaking and daring, and many of Zwickau's conservative burghers did not share Hildebrand's modern tastes.

More sinisterly, the Nazi movement was gaining ground and the fascists understood that art is power. They were quick to embrace concepts of 'degenerate art' (*entartete Kunst*) that had taken root in the 19th

century. Max Nordau, a Jewish doctor and writer, had sparked much interest with his 1892 tome *Degeneration*, in which he equated artists with the mentally ill and warned of art's potentially 'corrupting influence on the views of a whole generation', particularly 'the impressionable youth'. He believed that all cultural disciplines should be state-controlled.

Though Nordau did not blame the Jews for social degeneration and became an ardent Zionist, the Nazis linked 'degenerate' modern art with mental illness, Bolshevism, Jews and threats to the health of 'the race', waging a poisonous, self-contradictory war against the cultural avant-garde. As early as 1927, the Nazi ideologue Alfred Rosenberg – who later masterminded the wholesale looting of the Jews in occupied France – had formed a unit that became known as the Militant League for German Culture and targeted, among others, museum directors who acquired works of contemporary art.

Hildebrand was in its sights. The art he loved the Nazis despised, and their contempt found resonance in the mainstream population, which did not understand or want to engage with modern art. When Hildebrand became ill in 1928 – he was bedridden for four weeks because of a complicated appendix operation – right-wing forces on the Zwickau city council used the opportunity to attack his exhibitions and acquisitions.[28]

One of the artists whose work Hildebrand championed and acquired for the museum was Ernst Barlach, a sculptor of humble human figures often portrayed reading, praying, begging or playing music. In February 1930, still three years before the Nazis took power, Hildebrand was attacked in a local Zwickau newspaper for trying to turn the 'sub-human' figures of a sculptor whose 'racial roots were in the eastern Baltic or Mongolia' into something socially acceptable.

Hildebrand had supporters. He wrote to the director of the Hamburg Museum of Arts and Crafts, Max Sauerlandt, who like Hildebrand had purchased many Expressionist works for his institution, thanking him for a letter of support. 'The outlook here is desolate. You have given me a great boost, as one can easily fall into dark depressions on such occasions.'[29]

A few weeks later, Hildebrand was fired, ostensibly on cost-cutting grounds. Yet in reality he was among the earliest victims of Nazi cultural policies as the first German museum director to be fired for advocating 'degenerate art'. 'Young as I was, I was trying to do the right thing in the wrong place,' he wrote after the war about his time in Zwickau.[30]

Hildebrand became a pivotal figure in the debate about modern art. The director of the Berlin state museums, Ludwig Justi, wrote an essay titled 'The Zwickau Scandal' about Hildebrand's departure, saying 'he was a victim of his preoccupation with our modern living art'. Both Justi and Sauerlandt would suffer similar fates in 1933.

Dietrich Gurlitt, Hildebrand's nephew and godson, remembers his Onkel Putz, as he affectionately calls him, as a lively, elegant and charming man with a sense of humour. He believes that Hildebrand had by now adopted communist ideas. He certainly moved in Marxist circles: the Dresden artist Otto Griebel recalled Hildebrand and Helene visiting with Hildebrand's friend Ludwig Renn in the late 1920s. Both Griebel and Renn were communists and over the tea table they fell into a debate about Austromarxism, a current of Marxism that developed in the Austro-Hungarian Empire.[31]

When confronted by his nephew at that time, Hildebrand denied being a communist and told Dietrich that he supported Gregor Strasser, the leader of the left wing of the Nazi Party. Strasser stepped down in 1932 after a power struggle with Hitler and was executed by the SS in 1934. Whatever the truth, Dietrich said his father Wilibald held more conservative political views and didn't rush to Hildebrand's defence in his clashes with the Zwickau Nazis. The brothers drifted apart after that.

After his dismissal, Hildebrand taught art in Dresden, worked again as a journalist and wrote a book about Kollwitz, a Berlin female artist with communist sympathies who produced tormented, realistic images of poverty and squalor among the working class, and whom the Nazis despised. He was unreservedly scathing about the Nazi ideologues in the Militant League for German Culture in his art writing. He described a Dresden lecture aimed at promoting 'German' art by the Nazi architect

and art historian Paul Schultze-Naumburg, to which local art lovers were invited as well as members of the League. 'A discussion arose, but the gentlemen from the Militant League were silent,' Hildebrand wrote in the *Vossische Zeitung*, the daily Berlin newspaper, in February 1931. 'They were darkly and determinedly silent. It is always the same: their stupid dilettantism is exposed whenever experts talk about specialist issues seriously.'[32]

Yet Hildebrand got another chance to lead an art institution. In 1931, he was appointed to head the newly built Art Association in Hamburg, thanks in part to references from Carl Georg Heise, the director of St Anne's Museum in Lübeck, who shared his love of Barlach's sculptures, and Fritz Schumacher, an architect and former colleague of his father at the Dresden Technical School.[33] In Hamburg, a much more cosmopolitan and liberal city than little Zwickau, Hildebrand's ambitious work at the King Albert Museum had been noted and admired – as had Justi's words of support for him.

His standard of living in Hamburg was high, with 'an apartment of twelve rooms, a very large library and a nice art collection', he told Allied investigators after the war. 'I had a good future ahead of me.'[34] The Hamburg Art Association, though short of funds, had just opened house in a newly renovated villa with a modern façade and a sky-lit extension on Neue Rabenstrasse, near the shores of the Alster Lake.[35]

Hildebrand's exhibitions at the Hamburg Art Association included an Ernst Barlach show and a display of modern British sculpture with seven pieces by Henry Moore, who was then just thirty-four and unknown in Germany. Hildebrand described him as the leader of a new wave of British artists who were 'producing incredible results'.[36] It was the first contemporary exhibition of British art in Germany since World War I. The British ambassador, Sir Horace Rumbold, gave a speech at the opening of the show, which was supported by the Tate Gallery, the British Museum and the Victoria and Albert Museum.[37]

Hildebrand was willing to fight for the art he believed in. He staged an avant-garde photography show and daringly included works by

Jewish artists such as Gretchen Wohlwill in his exhibitions.[38] One of his major battles was in support of Barlach's proposal for a monument to the victims of World War I by the town hall on Hamburg's main square. The memorial, a simple relief of a grieving mother with her child portrayed in profile on a 7-metre pillar, had invited virulent attacks from the nationalist establishment. Hildebrand joined forces with Hamburg's chief construction director to lobby for support, writing to such cultural heavyweights as Thomas Mann, Max Liebermann and Emil Nolde. Just eight people showed up for the monument's inauguration. It was later removed by the Nazis.[39]

His commitment to modern art again earned Hildebrand abuse in the press. The Nazi Party newspaper, *Hamburger Tageblatt*, accused him of 'jewifying the Art Association'. He knew it was only a matter of time before he was hounded out of that job, too. Yet in March 1933 he forged ahead with plans for an exhibition of modern Italian art, including works by artists such as Amedeo Modigliani, whose elongated figures Schultze-Naumburg had set alongside images of disabled people in his book *Art and Race*.

By now, the Nazis were in power, and in the months that followed, museum directors in Germany who collected and displayed modern art were ousted. Their successors banished the art to museum depots or, in some cases, even held 'shaming exhibitions' of the 'degenerate' acquisitions of the past. Some loans and gifts were returned to benefactors; a few museum directors even began to sell their modern works.

Artists were kicked out of their teaching posts – among them, Otto Dix, Max Beckmann and Käthe Kollwitz. Max Liebermann, a Jew, was in 1933 requested to resign from the Academy of Fine Arts in Berlin, where he was president. Some were even banned from working at all and were subject to raids by the Gestapo.

In Hamburg, Max Sauerlandt, the director of the Museum of Arts and Crafts who had sent Hildebrand a cheering letter, was forced to resign in April 1933 because of his support of 'degenerate art'. Days earlier, an exhibition of the elite group of avant-garde artists who had formed the

'Hamburg Secession', with whom Hildebrand shared exhibition space at the Art Association, became the first in Nazi Germany to be closed by police – at the instigation of the Militant League for German Culture. In May, the Secession was required to throw out all its Jewish members. Instead, it voluntarily disbanded at its last meeting on 16 May 1933. The funds left in its coffers were converted into champagne and consumed in one last party.[40]

Hildebrand left his post in July 1933. By his own account, he was denounced because he had the flagpole at the front of the gallery sawn off to avoid having to display a swastika banner. Whatever the final pretext, it was clear his approach to art was not compatible with the Nazis' ideas.

His career options were narrowing. As a quarter-Jew – Hildebrand's grandmother was Jewish – he could no longer work as a journalist or for the state. In April 1933, the Law for the Restoration of a Professional Civil Service called for the dismissal of anyone with one or more Jewish grandparents from government jobs. An 'Editors' Law' barring people of Jewish heritage from all areas of journalism followed soon after.[41]

Adding to the pressure, Hildebrand and Helene were starting a family. Their son Cornelius was born at the end of December 1932 and named after his grandfather. 'May the child become a real Cornelius Gurlitt, like his grandfather and great-great uncle,' Cornelius senior wrote in a letter to his sister-in-law Else. 'That sounds very vain of me, but I think I can stand by it.'

Hildebrand continued to give lectures and used his extensive contacts among collectors, museums and art dealers to set up his own independent gallery in Hamburg, becoming a full-time dealer.

'What it meant to be true to the art you love in the years that followed is impossible to imagine in the USA,' he wrote in 1955. 'It meant opposing the press and a public mood that finally allowed "ordinary" citizens to give full vent to their innate hatred of good art that challenged their cosy world, but it also meant countering clever art enthusiasts who said "this problematic new German art is not so important, let's stick with the good old stuff". These were the toughest opponents. You were alone.'[42]

3 An Isle of Free Thought

Hildebrand was not completely alone. There were others who supported the artists he admired. But by now they had to be discreet about it, and the dealership he opened in his Hamburg apartment was semi-clandestine. Visitors came, he wrote later, as though his gallery was a den of vice – 'a little bit furtively but eagerly'. And not just any visitors; museum directors he had seen around town in SS uniforms felt at ease there and didn't denounce him.[1]

Like most things Hildebrand turned his hand to, his gallery was successful. He took risks. Though he dealt in all kinds of art, his speciality remained the modern works he had done so much to promote during his stints as museum director in Zwickau and as head of the Hamburg Art Association. He moved from Klopstockstrasse to better accommodation on Alte Rabenstrasse near the Alster Lake, just around the corner from the Art Association building. There he was proud to host the only exhibition during the Third Reich devoted to the 'degenerate' artist Max Beckmann in 1936. Today considered one of Germany's greatest 20th-century painters, Beckmann fled to the Netherlands in 1937 and stayed there throughout the war.

Walter Clemens, Hildebrand's friend and lawyer, described the gallery, which Hildebrand called Kunstkabinett Dr H. Gurlitt, as 'an isle of free thought'. Gurlitt's house, he said, 'was a cultural centre where the concept of intellectual freedom was honoured and nurtured lovingly, regardless of the political and mental terror of the Nazis'.[2]

A visitor to Hildebrand's gallery on the last day of the Beckmann show was the impoverished thirty-year-old playwright Samuel Beckett, who spent nine weeks in Hamburg in the autumn of 1936 at the start of a tour of Germany. 'Strong & interesting with excellent colour sense,' Beckett noted in his diary after seeing the Beckmann exhibition on 13 November.

'Some admirable seascapes & a hilly wooded road.'³ Beckett was also shown fifty works on paper by Otto Dix, available for 750 Reichsmarks at Hildebrand's gallery. Even this Irish prophet of postmodernism was disconcerted. 'Gruesome & uneven,' he wrote. 'A nightmare talent.'⁴

The Hamburg artists, Beckett noted, 'are all profoundly serious and therefore only a little disturbed by the official attitude towards them'. He met Gretchen Wohlwill, a Jewish artist whose work Hildebrand had exhibited at the Art Association – part of the reason he had been accused of 'jewifying' it. Wohlwill showed Beckett her official ban from working, which he noted word for word in his diary. 'Your application to join the Reich Chamber of Fine Arts cannot be approved, because as a non-Aryan you are unreliable and not an appropriate person to manage German cultural property,' it read. 'I forbid you from professionally practising painting or graphic art.'⁵

Beckett much admired the almost abstract, reductive, cerebral portraits and landscapes of Karl Ballmer, a Swiss friend of Hildebrand's whose wife was Jewish. Ballmer was probably the most highly esteemed living artist in Hamburg before the Nazis took power and in 1929 his paintings commanded similar prices to those of Paul Klee and Wassily Kandinsky.⁶ He told Beckett that he wasn't even permitted to exhibit in Hildebrand's gallery⁷ because he was not a member of the Reich Chamber of Fine Arts – his application had been rejected and he was banned from working. Despite the ban, Hildebrand had staged an exhibition of Ballmer's art in 1935 and continued to sell his work in secret.⁸

At the time Beckett visited, Hildebrand was one of just two Hamburg dealers prepared to take such risks.⁹ Elsewhere, dealers in modern art had already become targets for isolated attacks. In Berlin, the opening reception for a Franz Marc exhibition at the Nierendorf Gallery was interrupted by the Gestapo in May 1936 because Marc's works were seen as a danger to Nazi cultural policies and, therefore, to public safety and order.¹⁰

Hildebrand's world and the society he kept were becoming endangered because of both the art they championed and the disproportionately

high number of Jews engaged in art sponsorship and scholarship. 'Who would stay, who would emigrate; what was right, what was courageous?' Hildebrand asked of those treacherous times.[11]

Max Sauerlandt, a great champion of the Hamburg avant-garde, died in 1934, the year after he had been forced out of his post as a museum director. His friends blamed his illness on the stress caused by the Nazis' abuse. His book on contemporary art was banished from circulation. Beckett desperately wanted to get hold of a copy and finally managed to extract one from Alice Sauerlandt, Max's widow.[12]

Hildebrand's friend Ballmer left Germany permanently in 1938, returning to Switzerland. He stayed in touch with Hildebrand for many years but, like many 'degenerate' artists, never regained the acclaim he had enjoyed before the Nazis put an end to his career in Germany. Gretchen Wohlwill emigrated to Portugal in 1940. Rosa Schapire, a Jewish collector and art historian who had been an early patron of the Brücke group, held art soirées that Hildebrand frequently attended; she fled to Britain in 1939 after the Nazis barred her from publishing and lecturing.

Hildebrand said later it was gratifying to help the artists who were banned from working by selling their art and paying them for it.[13] His cousin Mercedes Gurlitt, a single mother who needed to earn a living, worked for him in the gallery. She remembered him keeping a safe in his desk containing savings that he would hand out to needy artists. Hildebrand, she wrote, would occasionally mount 'completely harmless' exhibitions of artists like Hans Thoma, one of Hitler's favourites, to deflect unwelcome attention from his gallery.[14]

'Maybe I wouldn't have been able to keep courage if it weren't for the fact that young people hungry for art – students, schoolchildren, soldiers – came so often and stood amazed and delighted at the piles of "degenerates" that were nowhere else to be found except at my place,' Hildebrand wrote in 1955.[15]

Hildebrand's social circle included many Jewish artists, collectors and art historians. One of Hamburg's great Jewish collectors, Otto Blumenfeld, later testified from exile in Britain that the dealer was

'among the few who had the courage to continue socializing with me, despite my Jewish roots, until the day of my emigration in August 1938'. Blumenfeld said Hildebrand helped him to save pictures from confiscation by the Nazis and to export art out of Germany.[16] Hildebrand later claimed he had assisted Jews planning to emigrate by taking German art off their hands in exchange for paintings that they could find a market for abroad.[17]

Some of those who sold art privately to Hildebrand were collectors squeezed financially by the Nazis' anti-Semitic measures. He was among the few daring dealers to still conduct business with Jews after they were banned from selling art in 1938. Throughout his career he displayed willingness to bend or break the rules if he saw a business opportunity. Yet by buying art from those who were racially persecuted by the Nazis, he began to profit from the anti-Semitic policies of the regime he simultaneously opposed. The first signs emerged that his flair and passion for dealing outweighed his anti-Nazi sentiment and solidarity with the suffering of those who had more Jewish grandparents than he did.

In one such transaction in 1935, Hildebrand purchased a painting from Julius Ferdinand Wolff, a Jew who had been ousted from his position as the editor of the Dresden newspaper, *Dresdner Neueste Nachrichten*, two years earlier. The painting, by the Bulgarian artist Jules Pascin, was called *The Studio of the Painter Grossmann*. Hildebrand paid 600 Reichsmarks for it, much less than it was worth. Wolff committed suicide in 1942 shortly before he was due to be deported to a concentration camp. When US troops later confiscated the painting along with other artworks in Hildebrand's possession, he lied about its origins, saying it belonged to his father who had bought it before the Nazis came to power.[18] The Americans returned it to him.

Ernst Julius Wolffson, a doctor who was baptized as a Christian but classified as a Jew under the Nazi Party's Nuremberg Laws of 1935 because of his parentage (see pages 85–86), lost his job in 1933 and his licence to practise in 1938. After *Kristallnacht*, he was imprisoned for three weeks at Sachsenhausen concentration camp. On his return to

Hamburg, he was forced to pay the *Judenvermögensabgabe*, a wealth tax that only applied to Jews. It was imposed after the night of the pogroms – on top of the punitive 'Jewish atonement' tax extorted by Hermann Göring to pay for the damage caused on *Kristallnacht*.

In desperation, in December 1938, Wolffson brought Hildebrand nine drawings by the 19th-century Berlin artist Adolph Menzel that he had inherited from his father. The price Hildebrand paid was 2,550 Reichsmarks, a fraction of the drawings' value. He sold them within days to Hermann F. Reemtsma, a cigarette manufacturer and one of his most loyal clients, for 3,200 Reichsmarks, making a handsome profit of 25 per cent.[19] Wolffson, who headed the Jewish hospital in Hamburg from 1942 and survived the Holocaust, estimated they were worth at least 8,000 Reichsmarks and probably in excess of 50,000 Reichsmarks, the equivalent of more than two years of his salary as a doctor. After the war, he and his heirs tried to get compensation for them and approached Hildebrand to try to track them down, but he declined assistance (see page 129).[20]

Hildebrand would probably have argued that he was helping Wolffson in his dire predicament by buying the drawings, yet he also profited from it. His lack of empathy is especially shocking given that the plight of Germany's Jews could so easily have been his own (see page 86).

Hildebrand ran into trouble with the Nazis in February 1937, after opening a show of works by Franz Radziwill. The Militant League for German Culture that had so demonized Hildebrand in Zwickau was active in Hamburg, too. Despite being a Nazi, Radziwill was among the artists considered 'degenerate' and his war-critical work was particularly frowned upon. Censure of Hildebrand's exhibition was focused on the speaker at the opening, Wilhelm Niemeyer, a Hamburg art historian whose university lectures faced boycotts from Nazi student groups.[21]

The Hamburg Nazis knew about Hildebrand's Jewish grandmother and rumours were spreading that his gallery would be forced to close. From then on, he showed mainly 18th- and 19th-century art. In 1938, he exhibited fifty oil paintings and many more drawings by his grandfather

Louis Gurlitt, a landscape painter much admired by Albert Speer, Hitler's architect and later Armaments Minister. Yet even in the catalogue for that exhibition, Hildebrand advertised his current holdings as including art by 'Munch etc. and works by living German artists'.[22] He continued selling the modern works in clandestine transactions conducted in a secret room off his main gallery.

The Nazis' final crackdown on 'degenerate art' was a while in coming – partly because there was some confusion about what counted as 'degenerate' and what didn't. In the early years of the regime, even Goebbels was keen to support some of the contemporary German Expressionist artists.

In his memoirs, Albert Speer recalled obtaining some watercolours by Emil Nolde, a committed Nazi Party member, to decorate the Goebbels' official apartment in Berlin, which he was extending and refurbishing. Both Goebbels and his wife Magda were pleased, until Hitler came to tour their new home and poured scorn on the paintings. Goebbels summoned Speer immediately. 'Those pictures have to go instantly, they are simply impossible!' he said. Speer said he found it sinister that Hitler could exercise 'such unconditional authority in matters of taste even with his most senior and closest colleagues'. In the end it was Hitler's own preferences – the whims of a once-aspiring artist who was twice rejected by the Academy of Fine Arts in Vienna – which determined what was acceptable and what not. 'Even I, at home as I was with modern art, quietly accepted Hitler's decision,' Speer conceded.[23]

A planned 'purging' of the museums in 1936 was announced by Bernhard Rust, the minister responsible for culture. But he never carried it out, and it took Goebbels's intervention to make sure the job was done thoroughly. Casting aside his former taste for Expressionist art, Goebbels seized an opportunity to win influence in the culture wars and to curry favour with Hitler in the debate over 'degenerate art'. He commissioned Adolf Ziegler, the president of the Reich Chamber of Fine Arts, to organize an exhibition that would finally banish modern art from the public arena. Ziegler was a painter of wholesome, soulless

nudes much admired by Hitler but mocked by the artistic establishment, who dubbed him 'master of the German Pubic Hair'.[24]

In the first half of July 1937, some eleven hundred artworks produced since 1910 were hastily selected from thirty museums and sent to Munich, of which six hundred went on display. The 'Degenerate Art' exhibition opened on 19 July, in rooms that usually housed plaster casts belonging to the Archaeological Institute at the Munich Residence. 'Around us you see the spawn of madness, irreverence, incompetence and degeneracy,' Ziegler said on the opening night. 'What this show has to offer awakens shock and disgust in us all.'

Masterpieces by Paul Klee, Franz Marc, Wassily Kandinsky, Emil Nolde, Ernst Ludwig Kirchner, Max Beckmann, Otto Dix, Käthe Kollwitz and more than one hundred other artists – some now long forgotten – were presented chaotically, hung crammed together, many without frames. Partition walls that covered the building's windows were daubed with scrawled slogans like 'crazy at any price' or 'how sick minds see nature'. Drawings by the mentally ill and photographs of disabled people were placed alongside the figure paintings, with the aim of arousing revulsion and ridicule. Beneath individual artworks was the title, name of the artist, the year it was bought and the purchase price. Under that was a red label with the text 'Paid for with the tax money of the German working people'. Maximum scorn was directed at the works of the Brücke artists, whom Hildebrand so admired. From Munich, the exhibition travelled on to a further twelve cities and in total drew more than three million visitors.

The ageing sculptor Ernst Barlach was represented at the Munich show with one piece. His standing as one of Germany's pre-eminent artists had plunged to that of social pariah; his poignant World War I memorials were being ripped out of public spaces around the country. Once an admirer of Barlach, Goebbels had voiced outrage at a book of his drawings that was banned in 1936. 'This is no longer art,' he wrote in his diary. 'This is destruction, talentless sham. Horrible! This poison cannot be allowed into the people!'[25]

Yet Hildebrand continued to campaign on Barlach's behalf. The artist's health was suffering, and Hildebrand wrote to Barlach's assistant Bernhard Böhmer saying 'a frontal attack with commissions for work might help to bring him out of his depression'.[26] On 23 July, just days after the 'Degenerate Art' exhibition opened, he promised to look for a sponsor for a font that Barlach was to craft for St John's Church in Hamm. The sketches and casts for the font were among Barlach's last works before he died of heart failure in 1938. Hildebrand attended his funeral.[27]

The Munich 'Degenerate Art' exhibition presaged the final purging of the museums. On Goebbels's orders, approved by Hitler, Ziegler was assigned 'to confiscate any remaining products from the era of decay from all museums, galleries and collections in the federal, state and municipal museums of the Third Reich'. As Goebbels wrote in his diary, 'No picture shall find mercy!'

Starting from 6 August, Ziegler's task force seized more than twenty thousand artworks from about one hundred museums, including from the Munich exhibition.[28] More than fourteen hundred artists were among those whose works were confiscated. Occasional seizures continued to take place until March 1938 when the museums were declared to be 'purified'. They were indeed cleaned out of modern art, barring a few minor exceptions that curators managed to hide, mostly works on paper.

All the confiscated artworks were transported to a wheat silo on Köpenicker Strasse in Berlin, where they were stored and inventoried. Hitler paid a visit in 1938. There was some discussion among the eight-member Disposal Commission, made up of dealers and culture officials appointed by Goebbels, about the fate of the artworks. One idea put forward by a Propaganda Ministry official was for the works to be annihilated in 'a symbolic propagandistic bonfire action'.[29]

Fortunately, commercial interests prevailed. In May 1938, the Nazis passed a law allowing the government to sell the art (the museums were guaranteed no compensation) to 'make money from this trash', as Goebbels put it in his diary. After fixing the Reichsmark at an

artificial exchange rate, the Nazis urgently needed foreign currency to buy imported goods for their massive armament programmes.

The art considered suitable for sale abroad was transported from the granary to the Rococo Schönhausen Palace in the Pankow district of eastern Berlin – about eight hundred paintings and sculptures along with four thousand works on paper. Stacked on the ground floor and second floor, amid the ornate stucco, gilt mirrors, curving balustrades and elaborate cut-glass chandeliers, was probably the most spectacular selection of early 20th-century art ever assembled in one place. On the first floor was an exhibition space belonging to the Evangelical Church Art Service, which continued to hold public shows of regime-approved artists, sandwiched between the rooms stuffed with the 'degenerate art' that was now condemned to exile.[30]

Rolf Hetsch, a lawyer and amateur art historian, was the Propaganda Ministry official in charge of the sales operation. Two of the Evangelical Church Art Service employees were co-opted to help him – Gert Werneburg became his secretary, and the painter Günter Ranft was the dispatch clerk. Among the first art dealers to acquire the works considered saleable abroad were Hildebrand's cousin Wolfgang Gurlitt and Karl Haberstock, a Nazi Party member and confidant of Hitler, who was already purchasing art for Hitler's private collection. Reichsmarschall Hermann Göring helped himself from the trove to four Vincent van Goghs, a Paul Cézanne, an Edvard Munch and a Franz Marc. He then sold them for hard currency, which he used to buy the Old Masters and tapestries he preferred to hang on the acres of wall space at his vast country estate.

The Lucerne art dealer Theodor Fischer, chosen because he was the only non-Jewish Swiss auctioneer, was commissioned to sell 125 works expected to fetch high prices from international buyers, including by Henri Matisse, Georges Braque, Vincent van Gogh, Pablo Picasso, Paul Klee and Franz Marc. The auction on 30 June 1939 was not a success. Many collectors boycotted the sale, surmising – correctly – that the proceeds would benefit Germany's war machine, and some lots went unsold.

About forty buyers, mostly from Switzerland, Belgium and the United States, purchased art. By far the most expensive lot was a self-portrait by Van Gogh that reaped 175,000 Swiss francs; some of the German art sold at very low prices.[31] Hildebrand would later make friends with Fischer and purchased some of the unsold lots.[32]

From the end of 1938, only four dealers in Germany were granted permission to sell 'degenerate art' – Karl Buchholz and Ferdinand Möller from Berlin, Bernhard Böhmer from Güstrow near the Baltic Coast, and Hildebrand Gurlitt. Hildebrand had by now lost two jobs because of his commitment to modern art, and his Hamburg gallery faced the constant threat of closure. Yet the contacts he had nurtured in the art world, both at home and abroad, made him too useful for the Nazis to alienate. His Jewish grandmother was conveniently overlooked. He had already had dealings with Möller and with Böhmer, Barlach's former assistant.

The four authorized dealers were permitted to choose pieces to sell from both the stash of items considered more valuable at Schönhausen Palace and the wheat silo on Köpenicker Strasse, where the artworks deemed less marketable were stored. Though they had to pay in foreign currency, the prices were low and they earned between 5 and 25 per cent commission.

They were only allowed to sell to foreign buyers because the whole purpose of the exercise was to rid the country of art the Nazis deemed to be sick and un-German. This was not an easy task – the market abroad for the challenging and provocative art of the German Expressionists was small and the prices were low.

Hetsch gave Hildebrand a tour of the Schönhausen depot in October 1938 after the dealer had written requesting information about the Edvard Munch artworks held there, for a potential foreign buyer. His correspondence with Hetsch suggests Hildebrand at first had doubts about trading the confiscated art – on business rather than moral grounds.

He wrote to thank Hetsch for the tour on 28 October 1938: 'I hope to be able to return the trust that you have shown me with discretion and conscientious work on your behalf.' Yet he said the ministry's policy of

naming no fixed prices and instead inviting offers from potential buyers would complicate his task: 'I take the liberty of pointing out how difficult it is to persuade customers to make offers out of the blue.'

He expressed disappointment that the Munch paintings had been promised to another buyer – this was the Norwegian dealer Harald Halvorsen, who auctioned them in Oslo. Another snag was the requirement that all payments be made in foreign currency only. 'I am not in a position to invest in substantial expenses such as foreign trips and so on, but will do everything I can in writing to secure offers for you,' Hildebrand wrote.[33]

His efforts paid off. In 1939, he obtained an offer of 10,000 Swiss francs for five Wassily Kandinsky paintings and a Robert Delaunay, and the ministry accepted it.[34]

He also became adept at cunning exchange trades that negated the need for foreign currency. The museums had received vague promises of compensation for the confiscated art, yet none had been forthcoming, and they were left with space on their walls to fill and little in the way of acquisition budgets. Hildebrand offered them works that were palatable to the Nazis and, in exchange, took 'degenerate art' from the Berlin depots that he could then sell – sometimes for the foreign currency he needed to operate abroad. The Propaganda Ministry would, under the terms of these transactions, deduct the cost of the paintings acquired by the museums from the compensation that it would one day pay them for their losses. The museums paid nothing and got artworks in return for a reduction on future compensation that they had in any case received no guarantee they would ever get.

Perhaps not surprisingly, museum directors wondered what the catch was. Hildebrand wrote to Werner Kloos, then director of the Hamburg Museum of Art (Kunsthalle), saying that Hetsch, the Propaganda Ministry official, had confirmed the arrangement and the plan for future compensation as he had presented it: 'Dr Hetsch emphasized that the Museum of Art in Hamburg has no legal claim to this money, but that the sum will be paid out in the form of a gift from the Führer.'[35]

On 4 December 1940, Hildebrand wrote to Hetsch proposing three such exchanges. One painting he offered was a Rome landscape by his grandfather Louis Gurlitt. He described it as 'without doubt one of the most beautiful masterpieces by the artist'. Hildebrand said the work was on loan to the Hamburg Museum of Art, which wanted to acquire it. In return, he requested from Hetsch no fewer than nine paintings seized as 'degenerate', including seven by Erich Heckel of the Brücke group, a work by Oskar Kokoschka and one by Lovis Corinth.

He also suggested swapping a landscape by Johann Faber – a Hamburg artist who is today virtually unknown – for twenty-two seized works, including Beckmann's paintings *Masked Ball (Double Portrait Carnival)* and *Self-Portrait with a Red Scarf*, two oils by Nolde and a Dix work. The two Beckmanns were among the paintings that had failed to sell at the Fischer auction in June 1939.[36] He said the Museum of Art wanted to purchase the Faber painting from him for 3,500 Reichsmarks, 'certainly very cheaply priced', and was 'willing to subtract this amount from the sum that the Ministry will later award'.[37] The third swap, on behalf of the Wallraf-Richartz Museum in Cologne, concerned two Albrecht Dürer prints and a Dutch woodblock print that Hildebrand would give them in return for a Corinth painting from the depot.

All these swaps were approved a month later. Hildebrand, who a few years earlier had refused to fly a swastika banner, now signed his letters to Hetsch with the obligatory official 'Heil Hitler!'

After dealers had picked over the contents of the Berlin wheat granary depot, the remainder – some five thousand paintings, sculptures and works on paper – was destined to be burned in the courtyard of the headquarters of Berlin's fire service on 20 March 1939. These items deemed unsaleable included art by Heckel, Nolde and Schmidt-Rottluff. It's perhaps better not to speculate on how much the contents of that bonfire would fetch at auction today. Yet according to the Free University of Berlin, at least 150 of those works survived. It is still not known how many, if any of them, were incinerated.[38]

The anatomy of a sale Hildebrand made to Basle's art museum shows how profitable his deals could be – and how fine a line he trod between being a deft businessman and a trickster.

He approached the Basle curator Georg Schmidt in 1939, asking whether he was interested in any particular modern artists, then sent photos of artworks by Franz Marc and Max Beckmann that were stored in the Schönhausen depot. Schmidt was interested in two Marc paintings, *The Fate of the Animals* and *Composition of Animals*, and four of the Beckmann works as potential acquisitions for the Basle museum. He travelled to Berlin to meet Hildebrand and Karl Buchholz and tour Schönhausen. Hildebrand thanked Schmidt in a letter for his visit, saying 'we, and also later generations, will thank you for what you are planning to do' in saving the art from the Nazis.[39]

The Fate of the Animals is an extraordinary, disturbing painting that almost seems to predict its own turbulent story. One of Marc's major masterpieces, it features a blue deer at the lower centre, its white throat stretched back as though screaming in anguish. Two green horses, white at the mouth, appear to be fleeing with ears and manes streaming behind them. Towering trees are torn from the soil and crash towards the earth. Diagonal flashes of vibrant reds and chaotic movement create a violent apocalyptic vision.

Marc painted it in 1913, three years before he was killed by a grenade at the front. A year after his death, the right side of the painting was destroyed in a fire. His friend Paul Klee restored it carefully, using muted browns to distinguish his work from Marc's vivid blues, reds and greens. It is a tribute by one great artist to another as well as a tour de force in its own right. If it were to be offered at auction today, it would fetch millions.

Yet then it was unwanted trash, only useful for the hard currency it could raise. Schmidt had the entire depot at Schönhausen to choose from, and he needed to use his limited budget wisely. He wanted to take his time to examine and compare potential acquisitions.

Hildebrand, on the other hand, pushed for a quick sale. He wrote to Schmidt saying that Marc's *Fate of the Animals*, which he described

as one of the artist's most famous paintings, had awoken the interest of another buyer and he should hurry up. Schmidt bowed to the pressure and offered 6,000 Swiss francs for the painting.[40]

Hildebrand told the Propaganda Ministry Schmidt's offer was 5,000 francs. 'Please do me the great favour of letting me know whether this offer meets your expectations,' he wrote to the ministry. 'I should stress that given its size and its abstract portrayals, *Fate of the Animals* remains a very difficult picture to sell.' That same day, he wrote to Schmidt saying that his offer wouldn't be accepted, but might help to keep Basle in the bidding for the picture. Schmidt wrote back, saying it was the highest price he could pay privately before his purchasing committee approved it, and that would take time.[41]

Hildebrand then began hassling the ministry, saying Schmidt's offer could be retracted at any time.[42] Days later, it was accepted. Hildebrand wrote to Schmidt saying he had been forced to purchase the picture himself because otherwise it would be sold to another buyer, and he therefore needed 900 Swiss francs commission as well as the 6,000 Swiss francs purchase price. The 900 francs were paid to him via a middleman – Karl Ballmer, the Hamburg friend who had exhibited in Hildebrand's gallery before he fled to Basle with his Jewish wife, and whose career Hildebrand was seeking to revive by putting him in touch with Swiss museum directors. It took some months for Hildebrand to convince the ministry to pay him the 1,000 Swiss francs difference between his price and Schmidt's payment, as the usual arrangement was that the dealers received their commission in Reichsmarks, and not normally such a high percentage. Yet he wound up earning 1,900 Swiss francs from the sale of a painting worth 5,000.

His dealings belie Hildebrand's claim that his primary motive in selling 'degenerate art' on behalf of the Nazis was to save the paintings. If that were truly the case, he would have tried to keep prices as low as possible to enable Schmidt to buy more art from the depot with the 50,000-franc budget he had squeezed out of the Basle city parliament. Yet it's undeniable that Hildebrand's machinations saved this remarkable painting for

future generations of museum-goers. *The Fate of the Animals* hangs in Basle's art museum to this day.

———

Unlike his colleagues, Hildebrand focused mainly on low-priced works on paper rather than more expensive paintings. He later wrote that, in his view, 'the most important statements in German Expressionism were made in graphic art'.[43] In total, he acquired four thousand artworks from the 'degenerate art' operation, more than any of the other dealers. Only eighty of those were paintings, of which he obtained many through exchanges.[44]

After war broke out, it became even harder to sell modern German art to foreign buyers, and it had never been easy. The market was flooded with 'degenerate art' as a result of Hitler's desire to get rid of it. 'I don't need to tell you that foreign dealers have absolutely no interest in new German graphic art or how hard it is to find private customers in neutral foreign territory,' Hildebrand wrote to the ministry in March 1940.[45]

Yet Hildebrand was also prepared to take the artworks his colleagues had rejected, and scavenged hundreds of leftover works on paper in 1940 and 1941, which he bought himself rather than selling on commission. He offered 800 Swiss francs for all the remaining Nolde, Schmidt-Rottluff and Heckel pieces in June 1940. The ministry pushed him up to 1,000 Swiss francs. Hildebrand complained about the quality. 'After looking over the Nolde, Schmidt-Rottluff and Heckel graphics I realized the extent to which the collections have already been combed through,' he wrote. He demanded more works on paper – by the lesser known artists Christian Rohlfs and Rolf Nesch, a Hamburg printmaker who fled to Norway – to compensate for the paucity of the remnants.[46]

Like Buchholz, Möller and Böhmer, the other art dealers allowed to sell 'degenerate art', Hildebrand took a gamble in his sensitive role by violating the Nazis' rules. As he had told the ministry, foreign buyers were thin on the ground. As the seized artworks flooded onto the market, the prices collectors abroad were prepared to pay sank even lower. So he offered 'degenerate' works at good prices in secret to domestic

buyers – mainly, but not only, to his Hamburg friends. By now he had enough access to foreign currency that he could afford to sell them for Reichsmarks. One visitor to Hildebrand's gallery remembered piles of works on paper by Kirchner and Schmidt-Rottluff on the counter, which were sold for 1 Reichsmark each to any interested buyer.[47]

So Hildebrand was not telling the truth in January 1940, when he assured the Propaganda Ministry that the artworks he had acquired from Schönhausen Palace 'will not be seen in this country or by domestic residents. I have only shown this material to a few friends and acquaintances who helped me with the export'.[48]

The enthusiastic Hanover collecting couple Margrit and Bernhard Sprengel counted among his customers. Hildebrand trusted them enough to invite them into his back room full of banned art on their first visit. Sprengel purchased 409 Nolde graphics from Hildebrand in 1941 for the sum of 8,000 Reichsmarks.[49] Dozens of these are preserved for posterity in Hanover's Sprengel Museum, part of a gift the collector made to the city in 1963. Other regular clients were the Cologne collector Josef Haubrich, who donated his collection to the city in 1946, and the tobacco entrepreneur Hermann F. Reemtsma, who in the 1950s set up a philanthropic foundation that established a museum devoted to Ernst Barlach. 'There were always men whose great love for new art made them brave, but everything remained half-hidden,' Hildebrand wrote later. 'Even young people came again and again to buy one single work on paper – these were so cheap at that time.'[50]

Hildebrand also continued to conduct profitable business with museums. In 1941, he bought four Liebermann paintings from the Hamburg Museum of Art that it could no longer hang on its walls and had tried in vain to sell to foreign buyers. 'Liebermann is almost impossible to sell today,' Werner Kloos, the director of the museum, wrote to the city authorities in a letter. 'Jewish art dealers, until recently dominant in all European countries, have boycotted any sales of Jewish artworks in German ownership.'[51] When Kloos asked a Berlin print shop to send Hildebrand photos of the paintings in question, the company at first

refused, saying it was not permitted to circulate 'negatives of works by artists like Liebermann'. Hildebrand's eventual purchase of the paintings was to cause him more difficulties after the war than any of his other transactions, some of which, from today's perspective, seem far more morally questionable.

An added perk of his dangerous, lucrative work was that Hildebrand's personal collection started to take shape as he kept some of the defamed modern art sold at knock-down prices. 'I could acquire a small number of the watercolours for myself,' he wrote later. 'The art I wanted to buy in Zwickau and couldn't, I slowly began to possess myself. That included some good works I had purchased for the Zwickau museum which had been seized by the state and auctioned in Switzerland. But what trouble, what secrecy was required. How many Nazi bans had to be circumvented or violated? There was always the danger that the party would seize private property in the same way that it had the museums.'[52]

The 'degenerate art' sales operation wound down in 1941 as the depots emptied. An official report from the Propaganda Ministry concluded that it had earned the government foreign currency worth 131,000 Reichsmarks. 'Degenerate art has brought us lots of foreign currency,' a satisfied Goebbels wrote in his diary. 'It will go into the war coffers and will be used for art again after the war.'

Hildebrand wrote in the 1950s that 'many, many contemporary artworks passed through my hands' during his years in Hamburg. 'They came from the artists, from customers and friends who had emigrated, from people who preferred to get rid of them for safety, and from the big depot of seized art' at Schönhausen Palace. 'I saved many of these pictures from certain destruction.'[53]

With the end of the 'degenerate art' bonanza, Hildebrand was to widen his field of operations. He made his first trip to Paris in 1941 on a shopping expedition for the German art museums. There were to be many more, and his biggest customer would be Adolf Hitler.

4 Deals with the Devil

Adolf Hitler's early ambition was to be the Michelangelo of the 20th century – a dream that was dashed by his twice failing the entrance examination for the Vienna Academy of Fine Arts. As a young drifter surviving on the breadline in Vienna before the outbreak of World War I, he earned a scant living by painting watercolours. Even after entering politics, he continued to paint for himself. His secretary remembered him in the early years of the Third Reich taking out a pen to draw whatever scheme was going through his head at a given moment.[1]

Hitler began collecting art before he seized power, using the proceeds of his book *Mein Kampf* – which made him a millionaire – to buy art for his spacious apartment on Munich's Prinzregentenplatz.[2] A portrait of Bismarck by Franz von Lenbach, two Brueghels, a Lucas Cranach and six paintings by the popular 19th-century artist Carl Spitzweg adorned his Munich apartment in the early 1930s. After he became chancellor, he stepped up his collecting and purchased regularly from the Berlin art dealer Karl Haberstock, and from his photographer and friend Heinrich Hoffmann. He was prepared to pay high prices to get the works he wanted.[3]

The artists he admired were almost all German or Austrian 19th-century romantic painters, aside from Rembrandt and the masters of the Italian Renaissance. Above all, he liked art to be realistic in style, though not necessarily in content – so to be as photographically accurate a rendering of its subject as possible. He loved Hans Makart's operatically rich oils; the lavish historical scenes of Karl von Piloty and the now almost-forgotten Franz Defregger; Anselm Feuerbach's depictions of classical themes; Ferdinand Georg Waldmüller's Biedermeier landscapes; and Wilhelm Leibl's realist images of simple Bavarian country folk. Hitler believed these masters were undiscovered because they were still

relatively recent.[4] He was partially colour-blind from a poison-gas attack in World War I, so preferred lighter shades to predominate in his pictures.[5] Albert Speer, his chief architect and later Minister for Armaments, was not impressed the first time he visited Hitler's Munich apartment. 'Even the furniture provided evidence of bad taste,' he wrote in his memoirs.[6]

Plans for the Führermuseum began to take shape following the annexation of Austria by Germany in March 1938. Immediately after German troops marched into Linz, where Hitler went to school and grew up, he took the opportunity to discuss plans for an expansion of the city's cultural landscape with the director of its small art museum.

The rapturous welcome he received in his native country was accompanied by an outbreak of crimes by Austrian Nazis against Viennese Jews, including the seizure of the art collections of some of the wealthiest families – the Rothschilds, Gutmanns, Bloch-Bauers and Bondys, to name a few.[7] The question of what should become of the confiscated art that was piling up at the Hofburg Palace and the Museum of Fine Arts remained unanswered for a while. Vienna's Nazi leaders wanted to keep the choice pieces in the capital.

Hitler had other ideas. He loathed Vienna – the city that witnessed his failure as an artist and his social decline into near vagrancy – and wanted to set up provincial Linz as a serious rival in the Thousand Year Reich that he dreamed would follow victory in World War II. His plan for Linz was to incorporate the old city into a huge modern metropolis with a population of about five or six times its size, then 55,000. The Führermuseum was to be part of a colossal arts complex, also comprising a library, a theatre and an armoury, designed by the Nazi architect Roderich Fick. Hitler's passion for architecture equalled his enthusiasm for art, and he wanted a vast colonnaded façade and planned to move the railway 4 kilometres south to make way for the museum.[8] The museum became one of his favourite subjects over evening tea. His secretary recalled him ruminating over how the pictures should be hung: 'Not too close together, like for example in the Louvre, where, according to him, "one picture overwhelms the next."'[9]

In June 1939, he appointed Hans Posse, the director of the Dresden art collections who had been recommended to him by Haberstock, to take charge of the Linz Special Commission and to assemble the paintings for the new museum. Posse's intention was to make of the museum a seat of European culture with a broader sweep than the 19th-century German art favoured by Hitler. The affairs of the Linz Special Commission – including the fact that some of the art was confiscated from Jewish collections – were to be kept confidential. Among the first paintings Posse acquired were the jewels of the collections seized from wealthy Viennese Jewish families, including masterpieces by Canaletto, Holbein, Rembrandt and van Dyck that had been stolen from the Rothschilds.[10] He also visited repositories of confiscated art in occupied Poland to make selections for Linz.[11] Items deemed suitable for the Führermuseum were transported to the Führerbau, Hitler's Munich headquarters, where they were exhibited for his inspection. Whatever art in the 'Führer reserve' was superfluous to the Linz museum's needs was to be distributed among other German museums.

The 1940 conquest of France, the centre of the art world and the global art market, offered a vast new hunting ground for the acquisitive Nazi poachers. It was the scene for what the Art Looting Investigation Unit (ALIU) of the US Office of Strategic Services (OSS), the forerunner of the CIA, later termed 'the most elaborate and extensive art looting operation undertaken by the Germans in World War II'.[12] The unit in charge of appropriating cultural property in occupied territories was the *Einsatzstab Reichsleiter Rosenberg* (ERR). Acting on orders from Reichsmarschall Hermann Göring and Hitler, the ERR worked with the police to systematically plunder 22,000 cultural objects from Jews in occupied France and Belgium, and organized the transport of the loot to Germany. Alfred Rosenberg, the Nazi ideologue and fanatical racist who led the ERR, was hanged in Nuremberg in 1946 for crimes against humanity.

The plunder came from some of the great French collections of the day: those of the Rothschilds, the David-Weills, the Bernheim-Jeunes and Alphonse Kann, to name but a few. The most prestigious galleries in

Paris, owned by Jews, were also looted – among them the dealerships of the Seligmann brothers, Georges Wildenstein and Paul Rosenberg, who of course was not related to Hitler's anti-Semitic chief plunderer.

Paul Rosenberg's gallery was in rue la Boétie, the hub of the Paris art market. His wealthy customers were American, British and Swiss, as well as members of the French aristocracy. The gallery was described by contemporaries as a sumptuous temple dedicated to art. The window onto the street showcased just one or two choice pieces. Inside, the floors were decorated with marble mosaics by Georges Braque – still lifes of plates, pitchers, lemons and tablecloths. Deep leather armchairs, vast skylights and walls lined with red silk encouraged reverence. So did the immaculately groomed proprietor, with his cigarette holder, wing-tipped collars and round-rimmed spectacles. Rosenberg had exclusive deals with Braque, Matisse and Picasso, who was also an intimate friend and moved into the house next door. Yet many of his clients found the work of these young artists, which Rosenberg displayed on the ground floor, too daring. He would lead those flummoxed by Braque, Picasso or Fernand Léger up to the mezzanine, where he would instead tempt them with Degas, Renoir and Rodin.[13]

His gallery's inventory included works by Delacroix, Courbet, Cézanne, Manet, Monet and Toulouse-Lautrec as well as the modern painters. When war broke out, Rosenberg closed his gallery and the family relocated to Floirac, near Bordeaux. As the Wehrmacht advanced across France in 1940, he had 162 paintings sent to nearby Libourne, where they were stored in a bank vault for safekeeping. Among them were Van Gogh's *Self-Portrait with Severed Ear*, several Monets, Picassos and Braques, and fifteen or so Matisses, including *Seated Woman*.[14] The portrait, dating from 1921, shows a woman in a floral blouse and beige skirt sitting cross-legged in a brown leather chair, looking directly at the viewer. A fan lying in her lap and a scarf covering her hair, perhaps to protect it from the sun, suggest a stifling hot day. The woman is probably Henriette Darricarrère, a ballet dancer who became one of Matisse's favourite models.

The Rosenberg family stayed in Floirac until June 1940, a month after Paris was conquered. At a family powwow lasting three days, they decided to flee for the United States and left for Portugal via Spain on 16 June, taking only what they could fit in their cars. Obtaining passports and visas for twenty-one family members was arduous, and the journey was long. Paul Rosenberg later recalled going to the British Relief Office for refugees in Lisbon, where he was given a hard-boiled egg and a piece of bread. 'Imagine a man who had everything in life, and who a week earlier had lost his work, his house, his fortune, his friends,' he said. 'I sat on a stone wall with a hard-boiled egg and a piece of bread, and I had to laugh.'[15]

The family reached the US in September 1940, helped by Paul's connections in the New York art world. He left instructions with his assistant to send the paintings in the Libourne vault on to him. Yet the moving company delayed time and again. It transpired that two Paris antique dealers had betrayed the collection's existence to the German Embassy in Paris in return for a cut of the proceeds. On 15 September, a group of German soldiers and police arrived at the house in Floirac, demanded to speak to Rosenberg's assistant and seized crates of paintings, which they carried off in trucks.[16]

The Nazis also got wind of the artworks in the vault at Libourne and confiscated them from Safe No. 7 on 5 September 1941. Rosenberg's rue la Boétie gallery was looted. The destination for the stolen artworks was the Jeu de Paume, a small museum tucked away in a corner of the Tuileries Garden in central Paris that witnessed some of the most shameless looting of the war. Rosenberg would never set eyes on many of these paintings again. Matisse's *Seated Woman* was only to resurface more than seventy years later, in the Munich apartment of Cornelius Gurlitt.

The ERR had commandeered the Jeu de Paume to deposit and sort its booty in secret. Hitler claimed the right of disposition over all the confiscated artworks and gave Posse power to make decisions on his behalf. Their main competitor for the plunder was Göring, who visited the Jeu de Paume no fewer than ten times to choose works for the vast private

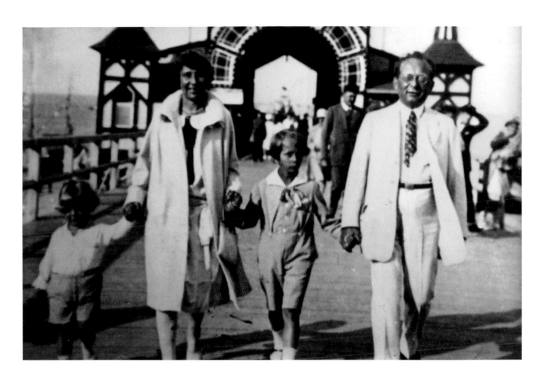

ABOVE David Toren (far left) with his parents and brother in Binz on the Baltic island of Rügen in the 1920s. Toren's parents were both killed in the Holocaust. Toren today is seeking to recover a painting from the Gurlitt collection that was stolen from his great-uncle by the Nazis.

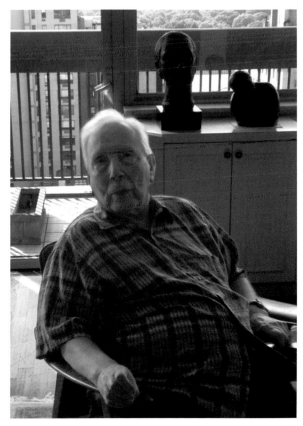

RIGHT David Toren in his New York apartment on Madison Avenue, 3 July 2014.

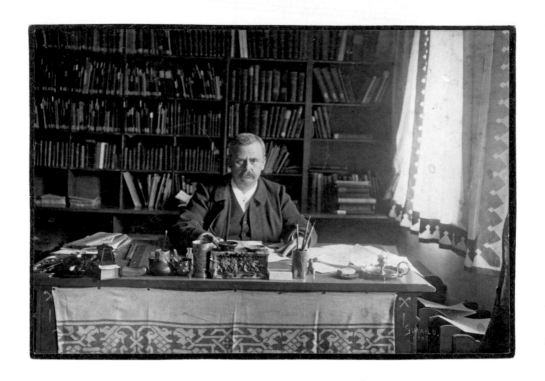

ABOVE Cornelius Gurlitt
senior, father of Hildebrand.
He was a patriarch of
Dresden, renowned for
his expertise in Baroque
architecture, town-planning
and art history.

RIGHT Hildebrand Gurlitt
in uniform with his mother
Marie in 1914.

Hildebrand, Cornelia and Wilibald
Gurlitt on leave in Dresden during
World War I in about 1915. Both
brothers served at the front and
Cornelia volunteered as a nurse and
tended the wounded in Lithuania.

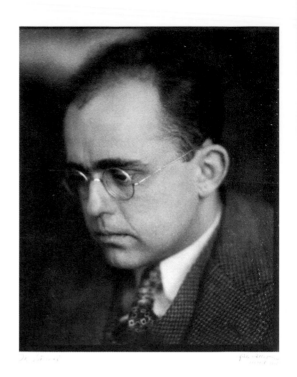

RIGHT Portrait of
Hildebrand Gurlitt
taken in about 1925 as
the newly appointed
director of the King
Albert Museum in
Zwickau.

LEFT Cornelia and Hildebrand
Gurlitt, undated. After her death
in 1919, Hildebrand described
his sister, who was five years
older, as 'the person who was
closest to me.'

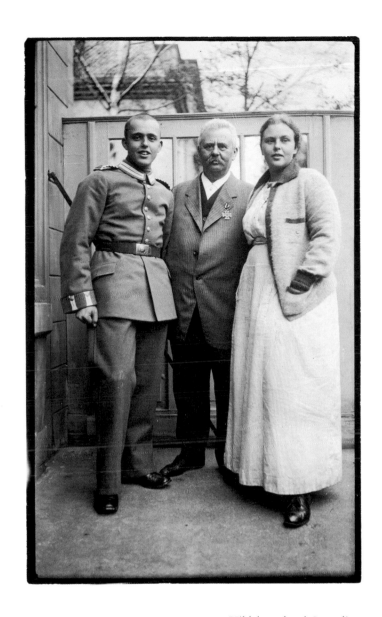

Hildebrand and Cornelia
Gurlitt with their father
Cornelius, taken during
World War I.

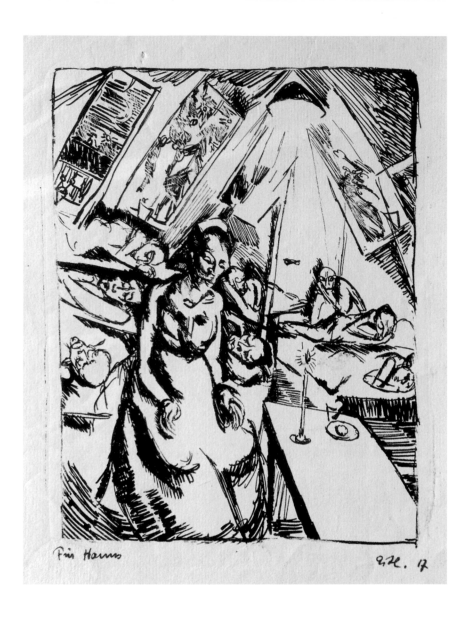

ABOVE A lithograph by
Cornelia Gurlitt of a
World War I hospital tent
in Vilnius, Lithuania.

OPPOSITE ABOVE A lithograph
by Cornelia Gurlitt of a woman
grieving, which she dedicated to
her lover, the art critic Paul Fechter.

OPPOSITE BELOW Max Liebermann,
Two Riders on the Beach, 1901.
This painting belonged to David
Toren's great-uncle David
Friedmann.

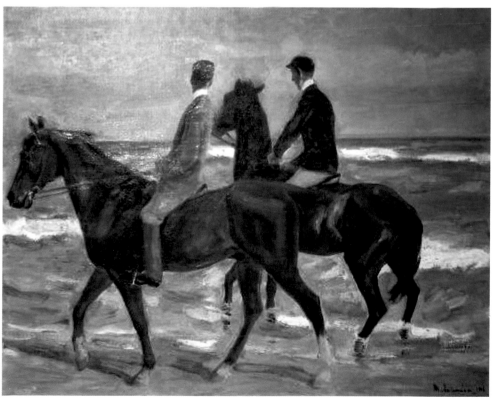

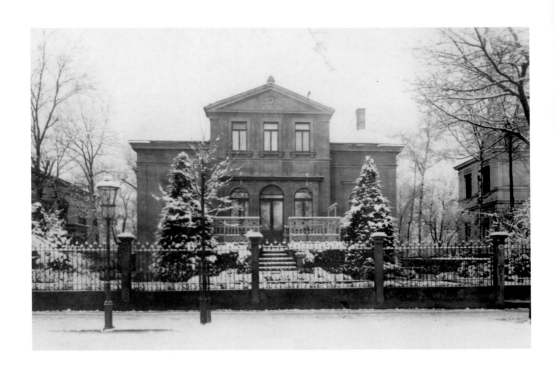

TOP The Gurlitt family residence on Kaitzerstrasse in Dresden.

ABOVE The same building after the Allied bombardment in February 1945.

collection he kept at his country estate near Berlin. His representative at the ERR, Bruno Lohse, organized exhibitions of looted paintings for him to make his choice. Only fifty-six objects from the Jeu de Paume wound up in the collection of the Führermuseum. Göring, however, helped himself to at least 875 pieces.[17]

Not all the artworks at the Jeu de Paume were of the kind the Nazis wanted. Picasso, Matisse, Braque and even Van Gogh were dismissed as 'degenerates' like Beckmann, Dix and Kirchner. Here, art dealers such as Gustav Rochlitz played a role, swapping approved art that could be shipped back to Germany for the unwanted modern works that could still fetch high prices on the Paris art market.

Rochlitz, who was a great friend of the ERR's Lohse, exchanged a portrait attributed to Titian that had caught Göring's eye for eleven paintings by Matisse, Cézanne, Degas, Renoir, Sisley, Corot and Braque, including some belonging to Paul Rosenberg. Through such swaps, Rochlitz acquired eighty-two paintings from the ERR,[18] one of which was Matisse's *Seated Woman*, which he obtained on 24 July 1942.[19] The German government 'Schwabing Art Trove' Task Force appointed in 2013 to investigate the provenance of artworks found in Cornelius's apartment said it hadn't managed to trace the circumstances under which he acquired it.[20] Later research showed he purchased it in Paris after the war.

The Paris art market boomed during the war, largely buoyed by swarms of German dealers with an artificially strong currency and deep pockets. They were ready to fork out huge sums to buy art for the depleted museums at home as well as for private clients. Allied interrogators described the economic conditions manipulated by the Nazis in France as 'one of the subtler methods of despoiling occupied territories'.[21] The purchases made by German dealers 'were only a more devious and more palatable form of looting than outright confiscation', they concluded.[22]

Yet the market also benefited from general instability: in times of crisis, as is still apparent today, art can be perceived as a safe investment compared with other assets more vulnerable to economic slumps. Not

just in Paris but in Germany, too, the wealthy had cash and there was little else to spend it on during the war. Foreign vacations were out of the question, luxury goods were hard to come by, servants were drafted into war work, fine dining was limited by food availability, and theatres and places of entertainment were closed. Meanwhile, household incomes for many in Germany rose as more family members joined the war effort. In search of a safer investment vehicle than the banks, the ranks of collectors of everything from art and antiquities to stamps and coins swelled accordingly.[23] High-ranking Nazis were on the hunt for trophy pieces to embellish their homes and affirm their status. This in turn led to price increases – and vast profit potential for canny suppliers.

Among the German dealers boarding the gravy train to Paris to take advantage of these artificially favourable conditions was the enterprising Hildebrand Gurlitt, who was to make about ten trips to France before the end of World War II. His Hamburg apartment and gallery was destroyed in one of the first bomb attacks on the city in December 1941, forcing him to move again. In the spring of 1942, he returned with his wife and children to the spacious family villa on Kaitzer Strasse in Dresden, where his mother had lived alone since the death of his father in 1938.

Instead of opening a new gallery in Dresden, Hildebrand chose to work as a free agent purchasing art for the German museums. His initial trips to Paris were on their behalf. One of his major clients was the Wallraf-Richartz Museum in Cologne, for which he bought thirty-two artworks,[24] including pieces by Eugène Delacroix, Claude Lorrain, Renoir, Degas, Corot, Manet, Ingres, Rodin and Maillol.[25] He bought a Monet and a Courbet, among other works, for the Hamburg Museum of Art;[26] a dubious Fragonard for the Bavarian State Painting Collections; and pictures for the Berlin National Gallery. The negotiations for the sale of the Fragonard, a sketch for *The Sacrifice of Iphigenia*, were conducted by Baron Gerhard von Pölnitz, a close associate of Hitler's confidant Karl Haberstock, on Hildebrand's behalf. The buyer was Ernst Buchner, the director of the Bavarian State Painting Collections. Pölnitz 'carried out all the negotiations except for presenting the bill,

which was done by Gurlitt', Buchner told the Allies after the war. He paid 45,000 Reichsmarks for the sketch, but later believed the attribution to be false.[27]

Hildebrand told his Allied interrogators that the only time he had enough cash to buy art at the Hôtel Drouot, the French state auction house, was at the sale of the dentist Georges Viau's Impressionist collection in December 1942. The event attracted the cream of Paris society and in the packed auction room, from which Jews were barred entry, prices spiralled to the highest of the war. Hildebrand was the biggest spender. He paid 5 million French francs for a Cézanne landscape called *Vallée de l'Arc et Mont Sainte-Victoire* – about the price of a chateau.[28] He bought for private clients, acquiring the Cézanne for Carl Neumann; a Corot landscape, a Manet, a Delacroix, a Rodin and a Maillol for the tobacco entrepreneur Hermann F. Reemtsma; and two Degas works for the Berlin art dealer Hans Lange. The expensive Cézanne turned out to be a fake.[29]

His nephew remembers Hildebrand visiting his apartment on Berlin's Kantstrasse en route to Paris from Dresden. Dietrich Gurlitt worked in the German capital as a geologist in the first half of 1942, mapping British and French mining activity in Africa for a company called Afrika Bergbau, which planned to take over the mines after Germany's victory in World War II. On one occasion, Hildebrand gave a beautiful pair of binoculars to Dietrich, but asked for a receipt for 500 Reichsmarks. Dietrich could not recall what the transaction was about, but remembered thinking that his Onkel Putz 'makes some strange business deals'.

Hildebrand's Paris shopping trips lasted about ten days each. On arriving, he would 'descend on his mistress Madame Chauvet, a Swiss woman who was separated from her diplomat husband of the well-known Swiss banking family, the Chauvets of Geneva', reported Michel Martin, a Louvre curator who was seconded to French customs to grant export permits for artworks during the occupation.[30] Olga Chauvet, whose maiden name was Zobowa, was in fact Russian by birth. She was eighteen years younger than Hildebrand, and finally divorced her husband in 1951.[31]

During his visits, Hildebrand 'would buy up huge quantities and examine works that were suitable for acquisition on his next visit', Martin wrote. 'He took photographs of these works back to Germany to submit them to the museum directors who might acquire them, and came back the following month with an answer – usually affirmative.'

No matter how much he pleaded after the war that he had no choice, Hildebrand was not coerced into working for Hitler's Führermuseum. It is one of the odd contradictions of his biography that he could somehow reconcile his anti-fascist beliefs with his work for the Nazis. After the war, many witnesses testified that Hildebrand frequently spoke derogatively about Hitler's regime. Yet the regime did not seek him out to buy art on its behalf; Hildebrand actively pursued the role, and his business pitches brought him into indirect contact with top Nazi brass. The lure of the prestige, privilege and money to be earned working for the Linz Special Commission clearly overcame his anti-Nazi sentiments.

Hildebrand initiated contact with Posse as early as 1940, asking him for help in buying a present for Göring, costing around 25,000 Reichsmarks, on behalf of a corporate client. Even Hildebrand, ever resourceful, found it a challenge to shop for someone of such insatiable extravagance. Hitler's right-hand man, a morphine addict, kept pet lions, jangled emeralds in his pocket like small change and had his own luxury train.

'The main thing is to find something that the Reichsmarschall will still find pleasure in, given the vastness of his collection,' Hildebrand wrote to Posse. 'We were thinking of an old stained glass window, early German paintings, significant artefacts – for example crafted gold or furniture – beautiful drawings etc.'[32] Posse recommended an early Gothic stained-glass window on sale in Cologne that was twice the suggested price.[33] Hildebrand wrote back full of gratitude for the tip.

Hildebrand sold a painting of the Acropolis by his grandfather Louis Gurlitt to Hitler's architect Albert Speer via Posse,[34] and offered the Special Commissioner works by Goya and van Dyck. Yet it was only after Posse's death of mouth cancer in 1942 that Hildebrand really gained

a foothold in the lucrative business of buying art for Hitler, thanks once more to his networking skills.

Posse's surprise replacement as Special Commissioner for Linz was Hermann Voss, the director of the Wiesbaden Museum.[35] Plucked from relative obscurity, he was, like Posse, also assigned to run Dresden's art museums, and moved to the city in March 1943. Voss was a specialist in the 19th-century German art that Hitler loved, and had boosted its standing in the Wiesbaden collection during his eight years there, in part by selling 'degenerate art' to buy the works Hitler sanctioned. Yet he was known to be an anti-Nazi, largely because he had managed to propagate the belief that he was ousted from the Kaiser Friedrich Museum in Berlin in 1933 on political grounds. Recent research suggests that he was passed over for promotion for other reasons, and it was hurt pride that took him to provincial Wiesbaden.[36]

Voss had done business with Hildebrand while he was in Wiesbaden. Anxious to get rid of the 'degenerate art' in the museum's collection in 1937, he had suggested swaps to Hildebrand, offering him two water-colours by Paul Klee for a French 19th-century landscape. Hildebrand wrote to him in July 1937 saying he was very interested in any sales or swaps of modern art. Voss invited him to Wiesbaden to examine 'paintings and watercolours by Kirchner, Schmidt-Rottluff, Kokoschka, Dix, Jawlensky, Otto Müller etc.'[37] Hildebrand visited in 1939.[38]

For an anti-Nazi, Voss had already demonstrated that he could put on a good show for the regime when it suited him. He gave a two-hour lecture in 1939 to leading members of the *Sturmabteilung*, the Nazi Party's paramilitary wing, extolling the close synthesis between Nazi cultural policies and the activities of the Third Reich's museums. His lecture mainly referred to Hitler's speeches and *Mein Kampf*. Voss complained to the city culture official that Alfred Rosenberg's unreadable, racist bestseller, *Myth of the 20th Century*, wasn't to be found in the museum library. He called it 'an indispensable reference work' that would have helped him prepare his lecture.[39] Even Goebbels was less flattering about Rosenberg's tome, describing it as a 'philosophical belch'.

Voss had shown no scruples about acquiring art seized from Jews in Wiesbaden. He worked as an appraiser for the police, evaluating the artworks left in the homes of those who had fled Germany or, worse, who had been deported to concentration camps. On one such assignment in 1941, he examined paintings in the apartment of Leopold and Dorothea Katzenstein at the police's request. Two years later, he bought the artworks for the museum from the tax authority that had seized them. By then, the Katzensteins were dead; Leopold had perished at Oranienburg concentration camp and Dorothea was murdered at Theresienstadt.[40]

Under Posse's rule, the fanatical Nazi and Hitler confidant Karl Haberstock was the main Paris purchaser for the Linz project. It was Haberstock who had brought Posse's achievements in Dresden to Hitler's attention and proposed him as Special Commissioner, so Posse had felt in his debt. With Voss's arrival in Dresden, Haberstock's star waned – he knew Voss disapproved of him and the two were enemies.[41] Voss fired the Berlin dealer and recruited Hildebrand in his place, giving his excellent contacts and competence in art history as the reasons.

Hildebrand told his Allied investigators after the war that Voss 'liked to work with me because we were of the same political opinion'. He also did Voss the favour of describing him as 'a fanatical opponent of the regime'.[42] This is hard to square with a man who preached *Mein Kampf* to Nazi thugs, assisted the police in wholesale plunder and played the central role in helping Hitler realize his dreams for Linz.

Hildebrand's first bill in the Linz Special Commission files is dated 25 August 1943, for a bust by Jean-Antoine Houdon showing Prince Heinrich of Prussia.[43] By the end of the year, he had sold the Linz project about twenty artworks, including a van Dyck painting of St Sebastian for 250,000 Reichsmarks and a Jean-Auguste-Dominique Ingres portrait of a copper engraver for 300,000 Reichsmarks. He also brokered a deal on behalf of his uncle, Hans Gerlach, who offered Voss an Italian landscape by a little-known German painter for 20,000 Reichsmarks.[44] Selling art to the Führermuseum became something of a family business: Hildebrand's cousin Wolfgang Gurlitt sold a marble sculpture to

the Special Commission in April 1944. Yet Hildebrand was by far the busiest. Alongside a Viennese auction house, he became the main dealer acquiring works for the Linz Special Commission in France. Equipped with a Linz travel certificate, Hildebrand had all of occupied Europe's art market at his disposal.

Ensconced at the Grand Hotel in the rue Scribe, which he used as his business address in Paris though he may have stayed with his mistress Olga Chauvet overnight, Hildebrand bought dozens of artworks for Voss. A Francesco Guardi view of Venice's Grand Canal, still lifes, battle scenes, portraits, landscapes and biblical scenes all passed through his hands. In early March 1944, he billed the Special Commission for more than 1 million Reichsmarks. At the end of that month, he sent another bill for 743,000 Reichsmarks.

By this stage, access to foreign currency was becoming trickier. Robert Oertel, curator at the Dresden Picture Gallery, wrote to the currency department of the Reich Chamber of Fine Arts requesting a specially accelerated process for Hildebrand, who he said had 'obtained a large number of offers which are highly desired for the purposes of the Linz museum'. 'Given the current situation on the French art market, everything depends on seizing the moment and encouraging the sellers to make further transactions by paying quickly,' Oertel wrote.[45]

Hildebrand enjoyed Voss's complete trust. His bills were never questioned. 'We had plenty of money,' Voss said after the war.[46] He described Hildebrand's role as something 'between an independent dealer and an agent. He purchased on his own account after having discussed with me or submitted photographs, and sold the paintings in Dresden to Linz. This arrangement was desirable in view of the fact that the Reich Chancellery made difficulties as to the payment of commissions, and it proved more expedient to let Dr Gurlitt purchase on his own initiative.'[47]

It was more expedient for Hildebrand, too, as he could set his own commission and include it in the price he charged the Führermuseum. He got richer and richer. In February 1944, he requested a loan from his bank in Dresden. The bank noted that he was 'in possession of great

personal means' and that more than 3.7 million Reichsmarks had passed through his account in a year.[48]

But the biggest deals were yet to come. Under the law of supply and demand, prices escalated as the number of available works diminished. In May 1944 alone, Hildebrand sent Voss bills for more than 2.29 million Reichsmarks, followed by one in June for more than 3 million. That included his most expensive acquisition: four Beauvais tapestries priced at 2.2 million Reichsmarks. 'Request urgent currency transfer Gurlitt three million three hundred and thirty thousand please as fast as possible under due circumstances,' Voss telegraphed to the currency department.[49] For the tapestries alone, Hildebrand made a commission of 156,500 Reichsmarks.[50]

Michel Martin, the Louvre curator assigned to French customs, was understandably appalled at the huge number of artworks leaving occupied France under such artificial conditions. He tried to make it as hard as possible for the German dealers to get export permits, contriving endless bureaucratic delays by demanding re-evaluations of artworks and reams of paperwork.[51] He was, of course, aware that the dealers could eventually circumvent him by appealing to higher authorities. Hildebrand was no exception. He considered the French customs authorization to be 'rather futile', Martin said.

'Dr Gurlitt answered our objections by saying that he was an employee of the state, and as he was under orders to buy he couldn't refuse without disobeying his superiors,' Martin wrote. 'When we created difficulties and opposition, he would appear to accept them, even though he then took objects away without authorization, or sought the good offices of the Embassy' to overrule the French, he said. 'This is how Dr Gurlitt lifted several important paintings against our will.'[52]

Martin was particularly aggrieved at the loss of a Delacroix portrait of a blacksmith, the Ingres portrait of the copper engraver Desmarets, which Hildebrand had acquired for the Führermuseum, and a portrait of a monk by Jean Fouquet, which the dealer considered his most important painting acquisition in France. This purchase entailed a trip

to Marseilles to meet the seller, Count Demandolx. Hildebrand handed him 500,000 Reichsmarks – the remaining 300,000 of the price was paid by Theo Hermsen, a Dutch art dealer living in Paris. Voss turned the Fouquet down, so Hildebrand instead sold it to the Rheinische Museum in Cologne in July 1944.

Many of Hildebrand's transactions went through Theo Hermsen. The German dealer later told interrogators that Hermsen went to great trouble to procure export permits promptly. 'He was the only one who allowed me to take away pictures that were not yet paid for, and he took them back if Voss didn't want them.'[53] Yet some of Hildebrand's bills to Linz identify artworks as acquired via Hermsen even though there is documentation proving he bought them in Germany. Could this have been a ploy to get access to more foreign currency to build up his own collection on the side? It's possible. He certainly acquired a large number of French drawings that he bequeathed to his son Cornelius, as well as some extremely valuable paintings.

He purchased six paintings from the art dealer Gustav Rochlitz, who was a regular visitor to the Jeu de Paume and acquired many paintings looted from Jews.[54] The transaction may have been facilitated by Philippe Adrion, a dealer who was reported to have worked with the German Propaganda Office in Paris. Rochlitz seems to be have been a little afraid of Hildebrand, who must have been prone to temper flares. He wrote to Voss on one occasion saying 'hopefully I won't get into trouble with Dr Gurlitt for writing everything to you, as sometimes he is as angry as a film diva but then very nice again'.[55]

By the end of 1943, the Allied bombardments forced Voss to find alternative storage for the stash of art at the Führerbau that was destined for Linz. A salt mine in the Austrian resort of Altaussee was chosen as the main depot, because it was absolutely bombproof, protected from mildew by the salt in its walls, and cavernous enough to hold vast quantities of art. While Voss was overseeing the preparation of the mines and the transport operation – from May 1944, precious shipment after shipment arrived by truck at Altaussee – his dealers were still buying for

Linz. They often delivered straight to Munich, from where their purchases were sent directly to the depths of the mine.[56]

Even after the Normandy landings in June 1944, Voss pulled strings to ensure that Hildebrand could keep buying copious quantities of art in France as currency restrictions became much more stringent. Crazy though it seems, as the Allies were advancing towards Paris and Germany's chances of victory looked ever slimmer, Hildebrand was still frantically shopping for Hitler's dream museum – which was to remain just that.

In the summer of 1944, the logistics of transporting the artworks from Paris to Dresden became increasingly challenging. In July, Hildebrand set off once more to acquire and bring back art. Voss agreed that for this particularly difficult mission in the face of the Allies' advance, the Special Commission would bear the risk of the transport, given the value of the freight and the perils involved. He reassured the office of Martin Bormann, Hitler's private secretary, saying, 'I know Dr Gurlitt's character, and can assume on the basis of experience so far that his drive and savoir-faire are the best guarantee he will carry out his task quickly and safely.'[57]

Michel Martin remembered his last meeting with Hildebrand during that July visit. The beleaguered customs official refused him permission to export two pastels by the 18th-century portrait artist Jean-Baptiste Perronneau. Hildebrand made clear he was going to take them anyway. The export ban for the pastels, he told Martin flippantly, 'is of no consequence. If we win the war, this will be sorted out; if we lose it, you'll come looking for them and I'll tell you where they are.'[58]

This suggests Hildebrand was fully aware of the Allies' London Declaration issued on 5 January 1943 (see page 199). It warned those who traded in items plundered in the occupied territories that the Allies 'reserved the right to declare invalid any transfers of, or dealings with, property, rights and interests of any description whatsoever which are, or have been, situated in the territories that have come under the occupation or control' of the enemy.

Hildebrand planned to visit Paris again in August 1944, accompanied by Erhard Göpel, the chief buyer for the Linz project in the Netherlands and Belgium. They never got that far. That month Paris was liberated by the Resistance and French troops with the support of the US Army. Yet Hildebrand's special privileges came in handy in Belgium. Göpel at this stage did not have access to sufficient foreign currency, so Hildebrand loaned him 2.5 million Belgian francs to buy an early Italian rotunda painting showing the Madonna with child among angels.[59]

On the final list of Linz Special Commission acquisitions there were purchases by Hildebrand in September 1944 in the Netherlands. In October, Voss planned to send him on a shopping spree to Hungary with 500,000 Reichsmarks. There's no evidence this trip took place.

The last trip to the Netherlands and Belgium with Göpel included a visit to see the artist Max Beckmann, then living in exile in Amsterdam in a state of permanent uncertainty with his wife Quappi, one of the most frequently portrayed women in art history. Beckmann was not Jewish, but he was undoubtedly a victim of Nazi persecution. He was ousted from his teaching job in Frankfurt and his work featured prominently in the Munich 'Degenerate Art' exhibition. He left for the Netherlands the day the exhibition opened in 1937, after Hitler had delivered his ferocious, unhinged rant pledging an 'unrelenting war of extermination' against un-German art at the official opening of Munich's House of German Art.

Unfortunately for Beckmann and thousands of other immigrants from Germany, Amsterdam was to prove no refuge from the Nazis after the occupation in 1939. The market for Beckmann's 'degenerate art' had collapsed, so his financial situation was precarious. At the age of sixty, the threat of war service loomed over him. Göpel, who like Hildebrand had worked as an art critic and been a staunch advocate of the contemporary artists, had twice saved him from the draft. Beckmann had shown his gratitude by giving him artworks.[60]

Beckmann wrote in note form in his diary on 13 September 1944 that Göpel and Gurlitt had come to see him. It was clearly no delight to

him; he described the pair as '*Dick und Doof*' (Fatty and Dummy). 'The tragedy of not wanting to sell,' he jotted in his journal. 'Gurlitt *Brown Bar*.'[61]

This referred to Hildebrand's purchase of a painting he called *Bar, Brown*. It shows Quappi, ever the epitome of self-possessed poise and sexual mystery in Beckmann's portraits, frowning and looking ahead, her blue hat at an elegant tilt. A man in a suit with an anxious look, probably the Beckmanns' Amsterdam host Helmuth Lütjens, is seated next to her, his face partially in deep shadow. At first glance, the foreshortened perspective gives the impression he is leaning needily onto Quappi's right shoulder. On closer inspection, it becomes clear that both his elbows are on the table, his hands propping his chin. The muted colours, shadows and worried expressions convey deep tension and uncertainty; the proximity of their faces suggests a claustrophobic intimacy.

Göpel and Hildebrand acquired five works from Beckmann that month. When the Allies later seized Hildebrand's collection, he told them *Bar, Brown* was a gift from the artist – doubtless to circumvent rules that would have made the sale invalid and forced him to return the picture to Beckmann. He kept it until his death, and his wife later offered it at auction in Stuttgart in 1960, where it didn't sell. Via Munich and Milwaukee, it wound up being sold at Sotheby's in London in 2000 for 1.2 million pounds. The American collector who bought it died in 2012 and his heirs donated it to the Los Angeles County Museum of Art in 2013.

Some argue that this is a case for restitution to Beckmann's heirs. Hildebrand exploited his special position as a buyer for Hitler to travel and transport pictures freely and his work meant he had money for such purchases. Beckmann was in desperate straits and was forced to sell at prices much lower than he had commanded before the Nazis took power.

Mayen Beckmann, the artist's granddaughter, views it as a fair sale. 'But of course Max Beckmann would have preferred to have already been in the US by then and in a situation where he could have got a better price for the picture,' she said in a newspaper interview.[62]

Beckmann left for the United States in 1947 and spent the last three years of his life there. He seems not to have held Hildebrand's dealings against him. He wrote Hildebrand a letter of reference in 1946, praising the dealer's courage in exhibiting Beckmann's work at great personal risk in Hamburg in 1936.[63] In a letter to his first wife in 1950, Beckmann recommended Gurlitt as the best person to sell his work, saying 'he is clever and has a fine feeling for art and is fair'. Hildebrand again helped to raise Beckmann's profile in an exhibition at Frankfurt's Städel Museum in 1947. *Bar, Brown* was among four pictures from his collection in the show.

This story captures many of the contradictions and the ambivalence of Hildebrand's career: absolute dedication to the art he valued to the point of self-endangerment, a passion for business that could overrule his moral compass, economy with the truth if he thought the truth would cost him, and a knack for winning the respect and liking of nearly everyone he had dealings with.

In total, Hildebrand delivered 168 artworks to Voss for Hitler's museum, making him the fourth most active buyer.[64] He told US interrogators he had bought a total of about two hundred artworks in Paris. That figure did not include the dozens of works he purchased for himself. His sojourns in Paris gave him plenty of opportunity to build up his private art collection, as Michel Martin noted. 'He profited from his official position to procure objects for his private collection and his gallery,' he commented. 'We are sure to find them at his home in Dresden.'[65]

He defended his wartime dealing by saying it allowed him to avoid forced labour. As a quarter-Jew, he was afraid of being conscripted to work in a munitions factory by the *Organisation Todt*: 'I had to decide between the war or working for the museums,' he told his Allied investigators after the war.[66]

Was Hildebrand really spared slave labour through his work for the Special Commission? The Nazi Party introduced the Nuremberg Race

Laws in 1935, which stripped all Jews of German citizenship. The laws differentiated between half-Jews ('first-degree *Mischlinge*', those with two Jewish grandparents, of which there were about 72,000) and quarter-Jews ('second-degree *Mischlinge*', with one Jewish grandparent like Hildebrand, who numbered around 40,000), according to the Nazi classifications of those with mixed 'Aryan' and Jewish ancestry. There is no doubt that the Nazis planned to annihilate half-Jews after they had massacred the fully Jewish population. Yet most *'Mischlinge'* ('cross-breeds') survived, mainly because Hitler was afraid of alienating their 'Aryan' families and repeatedly delayed action. By the same reasoning, full-Jews married to 'Aryans' were for some years protected by their 'privileged mixed marriages'.

As a 'second-degree *Mischling*', Hildebrand was not allowed to take public office, which included working as a teacher, journalist or museum director. Members of his own family had also suffered from Nazi anti-Semitism. His cousin Manfred was banned from conducting at the Berlin State Opera in 1933 and emigrated to Japan in 1939. Hildebrand's brother Wilibald, whose wife Gertrud was Jewish, was ousted without pension from his post as professor of musical history at the University of Freiburg in 1937. Even their father Cornelius, for all his honours, achievements and Nazi sympathies, wasn't immune from discrimination as a half-Jew. In 1934, a request by Wilibald that Cornelius senior receive an honour or a signed photograph of the Führer as official recognition of his 85th birthday was denied on the grounds that his father was 'not of pure Aryan descent'.[67]

Yet quarter-Jews like Hildebrand did not suffer the same degree of persecution as half-Jews and were tolerated as long as they didn't marry partners who had Jewish blood. The Nazis' long-term plan was to subject them to forced sterilization to ensure that they would not give birth to children with 'Jewish characteristics'. Some race fanatics, such as SS chief Heinrich Himmler and Reinhard Heydrich, the Deputy Protector of Bohemia and Moravia, favoured murdering them, too. Fortunately Heydrich died in 1942, and the medical capacity for forced sterilization

on such a scale was lacking. '*Mischlinge*' were rounded up and forced into working for the *Organisation Todt* from 1944 – joining homosexuals, eastern Europeans, Roma, Sinti and convicted criminals to slave for the Nazis under deplorable conditions on such projects as repairing the French railways – but only 'first-degree *Mischlinge*' were affected.[68]

So though Hildebrand had every reason to be afraid of the Nazi vision of the future, he was not in immediate danger of being coerced into slave labour – either with or without his special status as a dealer for Hitler. He was, however, spared military service through his work, as were the other dealers for the Führermuseum. The art historian Birgit Schwarz believes that the Linz Special Commission had become 'a life-saving machine for the men involved'.[69] Voss protected them; he obtained guarantees from Hitler that about ten dealers were 'absolutely indispensable' to the Linz Special Commission and therefore 'completely unavailable' for military duties.[70] In October 1944, when travel to Paris was no longer possible, he wrote a certificate for Hildebrand stating 'I set great value on his contribution to the Führer's Special Commission and therefore request the Hamburg labour office to allow him to continue his activities.'

The flurry of acquisitions in the last year of the war should be seen in this light. The Führermuseum spared the dealers from being drafted because their work was considered too important. To shop was to survive, or at least to avoid the army. Accordingly, the quality of the artworks purchased in the Special Commission's final months deteriorated, even as the prices rose. Some of Hildebrand's purchases were of an inferior calibre, as Martin noted in his report. 'Dr Gurlitt was not very particular about the quality of the artworks and above all demonstrated a desire to acquire works of art for marks, which he considered to have no value,' the Louvre curator wrote.[71] Hildebrand knew what was high quality and what wasn't, but he was also quick to recognize a business opportunity. As long as Voss was purchasing dross, Hildebrand would sell it to him.

Hildebrand also said he 'never bought a picture that was not offered voluntarily to me'. While he knew of the existence of the haul of looted

art at the Jeu de Paume, he said he never went there, and only once had contact with Bruno Lohse, Göring's representative. 'I always avoided meeting high Nazi officials in Paris,' he said. 'There was a rumour that the Gestapo bought under pressure paintings from private [people] or dealers, which I heard very often but I could never prove it.'[72]

It seems likely he did avoid the Jeu de Paume – Michel Martin or Rose Valland, the curator at the museum who later interrogated Hildebrand, would almost certainly have mentioned it in their reports if he had been spotted there. Instead, Martin wrote that Hildebrand 'insisted on carrying out his operations in a "regular" way and always said that he didn't want to traffic in art from Jewish collections, and we believe this is the truth'.[73]

Perhaps Hildebrand was aware that any dealings with Jews in Paris would be likely to catch up with him later if Germany lost the war – an eventuality that appeared increasingly likely during the period he was visiting France. Yet in Germany, Hildebrand definitely bought paintings from Jews who were selling under duress. He had begun buying from Jews who were banned from selling in the 1930s in Hamburg. This continued during the war years.

He noted in his business book on 1 January 1940 that he had bought four artworks from Henri Hinrichsen, the Jewish owner of the world-famous Leipzig-based music publisher C. F. Peters and a pillar of Leipzig society.

The elderly, distinguished Hinrichsen did not recognize that his life was in peril, believing that his patriotism, philanthropy and reputation would protect him from the worst. He had founded a girls' school, a music library and a musical instruments museum in Leipzig and sat on dozens of boards. Like David Toren's father in Breslau, Hinrichsen did not want to leave everything he had created and start anew somewhere else. He was even incensed with his eldest son and business partner, Max, for deserting the company and fleeing to London at the insistence of his Catholic wife in 1937.[74] His wife's nagging probably saved Max's life.

The events of *Kristallnacht* showed Hinrichsen he was mistaken. That night, his three youngest sons watched as the apartment and the

company offices were ransacked and looted. Sheet music, books, files and furniture were flung out of the windows and heaped onto a bonfire in the courtyard. Hinrichsen was thrown into jail in Leipzig for a week. His son Hans-Joachim was deported to Sachsenhausen concentration camp where he was tortured and only reappeared several weeks later, emaciated and battered.

In the aftermath of *Kristallnacht*, C. F. Peters was confiscated and 'Aryanized' (*Arisierung* – a Nazi Party term for its policy of expelling 'non-Aryans', mainly Jews, from economic life). Hinrichsen's art collection was seized in September 1939 and eight works were purchased by the Leipzig Museum of Fine Arts. What remained in his apartment was taken two months later on the pretext that the Hinrichsens might try to export it out of the country. It was stored at the museum.[75]

Hildebrand managed to obtain permission to purchase four pictures from the collection. He fully understood Hinrichsen's desperation and wrote to him on 7 January 1940, saying he had paid the purchase price into Hinrichsen's blocked account, to which the music publisher had no access.[76] The money in such accounts was confiscated by the Nazis to pay as many as eight different kinds of taxes extorted from Jews who were planning to leave the country. Though aware of this, Hildebrand nonetheless asked Hinrichsen to cover the costs of transporting the artworks. 'I assume you will acknowledge that this is absolutely normal practice,' he wrote. Perhaps he realized that in this situation it was also unreasonable, even callous, as he added a footnote saying, 'I am not making a condition of this request'.

Yet the Hinrichsens remained cordial with Hildebrand. Henri's son Hans-Joachim wrote to say he could not comply with the request but hoped the family would be able to make it up to him at a later date.[77] Hinrichsen never received any of the money due to him from the sale of his valuable collection.

Hildebrand sold one of the artworks, a painting by Camille Pissarro, a week later at great profit.[78] He sold another, a drawing by Moritz von Schwind, to the Führermuseum four years later for 12,000

Reichsmarks, compared with a purchase price of 1,000.[79] A third, an 18th-century portrait of the composer George Frideric Handel, has not yet been located.

The fourth is a charming drawing by Carl Spitzweg, portraying a woman at the piano and a man playing the flute in a 19th-century drawing-room. This harmonious, domestic scene has a mischievous twist – the man's shadow in the curtains creates a horned, Pan-like figure, as if to suggest that the flautist's intentions towards his accompanist are less innocent than they might appear. It hung for many years in the hallway of Cornelius Gurlitt's Munich apartment, as his mother Helene had hung it in hers before him.[80]

Three weeks after selling his last artworks to Hildebrand, Henri Hinrichsen, by then aged seventy-two, fled Germany with his wife Martha. After visa applications for several countries had been refused or delayed, they had managed to get to Belgium, from where they hoped to travel to the United States to join their second son, Walter. The luggage their sons in Leipzig sent after them was seized by the Gestapo and sold at a so-called 'Jew auction' with the proceeds going to the state. The Nazis had robbed them of everything they owned.

The Germans occupied Belgium in May 1940. The Hinrichsens were still there, waiting for their US visas. Martha died in occupied Brussels because she was denied insulin as a Jew. Henri was arrested by the Gestapo on 13 September 1942, put into a camp, then deported to Auschwitz where he was gassed the same day. Their son Hans-Joachim died of typhus in a French concentration camp.[81]

As well as purchasing from Jews selling under duress, Hildebrand also bought art that had been looted from Jews, even if he drew the line at visiting the Jeu de Paume and told Michel Martin that he wanted nothing to do with stolen objects. In Germany – perhaps sensing that his actions there would be less likely to catch up with him after the war – he showed few such qualms. He wrote to several museums enquiring about paintings in their collections that had fallen out of public favour without specifying that he did not want looted works.[82]

One of the museums he wrote to in 1941 was the Silesian Museum of Fine Arts in Breslau. The Max Liebermann painting, *Two Riders on the Beach*, was offered to him by Cornelius Müller-Hofstede, the unscrupulous director of the museum. Müller-Hofstede, who like Voss cooperated with the Gestapo by appraising paintings in Jewish homes, used the expropriation of the Jews as an opportunity to enhance the city's public collections.[83] But works by Liebermann were of no use to him because they couldn't be shown in the museum. So he wrote to Hildebrand in Dresden in August 1942, after David Friedmann had died and the Gestapo had confiscated his possessions, saying 'I would be happy to come to Dresden and show you' the two Liebermann paintings that Hildebrand had expressed an interest in when they met at an auction in Berlin.[84]

Hildebrand bought Paul Rosenberg's Matisse, *Seated Woman*, after the war from a Paris dealer. It is difficult to imagine that Hildebrand, who had grown so familiar with the Paris art scene over the course of the war, wouldn't have known whose collection such an important painting originally came from. The Rosenberg family points out that Cornelius Gurlitt kept the painting in a drawer, suggesting that his father may have told him not to display it publicly.

Years later, Hildebrand called his wartime dealing 'a dangerous tightrope dance'.[85] His statement to the Allies that he tried to maintain a low profile among the Nazi elite in Paris out of fear that he would be denounced as a quarter-Jew may have been the truth, yet he still managed to keep some unsavoury company.

Gustav Rochlitz, from whom Hildebrand bought six paintings for Linz, profited enormously from the looted art he acquired from the ERR. The Allies believed he was addicted to morphine and concluded he was probably forced to flee Germany in 1925 and Switzerland in 1932 because of shady business deals. Described by his interrogators as an 'unscrupulous opportunist', he was indicted for trafficking in stolen art and for fraud[86] and imprisoned by the French.[87]

Erhard Göpel, with whom Hildebrand visited the Netherlands and Belgium, was instrumental in acquiring the collection of the Schloss

family for Hitler after it had been looted by the Gestapo and family members had been threatened and imprisoned. This much-coveted array of Dutch and Flemish masterpieces was assembled by an Austrian-born French Jew, Adolph Schloss, and it included works by Rembrandt and Frans Hals. Göpel purchased for himself some of the works that didn't make the grade for the Linz project.[88] Even Voss described the Schloss affair as a tricky business. Yet Göpel evaded sentencing and spent his post-war career organizing Munich exhibitions.

Then there was Hermann Voss, Hildebrand's mentor and protector. He was complicit in the looting of the Jews and could play the perfect Nazi when required, even if he never joined the party. When questioned by the US Army's ALIU after World War II, he didn't reveal his dealings with the Wiesbaden police and his immoral acquisitions. He did admit to having bought seized paintings, but told his interrogators they were all paid for. 'The confiscated pictures were sure to go somewhere, and what difference did it make?' is how they summarized his argument.[89]

His examiners didn't take to Voss one iota, calling him 'an extraordinarily conceited and ambitious man' and recommended he be detained as a potential war criminal for trial at Nuremberg. 'Although his opinions and personal feelings about the Nazis remained as hostile as before, he accommodated them to existing circumstances,' they said. Yet they couldn't pin any specific charges to him and he was never tried. After the war, he moved to Munich and successfully revived his reputation as a scholar and writer. He died in his mid-eighties in 1969.[90]

Was Hildebrand, like Rochlitz, an unscrupulous opportunist? He profited immensely from the Nazi regime, particularly from his acquisitions for Hitler's museum. As Michel Martin saw it, 'he never displayed hostile sentiments to France but cynically exploited every opportunity to despoil it of its works of art'. The perceptive curator described him as 'eager for profit' and 'first and foremost, a businessman'.[91]

Hildebrand's income grew exponentially. He told US interrogators that it soared to 200,000 Reichsmarks (the equivalent of about $1 million today) in 1943 from 50,000 Reichsmarks a year before the war.

He reported his assets as 200,000 Reichsmarks in industrial bonds with the banking firm Ree in Hamburg and the same amount in cash, plus about 40,000 Reichsmarks at the Dresdner Bank. On top of that, he said he retained his art collection and family heirlooms.[92]

But not everything he told those interrogators was the truth. The Bamberg tax office later calculated his 1945 assets at 535,811 Reichsmarks.[93] Even that could have been a major understatement. Given the extent to which Hildebrand concealed the true dimensions of his art collection, it wouldn't be surprising if he hid other assets, too. Whether he was lying or not, he was extremely rich by the standards of the time.

While Hildebrand was mixing with the privileged elite of Paris, buying art for Hitler and for himself and growing ever wealthier, some of his family members were struggling to stay alive. There is no evidence he tried to help them.

His brother Wilibald had been dismissed from his teaching post at Freiburg University without pension in 1937 because of his Jewish wife and grandmother. In autumn 1942, his two youngest children, both daughters, were barred from school because of their mother's origins. Gertrud was in fact a devout Christian -- her parents had converted from Judaism. To the Nazis that was irrelevant; Gertrud was classed as a Jew under the Nuremberg Race Laws because all four of her grandparents were Jewish.

Uta, Wilibald's youngest daughter, remembers her father constantly writing letters after his dismissal to try to improve his own and his family's lot. In 1944, he took the two girls to a remote village called Hinterzarten in the Black Forest near Titisee lake, off the radar of the Gestapo, which was trying to enlist him for snow-shovelling duties. Gertrud stayed in their Freiburg home to forward his post and care for a sick canary.

On 13 February 1945, at 6.15 a.m., a Gestapo officer on a red bicycle called for her. She had already left the apartment, in order to be in time to deliver a hyacinth she had grown herself to the pastor for his birthday at the 7 a.m. morning church service. 'He had always had hyacinths for his birthday since childhood,' Gertrud wrote. 'And since the bombardment of 27 November 1944, there were no flowers to be bought in Freiburg.'

When she returned, she found the neighbours in a fluster. They told her the officer had left orders she should report to the Gestapo head-quarters by 11 a.m. She disobeyed and stayed home to cook her lunch. 'I wanted at the least to eat in peace first if I had to go there,' she wrote. An hour later he came back and knocked on the door but she refused to answer. The neighbours called her name but she remained silent. When all was peaceful again, she looked outside and saw the red bicycle had gone.

Gertrud gave the canary to a neighbour to look after and told her it was safer not to know where she was going. She ate her lunch, packed a suitcase and climbed onto the back of a coal truck that was heading in the right direction. She reached Wilibald the next day. He made some phone enquiries and was told Gertrud was only required to register with the Gestapo; there was no deportation order. She returned to Freiburg and discovered immediately that in fact there had been a Gestapo round-up of Jews and had she opened the door, she, too, would have been deported to a concentration camp.

Gertrud locked her door and stayed at home; the Gestapo officer with the red bicycle never returned. After the war, the officer demanded a character reference from Wilibald confirming that he had left Gertrud in peace. Wilibald provided it. According to Gertrud, he was in any case interned by the Allies for a long time.[94]

Hildebrand – perhaps remembering his brother's inaction when he was dismissed from his Zwickau post (see page 39) – did little or nothing to help Wilibald's family during the war.[95]

The war would catch up with Hildebrand again, too, destroying his home for the third time. His native city Dresden was to become a byword for catastrophe, grief and devastating loss as Hitler's criminal regime began to crumble.

5 Surviving the Inferno

Famed for its architecture, art and stately charm, Dresden was largely spared the devastating air raids the Allies carried out on other German cities until the war was nearly over. When it came, the attack was ferocious and deadly, the result of the bombers' practised techniques and perfect weather conditions.

More than 240 of the British Royal Air Force's Bomber Command planes dropped 880 tons of incendiary bombs and high explosives on the historic centre between 10.13 p.m. and 10.28 p.m. on the night of 13 February 1945, a Shrove Tuesday. In fifteen minutes, they ignited thousands of fires in attics and roofs. Many residents stayed in their cellars and shelters as they had been instructed, waiting for an all-clear that never sounded because the power supply was cut. With few daring to venture out to tackle the myriad small blazes, they spread rapidly. High-explosive bombs crashed through roofs and blew out windows and doors, creating draughts to feed the flames. They merged into one voracious firestorm that swept through the city, melting the tar on the streets and devouring palaces, churches, museums and homes.

A second, larger wave of 550 British bombers was already in the air by the time the first attack began. It advanced on the city after 1 a.m. This time there was no alarm for the historic centre. The only warning was the growl of the engines and the whistle of the bombs. The bombers needed no flares to light their targets because the whole city was ablaze. Dropping explosives into the inferno at the heart of Dresden seemed pointless, so they widened their field of attack to the outer districts. They hit the main station, where hundreds of refugees suffocated underground, and the parks and the banks of the Elbe, where many of those made homeless by the first wave of bombing had fled.

Blazing trees and chunks of brickwork flew through the streets in scorching tornadoes. The molten roads tore off the shoes of those trying

to escape and sucked in their burning bare feet, trapping them in the fire. Thousands asphyxiated in the toxic, oxygenless air, both outside and inside the underground shelters. The smell of charred flesh rose up from the basements. Falling masonry and collapsing buildings claimed hundreds more victims.

On that clear night, the glow of Dresden was visible from 100 miles away. 'The attack is believed to have been highly successful,' Bomber Command's intelligence reported the next day.[1]

Around noon on 14 February, three hundred US Air Force (USAF) planes carpet-bombed the west of the city, their crews' visibility impaired by the smoke, setting industrial areas alight. It was Ash Wednesday. In total, as many as 25,000 people died in the inferno.[2]

The Gurlitt family villa was just a kilometre southwest of the carnage at the main station, in the leafy Südvorstadt district. This part of Dresden was only lightly bombed in the first attack, but suffered heavy damage in the second wave of bombing. As he sat at his father's desk for minutes on end, listening to the hiss of flames consuming the adjoining library, Hildebrand realized that none of its contents could be saved. 'My family home with all its memories and pictures was burned to a cinder,' he later wrote.[3] Photographs of the house after the bombing show its white elegance stripped bare to expose a blackened, roofless skeleton (see page 72).[4] Family legend maintains that the day after the firestorm, Hildebrand's mother Marie Gurlitt, then aged eighty-six, made coffee in the ruins of her house before moving in with her sister. Dietrich Gurlitt, her grandson, said she was a robust if simple lady, and that such a gesture of defiant survival would have been typical of her.[5]

Hildebrand described seeing corpses piled in front of the blackened Frauenkirche (Church of our Lady) before they were turned to ashes by flamethrowers. He packed some essential possessions in a handcart, and together with his wife and children – Cornelius was now thirteen and Renate ten – watched from the hills on the outskirts of the city as USAF destroyed what little of Dresden remained intact following the attacks by Bomber Command.

Dresden's Baroque grandeur, which Hildebrand's father had dedicated his life to preserving and documenting, was reduced to smoking rubble. The opera house, theatre, city palace and the Zwinger, home to the priceless art collections of which Hermann Voss was custodian, lay in ruins. The gracious Frauenkirche, a Dresden landmark, survived the fire but toppled on 15 February, when the temperature inside it began to drop and the distortions caused by the heat led the cupola to collapse into the church, crushing the entire structure into an enormous pile of blackened sandstone bricks. The skyline immortalized by Canaletto was forever blighted.

'We swore to ourselves that we would never regret any material losses and would recognize this destruction as a logical consequence of what had gone before, and that though we were stricken with grief, we would choose life, even a very simple one,'[6] Hildebrand wrote ten years later.

The family made its way to the village of Possendorf, a few kilometres south of the city. Even after the bombing, Hildebrand owned more than most Dresden citizens had ever dreamed of possessing. The blaze at his home claimed a Courbet painting, a Rodin clay, some French drawings and Dutch paintings, along with the family library and furniture, he later told the Allies. Yet he had stashed most of his more valuable artworks in country hideouts around Saxony. Cornelius remembered helping him to hide it from the Russians, loading the artworks onto a vehicle that his father had managed to borrow and driving to a farm near Dresden.[7] Hildebrand must have spent the weeks after the bombardment rushing around to retrieve what he could.

He couldn't recover it all. Two years earlier, he had stored a Brueghel painting of a Madonna surrounded by a wreath of flowers and fruit at Weesenstein Castle near Pirna,[8] where many of the treasures of both Dresden's and Wiesbaden's public collections were kept during the war. He later told the Allies that the Madonna was consumed by fire, together with a portrait of a girl by Aelbert Cuyp, another Dutch Golden Age master. A pastel by Toulouse-Lautrec and another work belonging to him were destroyed at the Roemer art gallery in Berlin, Hildebrand said.

He had deposited a Rodin bronze in a Dresden warehouse; a François Boucher painting of a girl and another large Rodin bronze in a Cologne museum's depot; and a Horace Vernet battle scene in the Leipzig depot.[9] He also stored a Dürer work on paper in the bunker of the Dresden's Collection of Prints, Drawings and Photographs.[10]

He had hidden many of his modern works in an old smithy 30 kilometres from Dresden,[11] a fact he neglected to mention to his Allied investigators after the war. He only managed to recover these much later.

———

As Dresden smouldered and Hildebrand was taking stock of his possessions, Fritz Salo Glaser was counting his blessings. Glaser was due to be among the last Jews deported out of Dresden on 17 February. The Allied bombing raids spared him from Theresienstadt concentration camp and probably saved his life.

He protected his Dresden home, and with it the remains of his art collection, by removing the firebombs that penetrated it during the attacks. How exactly he did that isn't documented, but if thrown onto the street, the incendiaries fizzled and died. Immersing them in sacks of sand that had been distributed around Dresden houses was another way to extinguish them quickly.[12]

Like Hildebrand and his family, Glaser left the city in the mayhem that followed the fire. He managed to join his wife and daughter, who were sheltered and concealed in a farmhouse in Dippoldiswalde, 10 kilometres south of the Gurlitts' refuge in Possendorf. The farmer had courageously agreed to take the family in even without the requisite police registration.[13]

Glaser was a well-to-do lawyer who had built up a sizeable art collection, comprising many works by the Dresden artists he socialized with. His villa on Bergstrasse[14] was a few hundred metres away from the Gurlitts' home. During Hildebrand's tenure as the director of the Zwickau museum, Glaser had loaned him works for exhibitions.[15] Like Hildebrand, Glaser loved the art of his time and purchased mainly

graphics and watercolours, which were significantly cheaper than oil paintings.

Glaser's collection of about fifteen hundred works was 90 per cent composed of works on paper, though he owned about forty oil paintings. He bought pictures by Oskar Kokoschka, Wassily Kandinsky, Max Beckmann, Paul Klee, Emil Nolde and, above all, Otto Dix, whom he counted among his friends. 'I have always known your art has eternal value,' Glaser wrote in a 1924 letter to Dix.[16] He must have been a tolerant man; Dix's portraits of him were highly unflattering and showed him with an exaggeratedly long nose reminiscent of the anti-Semitic caricatures of the era.

Otto Griebel was among the Dresden artists grateful for Glaser's patronage. 'One morning Dr Glaser came to our home, threw one hundred marks down on the blanket of the bed, where Grete was still lying, and said he would come back another time and choose something from my portfolio for his collection of graphics as he didn't have time now,' Griebel wrote in his memoirs. 'Saved from all my financial troubles, I first paid back the rent debt to the landlady. I also needed a new suit, this and that purchase had to be made, and soon we had to watch the pennies again and there was nothing left.'[17]

An accomplished accordion and violin player, Glaser entertained regularly with his non-Jewish wife Erna at their Dresden home during the inflationary 1920s, offering their bohemian friends music and dancing (the 'shimmy' was the latest dance rage imported from the US) as well as lavish supplies of food and drink. The couple embraced the intellectual freedom of that heady era, and revolutionary poets, writers, painters and sculptors – many of them poor enough to be grateful for a good meal and wine – gathered at their home. Erna had studied art, and it was she who forged the contacts to Dresden's young creative world. Kokoschka painted her portrait in 1923 and gave it to her husband as a present.[18]

Griebel, who also knew Hildebrand, recalled a rowdy party at the Glasers' in his memoirs. 'Once Fritz Glaser couldn't get rid of us all after a very merry evening, despite the approach of dawn. The poor man had

an early court appointment and he tried hard, but in vain. He did everything possible and made the third round of strong coffee in the kitchen while we shouted across the room "those who can't keep up shouldn't invite artists; we're staying!" Yet the lawyer took even this behaviour with good grace and waited up patiently until we finally left.'[19]

The parties stopped when the Nazis swept to power. Glaser was banned from practising as an attorney in 1933, and could no longer work as a tax adviser from 1937. He began to peddle works from his collection to support his family as his financial situation deteriorated.

On *Kristallnacht*, the night of terror against the Jews in November 1938, Glaser narrowly escaped arrest and deportation to Buchenwald concentration camp by fleeing the city. Partially protected – at least for a while – by his marriage to a non-Jew, he was later arrested twice but released, then forced to work as a street sweeper and railway porter in Dresden.

Jews were banned from selling art after December 1938. Glaser secretly sold two Schmidt-Rottluff paintings, a Klee, a Kandinsky, a Kokoschka and a Nolde to pay the *Judenbusse* (Jew Penance), the tax Hermann Göring extorted from Jews after *Kristallnacht* as 'atonement for the hostile stance taken by Jews toward Germans'.[20] With his house subject to frequent searches by the Gestapo, Glaser destroyed all documentary evidence of the forbidden art sales and kept what was left of his collection hidden.

The Jewish diarist Victor Klemperer described an afternoon spent at the Glasers in July 1942, by which time Fritz appeared to Klemperer to be an old man with long snow-white hair, 'a curious mixture of senility and eccentricity. He is a musician and does not notice that he does not get a note out of his violin.' Klemperer and his wife were desperately poor and the Glasers, hospitable as ever, gave them coffee, cake, cigarettes, cigars and wine, played Paul Hindemith on their gramophone and lent them books. They also gave them 'a radish, a couple of pea pods, a couple of tomatoes' and a bag of potatoes to take away with them. And they divulged a dangerous secret to Klemperer. 'He has invested his

fortune in an art collection, which he keeps in hiding in his house,' wrote the diarist, who was clearly not a fan of modern art.

> It is all banned, Expressionist 'degenerate' art....Now an art lover willing to pay good prices has secretly been found, and Glaser wants to pay off a mortgage with the anticipated money (whose origins could be concealed). The conversation led to a scene that really could have been in a film. In an adjoining, fairly empty room there were curtains, behind which one might have expected shelves, for example for kitchen appliances. Frau Glaser drew back the curtains, there on the floor were a couple of wooden sculptures, which at first glance I found stomach-churningly unpleasant and still find unpleasant when I think of them.

Glaser, the successful lawyer, free thinker, gregarious host, art lover, musician and bon viveur was a broken man, diminished by his constant, gnawing fear of the Gestapo, according to Klemperer. 'He believes in Hitler's lasting victory; he saw the collapse of the Left at close quarters – "there is no organization there anymore," he repeats again and again, and trembles before the omnipotence of tyranny,' he wrote.

After the war, the Glasers and Klemperers reunited in Dresden, over-joyed to discover they had all survived. Fritz Glaser was by now 'somewhat decrepit and listless', according to Klemperer.[21] He was nevertheless com-pelled to find employment to feed his family. By then approaching seventy, Glaser took a post at the Justice Ministry in the state of Saxony, helping determine which of Hitler's laws should be retained and which annulled. He then resumed his work as a lawyer and died aged eighty in 1956.

His wife and daughter, left with little income after his death, sold some of the art he had saved from the fire to pay for their keep. Thanks to those sales, Glaser's legacy lives on in some of the most prestigious museums of the world. A 1921 portrait of Glaser by Dix now hangs in the Neue Galerie in New York. Another Dix portrait of Glaser with his family is one of the crown jewels of Dresden's public art collection.

A part of his legacy also survives in the collection inherited by Cornelius Gurlitt. At least thirteen works that had belonged to Glaser ended up in Hildebrand's possession and were passed on to his son, only to surface in his Munich apartment in 2012, sixty-seven years after the bombing of Dresden. They are drawings, graphics and watercolours by the Dresden artists Glaser knew personally – Griebel, Ludwig Godenschweg, Erich Fraass, Christoph Voll, Conrad Felixmüller and Wilhelm Lachnit. The circumstances under which Hildebrand acquired them are still not known.

Glaser's watercolours and drawings were among the artworks that Hildebrand managed to take with him when he left Saxony. After fleeing the burning city with his family, he visited the castle at Weesenstein, where he had stored some of his art with the Dresden and Wiesbaden collections. Hermann Voss and his wife were staying at the castle – they, too, had been bombed out of their apartment on that catastrophic night in Dresden – and Voss was sick.[22] The two men discussed what to do to save the Wiesbaden and Dresden treasures from the omnipresent risk of bombing and the intensifying fighting. Voss advised Hildebrand to go west to the region of Mainfranken around Würzburg, which the BBC had reported was safe, and to take the museums' pictures and his family with him.

With great difficulty, Hildebrand managed to find a truck with a trailer that was going to Nuremberg and persuaded the owners to take his family and the boxes containing the artworks from his own collection that he had managed to retrieve. He didn't take any of the Dresden or Wiesbaden treasures with him, intending to return to fetch them after he had found accommodation for his family and possessions. He never did go back for them, and told his Allied investigators that the course of the war prevented his return.[23]

If he had managed to extricate those treasures, he might have saved them from Stalin's 'Trophy Brigades', which discovered the cache in

the castle weeks later and packed up such jewels as Raphael's *Sistine Madonna* to ship them off to Moscow. For Joseph Stalin, the art treasures in the Soviet-occupied zone were fair game – an opportunity to secure some reparations for the devastation wrought by the Germans in the Soviet invasion. Already emptied of modern art by the Nazis, the eastern German museum collections were ransacked once again as Soviet 'Trophy Brigades' shipped 2.5 million art objects eastwards.

Hildebrand set off on 22 March 1945, his family settled on mattresses in the back of the truck with the boxes of art he had managed to salvage in Saxony packed around them. More boxes went into the trailer, along with wood for burning. The journey across war-ravaged Germany took forty-eight hours.

They were heading for Wiesentheid, a village whose castle had become a refuge for a host of artists and musicians bombed out of their homes.[24] Yet before Hildebrand got that far, he was received at the village of Aschbach, between Würzburg and Bamberg, by Baron Gerhard von Pölnitz, a wealthy Luftwaffe officer who had been stationed in Paris during the occupation. Hildebrand later told his Allied investigators he knew Pölnitz only very slightly, having met him in Berlin and three or four times in Paris.[25] He said he had avoided any business dealings with the baron because of his friendship with the infamous Nazi art dealer Karl Haberstock, Hitler's personal art buyer. He may not have been telling the truth. It is documented elsewhere[26] that Pölnitz negotiated at least one transaction for Hildebrand in Paris (see pages 74–75).

Whatever their relationship, Pölnitz was hospitable and put the family up for eight days in his 17th-century castle, where Haberstock and his wife were already guests. The baron also let Hildebrand store his boxes there. The Gurlitts then found a small house on the main street of Aschbach village, with just a kitchen and one room for the four of them to sleep.

In Aschbach, where Hildebrand sat out the rest of the war, the artworks he had managed to bring from Saxony provided a welcome distraction. 'On low-key, unforgettable evenings at the village pastor's

home they would pass from hand to hand among the refugees and residents, bringing solace to those living in emergency accommodation,'[27] he wrote ten years later.

Two American tanks rolled into Aschbach on 14 April 1945, followed by infantry. The residents hung white sheets from their windows and the surrender was smooth. Pölnitz, who was the local Nazi Party leader, was arrested and jailed.[28] No damage was inflicted on either the castle or its contents -- which included some of the Bamberg and Kassel museums' collections as well as those of Hildebrand, Haberstock, Prinz Reuss zur Lippe and General Heribert Fütterer, who had commanded the Luftwaffe in Hungary.

In May 1945, a week before Germany conceded unconditional defeat, Captain Robert Posey of General George Patton's illustrious Third Army paid a visit to Aschbach Castle. An architect who grew up in poverty on an Alabama farm,[29] Posey was assigned to the Monuments, Fine Arts and Archives (MFAA) section, a group of American and British curators and restorers who specialized in art and architecture and were known shorthand as the Monuments Men. They owed their presence in Europe to the American museums community, which had lobbied for a policy to prevent valuable ancient monuments, buildings, art and archives across Europe from being destroyed in the last battles of the war.

As well as recovering hidden art from mines, bunkers, castles, palaces and caves around Germany, the MFAA team's mandate was to repatriate looted items to the governments of the occupied countries from which they originated, to restitute works plundered from private, mostly Jewish collectors in Germany, and to put in place administrative agencies that would oversee the re-establishment of the emptied-out, war-damaged museums and the revival of German public cultural life.[30]

Posey had advanced through France with the Third Army and helped safeguard what was left of the treasures of Trier, which he described as 'smashed'.[31] He had seen skeletal cities, their inhabitants eking out an existence from cellars beneath landscapes of rubble and ash. Just four weeks before his visit to Aschbach, he had uncovered a trove of Nazi

gold worth billions of dollars along with thousands of artworks from Berlin museums at a salt mine in Merkers, where they had been stashed to keep them safe from the bombs.

Suspecting that Haberstock's and Hildebrand's collections could contain art looted from the occupied territories, Posey ordered 'Off Limits' signs to be posted around the castle's rooms and warned that nothing should be removed.[32] The Monuments Men counted forty-seven wooden boxes, two rugs and eight packages of books belonging to Hildebrand.

While Haberstock was arrested and taken in for questioning, Hildebrand was allowed to remain in Aschbach. Haberstock was incensed that Hildebrand met such leniency: 'I was able to prove everything, including, for example, that I was not the main supplier for Linz, whereas Mr Voss, during his short tenure in office, bought 3,000 artworks and took over confiscated collections together with his main buyer, Dr Hildebrand Gurlitt.'[33]

Hildebrand was interrogated over three days in June 1945 by First Lieutenant Dwight McKay of the War Crimes Section of the US Third Army. The Jewish grandmother who could have cost him his livelihood months earlier suddenly became an asset. He told McKay that he had turned to art-dealing for museums to avoid being drafted into forced labour at the *Organisation Todt* as a quarter-Jew. He also said that he 'never bought a picture that was not offered voluntarily to me'.[34]

He and his family were put under house arrest and Hildebrand was banned from selling any possessions until the investigation was complete. Twenty-two boxes were opened. Their precious contents included the Max Liebermann painting *Two Riders on the Beach*, Beckmann's *Bar, Brown*, the drawings that had belonged to Fritz Glaser, the Picasso painting *Portrait of a Woman with Two Noses*, Marc Chagall's *Allegorical Scene*, two Degas works, a Courbet, a Fragonard, a Dix and a Nolde.

The Western Allies' policies in dealing with post-war Germany – its politics, economy, assets and individuals – were still being formulated. There was a sense among the Allies that Germany should be made to pay

for the devastation it had wrought. Initial draconian plans put forward by US Treasury Secretary Henry Morgenthau had called for a complete dismantling of German industry, the eradication of Nazi influence in politics, business and society, and a period of punitive deprivation as the only just consequence of Germans' collective guilt for the war and the terrible crimes against humanity that had taken place.

Though Morgenthau's plans were softened somewhat in the Joint Chiefs of Staff 1067 occupation directive of 1945, this still declared 'Germany will not be occupied for the purpose of liberation, but as a defeated enemy nation.' Allied troops on the ground, especially those who had witnessed the emaciated, terror-stricken, ghost-like figures emerging from liberated concentration camps, were in no mood to be lenient with the Germans.

The Monuments Men were not welcomed as heroes everywhere. Though many were relieved the war was over, Germans did not know what to expect of the occupation, and most were suspicious of the victors. In the last weeks of the war, Nazi propagandists fumed at the 'Anglo-American barbarians' occupying the western territories. One radio broadcast claimed they were 'falling upon German works of art and beginning a systematic looting campaign. Under flimsy pretexts all private houses and public buildings in the whole area are searched by art experts, most of them Jews, who "confiscate" all works of art whose owners cannot prove beyond doubt their property rights....These works of art, stolen in true Jewish style, are transferred to Aachen, where they are sorted and packed and then dispatched to the USA.'[35]

There were plenty of instances of small-scale (and some large-scale) looting by Allied troops, and forgotten treasures still emerge from the attics of former American servicemen to this day. Yet contrary to the wild stories generated by the Nazi propaganda machine, the policy of the Monuments Men was to preserve the cultural goods that genuinely belonged to the German people for their museums. It came as a surprise to them to discover that not everyone involved in the occupation saw things the same way.

General Lucius Clay, appointed the Deputy Military Governor of Germany, and Edwin Pauley, the official in charge of reparations discussions with Britain and the Soviet Union, were in favour of using German cultural goods as reparations. In July 1945, Clay drafted a plan to return artworks to the United States 'to be inventoried, identified and cared for by our leading museums'. Arguing that museums in Germany were not fit to house such treasures, he recommended that they 'be placed on exhibit in the US but that an announcement be made to the public, to include the German people, that these works of art will be held in trusteeship for return to the German nation when it has re-earned its right to be considered as a nation'.[36]

This concept of 'safeguarding' reminded many of the language the Nazis used when seizing Jewish collections. Monuments Men and other Western Allied officials responsible for cultural property in Europe were appalled, and the British opposed the policy. Walter Farmer, an American in charge of the Central Collecting Point (CCP) for art at Wiesbaden, described his reaction in his memoirs. 'My emotions overcame me, and I wept tears of rage and frustration,' he wrote. 'It seemed to me that everything that had been done to demonstrate the integrity of the United States government in the matter of handling of German cultural properties would be discredited if this shipment took place.'[37]

In the end, just 202 artworks were shipped from Wiesbaden to the United States, in December 1945. After major protests, the controversial booty returned to Germany in 1948.[38]

This strange incident is a reminder that Western principles on cultural heritage protection in wartime were by no means set in stone by World War II. The MFAA was very low down the military hierarchy, and many saw no need for it, believing that such lofty ideals had no place on the battlefield and could hinder military operations and endanger lives. Yet the work and policies of the Monuments Men set a precedent for future standards of cultural protection in wars. The United Nations Educational, Scientific and Cultural Organization (UNESCO) was founded in 1945 and the Hague Convention for the Protection of

Cultural Property in Armed Conflict, which requires occupying armies to assist in preserving cultural heritage and prevent pillage and vandalism, was adopted in 1954.

Although suggestions that the Allied victors should be entitled to 'trophy' art were overridden, there was a general agreement that all property 'taken to Germany during the occupation would be presumed to have been transferred under duress and accordingly treated as looted property'.[39] And there were some who believed that America should not lose out, despite the fact that it was never occupied. Theodore Rousseau, a member of the Art Looting Investigation Unit (ALIU) who went to work for the Metropolitan Museum of Art, told the *New Yorker* magazine as late as 1948 that 'America has a chance to get some wonderful things here during the next few years. German museums are wrecked and will have to sell....I think it's absurd to let the Germans have the paintings Nazi bigwigs got, often through forced sales, from all over Europe. I don't mean especially to the Metropolitan, which is fairly well off for paintings, but to museums in the West, which aren't.'[40]

Hildebrand may not have been aware of all these discussions at the end of the war and shortly after Germany's defeat, yet he knew that under Allied restitution policies he could be required to forfeit any artworks he had purchased in the occupied countries.

So he lied about how he had come by some of his artworks. He initially told his investigators the Max Liebermann painting, *Two Riders on the Beach* – stolen by the Gestapo from David Friedmann in Breslau (see page 23) – was purchased from a private collector, then in 1950 included it in a list of artworks he claimed had belonged to his father (and even found two witnesses to sign sworn affidavits saying they remembered them in his father's house).[41] He first said he bought Picasso's *Portrait of a Woman with Two Noses* directly from the artist in Paris, and that the Chagall, *Allegorical Scene*, had belonged to his sister.[42] In December 1950, he maintained both were gifts from his Swiss artist friend Karl Ballmer, who wanted to thank him for helping to secure the safe passage of his oeuvre when he fled Hamburg (see pages 116–17).[43]

His stories changed several times – only years later did the truth about the ownership history of these paintings begin to emerge. It will take many years of research for all the pieces of the puzzle to fall into place, if they ever do.

Hildebrand said the unopened boxes at Aschbach contained Rodin sculptures and rugs that had belonged to his father, a Liebermann garden scene, a Tischbein portrait that he only part-owned, 'modern graphics, purchases dating from 1938' that he valued at about 2,000 Reichsmarks because 'these things were at that time very cheap', and his art history books, among other items. He swore that he had given 'a full and complete declaration of all my possessions, property and fortune'. We now know with certainty that this was not the case.

The art collections at Aschbach, including Hildebrand's, a trove of treasures estimated by the Monuments Men to be worth about $100 million, remained in the castle, where anyone prepared to ignore an 'Off Limits' sign could access them. A month after Hildebrand's interrogation, troops from a US unit based in neighbouring Schlüsselfeld made an alcohol-fuelled plunder attempt at the end of a big night at the village brewery. After that, a guard was posted full-time outside the castle. All the looted items were returned.[44]

It was several months before a part of Hildebrand's collection was taken away from him. At a time when thousands had lost their homes in the bombings and millions of refugees from the occupied territories in eastern Europe were looking for shelter, accommodation was scarce. Aschbach Castle was too useful to serve merely as an art depot. In October 1945, First Lieutenant R. D. Klyver, the Education and Religion Officer of the military government and the Monuments officer for the Bamberg region, requested permission to move all the artworks stored at Aschbach to the New Residence palace in Bamberg, so that the castle could be requisitioned as a rehabilitation project for Jewish refugees to learn agriculture.[45]

He secured the approval of the Monuments Men, but they were spread thinly, and neither Klyver nor any of his colleagues were present

when the move took place. Eugen Leitherer, who was then sixteen, remembers the operation. His father was responsible for heritage protection in Bamberg and Leitherer's schoolboy English had been enlisted to help translate for Klyver.

In Aschbach, Leitherer was among the men helping to load the boxes onto two US Army Dodge vehicles. Hildebrand Gurlitt arrived on the scene. 'He made a surprising impression in an elegant grey suit with a white shirt and tie,' recalled Leitherer. 'No one else was going around dressed like that in 1945, so I remember it well. He looked like an experienced businessman.'

Hildebrand introduced himself as an art dealer and brandished a document, which he showed to the men loading the boxes onto the trucks. He told them that American art experts had released some of his boxes and that the paper he had provided confirmation that he was allowed to keep them. Other crates belonging to Hildebrand were included in the load transported to Bamberg – the solid plywood boxes were about 1.5 metres long. Leitherer remembered the whole operation as very civilized: the baroness served real tea and butter biscuits – rare luxuries for Germans at that time.[46]

Both Hildebrand and Wolfgang von Pölnitz, the baron's son, reported that the boxes were carried off in open-topped vehicles without being inventoried. According to one witness, a painting on fragile, aged wood from the school of Leonardo da Vinci cracked down the middle in the move. It belonged to the city of Bamberg's collection.[47]

From Bamberg, Hildebrand's seized boxes were transported to the Wiesbaden CCP in December. Yet it seems that only the open boxes were removed – about twenty-two in all. If that initial inventory of Aschbach Castle's contents by the Third Army was accurate, twenty-five of Hildebrand's boxes either remained with him or had already been hidden. He stated under oath later that he was left only with a 'large number of packages containing books and modern graphics' and 'a very small number of paintings'.[48]

His interrogators didn't trust Hildebrand. He 'gave an impression of

extreme nervousness and of offering only a minimum of information'.[49] Rumours abounded that he owned more than he was letting on.

Wolfgang von Pölnitz said in his interrogation on 18 February 1946 that Hildebrand had shown him two paintings by Renoir and a box containing one by Cézanne. The information was passed on to a Monuments Men investigator, who in turn confronted Hildebrand. Furious with Pölnitz, Hildebrand made him sign a statement saying he had never seen the Cézanne (which was true, as he had only seen the box).[50]

A witness who gave evidence to the military government of Bavaria in 1946 recounted another intriguing story. Karl Gruell, a forester and the former mayor of Aschbach, said Pölnitz junior had told him that among Hildebrand's possessions loaded onto the truck he brought from Saxony were several kilos of gold bars. Gruell also said he knew that young Pölnitz had helped Hildebrand to hide from the Allies a part of his collection acquired in France.[51]

A search for the Cézanne was conducted in June 1946 by Captain J. Vlug, a Dutch intelligence officer working with the ALIU. Vlug interrogated Hildebrand and didn't find the painting, so concluded Pölnitz's denunciation was false. He seized four more pictures that Hildebrand had bought in Paris, including two by André Derain. They were taken to the CCP in Munich to be returned to France.[52]

Hildebrand vehemently denied Gruell's accusations, signing a sworn statement that the rumour of the gold bars was completely unfounded. 'I have never owned gold bars or any kind of precious metal items (apart from the usual cufflinks, watch etc.),' he wrote.[53] Monuments Man Edgar Breitenbach was convinced by his protestations and recommended the closure of investigations into Gruell's declaration.[54] 'The Americans were really more than nice and we cleared this nonsense up in a quarter of an hour,'[55] Hildebrand told his friend Ernst Holzinger, the director of the Städel Museum in Frankfurt.

Yet Hildebrand also swore he had 'never hidden artworks or anything else'. After the spectacular discovery in Cornelius Gurlitt's apartment, we know that this was a lie. The Allies seized only a fraction of Hildebrand's

collection. Ten years after the war, he wrote himself that he had saved a part of it 'sealed in the walls of an old Franconian watermill, and it was still there'[56] when he returned for it. The fact that it was in Franconia (the region around Aschbach) and not in Saxony suggests that Gruell's information was right, and that he concealed boxes of valuable art in the six-month period between his arrival in the village and the removal of a part of his collection to Bamberg. Wolfgang von Pölnitz would have known appropriate local hiding places.

So was Gruell right about the gold bars, too? Did Hildebrand stash them alongside the art in the walls of the watermill? It's certainly conceivable. He had become very wealthy through his work for the Führermuseum. After his death, neither his wife or son had a regular income, yet they managed to live for the rest of their lives off his wealth. In Cornelius's case, his father's fortune supported him for almost six decades.

6 Secrets and Lies

While Hildebrand's own collection was being investigated and he was hiding what he could, he also came under pressure to reveal information about the art he had purchased for the Linz Special Commission and German museums. The Art Looting Investigation Unit (ALIU) had concluded that determining 'the scope of the activity of such men as Karl Haberstock, Hildebrand Gurlitt and Hans W. Lange and their affiliates' was 'vital to the satisfactory resolution of the whole looting problem'.[1]

The legendary Louvre curator Rose Valland summoned Hildebrand to Munich in October 1946 to examine the Linz collection, salvaged by the Monuments Men from the salt mine at Altaussee in Austria. Her aim was to find paintings acquired in France for the Führermuseum and secure their return.[2]

Valland was one of the heroes of the French Resistance. While ostensibly working for the Nazis as the only French curator at the Jeu de Paume, she had kept meticulous inventories of the artworks that arrived there and were shipped to Germany, and passed the information on to the Resistance. Frumpy and unassuming with a mousy bun and small round-rimmed spectacles, she was not the type of woman to grab the attention of the German male visitors arriving at the Jeu de Paume intent on stealing art. Yet her inventories were to prove invaluable in tracing the origins and whereabouts of looted artworks after the war and ensuring their return to France. Valland led that quest, tirelessly seeking to recover the treasures whose theft she had witnessed.

Interrogated by this formidable woman, Hildebrand identified from photographs of the Linz collection forty-one artworks he had bought, mostly from the Dutch art dealer Theo Hermsen in Paris. Valland was puzzled by the fate of the rest; Hildebrand himself said he had bought about 150 paintings for the Linz project and more than 200 in total in Paris. 'He was required to look at all the paintings in the collection

which hadn't yet been identified one by one, a job which took two days and didn't result in the identification of one single painting,' Valland reported in frustration.[3]

Hildebrand was asked to provide a list of the paintings he acquired in Paris. 'All too often he claims his memories aren't precise,' Valland said. Hildebrand's excuse was that all his files were destroyed in the Dresden fire. 'I can't reconstruct a list from memory,' he wrote after the investigation. He also said that his business books were claimed by the fire, but we know that at least some of them survived with his son.

After all those years of silently watching the Nazis help themselves to the looted collections of France's Jews while knowing that speaking out would mean risking her life, perhaps Valland enjoyed the opportunity to give the German art dealers she interrogated a piece of her mind. Hildebrand's letter to her after their meeting suggests he was chastened, if not remorseful.

In execrable schoolboy French for which he apologized, he wrote that their conversation had 'moved me very much. I saw that even the best will in the world cannot allow people to forget the things that Nuremberg showed. The more one tries to understand your ideas, the more one feels distanced from the crimes of the Nazis, and the more one understands what it means to be compatriots of these men at Nuremberg – and only sadness and shame remain.'[4] He provided her with the list she had asked for, giving details of paintings he had acquired in Paris for German museums and private collectors.

Ironically, it is possible that some of the paintings Hildebrand bought in Paris for the planned Linz museum and that Valland was so frustrated at not being able to trace had been stolen from the Führerbau more than a year earlier. On 30 April 1945 – the night Hitler shot himself in his bunker in Berlin – his art collection, much of it acquired through looting, was itself plundered. The SS guards protecting the Nazi headquarters of power on Munich's Königsplatz had fled. Crowds stormed the buildings, first looting food, liquor and furniture. They then turned to the air-raid cellar of the Führerbau and stole as many as 650 paintings,

including some fine Dutch Old Masters from the Schloss family col-
lection (see page 92), which had not yet been moved to the mines at
Altaussee because of a shortage of transport.[5] The plunder spree lasted
two days. None of the Monuments Men were present, and later appeals
to Müncheners to return the artworks met with limited success. A maid
had buried some artworks in a potato patch; these were uncovered. A
piano maker had bought several from a small-time dealer and these could
be traced. 'It's a pity that Army regulations at that time did not permit
the use of rewards in the form of food and cigarettes,' Breitenbach wrote
in a report several years later. 'This would almost certainly have been
instrumental in recovering considerable parts of the stolen collection.'[6]
By 2014, about two hundred of these paintings had been found, while
more than four hundred were still missing.[7]

US investigators received information that Hildebrand still held art-
works by Max Liebermann, which he had purchased in Paris during the
war, in his house in Aschbach. He owned up in an interrogation and
agreed to hand over an oil painting, two pastel works and nine draw-
ings, all by Liebermann, that were still in his possession; they were
returned to France. Hildebrand reported to Breitenbach that he still
retained three Liebermann works acquired before the war from German
private owners.

The US Military Government in Bavaria appeared more inclined to
be lenient with Hildebrand than the French investigators, who were
intent on recovering everything the Germans had taken during the occu-
pation. In March 1947, Hans Konrad Roethel, a German art historian
employed as chief curator at the Central Collecting Point (CCP) in
Munich, concluded that Hildebrand was not hiding any illegal property,
though 'that, of course, needs to be checked on the spot'. Roethel had
lived in Hamburg and Lübeck before the war and knew Hildebrand.[8]
He, too, had been an enthusiastic supporter of Ernst Barlach's work and
had helped hide some of his sculptures to protect them from the clutches
of the Nazis.[9] Roethel recommended that Hildebrand's possessions be
returned to him if nothing new was discovered.

A month later, Hildebrand wrote to Roethel asking for his books, which he needed to prepare a lecture in Krefeld. He also said he had heard a rumour that people may be permitted to keep 'pictures which were bought completely normally in France' and asked whether it were true.[10] Hildebrand's relations with Roethel, who was fifteen years his junior, were cordial – on one occasion, he asked him for help on behalf of a Jewish acquaintance who was trying to recover lost art.[11]

Hildebrand's Allied investigators still thought he was hiding something; he didn't strike them as honest. On a visit to the Wiesbaden CCP in December 1950, shortly before his collection was returned, he first pretended that a Renoir shown to him was one of his, then seeing the label, said, 'No, it does not belong to me.' His interrogator concluded 'he does not seem very open-hearted'.[12]

But by now the CCPs were winding down and their personnel were in a hurry to dispose of the contents. Clay, the chief administrator for occupied Germany, had tried to set a deadline for all restitutions to previously Nazi-occupied countries by the end of 1948. The depots were finally closed in September 1951.[13]

Theodore Heinrich, Monuments officer at the Wiesbaden CCP, returned most of Hildebrand's collection to him on 15 December 1950. Some works had been restituted to France; a Rodin drawing, *Atlas,* was mistakenly also sent to France and efforts to retrieve it failed. Two paintings and a drawing had been stolen from the CCP, and a Rodin sculpture had also disappeared. However, Hildebrand took back possession of 115 paintings, 19 drawings and 72 other objects – including the stolen Liebermann, *Two Riders on the Beach*, Glaser's drawings and Max Beckmann's *Bar, Brown* painting.

Two paintings, the Chagall he had previously said was his sister's and the Picasso he claimed to have bought from the artist, were retained pending proof of legal ownership.[14] On 2 January 1951, Hildebrand sent an affidavit signed by his friend the artist Karl Ballmer, who was married to a German Jew and had left Hamburg for Switzerland in 1938. It offered a new storyline, saying Ballmer had given Hildebrand

the Picasso gouache *Portrait of a Woman with Two Noses* and Chagall's *Allegorical Scene* when the dealer had come to visit him in Switzerland in 1943.[15] William Daniels, Chief of the Property Division of the Office of Economic Affairs, deemed that sufficient proof and agreed to return them to him on 9 January 1951.

The Chagall, it emerged in 2013, was probably looted by the Gestapo from a Jewish family in the Latvian capital Riga in 1941. Savely Blumstein included the gouache in a 1957 list of artworks and furniture missing from his home when applying to the German government for compensation.[16]

Most of Hildebrand's collection had escaped the scrutiny of the Allies. He could recover it later – from the Franconian watermill and from his home state of Saxony, where the artworks were 'ripped out of their passepartouts and scattered around different locations'. Some were harder to retrieve than others; several artworks, Hildebrand later divulged, had been seized by a communist village mayor in Saxony, and he 'could only liberate them and bring them through the Iron Curtain later, by applying a little cunning, and thanks to a good Russian, who was very happy to have two bottles of Schnapps on a rainy night'.[17]

While negotiating with the Allies to recover his art, Hildebrand was also pulling strings with old business contacts in an effort to rehabilitate himself and find work – preferably returning to his old career as a museum director. Like millions of other Germans, Hildebrand underwent the denazification process initiated by the Allies, under which Germans were to be categorized according to how deeply they were implicated in Hitler's rule, with the aim of keeping Nazis out of influential positions and conducting a political purge so that the new Germany would pose no threat. It was, as Frederick Taylor put it, 'perhaps the most ambitious scheme to change a nation's psyche ever mounted in human history'.[18]

Denazification was most rigorously implemented in the American zone, which included Aschbach and the state of Bavaria. Hildebrand found the constant interrogations and efforts to clear his name wearying. He wrote to his friend Ernst Holzinger, director of the Städel Museum in Frankfurt, in self-pity.

Anyone who, like me, experienced enough anxiety and shame all those years as a mixed-race person, anyone who was ousted from his post twice because he spoke out against this vision of the world, anyone who was forced to change his profession and still – as a kind of act of defiance – achieved successes as a dealer even though he was not actually inclined to dealing, anyone who lived in fear and worry about denunciation, slave labour and mixed-race battalions – really, he has hardly the strength left to open his mouth. I know what it means to be German, I know that we all could have done more, but what use are the self-accusations?'[19]

His activities in the Third Reich were investigated by a civilian tribunal in Bamberg in the denazification process. Hildebrand was not one of the 8.5 million Germans who had belonged to the Nazi Party, yet it was known that he had enjoyed considerable privileges in his role as an art buyer for German museums and had become very wealthy as a result.

Until his name was cleared and he had the papers that would make him employable and free to travel, he needed special permits to leave Aschbach. Holzinger helped him regularly with permits and train tickets. Hildebrand was offered posts in Dresden, but decided against returning to live in his home city, now in the Soviet zone. At a time when most still wanted to believe the four occupation zones would be capable of cooperating, he showed some foresight. 'I cannot get rid of the image that Germany will be divided into East and West,' Hildebrand wrote to his father's old friend and colleague, the Hamburg architect Fritz Schumacher. 'I can't make up my mind to go to Saxony, behind the curtain where you can't get any information and where you don't even know what is happening in the neighbouring country. If I could, I would have more projects and work than I could cope with.'[20]

Some of his colleagues in the German museum world were unwilling to help Hildebrand clear his name. Carl Georg Heise, once a close associate in promoting the work of Ernst Barlach in Hamburg, had been ousted from his post as the director of Lübeck's St Anne's Museum in

1934 and had even been briefly imprisoned in a concentration camp during the Third Reich. He was appointed to run the Hamburg Museum of Art (Kunsthalle) in 1945. One of his first tasks in this new position was to return to France many of the artworks Hildebrand had acquired for the museum during the war. Perhaps not surprisingly, he was angry.

Heise accused Hildebrand of financial greed in his dealings in the occupied countries and in 'degenerate art'. He condemned his purchase of the four Liebermann paintings from the Hamburg Museum of Art, saying Hildebrand had bought them at ridiculously low prices and sold one of them, *Christ in the Temple*, shortly afterwards at enormous profit. 'This matter is not quite as harmless as you present it,' Heise wrote to Hildebrand. 'Not only I, but all Hamburg's art lovers who are aware of this, believe that you shouldn't have turned your hand to ensuring the loss of such beautiful and important paintings from the Museum of Art.' He engaged a lawyer to pressure the dealer into revealing who had bought the paintings from him.[21]

Hildebrand responded by presenting himself as a victim, pleading poverty and the dangers of his mixed heritage. 'I lost a great deal in Dresden (including art) and managed to bring my family to safety here to lead a very primitive existence,' he wrote to Heise from Aschbach in 1945. He described his wartime activities as 'many years in which I (perhaps too faint-heartedly) believed that I could save my family from the dangers of their mixed Jewish background by doubling the pace (increasing my performance at work as a way of proving the importance of the business) and by purchasing. I am waiting quietly to see what the Americans plan to do with my property and with me.'[22]

Clearly concerned about his reputation in Hamburg, Hildebrand also defended the purchase of the Liebermanns. He wrote to Heise:

Was that really wrong at the time? Doesn't it now appear almost like forgetfulness or inconsistency that the Nazis didn't burn Liebermann's pictures along with the Jews? In good private hands the pictures were safer from the arm of the state than in the

museum. The fact that I earned money from the pictures doesn't seem to me to be something I have to atone for now, not as long as no one compensates me for the fact that my position and my income were taken from me twice and I was standing in front of an abyss. I didn't become an art dealer of volition, and you know that.[23]

Heise was not convinced. 'I am not equal to your dialectics,' he wrote.[24] He denounced Hildebrand to the Bamberg court that was investigating his activities during the Third Reich, saying he was 'very surprised to hear' that Hildebrand was now seeking a post as a museum director.[25]

Heise was somewhat mollified by Hildebrand's pledge to return the only museum Liebermann still in his possession, *Wagon in the Dunes*, as soon as the CCP let him have it back. It took years to recover it, and it was only then that Heise stood down from his attacks. Even so, he asked Hildebrand what had happened to the frame. Hildebrand responded that it was burned in the Zwinger, home of Dresden's art collections, along with some of his pictures.[26]

Overwhelmed by the task of denazification, the Americans handed over responsibility to the Germans in March 1946 with the 'Liberation Law'. It pledged that 'all those who have actively supported the National Socialist tyranny or are guilty of having violated the principles of justice and humanity, or of having selfishly exploited the conditions thus created, shall be excluded from influence in public, economic and cultural life and shall be bound to make reparations. Everyone who is responsible shall be called to account. At the same time he shall be afforded opportunity to vindicate himself.'[27]

Those subject to denazification were required to fill out unpopular questionnaires with details of membership in Nazi organizations and to assemble character references shedding light on their Third Reich activities. These became known colloquially as *Persilscheine* (Persil certificates), a washing-powder reference that conveys the reputation-laundering they

were designed to achieve. They could be meaningless: there were even reports that a black market for character endorsements evolved among former Nazis, who would mutually declare each other guiltless.[28]

This was a time when people were trying to re-establish themselves in the new post-war order and seeking to present as positive an image of their Nazi-era activities as possible. Even where there was no black market, the character references offered a means of doing favours for friends, while denunciations to the tribunals were a way of taking vengeance against enemies, so the veracity of both should be questioned.

Hildebrand's denazification file includes statements from Jews who said he helped them cross borders illegally and escape concentration camps, as well as letters of recommendation from artists including Beckmann, collectors who were his clients and several museum directors.[29] Some of these came from people in exile, who had little immediate to gain by speaking in Hildebrand's favour. Not all were truthful, however. One of his secretaries – half-Jewish Maya Gotthelf, who had worked for him in Dresden from 1942 to 1944 – declared that Hildebrand was always helpful to Jews and never signed his letters 'Heil Hitler'.[30] This last part is demonstrably untrue: Hildebrand ended almost all his official letters with the obligatory sign-off. Some were even signed on his behalf by Gotthelf when he was travelling.

Hildebrand even turned to Jacques Jaujard, the director general of the French museums, with a request that he endorse his application for a position as museum director.[31] The French response was lukewarm, concluding that though he wasn't a Nazi, hadn't taken part in the wholesale pillage of the Jews in France and had cooperated with French interrogators, he 'effected considerable purchases that favoured the occupiers and massively contributed to the impoverishment of the national patrimony'. Hildebrand's dealing background 'would not be compatible with the role of a museum curator in France'.[32]

His case dragged on as the Bamberg tribunal sought police references and tax declarations from the authorities in Hamburg and Dresden. Perhaps it was partly because the tribunals were overloaded and often

ill-equipped to make judgments that it took so long, but the court also struggled with Hildebrand's contradictions: his anti-Nazi credentials and Jewish background on the one hand; on the other, his wartime career working for Hitler and the immense wealth he accumulated. At one stage, the Bamberg court tried to shift responsibility for his case to Düsseldorf in the British zone, where procedures were more lenient and it would probably have been instantly dismissed as he was never a Nazi Party member, but the Düsseldorf authorities quickly passed it back to Bamberg.[33]

As long as Hildebrand remained without the declaration *unbelastet* ('exonerated'), he couldn't take up a post in the western zones. Though hankering to get back to work, he was far from destitute. At a time when malnutrition was widespread in Germany, the Gurlitt family had enough to eat, even if their accommodation was modest. 'Helene is bearing the lack of civilization with humour,' Hildebrand wrote to his friend Ludwig Renn.[34] From his exile in Mexico, Renn had sent money to the US Cooperative of American Remittances to Europe (CARE) to have food aid shipped to the Gurlitts. The CARE packages typically comprised such treats as bacon, corned beef, fruit preserves, honey, sugar, coffee and chocolate.

In a letter to his father's friend Fritz Schumacher, Hildebrand said he shared the Americans' admiration for those who rolled up their sleeves to start growing vegetables and raising chickens in their gardens. 'But I am not digging in the garden, at least not as a job – at the most for relaxation,' he wrote. 'Instead I am trying to wrack my sadly no-better-than-average brain to come up with ways to make progress that don't include working with my hands so that I can be of more use to others.'[35]

He wrote an impatient letter to the tribunal in April 1947, pleading for it to 'complete my very simple case now or to tell me the reasons for any doubts you may have so that I can clear them up'. His ample income during the Nazi era, he wrote, 'cannot compensate me for the fact that I couldn't practise my academic work and now you are making it impossible for me to take part in the reconstruction process!'[36] In May, he wrote again to the prosecutor, saying he could 'miss the chance of a

lifetime' if his name wasn't cleared soon, as he was in negotiations for posts in the Rhineland and Dresden.[37]

The next month the tribunal charged him as a 'profiteer' of the regime, the second-most serious category of offender and punishable with a prison sentence of up to ten years.[38] Shortly afterwards, the charge was withdrawn but Hildebrand still lacked the all-clear he needed to get on with his life as the investigation continued.

Towards the end of the year some bad news for Hildebrand arrived from Hamburg. His former secretary, Ingeborg Hertmann, testified – not inaccurately – that he 'often spoke derogatively about the Nazi state but profited enormously from it'. She accused him of having business ties with Nazi top brass including Albert Speer, and said he took advantage of Jews' desperation by buying their paintings immediately before they were deported to camps. 'After a time these people would write, saying "please send us the money, we are starving." Casually and indifferently, G. then ordered me to "send 10 Reichsmarks to the Jew,"' Hertmann said.

Hertmann reported that Hildebrand regularly received secret packages from France that she was not allowed to see, and that he met frequently with counter-espionage agents. Her statement ended on an exceptionally catty note: 'From a human perspective I can only describe Gurlitt as a cowardly and mean person,' she wrote. 'His wife, who must have known about the whole business, was even meaner.'[39] Her case against Hildebrand was somewhat weakened by letters she had written to him after he departed Hamburg for Dresden. 'I would like to say again that I found working for you very satisfactory despite our occasional confrontations,' she wrote to him in Dresden in March 1942.

Their relationship had soured in 1944, when Hertmann had suggested trading a picture for tea and coffee in a deal with a Swedish client, a proposal Hildebrand had vehemently shot down. Her extremely nasty response: 'I wish from the bottom of my heart that this letter finds you at work where other half-castes of your type are employed; i.e. shovelling. And if that isn't the case then rest assured, it can still happen.'[40]

She must have been a volatile woman – even after that, as late as 1946, she wrote suggesting he set up shop again in Hamburg, using the spare room in her apartment.[41]

Hildebrand presented these letters to the tribunal to undermine her testimony and said that after she had wished him in a labour camp, he had been afraid Hertmann would denounce him as a quarter-Jew to the authorities, one of the reasons he had spent so much time on the road. Speer, he said, had contacted him once about his grandfather Louis Gurlitt's paintings, but he didn't follow it up. He didn't mention that he had in fact sold a view of the Acropolis by Louis Gurlitt to Speer in 1941 (see page 76).

He responded to Hertmann's accusations that he took advantage of the desperation of the Jews by saying 'I didn't exploit Jews who wanted to emigrate but tried to help them by swapping German pictures for those which had value internationally. I never bought from Jews who were being deported; on the contrary, I tried to help them.' He said he didn't remember the incident of the 10 Reichsmarks that Hertmann described. 'But I wasn't so stupid that I didn't help Jews in secret, meaning that fortunately, it managed to escape the notice of the ever-curious Frau Hertmann.'[42]

By now, Hildebrand had been appointed director of the Art Association (Kunstverein) for the Rhineland and Westphalia, based in Düsseldorf. Such associations, which aimed to bring contemporary art to a wider public through exhibitions and lectures and by selling art to members, had sprung up throughout Germany in the 19th century, mainly funded by members' subscriptions. Hildebrand obtained the post with the help of a recommendation from Otto Förster, the former director of the Wallraf-Richartz Museum in Cologne. He was desperate to start but not permitted to leave Aschbach. He wrote an impatient letter to the tribunal in Bamberg: 'I am requesting you urgently to put an end to a grotesque situation where I am stuck here because of these lies, and meanwhile have been drawing a salary since 1 Jan. in Düsseldorf, where the German and British authorities are waiting for me.'[43]

In the meantime he had taken up dealing again, and wrote to his former colleague Ferdinand Möller in November 1947 asking whether he had any paintings for a particularly picky customer who would be interested in a Corinth, a Klee or a good Kirchner. 'I have lost a dreadful amount, in so many different ways; I don't want to write about it,' he told Möller.[44]

The civilian tribunal in Bamberg eventually dropped its investigation into the profiteering charges in January 1948. The tribunal concluded that the high income he had enjoyed during the Nazi era 'did not proceed from the Nazi terror regime, from armament, from war or from political connections'; rather, the final statement said, his wealth 'should be attributed to his business acumen and to the boom on the art market in these years'.[45]

At last Hildebrand could take up his post in Düsseldorf, the first opportunity to devote his energies to the modern art he loved without risk of political intervention, and he embraced his new role with gusto. He wrote to his friend, the writer Arnold Zweig, saying it was no easy start, 'but we are trying to get things moving again amid all the ruins'.[46]

Düsseldorf had been badly bombed. In 1949, the Art Association was allocated a few rooms in the Düsseldorf Art Gallery (Kunsthalle), whose upper floors were reduced to the bones of the walls. The ceilings on the lower floors were intact and the rooms were usable for exhibitions.

With his customary energy and organizing skills, Hildebrand staged an exhibition of the Expressionist painter Christian Rohlfs for the opening of the Art Association in the rooms of the art gallery. In November 1949, he organized a show of Chagall, whose work had disappeared from public view under the Nazis. Chagall wrote to say he was 'touched by the sympathy the German art world is showing me after such a tragic epoch for humanity'. He asked Hildebrand to send some photos of the artworks he hadn't himself seen in years – including some he'd last set eyes on in a Berlin exhibition in 1914 – for a catalogue of his oeuvre that he was compiling. Hildebrand complied, and sent him a bill for the photos. Ever the businessman, he suggested Chagall

might perhaps prefer to 'send us an artwork by your hand' than pay the sum of 83.90 Deutschmarks.[47]

Hildebrand staged an incredible seventy exhibitions in five years and pushed the Art Association to the forefront of artistic life in the Rhineland, drawing 6,500 members. He devoted exhibitions to Lovis Corinth, Max Beckmann, Aristide Maillol, Max Ernst, Karl Schmidt-Rottluff, Fernand Léger, Pablo Picasso, Emil Nolde and Max Liebermann. A particular success was his 1954 show 'Masterpieces from the Museu de Arte in Sao Paulo'. It attracted 155,000 visitors, among them, as guests of honour, German President Theodor Heuss and the novelist Thomas Mann. A Renoir exhibition in 1956 showed small, intimate paintings from the collection of Philippe Gangnat against red walls, and opened with top diplomats and a red carpet. Visitors streamed to see the work of an artist who had been banished from German museums during the years of the Third Reich.[48]

However much Hildebrand protested that he only became a dealer by necessity, he was an extremely skilled businessman and his success suggests he loved the thrill of the deal. So does the fact that he continued to broker art sales after the war, as director of the Art Association. This time, though, at least some of the commission he earned benefited the Art Association's coffers, not his own pocket.[49]

His commercial activities disgruntled Düsseldorf's art dealers, who resented the competition. To placate them, he held an exhibition focused on the city's art trade and invited the dealers to display their wares at the Düsseldorf Art Gallery in what was one of the world's first art fairs. They were 'enthusiastic, happy and appeased', wrote Hildebrand's assistant and successor as director, Karl-Heinz Hering.[50]

He also reconciled with his cousin Wolfgang Gurlitt after many years of bitterness, including a 1941 court case over a painting that Hildebrand won.[51] In 1955, Wolfgang came to visit and afterwards wrote to say how happy he was that 'we have finally put an end to the hot and cold war that existed between us for so many years and that prevented us from being together as friends'. He offered Hildebrand 'eternal peace' for

his sixtieth birthday and proposed cooperating on an exhibition of the Mannerists and a show of Oskar Kokoschka graphics.

Hildebrand continued to purchase works for his own collection. He bought Gustave Courbet's *Village Girl with Goat* for 480,000 French francs in Monte Carlo in 1949, according to the catalogue raisonné of Courbet's work, and it remained in his collection, to be inherited by his son. Money was not a problem for Hildebrand.[52]

He swore in 1955 that he would never sell one artwork: 'I see this collection, unexpectedly returned to me after so much peril, not actually as my possession but as a kind of lease that was given to me to make use of. I know what these works have meant to me: the best of my life.'[53] But he continued to sell artworks from his own collection as well as buy new ones after the war. In October 1950, for instance, Roman Norbert Ketterer's auction house, Stuttgarter Kunstkabinett, auctioned a Paul Klee landscape painting consigned by Hildebrand.[54]

He was also prepared to lend pictures, and even began exhibiting some before they were released by the Allies. He had borrowed, for example, Max Beckmann's *Bar, Brown* from the Wiesbaden CCP for an exhibition at Frankfurt's Städel Museum.

After their release, his artworks were shown in Lucerne, many German cities, Amsterdam, The Hague and even Santiago in Chile.[55] The most significant show was a travelling US exhibition sponsored by the German government and organized by the American Federation of Arts. Hildebrand wrote a preface for the catalogue, yet for reasons that remain unclear, it was never published, though it can still be found in the Düsseldorf City Archive. The exhibition, called 'German Watercolors, Drawings and Prints: A Mid-Century Review' went ahead.

It featured twenty-three works from Hildebrand's collection along-side art from other private collectors and German museums. Thomas Messer, the director of the American Federation of Arts, credited Hildebrand in the catalogue as 'the major contributor to the exhibition which, owing to his generosity, could be planned on an impressive scale'.[56]

He loaned two Beckmann works including the powerful *Lion Tamer* gouache, woodcuts by Erich Heckel, Karl Schmidt-Rottluff and Ernst Ludwig Kirchner, two Wassily Kandinsky watercolours, two Klees, a Kokoschka lithograph, watercolours by August Macke, Oskar Schlemmer and Schmidt-Rottluff, two Franz Marc pictures of horses and four Nolde lithographs and a watercolour.

The show was first mounted at the Dortmund Museum Am Ostwall. Hildebrand was very worried about the conditions his pictures were subjected to. He wrote to Leonie Reygers, the curator there, before she sent the works on to the United States, berating her for failing to take proper care of them: 'The paper yellows in sunlight in a few hours. It must be protected from the sun. This has to be said loud and clear, the best thing is to post it on every box, otherwise they will forget in America just as you forgot.' The imperious tone suggests he had to fight the temptation to use capital letters, especially for those last four words.

His attitude towards his collection was almost parental: pride mixed with a concern that verged on neurosis. He evidently wanted it to make a mark in the world without him, but was frightened for its safety. He complained stridently to the Foreign Ministry and the German Embassy in the US that he was receiving no progress reports or press clippings about the success of the exhibition. The loaned artworks didn't make the return journey across the Atlantic until after his death.[57]

When the Allies questioned him, Hildebrand had no choice but to cooperate if he wanted his artworks back. If Jews came to him asking about the fate and whereabouts of the works he had purchased from them cheaply under duress, it was a different story.

Ernst Julius Wolffson, the Hamburg doctor who in desperation had sold him nine Adolph Menzel drawings at knock-down prices in 1938 (see page 47), wrote to the Office for Compensation in 1947, explaining that he had sold the drawings in order to be able to pay the Jewish wealth tax: 'The price was completely incommensurate with the value because of my distressed circumstances.'[58]

After Wolffson's death in 1955, the family continued trying to find the artworks. Their lawyer wrote to Hildebrand, asking whether he still possessed the drawings or, if he had sold them, whether he could supply details about the purchaser. Hildebrand answered only through his lawyers, who provided no information and said that most of the dealer's records had been burned.[59] Although Wolffson received partial compensation for the punitive Jewish wealth tax, neither he nor his family ever recovered the pictures or the losses on the sale. It emerged in 2014 that shortly after acquiring them, Hildebrand had sold all nine drawings to the cigarette manufacturer Hermann F. Reemtsma, one of his most loyal and wealthiest customers, at a 25 per cent profit.[60] It's difficult to imagine he would have forgotten such a sale.

⸺

Hildebrand suffered from cataracts – an affliction he shared with his father who also underwent eye surgery – and he wore glasses with thick lenses.[61] He nonetheless drove a very fast DKW car, occasionally up one-way streets in the wrong direction.

Returning to Düsseldorf from a business meeting in Berlin in October 1956, he skidded while trying to overtake a truck on the autobahn near Oberhausen. His car careened across the road into the opposite carriageway and collided with an oncoming truck. He was in a coma for nearly two weeks. His left leg had to be amputated and the right leg was broken in several places, as were both arms.[62] He never awoke from the coma and died on the morning of 9 November 1956, at the age of sixty-one.

According to his nephew Dietrich Gurlitt, the family blamed Hildebrand's wife Helene for hesitating over the amputation and first responding to doctors' requests for her permission to operate by saying she didn't want a one-legged husband. Dietrich still believes that Hildebrand may have lived if she had decided differently. He didn't stay in touch with his aunt or her son Cornelius after his uncle's death, though he kept up contact with his cousin Renate – Hildebrand's daughter, who later called herself Benita – until the end of her life.

Hildebrand's life's work was honoured in many newspaper articles and speeches after his death. Düsseldorf city council even named a street after the 'beloved' Hildebrand Gurlitt.[63] The *Rheinische Post* headlined its obituary 'A Big Loss', praised his 'intellectual agility and negotiating skills' and described him as a clever planner and organizer. His obituary in the *Düsseldorfer Nachrichten* newspaper said of his war activities only that 'Gurlitt weathered the years of darkness through his humble work as an art dealer'.

His friend Leopold Reidemeister gave a memorial speech on 24 January 1957, extolling his courage in facing down detractors in Zwickau, his dynamic commitment to modern art and his 'sensational successes' in Düsseldorf. Reidemeister glossed over Hildebrand's years as an art dealer in the Third Reich, saying only: 'Gurlitt was resented for being successful at this business too. But how could it be any other way with a person who threw himself into every post in a burst of activity and always showed impeccable artistic judgment?'[64]

The glowing epitaphs were not to be the final word on Hildebrand's life and career. The discovery of his son's collection prompted much re-evaluation, some of it fiercely critical. Hildebrand was inaccurately reduced in the media to a 'Nazi art dealer'. He was an art dealer for the Nazis, but he was never a Nazi, either by party affiliation or conviction. He was an anti-Nazi who became corrupted by the regime he professed to hate; whose fear and ambition combined led him to compromise his own beliefs and, in the process, forfeit his integrity. The courage he had shown in the first years of the Nazi regime – by protecting the art and artists Hitler hated – evaporated as the pervasiveness of the terror and his own status anxiety increased. In this sense, his life story echoes that of millions of other Germans: the silent majority who played no direct role in the genocide but also never spoke up against it.

It is unlikely Hildebrand was anti-Semitic. Part Jewish himself, he socialized with Jews throughout his life, yet he profited from their plight by buying their art cheaply when they were desperate and selling it on at higher prices. This, too, is mirrored in the lives of thousands of

Germans who benefited from the persecution of the Jews: the people who moved into the vacated apartments, took over 'Aryanized' businesses or hunted bargains at the 'Jew auctions' of household goods that belonged to those deported to camps and ultimately murdered. Hildebrand's career during the Third Reich is a reminder that criminal regimes also criminalize their citizens. Only a tiny minority was brave enough to resist, and most of them either escaped abroad or were killed. What is most regrettable in Hildebrand's case is that despite his immense wealth, he never tried to make amends after the war when he could have done so without fear of repercussion. Not only did he fail to seek out those whose artworks he had purchased under duress, he also ignored their pleas for help. This perhaps more than anything else in his biography is a sign of how far the Nazis' inhumanity crept into the minds of those who lived under them.

Hildebrand died leaving two projects that were close to his heart unfinished. One was a new building for the Düsseldorf Art Association, a plan that was only brought to fruition ten years after his death. The other was an exhibition of 150 art treasures from Dresden – including works by Canaletto, Caspar David Friedrich, Hans Thoma and Max Liebermann – that Hildebrand had, amazingly, managed to persuade the communist authorities to lend in the interest of building a metaphoric bridge across the Iron Curtain from Dresden to Düsseldorf. The catalogue was ready to print, the paintings selected, the opening speeches prepared.

Yet with Hildebrand's death, the necessary trust had evaporated. The political tensions between East and West had heightened, in particular as a result of the anti-communist uprising in Hungary at the end of 1956. Weeks before it was due to open, Dresden cancelled, saying recent events had created 'new tensions and an atmosphere in which it doesn't seem appropriate to send precious, irreplaceable artworks from the Dresden Picture Gallery to the Federal Republic'.[65] Even after his death, Hildebrand managed to get caught up in the politics of the era.

7 A Dark Inheritance

Rolf Nikolaus Cornelius Gurlitt was born in Hamburg on 28 December 1932, weeks before the Nazis took power, as a 'strapping, healthy' baby, according to his grandfather,[1] who named him Cornelius III.

His was a turbulent childhood, punctuated by bombings, forced moves and the upheaval of war. Perhaps the paintings – the Liebermann, Chagall and Beckmann – were among the only constants in his tumultuous early life. Cornelius remembered his father hanging an Ernst Ludwig Kirchner portrait with a green face over his bed, because, Hildebrand said, Hitler didn't like green faces. This was among the few details about his childhood that he revealed in the only interview he ever gave, to *Der Spiegel* magazine.[2]

Timid like his mother and with delicate, fine features, Cornelius attended primary school in Hamburg. He recalled the family home on elegant Alte Rabenstrasse, just metres away from the Alster Lake, where anti-aircraft guns were concealed in camouflaged shelters. While his father was shopping for the Führermuseum in Paris, Cornelius was at secondary school in Dresden. While there, he remembered that he once saw Hitler waving from a train.[3]

Cornelius's childhood ended abruptly and prematurely when he was just thirteen, with the catastrophic bombing of Dresden on the night of 13 February 1945. He witnessed the scenes of carnage the next day that Hildebrand later described. Images of the heaps of corpses in the blackened streets, ready to be burned, were to haunt him for years.[4]

After the family's escape from Dresden, Cornelius attended school for a while in rural Aschbach. His classmate Lotte Herdegen remembered him as 'well-dressed, friendly but reserved. He didn't speak much.'[5] Fritz Schumacher, an old family friend who had worked with Cornelius senior, described him as a sweet and reflective child.[6]

He showed some artistic leanings at an early age. In Aschbach, he built a puppet theatre that his father described in a letter to Schumacher. His younger sister Renate, later known as Benita, pedalled patiently for two hours on the bicycle that generated the lighting. 'All the children from the village were in our kitchen,' Hildebrand wrote. 'It's amazing what is possible.'[7]

At fourteen, Cornelius expressed an interest in studying theology to become a pastor. 'It's very possible he will change his mind,' was Hildebrand's take on that ambition.[8] Yet at the same age, Cornelius also expressed the desire to become a professional 'hermit', much to his father's dismay; this was a goal he would achieve.[9]

His inclination towards the church was probably the influence of the Aschbach pastor who shepherded Cornelius through his confirmation. His boarding-school roommate Cornelius von Heyl (known as Cornibert at school, to avoid confusion with his roommate) remembers Cornelius hanging a large map of Palestine on the wall, marked with milestone events in the life of Jesus. It was a present from the Aschbach pastor, to whom Cornelius was attached and for whom he expressed great admiration.[10]

Hildebrand took Cornelius and his sister to the Odenwaldschule, a famously progressive boarding school in the state of Hesse in southern Germany, in September 1946. Owned by the cellulose manufacturer Max Cassirer, a prominent Jewish Berliner who had fled the Nazis, the school was founded on the principle that each child has different needs to be met and individual talents to be nurtured. It aimed to be democratic and expected pupils to contribute to its running and take part in decision-making. Before the Nazis came to power, a fifth of the pupils were Jewish. During the Nazi regime, the school had managed to stay open despite threats of closure because its provisional headmaster made some tactical compromises. During the war, pupils included the offspring of the local gauleiter – the regional head of the Nazi Party – as well as the sons and daughters of resistance fighters and several Jewish children whose identities remained hidden.

Hildebrand may have chosen the school because of his pre-war connections: Max Cassirer was a patron of the arts and his nephew, Paul Cassirer, owned one of Berlin's most famous art galleries in the 1920s. A few months before Cornelius and Renate joined the Odenwaldschule, a new headmistress had taken office. Minna Specht had spent the war years living in exile in Britain. A committed socialist who was both loved and respected by her pupils, she had progressive views on education, but her most pressing challenges in the early days were finding teachers who were untainted by the Nazi regime and keeping the children fed and warm.

In 1946, the Odenwaldschule was part exclusive country boarding school and part orphanage and care home for expellees from the German eastern territories that had been transferred to Poland and Czechoslovakia; the pupils were a mix of 'princes and refugees'.[11] Some children were waiting anxiously for news of missing relatives who may have been in camps or prisons but could also have died. Many of the teachers had been in exile during the regime and the school had an international flavour and crossed class divides.

The cuisine comprised 'too few potatoes and endless swedes and cooking cheese'.[12] Heyl remembers the daily diet as a piece of wholemeal bread for breakfast, a soup of swedes for lunch and diced swedes for supper. On Sundays there was tough wild boar. Diarrhoea, weight loss, worms and boils were all common symptoms of malnutrition among the pupils. In the harsh winter of 1946–7, not all the rooms could be heated in the Goethehaus, where Heyl and Cornelius lived. Morning showers were ice-cold.

Nonetheless, as Specht wrote in her letter to parents in January 1948, 'we are undoubtedly an oasis in the German desert of poverty and need'.[13] The school day was regimented, starting at 7 a.m. with sport and including two hours for activities such as darning, carpentry and gardening from 4 p.m. to 6 p.m. before supper.[14] By early 1948, the school counted about two hundred pupils aged between six and eighteen.

Cornelius and Heyl gravitated towards each other because they were both shy, both a little adrift and both disturbed by childhood

experiences. Heyl's parents had divorced and Cornelius was traumatized by the horrors he had witnessed in Dresden. 'It had branded him deeply inside; you noticed when he spoke about it,' Heyl said. 'He didn't talk about it often, but he did with me.'

They shared a room in the school for the entire two years that Cornelius was a pupil there. Heyl remembers Cornelius speaking with reverence and pride of his male family members: his father, the grandfather after whom he was named and his great-grandfather, the landscape painter Louis Gurlitt. 'He was proud to be a Cornelius Gurlitt.' He rarely spoke about his mother. His sister Renate was 'much more normal than Cornelius, very lovable and the kind of person who likes to look after others'.

The boys adapted a doorbell transformer to operate secret lamps so that they could read undetected under the bedclothes after lights out. Their heroes were racing drivers: Heyl idolized the Grand Prix champion Hans Stuck, while Cornelius worshipped Bernd Rosemeyer, who had set a world land speed record as the first driver to break the 400-kmph barrier on a public road in 1937, and had died trying to improve on that time on the motorway between Frankfurt and Darmstadt in 1938. Heyl felt that it was somehow 'typical of Cornelius that his idol would be the lonely driver trying objectively to be the fastest in the world on a sealed-off strip of road'.

Cornelius's quirkiness and his desire for personal space were already apparent at school. Cornelius drew up a meticulous plan partitioning the room he shared into three distinct spaces: one part was Heyl's, one section was reserved for Cornelius and one area was allocated for common use. Heyl's guests were only permitted into the common area or into his own part of the room; if they wanted to enter Cornelius's territory, they had to ask his permission. Heyl 'went along with it but I found it very strange'. When Heyl's elder sister came to visit she made fun of the scheme, refusing to ask Cornelius's permission to enter his space and telling him his rules were ridiculous. He was, Heyl recalled, more shocked than angry at her mockery.

Academically, Cornelius was consistently average at school, accord-ing to Heyl. He didn't shine in any particular subject apart from technical drawing, where Heyl remembered him conceiving some intriguing and original floor plans for buildings. The love of music he later developed was not then apparent. Cornelius also showed no real passion for art, unlike Heyl, and never mentioned his father's collection, some of which was still in the custody of the Monuments Men at that time. When Heyl visited exhibitions with his family, he reported back to Cornelius. Yet Cornelius never wanted to join him on museum visits and barely glanced at the art books his roommate borrowed from the Odenwaldschule library. They did, though, once go to a motor-racing event together at Hockenheim.

During the post-war years, Hildebrand sent Cornelius and Renate to Switzerland on several occasions, where they were looked after by their father's friends, the artist Karl Ballmer and his wife. The couple had escaped from Hamburg before the war and lived in Lamone in rural Ticino, 5 kilometres north of Lugano. Their house was small, with a studio and living room, but they welcomed the Gurlitt children to stay. Franziska Engelking (née Gessner) remembered their visits from her own childhood: her father Hans Gessner was an artist and close friend of Ballmer who had followed him to Ticino and lived half an hour's train ride away. She was two months older than Cornelius, and recalled him helping with the grape harvest and playing a raucously fun ball game with Ballmer afterwards. She also drank her first ever beer with Cornelius, supplied by Ballmer, on a subsequent visit by the Gurlitt children when she was fourteen.[15]

When Cornelius was fifteen, his father removed him and Renate from the Odenwaldschule. Cornelius told Heyl the reason he was leaving was because his family was now settled in Düsseldorf, so he could attend a regular day school and live at home. Heyl never heard from his friend again.

Cornelius took his Abitur, the German school-leaving examination, in 1953 in Düsseldorf at the age of twenty. Following in the footsteps of

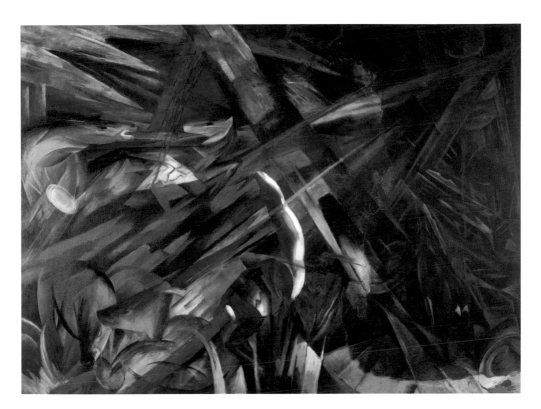

ABOVE Franz Marc,
*The Fate of the
Animals*, 1913.

RIGHT Paul Klee's painting
Swamp Legend on display
at the 1937 'Degenerate Art'
exhibition in Munich, below
centre. Scrawled quotations
on the walls aimed to
ridicule the artworks.
This one says: 'Take Dada
seriously! It's worth it.
Georg Grosz.' The heirs of
Sophie Lissitzky-Küppers
are still trying to recover
Swamp Legend from the
city of Munich.

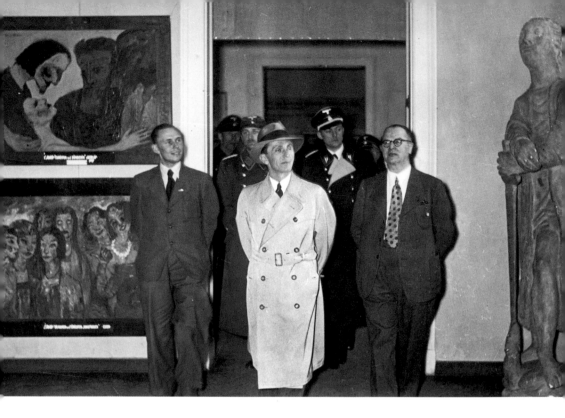

ABOVE Propaganda Minister Joseph Goebbels (centre) at the 'Degenerate Art' exhibition in Berlin on 27 February 1938. To the left are paintings by Emil Nolde; on the right is a statue by Gerhard Marcks.

BELOW The 'Degenerate Art' exhibition travelled from Munich to several more cities. This photo shows the opening night at the Haus der Kunst in Berlin in February 1938.

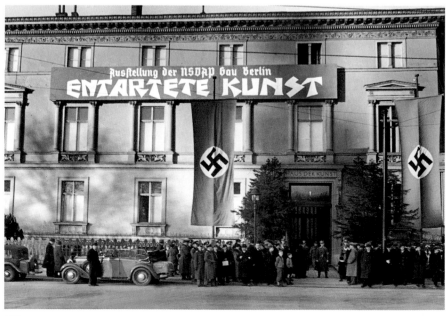

RIGHT Pablo Picasso, Marc Chagall and Vincent van Gogh were among the artists whose works were seized as 'degenerate' by the Nazis and stored at Schloss Schönhausen, where this photo was taken in 1937.

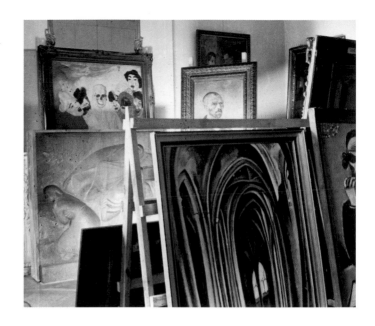

BELOW The depot of 'degenerate' art seized from German museums at Schloss Schönhausen in Berlin, including works by Wilhelm Lehmbruck and Lovis Corinth.

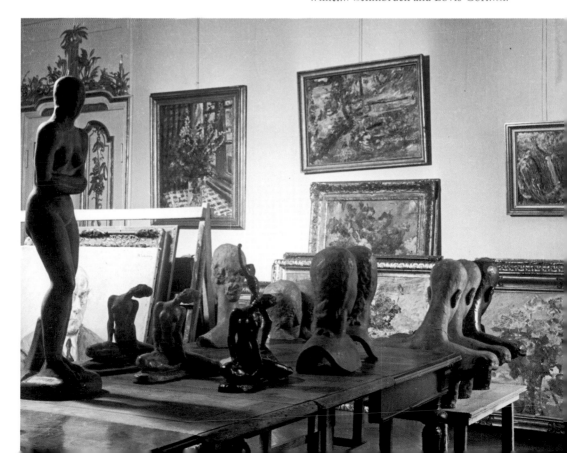

ABOVE Hitler examines a model of the planned Linz Führermuseum with the architect Roderich Fick, centre left, at his Berghof residence in the Obersalzberg in the Bavarian Alps on 9 May 1939. His chief architect and later Armaments Minister Albert Speer (centre right) and Reichsleiter Martin Bormann, Hitler's personal secretary (far right), look on.

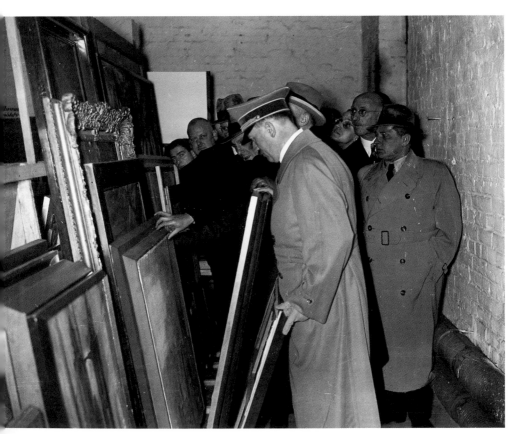

OPPOSITE BELOW Hitler examines the 'degenerate art' stored in the granary on Berlin's Köpenicker Strasse on 13 January 1938. His official photographer and art adviser Heinrich Hoffmann is on the far right in a hat; next but one to him is Rolf Hetsch, the Propaganda Ministry official in charge of the operation to sell 'degenerate art'.

ABOVE Reichsmarschall Hermann Göring visits the Jeu de Paume in Paris, where the Nazis assembled art stolen from French Jewish collections.

LEFT Göring examines paintings at the Jeu de Paume in Paris.

RIGHT Georg Oehme, *Portrait of Hermann Voss*, 1943.

BELOW The Leipzig music publisher Henri Hinrichsen. Hildebrand Gurlitt bought his artworks weeks before Hinrichsen emigrated to Belgium. He was later murdered at Auschwitz.

OPPOSITE Max Beckmann, *Bar, Brown*, 1944. This work was purchased directly from the artist by Hildebrand Gurlitt, who visited him in exile in Holland. It now hangs in the Los Angeles County Museum of Art.

A photograph of Henri Matisse's *Seated Woman*, 1921, from records of the Nazi ERR (see page 62) that were later seized by the Americans and held at the US military's Central Collecting Point in Munich. This painting was stolen by the Nazis from the Parisian Jewish art dealer Paul Rosenberg, who had stored it in a bank vault in southern France for safekeeping. It was discovered in Cornelius Gurlitt's Munich apartment in 2012.

the father he worshipped, he went on to study art history at Cologne University. Given his lack of interest in art at school, this may have been a choice made to please Hildebrand. He was registered until 1960 as a student in Cologne, where he also attended lectures in music and philosophy, passions that stayed with him all his life. During that time, he began a vocational training as an art restorer at the Museum of Fine Arts in Düsseldorf.[16]

Hildebrand's sudden death came as a great shock to his children. Exactly what instructions he left Cornelius regarding the art are left to the imagination, but there is no doubt that Hildebrand burdened his son, at the age of twenty-three, with a life-long responsibility that was to weigh ever more heavily as he grew older. Cornelius saw it as his role to protect the art his father had managed to save from the Nazis, the bombs, the Russians and the Americans. To him, his father was a hero whom he revered for his ability to recover time and again from all the hard knocks life had dealt him. He was convinced his father had been a staunch opponent of Hitler, even if he had concealed his antipathy so well that no one else noticed it. Cornelius refused to believe Hildebrand would have bought art from Jews who were selling under duress.[17]

In Düsseldorf, Cornelius fell in love with a young woman who was working with him as an intern during his apprenticeship at the Museum of Fine Arts in 1957. Though they wrote letters to each other for many years, she did not return his feelings and sent him a newspaper clipping announcing her engagement to another man in 1965. He stopped writing. There is no more mention of love affairs in his correspondence after that.[18]

Cornelius broke off his art history studies without completing his degree, but didn't like to talk about why. Five years after Hildebrand's death, Helene bought two apartments on Artur-Kutscher-Platz in the genteel Munich suburb of Schwabing. She dreamed of a bohemian life among rich people who asked no questions about other people's wealth. At twenty-seven, Cornelius was not one to make decisions by himself and had gone with her. It was a move he later regretted and resented.

Munich was to him the 'source of everything bad' as the city where the Nazi movement was founded.[19]

As early as 1962, Helene worried about her son's 'alarming persecution complex' in a letter to a friend. She confronted him directly, asking, 'What is the origin of your delusions?' Benita also later wrote in a letter that her brother felt he was being constantly spied on and bugged. He later developed a conspiracy theory, believing that Munich's Nazis were out to seize his collection.[20]

But for now, the art collection was in Helene's hands. She sold some pieces in 1960, including the Picasso gouache, *Portrait of a Woman with Two Noses*, which Hildebrand first told the Allies he had purchased directly from the artist, then that he had received as a gift from Karl Ballmer (see pages 116–17).

Her policy in responding to queries about the art after Hildebrand's death was to lie, as her husband had before her; she claimed it was all lost in the Dresden bombing. Approached in 1966 by the Office for Compensation in Berlin, which was trying to track down the artworks looted from Henri Hinrichsen in Leipzig (see pages 88–90), she said all the contents and business documents relating to her husband's art dealership had been destroyed and signed an affidavit to that effect.[21] As Cornelius later revealed, the Spitzweg drawing of the couple making music that Hildebrand purchased from Hinrichsen in 1940 hung in her hallway.

Perhaps to get away from Munich, Cornelius had built for himself a little house on quiet Carl Storch Strasse in Aigen, an affluent suburb of Salzburg. He moved into it in 1961 and lived there permanently, 'quite alone and reclusively and very content and happy', according to Renate, by now known as Benita. She was at that time working on her history of art doctorate and living with Helene in Munich.[22] Helene would visit Cornelius in Salzburg 'to recover from the stresses of the city', she wrote in a 1967 letter.[23] In whichever of the homes, workmen encountered Cornelius's resistance before he would let them in. He wanted to shield his father's pictures from the prying eyes of strangers.[24]

Cornelius seldom travelled – apart from his trips to Switzerland, the only record of a vacation abroad is a visit to Paris with Benita in 1962. Despite his early leanings towards the church, neither Cornelius nor his mother were known to his local parish parson at the Erlöserkirche in Schwabing.

Helene died in January 1968. Benita married and moved to Baden-Württemberg with some of the pictures they inherited, though most remained with Cornelius. He himself had never fallen in love, he told the *Der Spiegel* reporter, giggling at the question. His loved his pictures more than anyone or anything. But did he really love them the way he claimed to, or were they more of a millstone than a pleasure?

His sole source of income was his inherited wealth and the paintings he sold from his father's collection. It is unclear how many works he sold and how much wealth he inherited. He rented safety deposit boxes in a Swiss bank vault in 1983, yet their contents have never been revealed.

If information about his early life is sparse, the four decades after his mother's death represent even more of a mystery. It may be that he became so withdrawn, there is simply not much to tell. His parents had died, his sister had married and he was alone. Benita was the only person he trusted, yet he didn't even go to her wedding. People who knew him suspect that he may have been jealous of his brother-in-law, Nikolaus Frässle, and resentful towards him for taking Benita away.

Old friends tried to track Cornelius down. Heyl remained fond of his old roommate despite his quirks, and said he sought contact about once every ten years. His letters went unanswered.[25] Benita at one point communicated to Heyl via a mutual friend that Cornelius did not want to be in touch. Franziska Engelking saw Benita a few years before she died and took down Cornelius's address and telephone number. He never responded to her attempts to reach him.[26]

For decades, Cornelius lived alone, dividing his time between the fifth-floor Munich apartment and his Salzburg house, surrounded by his art. The works on paper and prints he preserved in a specially designed cabinet in his flat. The framed works were kept on shelves. He never

watched television and had never used the internet. The last time he went to the cinema was in 1967.

He lived modestly. His car was a Volkswagen Fox, one of the smallest the company has produced. The only sign of extravagance in his apartment was an expensive sound system that he had purchased in the 1970s and was still using forty years later. Classical music had become one of his great passions, and he was especially devoted to the music of Richard Wagner. He also read a great deal, particularly philosophy, and loved Arthur Schopenhauer's writing.

Sometimes he played with his model railway; sometimes he painted and drew figurative works – often portraits of Benita. When he was angry with her, he painted a knife descending towards her.[27] His own art, according to one person familiar with it, would have fascinated a psychoanalyst.

Cornelius had taken Austrian citizenship, was registered as a resident of Salzburg and paid his taxes there. Yet his visits to his Aigen home became less and less frequent as he grew older. Occasionally, a 'ghostly light' glowed from the first floor, according to Helmut Ludescher, a neighbour. He had learned from the architects that Cornelius insisted on one room with bright lighting. From that, the neighbours had concluded the reclusive part-time inhabitant was an artist.

As time went on, the blinds were almost permanently down. Ludescher lived next-door-but-one for almost fifty years, yet he barely exchanged words with him. He approached Cornelius once, but was brusquely brushed aside. 'I'm not giving any information,' Cornelius said. When he drove down Carl Storch Strasse in his little black car, he would look straight ahead, avoiding eye contact with anyone. If a neighbour spotted him on his balcony, he would quickly disappear into his house.

He was surly with the neighbours after they complained about his unkempt garden, which constantly threatened to encroach onto adjacent properties. In 2009 or 2010, another neighbour saw Cornelius attempting to cut back some of the excess growth. Asked whether he was the owner of the house, the recluse replied, 'Talk is silver, silence is golden.'

In October 2010, a neighbour called the police because she suspected that there could be a corpse decaying inside the house. Salzburg police tried to make contact with Cornelius – to no avail. They sent two officers with a sniffer dog and four firemen, who broke in and searched the premises. They found nothing. 'They were looking for a body or someone who could have been lying helpless in the house,' Salzburg police spokeswoman Eva Wenzel said. 'They weren't looking for a load of stolen art.' A locksmith replaced the broken lock and left a note for the owner to pick up the new keys from the police.[28]

Cornelius grew more and more isolated, increasingly trapped in a bygone era and detached from the world he lived in. His sister was the only person who visited Cornelius frequently, and perhaps his sole connection to the people who knew him. For many years, she shielded him from their unwanted approaches. After Benita's death of cancer on 3 May 2012, his contact with people was even more limited. The two apartments in Munich had belonged to her and she bequeathed them to Cornelius.

His doctor in Würzburg may have been the only person Cornelius exchanged more than a few sentences with on any regular basis. When planning his trips to Würzburg, a two-hour train journey away from Munich, he would book his hotel room by sending a typewritten letter a month in advance, signed in fountain pen and with a request for a taxi to pick him up at the station. He took food and drink with him so that he could eat in his hotel room in the evenings, and set off two days before the appointment in order to have plenty of time to prepare. He even wrote down the sentences he wanted to deliver to the doctor on cards so that he could learn them in advance and express himself smoothly. He planned to rise at 2 a.m. to start getting ready for an 8.45 a.m. appointment. The doctor's practice was only 300 metres from his hotel, but he took a cab. He paid for his treatment in cash.[29]

His poor health may have been the main reason Cornelius had given up on his Salzburg home. On his last visit there, he told *Der Spiegel*, he been unable to walk because of his weak heart and had ended up in the private Wehrle clinic in Salzburg. He stayed in hospital for a month,

infuriated by an alarm that sounded every time he tried to leave his bed. His passport, which he had always renewed at the German consulate in Salzburg, expired in 2011 or 2012.

Even after that stay in hospital he was incapable of walking far without taking a rest and took a taxi to go to the shops in Munich. The days passed in his darkened apartment. He talked to no one in Munich – even his neighbour had barely exchanged a few words with him. There was just one chair at his kitchen table because Cornelius never had company. He wrote little messages to himself on post-it notes and attached them to a board on the wall in his study. Some were practical: train times, a phone number. Others were nuggets of philosophical wisdom. Still others were nonsense, reflecting his strange neuroses. On one he had written '*Hanns Seidel Stiftung – Heil Führers Sieg*', a bizarre pun equating the foundation attached to Bavaria's biggest political party with the Nazis.

The Würzburg doctor tried to persuade him to move into a nursing home. Like his father and grandfather before him, he suffered from cataracts. He had no pension and no health insurance, so sold his artworks when he needed money to pay doctors' bills.[30]

Who knew about the art? Alfred Weidinger, the deputy director of Vienna's Belvedere art museum, said the existence and size of Gurlitt's collection was common knowledge among dealers in southern Germany. 'This was no secret,' he told the Austrian press agency.

Wolfgang Henze, who manages the Berne-based Galerie Henze & Ketterer together with his wife Ingeborg Henze-Ketterer, said his family had known about the Gurlitt collection for decades. In 1950, Hildebrand sold a Paul Klee painting at an auction held by Roman Norbert Ketterer, Henze's father-in-law, at Ketterer's Stuttgarter Kunstkabinett. When Helene sold Picasso's *Portrait of a Woman with Two Noses* ten years later she took it to Ketterer, where it fetched 46,000 Deutschmarks. She also offered a 1927 portrait of Bertolt Brecht by Rudolf Schlichter, a Georg Schrimpf painting, *Two Women at the Farm Well*, and Max Beckmann's *Bar, Brown* at the same auction. The Beckmann didn't sell, so Cornelius consigned it to Ketterer again in 1971.[31]

'The last contact we had with him was in 1972 in Campione d'Italia, when my father-in-law sold Beckmann's *Bar, Brown* for him and paid Cornelius Gurlitt 90,000 Deutschmarks for it,' Henze said. 'We knew Cornelius Gurlitt's address in Munich and in Salzburg.'[32] Henze's father-in-law had noted in his business books that contact with Cornelius should be in writing, not by telephone. But while Henze was aware of the art hoard, he said 'a small "dark" part of the collection was not known about'.

Benita must have known and perhaps her husband Nikolaus Frässle did, too. He declined to be interviewed for this book. Other members of the family, including Cornelius's cousin Dietrich Gurlitt, were completely taken by surprise.

Some outsiders had inklings. In 2005, Max Beckmann's granddaughter Mayen Beckmann and an art historian, Siegfried Gohr, placed an advertisement in the *Frankfurter Allgemeine* newspaper. They were preparing a catalogue raisonné of Beckmann's pastels, watercolours, colour prints and drawings. 'As there are works on paper whose location could not be established, particularly works that were in the possession of Hildebrand Gurlitt, the authors request the owners of such works for assistance,' they wrote, and gave a Berlin telephone number.

Gohr said they were particularly interested in the whereabouts of *The Lion Tamer*, the Beckmann gouache that Hildebrand had exhibited in the United States in 1955. 'We were only interested in the Beckmanns,' Gohr said. 'We hoped that Gurlitt might have more.'[33]

8 Selling Plunder

It's surprisingly easy to sell Nazi-looted art without being detected. The Gurlitt family managed it on several occasions over the decades, probably more often than we'll ever know. Equipment found in Cornelius's apartment included a book of erotic texts from famous English authors with the pages cut by a machine inside to create a secret space for banknotes. Investigators also found a metal strongbox artfully disguised with the pages of a newspaper that could have been used to transport artworks.[1]

Yet despite the cloak-and-dagger gear, Helene and Cornelius had no need to be surreptitious about selling their art by resorting to backstreet dealers. The Gurlitts approached some of the most prestigious auction houses in Germany and Switzerland, which readily accepted their wares. The truth is that auction houses in Germany, and not only in Germany, still do a brisk trade in Nazi plunder that has never been restituted to the heirs of Jewish victims of theft, persecution and in some cases, murder.

The art market is notoriously opaque and resistant to self-regulation, making it a haven for money launderers, forgers, tax evaders and anyone who wants to be able to roll up an expensive investment and hide it in an attic or a bank vault for a rainy day. Buyers are often cavalier about checking provenance. Anyone who failed to ensure that they have undisputed legal title when purchasing a house would be considered foolish. Yet it happens with art all too frequently – even with paintings worth millions.

Heirs hoping to claim back stolen artworks that have found their way into private collections like Cornelius Gurlitt's need to be watchful, persistent and prepared to do battle. They also need considerable resources. It is like a long, drawn-out game of Whac-a-Mole, requiring decades of patient waiting for an artwork to surface at auction, and then pouncing at the right moment with the right amount of force before it disappears again.

Mike Hulton, the heir of a Jewish art dealer who was persecuted by the Nazis, got lucky in 2011. Two years before his trove was exposed, Cornelius offered a striking gouache and pastel work by Max Beckmann to the Cologne auction house Lempertz. The colourful *Lion Tamer* shows the powerful torso of a man stripped to the waist from behind, exercising his authority over a comically acquiescent lion who sits meekly on a stool, towering above his master. Hildebrand Gurlitt acquired it from Alfred Flechtheim, Hulton's great-uncle, a Jewish dealer who ran galleries in Düsseldorf and Berlin before World War II.

The founder of an art magazine and one of Germany's most prominent dealers in contemporary art, Flechtheim was among the first targets of anti-Semitic victimization, attacked in a barrage of hate articles in the Nazi press even before 1933. He fled to London via Zurich and Paris soon after Hitler seized power – in a 1933 letter from exile to the artist George Grosz, Flechtheim said he and his wife were 'poor as church mice and nervous'. Flechtheim died of blood poisoning in London in 1937 after treading on a rusty nail. The Flechtheims had no children and Hulton, a doctor based in California, is the sole heir.

Flechtheim's Düsseldorf gallery was 'Aryanized' in 1933 and passed to Alex Vömel, his assistant, who became a member of the Nazi Party. The Berlin gallery was liquidated later that year and his private collection sold. It included works by Pierre-Auguste Renoir, Wassily Kandinsky, Fernand Léger, Georges Braque and Henri Matisse. Beckmann scholars believed *The Lion Tamer* was either lost during the war or hidden away in a private collection. Then out of the blue, Cornelius contacted Lempertz in September 2011, offering it for auction. He later revealed that he had actually intended to sell the Max Liebermann painting *Two Riders on the Beach* that belonged to David Friedmann of Breslau, but he hadn't been able to detach it from the wall so he took the Beckmann instead.[2]

Emmarentia Bahlmann, a Munich-based representative of the auction house, went to an apartment to pick up the gouache as agreed. Cornelius may have given her the address of the second Munich apartment his mother purchased in the same house, not his own – investigators said he

used this to conduct negotiations with art dealers.[3] She found him, courteous, shy and elegantly attired, alone in the gloom with a single artwork – just the Beckmann hanging on the wall. The glass covering it was dusty and the picture was torn in two places. Immediately bowled over by the painting, she asked him whether he possessed other artworks. He said that was the only one.[4]

'We were left with the impression that this was an elderly man selling his last important piece in order to have a bit of money in his twilight years,' said Karl-Sax Feddersen, a Lempertz executive. 'No one could have guessed then that Mr Gurlitt was sitting on a huge hoard.'[5]

The auction house featured the work prominently in the catalogue for its modern art sale on 2 December 2011. Hulton's sharp-eyed lawyer Markus Stötzel spotted it. He contacted Feddersen, who agreed to discuss Hulton's claim with Cornelius Gurlitt. The timid old man did not want to deal with Stötzel directly, but was happy to let Lempertz negotiate on his behalf. Cornelius was, Feddersen said, very cooperative and 'a real gentleman' and the talks ran smoothly. The two parties reached an agreement to share the proceeds two days before the Cologne auction. Stötzel said he only found out the name of the consignor when he saw the signature on the contract. *The Lion Tamer* fetched 864,000 euros, almost three times its estimate.

Not all consignors are as willing to negotiate as Cornelius was. A claimant's chances of recovering an artwork looted by the Nazis or, as in the Flechtheim case, sold under duress, depends largely on the goodwill of the current holder. German law is firmly on the side of the current possessor, not the victim of looting.

In the case of artworks lost through Nazi confiscations or forced sales, the original owner might in theory have retained legal title, as the dozens of methods the Nazis employed to plunder Jews are deemed illegal today and therefore invalid, but he or she has probably lost the right to recover the artwork. This separation of title and possession is one of the idiosyncrasies of German law that makes civil suits to recover Nazi-looted art especially unlikely to succeed.

Like US and British law, German law in principle states that a thief cannot pass good title. Yet it also protects 'good faith' buyers of movable objects – a buyer who purchases an artwork at public auction may be considered to have acquired it in 'good faith'. This has prompted some to describe German auction houses as 'washing machines' for laundering Nazi-looted artworks.

Under a quirky rule known as *Ersitzung*, if someone has acquired an object and possessed it for ten years in 'good faith', he or she can gain legal title. Anyone contesting ownership has to prove that the object was acquired or held in 'bad faith', i.e. that the current possessor knew it was stolen or could have easily found out it was stolen.

Even if the pre-war owner can prove the current holder knew an artwork was stolen and that the pre-war owner, therefore, retains legal title, he or she may still not be able to recover the property. In civil cases, the current holder of a stolen artwork –– even if the thief – can argue that the pre-war owner's claim is time-barred after thirty years.

Attempts to prosecute a Nazi-era thief are also destined to failure, in the unlikely event that thief is still alive and still in possession of the stolen property. While the statute of limitations for murder and genocide was lifted in West Germany in 1979 so that Nazi killers could continue to be brought to justice, for theft and robbery it remained intact at as little as five years, depending on the seriousness of the crime.

The art market is global and filing suit in a different jurisdiction is the best hope of success for many claimants. If that is not an option, the only fallback is to exert moral pressure.

But for this it is necessary to determine the identity of the current holder. Auction houses will rarely divulge the names of consignors without their permission, citing their liability under privacy protection laws. Catalogues often vaguely describe the seller of an artwork as 'a private collector from Germany'. All too often, auction houses quietly return disputed works to a consignor when a red flag is raised, and a piece of Nazi plunder vanishes back into the darkness it came from, unattainable and untraceable until the next time it comes to the market.

Getting information out of dealers in the secretive art world is a struggle. In 1988, Cornelius Gurlitt sold eleven works, including a Degas pastel, via Galerie Kornfeld in the Swiss capital Berne, according to research by Stephan Klingen at the Central Institute for Art History in Munich. The catalogue neglected to mention the Degas's previous owner in Paris, Charles Comiot. The other works included an Otto Dix watercolour of his wife in a hat; three Erich Heckel landscapes and a watercolour of a musician; three works by Christian Rohlfs; and drawings by Max Pechstein and Otto Müller. Cornelius mentioned he had sold art to Kornfeld in 1990 to customs officers who searched him on the train twenty years later, saying that was the source of the money he was carrying.

Eberhard Kornfeld, who has run this venerable auction house and gallery since 1951, was overwhelmed with press enquiries when Cornelius's collection became public. He responded with an article in the *Neue Zürcher Zeitung* (*New Zurich Newspaper*) saying he was appalled at the 'media hysteria' and at his own portrayal as 'the big baddie'. The company distributed a statement saying it had included four works on paper in an auction in 1990, for which it paid Gurlitt 38,250 Swiss francs. The works in question, it said, were among those purchased by Hildebrand Gurlitt from the stores of 'degenerate art' seized by the Nazis from German museums.

This was impossible to verify as Kornfeld volunteered no details about them. Eberhard Kornfeld responded to a request for information for this book by saying he couldn't provide answers for at least six months because he was too busy with auctions and he didn't know whether the documentation was still in the company files.[6] It is only thanks to Klingen's research that we know what the artworks sold in 1988 were, and it seems unlikely that the Degas was a seized 'degenerate' work. Not one single Degas is among those confiscated and listed on the database of more than ten thousand 'degenerate' artworks compiled by the Free University of Berlin.

In 2015, the *Süddeutsche Zeitung* uncovered correspondence proving

that Kornfeld's business contacts with Cornelius dated back to 1970. The auctioneer even visited his consignor at the apartment on Munich's Artur-Kutscher-Platz, promising 'an uncomplicated, quiet and direct transaction' and suggesting payment could be made in person and in cash in Berne.[7]

Two Riders on the Beach, discovered in Cornelius Gurlitt's apartment in 2012, was one of two Liebermann works stolen from the villa of the Breslau sugar entrepreneur David Friedmann that found its way into Hildebrand Gurlitt's collection. The other, to which Friedmann's great-nephew David Toren also lays claim, was a pastel from about 1900 with the title *Basket Weavers*. That was sold, unnoticed at the time, at the Berlin auction house Villa Grisebach in 2000. It was purchased by a private Israeli collector for 130,000 Deutschmarks, more than double its estimated price.[8] The catalogue listed previous owners as Dr Hildebrand Gurlitt, Düsseldorf, and a private collector from Baden-Württemberg. It was Gurlitt's son-in-law Nikolaus Frässle who consigned the painting for auction.[9] Bernd Schultz, the founder and chief executive of Villa Grisebach, declined an interview request for this book (as did Frässle). Media reports in March 2014 said police searched the premises of two auction houses in connection with the Gurlitt case – that may be why Schultz didn't want to discuss the sale.

Toren often wonders whether he has purchased back works that once belonged to his parents from Villa Grisebach. His father's first wife, who died in World War I, was a niece of the artist Lesser Ury. Ury used to give her his paintings on birthdays – about a dozen of them hung in Toren's family home in Breslau before World War II. They have never been recovered, but Toren has since bought many Ury works from the Berlin auction house.[10]

Toren registered both Liebermann's *Two Riders on the Beach* and *Basket Weavers* on a database of missing art, yet that alone is unlikely to lead to the recovery of art if it is in a private collection. Many artworks listed on public databases such as www.lostart.de in Germany are sold on to other owners regardless. A slightly different title or a changed

attribution can make tracking the work virtually impossible without photographs.

Investigating the ownership history of an artwork, a discipline known as provenance research, is a painstaking and time-consuming task. Few auction houses are prepared to invest considerable resources into it. Noteworthy exceptions include the big international houses, Christie's and Sotheby's, both of which set up restitution teams in the 1990s to focus on identifying artworks that are potentially looted or the subject of an ownership dispute, and conducting the necessary checks.

Richard Aronowitz heads the European research team at Sotheby's in London. The team first checks the back of the artwork, as clues to previous owners can often be found on labels from exhibitions, dealers and collectors. They also search on the company's own database, built up over fifteen years, the artist's catalogue raisonné (a register of all known works in his or her oeuvre), and the main lists of lost works published online by national governments. The findings are then sent to the London-based Art Loss Register (ALR), which runs a second check.

According to Aronowitz, out of about five thousand lots a year, fifty to sixty may raise concerns serious enough that the team sends someone to investigate in archives abroad. Of those, some ten to fifteen may turn out to be unrestituted Nazi-looted artworks. Sotheby's tries to keep hold of looted works to encourage the consignor to negotiate. Aronowitz and his team work on finding settlements so that both the heirs and the consignor take a share in the proceeds when the artwork goes to sale.

The ALR, a privately owned company, charges a fee per search, or in the case of auction houses, offers a subscription service. The houses submit their catalogues routinely and the ALR checks them against its own extensive database of stolen art.

Its cramped, tiny offices among the jewelry sellers on London's Hatton Garden suggest the ALR is not making a great profit. It conducts 400,000 searches a year, but according to James Ratcliffe, director of recoveries, 'You'd be surprised at how little people are prepared to pay for this service.' The ALR's database work is mainly carried out by

a team in Delhi, which also searches for 'red-flag' names in the provenance of artworks. The company had just one staff member dedicated to Holocaust-era assets in 2014.

When the ALR identifies artworks as suspected Nazi loot, the response of auction houses and consignors can vary enormously. Some react with horror at the idea of owning something tainted by Nazi crimes for which there has so far been no redress and immediately want to reach a settlement with the heirs. Others shrug their shoulders as if to say 'Why should I care? That was years ago.'

The ALR doesn't run checks on any piece of art worth less than about 1,000 euros. The prints that were the focus of Hildebrand Gurlitt's collection often trade at around that price or not much higher. These are far easier to sell unnoticed than a big oil painting that is one of a kind.

Sitting in a cluttered meeting room, Ratcliffe was quite clear that the Art Loss Register makes no claim to catch every stolen artwork: 'The ALR is not the be-all and end-all. We are a tool in due diligence, arguably the best tool, but there is a case for more. For some auction houses we are the only due diligence, which is frustrating.'[11]

Van Ham Fine Art Auctions in Cologne is one such auction house. In 2013, the company offered three works in its May sale that had been seized from Max Stern, a Jewish art dealer who fled Nazi Germany. All three had been listed as missing on lostart.de, the German government database, since 2005. Van Ham submits its catalogues to the ALR, according to Anne Srikiow, a spokeswoman for the auction house. If there is a reason to be sceptical about a work's provenance, Van Ham conducts some basic checks.[12]

Those 'basic checks' failed to uncover the dark history of the three pictures. Max Stern took over his father's Düsseldorf art gallery in 1934, a year after the Nazis seized power. He was informed in 1935 that as a Jew, he could no longer practise his profession. In 1937, the Nazis forced him to sell the contents of his gallery at the Cologne auction house Lempertz. Stern never got the revenue and he fled to London in 1938, later making his way to Canada.

He settled in Montreal and became one of the most important art dealers in Canada. He died in 1987 without children, leaving the bulk of his estate to three universities: Concordia and McGill in Montreal and the Hebrew University of Jerusalem. In 2002, the colleges launched a campaign to recover the lost art, creating the Max Stern Art Restitution Project, administered by Concordia.

The project aims to recover the artworks Stern was forced to sell at Lempertz and those seized from his private collection. Yet despite investing considerable resources, it has so far recovered only eleven of about four hundred artworks. Clarence Epstein, the project's administrator, believes most of the rest are probably in German private collections.

Of the three paintings offered at auction by Van Ham in 2013, the universities recovered one, an 1837 landscape by Andreas Achenbach, by negotiating a settlement with the consignor. They may have lost track of the other two for good. Their consignor refused to negotiate with Stern's heirs, arguing that his grandfather bought the paintings legally at the Nazi-forced auction of Stern's gallery at Lempertz. Though the sale was unquestionably invalid under today's law, Van Ham returned the two paintings – *Canal in Dordrecht* by Hans Herrmann and Jakob Becker's *Children's Festival in the Country* – to the consignor. The company declined to reveal his name to Stern's heirs, leaving them with little hope of recovering the artworks. Srikiow said German data protection laws prevent the company from passing the names of consignors of Nazi-looted art to claimants. The Stern estate has no option but to wait patiently in the hope that the consignor will either try to sell the works again or decide to initiate negotiations. They cannot approach the consignor without knowing his or her identity.

Rene Allonge, the police officer in charge of the art crime department of the Berlin police force, has identified one possible way for German law enforcers to break the information lock. Though the criminal act – the Nazi theft – is too far in the past to investigate and the perpetrator is probably in any case dead, it is possible to investigate auction houses or dealers on suspicion of handling stolen goods. Proving that the suspect

was aware the object in question was stolen, essential for a conviction, can be very difficult. The police, however, could search premises, expose the names of consignors and pave the way for the heirs to increase the moral pressure to reach an amicable settlement or file a civil suit.

And while the heirs have little chance of recovering the artwork as long as the current possessor holds onto it, the holder is also unlikely to be able to sell it or exhibit it unnoticed. According to Sibylle Ehringhaus, a Berlin-based provenance researcher and art historian, more and more private collectors are showing an interest in investigating the history of their own collections. The internet and online databases of stolen art are making it increasingly difficult for sales of such art to go undetected.

One courageous German auction house is showing others the way in documenting and publishing its history. In March 2013, Katrin Stoll, the owner of Neumeister in Munich, found a stash of annotated catalogues dating from the years 1936–44 in a metal filing cabinet. The auction house's wartime owner Adolf Weinmüller had consistently denied their existence and insisted that all his records were destroyed in bombardments in World War II. Weinmüller joined the Nazi Party in 1931 and had 'Aryanized' Jewish art dealerships in Munich and Vienna. He counted Hitler's chief of staff Martin Bormann among his customers. Many works that Jews lost in forced sales or Gestapo looting passed through his hands. Weinmüller was classified as a *Mitläufer* (collaborator) in the denazification process, but was allowed to continue running his business from 1948 to 1985, when it was bought by Stoll's father, Rudolf Neumeister.

Working with the Central Institute for Art History in Munich, Stoll ensured that the catalogues were made available online. In total, 32,000 items offered for sale by Neumeister in May 2014 were searchable, an invaluable resource for heirs seeking lost collections.[13] Sometimes it takes a new generation with a different attitude to open up the books; if only others would follow Stoll's example, the work of those trying to track plunder would be made infinitely easier.

Law enforcers in the United States are more likely than those in Germany to take action to impound Nazi-looted art from private collections. In April 2009, Immigration and Customs Enforcement (ICE) officials seized from a New York gallery a Dutch Old Master portrait that had belonged to Max Stern. The oil-on-wood portrait, by an unknown Utrecht master and dated 1632, shows a musician holding a bagpipe; behind him, a violin hangs on the wall.

It was on sale at Lawrence Steigrad Fine Arts in Manhattan. The owner, Larry Steigrad, had discovered three days before the 2 April seizure that the painting was auctioned under duress before World War II. The London art dealer Philip Mould and his gallery director Bendor Grosvenor had found the painting on the Max Stern Restitution Project's website while doing some research for a BBC programme on Nazi-looted art. They recognized it as a painting they had sold to Steigrad and immediately alerted him.[14]

The painting was also spotted on Steigrad's website by a former student assistant of the Holocaust Claims Processing Office (HCPO) in the New York State Banking Department, who recognized it as a Stern painting. The HCPO informed the Max Stern Estate, which in turn contacted ICE. Posing as customers, Special Agent Bonnie Goldblatt and a colleague from ICE made an appointment to look at some portraits with Alexa Suskin, the director of Steigrad Fine Arts.

They looked at several pictures before specifically asking to see the portrait of the bagpipe player. Suskin fetched Steigrad from his office and he explained that the portrait was sold under duress and needed to be returned to the heirs. At that point, Goldblatt showed him her Homeland Security badge and secured the painting.

Philip Mould had purchased the portrait from Lempertz in Cologne in November 2007 – the same auction house that conducted the forced sale of Stern's paintings in 1937. Lempertz had submitted its catalogue to the ALR, which failed to identify the artwork even though it was listed on the company database as missing. Its database was foiled by the Lempertz catalogue description of the painting as a portrait of a

musician aged fifty-seven. The ALR listed it as a portrait of a bagpipe player. Mould reimbursed Steigrad for his purchase immediately and later reached a settlement with Lempertz.

The case prompted another New York art dealer, Richard Feigen, to ponder the provenance of an Italian Baroque painting in his private collection that he had purchased from Lempertz nearly ten years earlier. The picture of St Jerome in the wilderness, attributed to Ludovico Carracci, shows the bare-chested saint turning from his book as two angels greet him. It hung in Feigen's living room and he had never intended to sell it.[15]

A Lempertz employee had told Feigen that the provenance of the Carracci painting was 'clean' and the New York dealer paid 100,000 Deutschmarks (then about $45,000) to acquire it in 2000. According to Feigen, another employee told him on the telephone that Max Stern was not Jewish. After establishing that, on the contrary, the painting was indeed part of a Jewish dealer's forced sale at the Lempertz auction in 1937, Feigen contacted the Max Stern Art Restitution Project to discuss returning it. ICE agent Goldblatt picked it up from his apartment.

Feigen's request for compensation was rebuffed by Lempertz, so he took the company to court in Cologne. The Cologne Regional Court rejected his suit in 2013, stating that under German law, he had acquired legal title as he purchased in good faith. The decision to transport the painting to the United States, where a different legal situation may apply, was his, so Lempertz could not be held liable.[16] Feigen appealed and the Cologne Supreme Regional Court is still examining the case.

Civil lawsuits to claim Nazi-looted artworks are rarely successful in any country. In Germany, they are almost inevitably doomed because of the statutes of limitations and *Ersitzung*. Yet where private collectors are bound only by German law, the German government has pledged to restitute stolen art in public collections as one of forty-four countries who in 1998 endorsed the Washington Principles on returning art. These principles, however, are non-binding – and not all public authorities agree to apply them (for a full discussion of the Washington Principles, see Chapter 11).

The heirs of Sophie Lissitzky-Küppers have been fighting a byzantine legal battle against the city of Munich for a Paul Klee painting for more than two decades. Lissitzky-Küppers was a German art historian who lent some works from her private collection to Hildebrand Gurlitt when he was director of the King Albert Museum in Zwickau. She emigrated to the Soviet Union in 1927 to join the Russian-Jewish artist El Lissitzky, whom she married. She left her art collection on loan to Hanover's Provincial Museum in 1926, before her departure – including the Paul Klee painting *Swamp Legend*. The painting is a dreamlike, abstract landscape in shades of yellow and violet punctuated by obscure, childlike symbols – windows, trees and crosses.

Banished to Siberia by Stalin as a German living in the Soviet Union during the war, Sophie Lissitzky-Küppers never recovered her paintings from Hanover. She died in penury in Novosibirsk in 1978.[17]

Swamp Legend was seized in 1937 as part of Joseph Goebbels's campaign against 'degenerate art'. It was mocked in the Munich 'Degenerate Art' exhibition as the product of the 'confusion' and 'disorder' of a 'mentally ill person'. The painting wound up in the stash of defamed modern art in Berlin that Hildebrand had access to, as one of the four dealers permitted to sell the works abroad for foreign currency. He purchased it but didn't sell it abroad. It remained in Germany, and Helene Gurlitt may have sold it after his death – the trail is lost until 1962, when it was offered at auction by Lempertz.

After two more changes of ownership, it was purchased in 1982 by the city of Munich and an art foundation, and entered the stunning collection of Expressionist works at the Lenbachhaus museum. The heirs first filed suit in 1992. The case was thrown out by the Bavarian Regional Court in 1993, on the grounds that statutes had expired.

The heirs didn't give up their campaign. They dropped the legal challenge, instead trying to apply moral pressure on Munich mayor, Christian Ude. Their case was strengthened after 1998, when Germany agreed to the Washington Principles on returning Nazi-looted art in public collections. Several countries set up panels to mediate or

adjudicate on disputed artworks, among them Germany. The German panel, led by a former constitutional judge Jutta Limbach, is known as the Limbach Commission.

The panel can only be called if both sides agree to the mediation. Bernd Neumann, the German culture minister in 2009, urged Ude to take the dispute to the Commission. Limbach approached Ude, proposing to resolve the dispute, but was rebuffed in September 2010. Instead, Ude's lawyers offered a payment that the heirs claimed was equivalent to less than a third of the painting's value. They rejected it.

The painting, with a value of at least 2 million euros, is now back in court. Three grandchildren of Sophie Lissitzky-Küppers again filed suit for its return at the Bavarian Regional Court on 23 March 2012, arguing that under civil law, Lissitzky-Küppers never lost title to the painting. They also pointed out that under the terms of the Washington Principles and a pledge made by German public authorities, the city of Munich agreed not to employ technical defences like statutes of limitations. If statutes of limitations are applied, they argue, they should take effect from when the painting entered public ownership.

Munich has insisted that the case is about 'degenerate art' seized from the museums and argues that the Washington Principles are not applicable, refusing to accept that Lissitzky-Küppers was the victim of Nazi plunder. It will be interesting to see whether the pending court decision reflects the shift in attitude towards the restitution of Nazi-looted art that has taken place in Germany since the 1980s.

Hildebrand kept some of the 'degenerate art' he snapped up from the depot at the Schönhausen Palace in eastern Berlin. A few works have since surfaced at auction, sold by Cornelius or his family. One such painting was August Macke's *Woman with a Parrot*, which Hildebrand purchased for about 200 Swiss francs. In 2007, the painting fetched 2.38 million euros at a Villa Grisebach auction in Berlin. The consignor was an unnamed 'southern German collector', possibly Cornelius's sister Benita.[18]

This sale was perfectly legal. German museums have no claim to the artworks they lost in Goebbels's mad crusade to purge them of 'degenerate art'. While the four hundred or more laws passed by the Nazis to expropriate the Jews are all regarded today as invalid, the law of 31 May 1938, under which Goebbels legitimized the spoliation of the museums, has never been repealed and the confiscations are still considered valid.[19]

After the war, the Western Allies decided to leave the law in force, partly because they envisaged how fiendishly complicated it would be to unravel the transactions that had already taken place and track down the artworks to be returned, many of which were now abroad. The few Monuments Men on the ground already had their plates full with the restitution claims from foreign occupied powers and from private individuals whose collections had been plundered. There was limited sympathy for the German people among the Allies at that time, and many of the museums, run by Nazi appointees, had after all contributed to their own impoverishment by selling off their 'degenerate art' before the government could grab it.

Alfred Barr, the founding director of the Museum of Modern Art in New York, acquired dozens of works confiscated from German museums via Curt Valentin, a Jewish dealer who served as agent for Karl Buchholz, himself one of the four dealers (including Hildebrand) who was permitted to sell 'degenerate art' for hard currency abroad. Barr justified his purchases, mostly acquired very cheaply. Again, there was a sense that the Germans deserved to be punished. 'I frankly thought it was a good thing for the Germans as a whole to have some reminder of their collective guilt and folly,' he wrote in a letter to a fellow curator.[20]

German museums endorsed a decision to recognize the confiscations as legal and permanent at a meeting in September 1948, noting that it would be impossible to recover the works that had been sold abroad and praising the collectors who had risked the ire and retribution of the Nazis by buying the art to keep it in Germany.[21]

So Hildebrand never came under any pressure from either the Allies or the German museums to return the artworks he had acquired from the depot at Schönhausen Palace after the war (although in the Soviet zone, his colleague Ferdinand Möller was forced to hand over some of his.) Both Hildebrand and Möller portrayed themselves as saviours of the art that the Nazis reviled, and pointed out that if they hadn't purchased the 'degenerate' works, these may well have been incinerated along with the other leftovers.

For the museums, the only way to replenish their stocks of early 20th-century art was to buy back artworks or receive them as donations from those individuals who had violated the Nazi rules. Some people, especially in the German museum scene, argue that the law should be changed. This debate gained a new impetus with the discovery of Cornelius Gurlitt's art trove. Museum directors at the Mannheim Museum of Art and the Von der Heydt Museum in Wuppertal have said they are investigating the legal options for recovering paintings seized during the 'degenerate art' operation from the Gurlitt collection.[22] In March 2014, the Bundesrat, Germany's upper house of parliament, even asked the lower house to examine whether legislative action was needed to address the consequences of the 1938 law.

Yet most experts revert to the Allies' position, arguing that changing the law could result in an avalanche of expensive and time-consuming lawsuits and would penalize the German museums that were most conscientious about rebuilding their modern art collections after World War II. As for the foreign houses, it is hard to imagine the Metropolitan Museum of Art and the Basle Art Museum, for instance, letting go of artworks that have enhanced their collections for decades without putting up a robust fight.

9 The Augsburg Prosecutor

Cornelius Gurlitt was travelling from Zurich to Munich in a fast train on 22 September 2010, with 9,000 euros in crisp new 500 notes tucked away in an envelope in the inside pocket of his jacket.[1] At about 9 p.m., the train reached the Swiss-German border region near picturesque Lake Constance.

Under customs rules, people carrying more than 10,000 euros are required to declare it at the border. In recent years, international pressure on Switzerland to lift banking secrecy and stop protecting tax evaders has mounted. German tax authorities have purchased CDs containing Swiss bank account data from whistle-blowers, and used the information to hunt down miscreants. All this has frightened many Germans into emptying their secret Swiss accounts. Customs officials monitoring the border have become very watchful. They frequently encounter Germans, often elderly, with thousands of euros stuffed in odd places – their shoes, incontinence diapers, or even, in one instance, in a gingerbread house.[2]

Cornelius first lied to the customs officers about how much cash he was carrying, according to the interview he gave to *Der Spiegel* magazine. Yet he had been searched that very morning, on the train from Munich to Zurich. Officers had found three empty white envelopes in his briefcase, alongside newspapers and timetables. Now there were only two left.[3]

Where was the third? Cornelius repeated that he was carrying no cash. A body search in the train toilets revealed the truth. He first refused to say where the money came from, then he said his father had sold a picture at Galerie Kornfeld in Berne, and that was the source of the money.[4] He told them he was temporarily living in the Munich apartment of his sister Benita. The customs officers let him continue his journey.

The amount he was carrying was within the legal limit but as Siegfried Klöble, the director of the Munich customs investigations office, put it, 'If someone has 9,000 euros on them, we assume that this person is

familiar with the legal limits for transferring money from Switzerland to Germany, and then, of course, we want to know why.'[5]

Cornelius piqued the interest of a Lindau customs officer, identified by *Die Zeit* newspaper only as H. He quickly found out that the elderly suspect was not registered as a Munich resident, though he had a German passport, and was not paying German taxes. He was, however, registered in Salzburg, Austria, as a resident of Carl Storch Strasse. The customs investigator began to wonder whether Cornelius had something to hide. He first suspected him of tax evasion, then discovered that Cornelius's father had sold artworks on behalf of the Nazis. He contacted the Magdeburg Coordination Centre for Lost Art and asked the German Culture Ministry for information about art seized from Jews by the Nazis. Appended was a list of art dealers involved in trading such art; Hildebrand Gurlitt's name featured on the list. The officer wondered whether Cornelius was frequently smuggling the proceeds of sales of immorally obtained art back to Germany.

Based on the findings of the customs officials, the Augsburg prosecutor, responsible for the region of Bavaria that encompasses Lindau, opened his investigation on 20 May 2011.[6] Reinhard Nemetz, an experienced investigator who had been in charge of the state prosecutor's office in Augsburg for fourteen years, had a reputation for being tough, thorough and driven. He had had his fair share of spectacular cases, including one inquiry into anonymous, illegal donations and secret accounts held by Helmut Kohl's Christian Democratic Union. (Nemetz had wanted to call Kohl – one of Germany's pre-eminent political figures – as a witness. His boss overruled him, saying it wasn't necessary.)

The investigators suspected, wrongly of course, that Cornelius was part of a shady mafia of dealers in stolen art. The investigation was widened from tax evasion to encompass embezzlement, on the basis that Hildebrand Gurlitt had lied about the provenance of the art to the Allies after the war, and closed-circuit television cameras were trained on Cornelius's Artur-Kutscher-Platz apartment in Munich to follow his movements. It is possible the prosecutor was watching when the auction

house Lempertz's representative called in September 2011 to collect Max Beckmann's *Lion Tamer*, which Cornelius had offered for sale. In this instance, Cornelius did the decent thing by reaching a settlement with the heir (see pages 153–54).

So when Nemetz ordered a search of the apartment, the investigators had little evidence against the elderly recluse. The official grounds for the raid were suspicion of value-added tax evasion. In such cases, it is usual for officials to seize documentation and computers, including bank statements, receipts, correspondence and business records. But what they found – much to their surprise – was an enormous stash of valuable art.

Cornelius was in his nightshirt when the customs officials and the team from the prosecutor's office, about thirty in all, broke the lock and battered down his door at 6 a.m. on 28 February 2012. He sat quietly in a corner, watching as the plain clothes officers packed up the art collection he had pledged to protect, the treasures he said meant more to him than anything else in his life.

Among the many who swarmed through his apartment was the art historian Vanessa Voigt, who had written about Hildebrand Gurlitt in her doctorate. The prosecutor had called her and asked her to look at the pictures. Cornelius, by now smartly dressed in a jacket and tie, had withdrawn to the darkened living room and was sitting in an armchair in the corner, pale and blotchy. Voigt went to introduce herself. 'He didn't take it on board at all,' she said. 'He wasn't communicating, he was in his own world.' Cornelius became confused and upset, pacing restlessly around his apartment and muttering to himself repeatedly 'Now they are taking everything from me.' She tried to calm him.[7]

The artworks were mostly stored in a small second bedroom that served as a depot. Together with her colleague Andrea Bambi, the provenance researcher for the Bavarian State Painting Collections, Voigt examined the artworks in the rack behind a sliding door and the stacks of graphic works in the drawers of a steel cabinet. Both art historians were reluctant to touch the art and anxious that restorers should attend to

the collection first as they didn't know whether the climatic conditions in the apartment were appropriate. The investigators showed no such qualms, and held up paintings to speculate inexpertly on whether they were by Renoir or Picasso.[8] Voigt spotted the Max Liebermann painting *Two Riders on the Beach* and realized the quality of the collection. She quickly saw that many of the graphic works were 'degenerate art' and surmised that Hildebrand Gurlitt had probably acquired them from the depots at Schönhausen Palace and in the Köpenicker Strasse. Her impression was that the investigators were completely overwhelmed by their find.

Voigt tried to tell them it was not all stolen art, and that even if some of it was looted, there were no legal grounds for taking it all away. The law-enforcers' argument for seizing it was that, if they did not, Cornelius might try to sell or hide it. She told the investigators that it was top priority to store the art somewhere climate-controlled and to let restorers work on it. After her visit to the apartment, she received a few calls from customs officials and the state prosecutor seeking information, but everything was top secret, and despite her expertise as a provenance researcher and her knowledge of Hildebrand Gurlitt, she wasn't invited to examine the artworks more closely.[9] Cornelius's treasures were taken to a secret location – a major storage facility for fine art near Munich – where they still are at the time of writing.

Left alone in his bare apartment with the lock broken, Cornelius didn't understand why the authorities couldn't have waited for his death to take his pictures away. It was, he said, the worst experience of his life. 'I have never committed a crime,' he said in his interview with *Der Spiegel*. 'If I were guilty, they would have put me in prison.' All he wanted was his pictures back.

Yet to his horror, the authorities sent a psychotherapist to speak to him. Though Cornelius of all people could have used some therapy, he described this visit by a strange woman wanting to talk to him about his innermost feelings as 'dreadful' and 'terrible'. He told her he had no suicidal thoughts and asked her to leave.[10]

Nemetz informed officials in the Finance Ministry and the Culture Ministry about his find in March 2012, shortly after the apartment raid. One Finance Ministry official, speaking on condition of anonymity, said he had not considered it his role to interfere in a criminal case and that the prosecutor gave no details about the size or the content of the collection. The government officials made aware of Cornelius's trove saw their contribution as limited to answering Nemetz's questions about the legal situation, providing assistance and suggesting who could help with research. The relevant ministers were evidently not even informed.

By summer of 2013, the campaign for the September national election was in full swing and anything unrelated to votes was relegated to low priority. Culture Minister Bernd Neumann fell ill and was hospitalized shortly after the election. He never returned to his post. The temporary vacuum at the top of the ministry may have contributed to the political inaction: Neumann, a seasoned minister who had on several occasions secured increases in public spending on provenance research and understood international sensibilities about Nazi-looted art, would have probably grasped the significance of the Gurlitt trove and recognized its political implications in a way that the civil servants who were in the know clearly didn't.

In his absence, no one in government took responsibility. The image that springs to mind is of harried civil servants treating the case documents like a hot potato to be quickly offloaded onto someone else's desk. As long as the investigation was secret, no one saw the need to take charge. As soon as the public learned about Cornelius's trove, the government had to step in, but in March 2012 that was still a way off.

At the prosecutor's request, the Culture Ministry appointed two art historians to examine the hoard – Meike Hoffmann, coordinator of the 'Degenerate Art' research unit at the Free University of Berlin, and an unidentified employee of the Magdeburg Coordination Centre for Lost Art. A third art historian who had worked with the Magdeburg office, Sibylle Ehringhaus, was invited to join them for a two-day initial examination of the trove. In September 2012, they congregated at the secret

storage facility, a nondescript, above-ground, well-lit, climate-controlled warehouse outside Munich.

In two days, the three art historians looked at each of the works in the hoard and compiled a list. 'We didn't have much time,' explained Ehringhaus, whose expertise is in 19th-century art, although it was long enough for her to form an opinion about the quality of the collection: 'You could see that this was the legacy of a family of art historians, collectors and dealers with a fine eye for art.'

As well as the big-ticket items by the attention-grabbing names, there were wonderful Japanese woodcarvings, Dutch Old Masters and fat folders containing series of graphics by Expressionist artists. Yet like Voigt, Ehringhaus felt uneasy about examining the hoard without Cornelius Gurlitt's permission, and doubted whether the prosecutor's seizure of it was justified: 'It was Gurlitt's private property. I didn't have a commission from him to investigate it.'[11]

Hoffmann, bespectacled and serious with an auburn fringe and bun, was appointed to carry out a more detailed survey of Gurlitt's collection. She is a leading expert in the field of 'degenerate art' and she and her colleagues at the Free University of Berlin have compiled a database that lists the approximately 21,000 artworks the Nazis seized from German museums, of which about 12,000 are searchable online.[12] Her task was first to examine the four hundred 'degenerate' artworks found in the apartment and give an initial assessment of the collection.

An unidentified expert connected to the Magdeburg Coordination Centre for Lost Art was assigned to compare the remaining works against the office's own database. This is a basic first step in provenance research, but it is nowhere near the depth of investigation needed to determine with any degree of certainty which works were looted by the Nazis.

Hoffmann earned her doctorate with a dissertation about the Brücke artists, whom Hildebrand knew personally and whose work he collected with passion and discernment. She was struck by the radiance of the watercolours, maintained because the artworks had been protected in drawers in a cabinet. There were vibrant works by Ernst Ludwig

Kirchner, Erich Heckel, Max Pechstein and Karl Schmidt-Rottluff, and by Otto Müller, whose watercolours are rare to find in museums. 'The sheer number and quality of the works was astonishing. Looking at one exquisite watercolour after the next was overwhelming, the colours were so fresh. Watercolours that have been hanging in museums since the war have since long lost that radiance. Today, museums have the correct light conditions to preserve the colours, but they didn't in the 1960s and 1970s.'[13]

Her first step was to compare the 'degenerate' artworks found in Cornelius Gurlitt's apartment against the Free University's database and to examine the backs of the pictures for evidence that they had been seized from museums. She worked with photographs and notes provided by customs. This was a painstaking process: Hildebrand Gurlitt had been careful to erase or scratch out the stamps and inventory numbers from many of the artworks, presumably, Hoffmann thought, because he was planning to sell them and wanted to avoid questions about their origins. Some stamps were just partially erased, and by examining their shape and size, the museums from which the artworks had been seized could be identified. Others had stickers bearing inventory numbers that could be compared with Nazi lists of works confiscated from museums. In cases where all traces were erased, Hoffmann had to delve into archives and deepen her investigation to identify the works. For her, this work was rewarding and revealing: 'To know that these artworks were not destroyed or lost forever was wonderful. I am a specialist in graphic art and to suddenly rediscover all these missing works was amazing.'[14]

Hoffmann juggled this vast secret research project with her regular teaching duties for a year and delivered her report on the 'degenerate art' in Gurlitt's trove in March 2013. Nemetz then asked her to examine the rest of the modern art in the collection. Given the need for quick results, she conducted what she called a superficial examination by selecting individual works to investigate more closely. One of her first targets was Matisse's *Seated Woman*, which she identified in an online inventory of the treasures seized from French Jews by the *Einsatzstab Reichsleiter Rosenberg*

(ERR),[15] the Nazi unit responsible for the plunder of cultural objects from occupied territories during World War II. She began to contact relevant archives and completed her interim report in August 2013.

Perhaps it's unrealistic to expect investigators in a tax case to grasp the art-historical implications of their find, or to understand the complexity of provenance research. The prosecutor was, it seems, out of his depth in these unfamiliar waters and the investigation was half-hearted. As one government official put it, the whole criminal investigation was 'terribly amateur'. Yet Nemetz's team didn't have the resources for thorough provenance research, and no one in government stepped into the breach to organize and fund it. Responsibility for the case fell down a crack between the prosecutor's office, which was not equipped with the funding or know-how to handle it, and the government, which failed to seize the reins.

Once the seizure was a fait accompli, the provenance research was understaffed and under-resourced. Hoffmann was under no illusions that the initial steps taken were adequate. Although there were plans to assemble a team of provenance researchers to investigate the trove at a later stage, the prosecutor's concerns about confidentiality meant Hoffmann worked for months alone and in secret.

For the heirs of those collectors whose stolen artworks surfaced in Gurlitt's apartment after more than seventy years, it was hard to understand why no attempt was made to contact them. Nemetz justified the secrecy in a later television interview: 'We had to follow legal protocol regardless of historical responsibilities.' He also pointed out that the authorities had no way of finding out quickly how many of the artworks found in Cornelius's home were looted. 'We had to presume that among the things we were taking were objects that undoubtedly belonged to him. That made it our duty, given the presumption of innocence, to immediately ascertain which works were known not to be suspect and what had to be returned to him.'[16]

The prosecutor first offered to return works he deemed to be unequivocally Cornelius's property – because they either were produced by

members of his family or dated from after the war – in January 2013. Yet Cornelius postponed the date, then ignored at least ten more attempts to reach him by telephone or letter. He told *Der Spiegel* he didn't know which artworks the prosecutor wanted to return and said he didn't trust the letter.

The investigation into Cornelius's tax affairs dragged on inconclusively. After questioning him, customs officials learned he had been paying taxes in Austria. A year and a half after the raid on his apartment and seizure of his collection, they still had no evidence that he had evaded any taxes. Yet he would never get his artworks back. Some speculated that the prosecutor kept hold of the artworks hoping that the problem would resolve itself through Cornelius's death.

Cornelius made it easy for the prosecutor's investigation to continue without scrutiny. All this time, during the extensive probe with its numerous omissions and mistaken priorities, he neglected to get a lawyer. The justice officials involved in the case could have appointed one for him, but they chose not to. The only pressure he exerted was to write letters asking politely for his collection back. He was suffering serious heart problems. His sister – the only person he had been close to – had died after a battle with cancer in 2012.

While Nemetz was carrying out his investigation, Markus Krischer and his colleague Thomas Röll at *Focus* magazine were conducting their own. For a year they had been researching the Gurlitt case. It had taken a while to identify the subject of the investigation. When they had found Cornelius's address, they sent him repeated requests for an interview – all of them ignored. The prosecutor also rebuffed about twenty requests for a statement and said their story was completely false and he would deny it. By November 2013 they had got as much reporting together as was possible and decided it was time to publish.

'We knew it was a big story,' Krischer later said. 'We did not anticipate the scale of the worldwide interest.'[17]

10 The World Gasps

'NAZI TREASURE' thundered the title on the cover of *Focus* magazine the week of 4 November 2013. 'SENSATIONAL FIND AFTER 70 YEARS'. The scoop inside related how works by Picasso, Matisse, Chagall, Klee and more worth 1 billion euros – now considered to be an overestimate – had been uncovered in a Munich apartment, alongside a hoard of food in packets and cans, some of them decades out of date. The secret Cornelius had been guarding for sixty years was finally out in the open, probably leaked by an unidentified whistle-blower at the customs office.

Uproar followed. Cornelius's Munich apartment block was besieged by journalists. Reporters also staked out his neglected Salzburg house with its boarded up windows and overgrown garden. Newspapers from the *New York Times* to the *Sydney Morning Herald* and broadcasters from Russia to Argentina carried the story. The interest was truly international – and so too was the sense of outrage. Who was this strange hermit who had hoarded looted art in his home for decades? And how could the German government and the Augsburg prosecutor have sat on his trove for a year and a half without telling the heirs of those robbed by the Nazis? Details emerged about Cornelius's father – was he implicated in the mass looting of France by the Nazis?

Much of the outcry focused on the German authorities' failure to inform the public of their astonishing find. Julius Berman, the chairman of the Conference on Jewish Material Claims Against Germany (Jewish Claims Conference), remonstrated from New York: 'Had this discovery been made public at the time it was made, families looking for their lost art would have been able to potentially identify works within the collection. With the time that has been lost, every possible effort must now be made to determine the original owners of these artworks.'[1]

Some of the news coverage was salacious and colourful. Cornelius's second cousin Ekkeheart Gurlitt, a Barcelona-based photographer specializing in postcards and nudity, suggested that the elderly recluse had inside information about the whereabouts of the legendary Amber Room, stolen by the Nazis from the Catherine Palace near St Petersburg.[2] Known by some as the Eighth Wonder of the World, it has been missing since 1945 and has become an inexhaustible source of conjecture for conspiracy theorists and treasure seekers. It is not clear that Ekkeheart ever met Cornelius; if he had, it was decades earlier and he barely knew him. Cornelius had maintained his distance from all his relatives apart from his sister.

Prosecutor Reinhard Nemetz, who had wanted to keep his tax investigation into Cornelius Gurlitt out of the public domain, was forced to call a hasty press conference two days after the *Focus* report was published. Meike Hoffmann projected grainy images onto a screen. There they were: Liebermann's *Two Riders on the Beach* stolen from David Friedman's villa; Matisse's *Seated Woman* looted from the Rosenbergs' vault; and the Spitzweg drawing seized from Henri Hinrichsen.

Nemetz told the press conference that he wouldn't publish a list of the works in the Gurlitt collection, and that his preference would be for families missing art to contact him. He apparently did not appreciate how many heirs were still seeking thousands of artworks looted by the Nazis, and how unrealistic it would be for his office to handle enquiries from each one.

Heirs' representatives clamoured for an inventory of Cornelius's trove to be published online. 'How are we supposed to know if pictures belonging to our clients are among them if they don't publish a list?' asked one bewildered lawyer who represents the Argentinian heirs of a collector killed at Auschwitz.

This was exactly the kind of international attention that Germany is anxious to avoid. Successive governments have devoted considerable energy and funds to remembering, documenting and educating children about the crimes of the Nazis and to honouring the victims. Holocaust

memorials, documentation centres and museums have proliferated in the years since the reunification of Germany in 1990. There is even a word for this work: '*Aufarbeitung*', untranslatable in one English word, refers to the task of coming to terms with the crimes of the Nazis by working to expose and chronicle them and to keep the memory of the victims alive.

For Germany, being a respected member of the global community depends on acknowledging responsibility for the genocide of the Jews and for World War II. It is a burden that successive generations of politicians have inherited, and, particularly since the 1990s, they have shouldered it conscientiously and courageously – even as the last generation old enough to take an active part in those crimes is dying out. As one of the world's biggest exporters, Germany has reaped the benefits, its hard-won place at the top table of nations secure. It is a trusted partner of its erstwhile enemies and Israel. In the European debt crisis that erupted in 2009 and threatened to destabilize the eurozone, Germany emerged as the leader, the only country capable of holding the currency union together.

And now the World Jewish Congress was accusing Germany of irresponsibility and negligence. A diplomatic debacle loomed. As German embassies around the world frantically sought guidance from the Foreign Office on how they should handle the flood of press enquiries, Foreign Minister Guido Westerwelle warned against underestimating the sensitivity of the subject: 'We have to be careful that we don't squander the trust that has built up over long decades. What is most required from us now is transparency.'[3]

Stuart Eizenstat, a former Deputy Secretary of the Treasury and US Ambassador to the European Union, joined forces with the State Department to lodge a '*démarche*', an official complaint, to the German government. They demanded that Cornelius's seized collection be made public and its provenance examined.[4]

Even Chancellor Angela Merkel got involved, asking officials how they planned to respond to the uproar. Bavarian Justice Minister Winfried

Bausback called a hurried crisis meeting on 8 November with represent-atives of the federal government. The criminal investigators could not be expected to handle all the issues raised by Cornelius's treasure alone.

Ingeborg Berggreen-Merkel, a former deputy culture minister, was on the Berlin S-bahn commuter train on her way to Ikea to buy a 'Billy' bookshelf when she received a call on her mobile phone that would put an abrupt end to her peaceful retirement from a long career in public service. The call was from Günter Winands, the civil servant deputizing for Culture Minister Bernd Neumann, who was still unwell.

Winands asked her to lead a 'task force' to investigate Gurlitt's col-lection.[5] Tall, angular and dressed with impeccable understated elegance, steely hair drawn back in a severe bun, Berggreen-Merkel is a com-manding presence. Though she grew up in Bavaria, her upright bearing and acute sense of public duty call Prussian stereotypes to mind. She accepted straight away and acquired a team of fourteen experts in prov-enance research.

The 'Schwabing Art Trove' Task Force promised to be 'as quick and as transparent as possible' in establishing the ownership history of Cornelius's artworks, 'in awareness of Germany's responsibility for the *Aufarbeitung* of Nazi crimes'.[6] The Jewish Claims Conference, the organ-ization that negotiates compensation payments for Holocaust survivors and victims of Nazi persecution and administers the funds, insisted that it should play a role in any such investigation. It appointed two research-ers to the task force – Agnes Peresztegi, the European director of Ronald Lauder's Commission for Art Recovery and a lawyer specializing in res-titution, and Sophie Lillie, an experienced provenance researcher and the author of a book about Vienna's lost Jewish collections.

On 11 November, the task force pledged to publish the works of art that it could not rule out as Nazi loot on the government website lostart.de. Twenty-five were posted that day, and the site duly crashed as journalists, heirs and their representatives scrambled to view them.

Of the 1,280 works seized in Munich, about 590 were deemed pos-sibly looted (this figure has since been reduced to 500). Another 380 or

so were thought to have been seized from German museums in the Nazi 'degenerate art' campaign. Around three hundred works, the task force said, were unequivocally Cornelius's property: either they were produced by members of his family or they dated from after the war.

Nemetz said he wanted to return those three hundred artworks to Cornelius as soon as possible, although he had so far failed to make contact with him to arrange it. Ronald Lauder, founder of the Commission for Art Recovery in 1997 and president of the World Jewish Congress since 2007, objected: 'The conduct of the Augsburg prosecutor has been less than exemplary. After keeping the find secret for nearly two years it now appears that he wants to rid himself of a problem that he has been unable to handle properly for a long time.'7

Cornelius's brother-in-law Nikolaus Frässle, meanwhile, had contacted the police in his home town of Kornwestheim informing them about his own collection of twenty-two valuable artworks – presumably also part of Hildebrand Gurlitt's legacy – and requested their assistance. The police arrived and took the paintings away with his consent. In February 2015, eighteen of the artworks were still in Magdeburg, where government provenance researchers were investigating them at Frässle's request. Four medieval paintings had belonged to Cornelius Gurlitt and were added to his estate.

Through all this confusion, Cornelius himself remained holed up in his darkened Munich apartment. He had written on his typewriter to *Der Spiegel* magazine, confusing it with *Focus*, with customary old-world politeness: 'I heard on a Bavarian Radio programme that your magazine, which is very highly regarded in Germany because of its especially intelligent and high-minded character, has published an article in which the name Gurlitt appears in print. May I please request you not to let this name appear in future in your very highly esteemed publication.' He signed off with friendly greetings.

Cornelius had already ignored at least ten attempts by the prosecutor's office to reach him and Nemetz had told journalists he did not know where the subject of his investigation was and that he had not been

in touch for months. Cornelius tried to shut out the commotion outside his apartment, ignoring the phone calls, his overflowing mail box, the rings and knocks on the door and the notes pushed through it. He even posted a sad little pleading post-it note on his door: 'Please give me peace and quiet. I suffer from serious heart disease and have trouble walking. A written statement will follow later. Thank you.'

Two French journalists, Denis Trierweiler and David Le Bailly entered his building and took the elevator to the fifth floor just as Cornelius was leaving his apartment with a shopping bag on wheels and his walking stick. He descended in a second lift at the back of the building that had escaped the notice of the press, and got into a taxi. Trierweiler and Le Bailly followed him to his local department store, observing as he selected groceries in Karstadt. Every tin of soup had to be carefully examined and the serving suggestions studied, then followed a few minutes of deliberation before he put it in his shopping trolley. Cornelius took an hour and a half to buy two bottles of Fanta, a few cans of soup, some batteries, fruit and bread. Trierweiler addressed him by name to check that they had correctly identified him and asked whether he would be willing to talk to the two journalists. Cornelius shied away in fear and delivered one of the cryptic idioms that he reserved for unsolicited approaches from strangers: 'Applause from the wrong people is the worst thing in the world.'[8]

Their pictures were the first paparazzi snaps of Cornelius. He appeared in the French news magazine *Paris Match*, a white-haired man looking suspiciously in the direction of the camera as he pushed his trolley in a heavy woollen overcoat several sizes too big.

Then on 18 November, *Der Spiegel* magazine published an interview with Cornelius Gurlitt. Reporter Özlem Gezer waylaid him in the lift when he was on his way to a doctor's appointment in Würzburg, and persuaded him to let her spend three days with him. Her interview, promoted on the cover under the title 'Conversations with a Phantom', revealed his loneliness, his sense of bereavement at the loss of his pictures, his bewilderment at being treated like a criminal by law enforcers

and perplexity at the fuss outside his front door every day. 'I'm not Boris Becker, what do these people want from me?' he asked Gezer. 'I am very quiet. Why are they photographing me for the newspapers like some shady celebrity?' He had not even by this stage appointed a lawyer: 'I've never needed one before.' It is a measure of his unworldliness that he didn't appear to grasp how badly he needed one now.

The interview in Germany's most prestigious weekly magazine sparked sympathy for this out-of-touch, forlorn old man who felt hunted in his own home, the little sleep he could snatch haunted by nightmares. Gezer captured a few seconds of Cornelius speaking on film, perhaps the only person to have ever done so. His papery skin and thinning white hair, the quavery, frail voice and his air of vulnerability as he peered in disbelief and horror into a newspaper that had published photos of his pictures were heartbreaking. Overnight, the public perception of Cornelius transformed. He became a tragic figure instead of a shady one. The debate began to shift. After all, he was not a thief. He may have inherited artworks from someone who acquired them from thieves; that can hardly be classified as a criminal offence.

Had Nemetz overstepped his mandate by seizing Cornelius's collection as part of a routine tax investigation? The general consensus among lawyers is that given the level of gravity of the offences of which Cornelius was suspected, the confiscation of his entire collection was completely disproportionate. After all, the suspicion of evading value-added tax on sales of art could only possibly relate to works he had already sold and no longer had in his possession. If they had seen a need to document the artworks he still had, investigators could have simply taken photographs.

The cumbersomely named German justice minister, Sabine Leutheusser-Schnarrenberger, said she was mystified by the path the Augsburg prosecutor's investigation had taken and suggested it was seriously flawed.[9] Her doubts were endorsed in a chorus of disapproval from German lawyers, including Hannes Hartung of Themis in Munich. Hartung, a specialist in art law, told Bavarian radio that he could see no

legal basis for a seizure and that the artworks not suspected of being Nazi loot should have been returned to Cornelius long ago.

Tido Park, who runs a law firm in Dortmund, pointed out that any charges against Cornelius relating to the pictures would have been time-barred decades ago. He, too, argued that their confiscation was illegal. 'Under the Nazis, we Germans experienced how people were expropriated under the pretence of an apparently legal process,' he said in an interview with *Der Spiegel* on 2 December 2013. 'We should have learned by now that in criminal procedures in a constitutional democracy, the rule of law cannot take second place to morality.'

Yet from a moral perspective, was it really possible to just return artworks potentially looted by the Nazis to this elderly hoarder? The prosecutor was clearly in a bind.

The Munich general prosecutor Christoph Strötz, Reinhard Nemetz's boss, invited lawyers, investigators and civil servants from five authorities to a crisis meeting at his office on 9 December with the aim of averting a catastrophe looming for the Bavarian justice system and addressing the questions swirling around the investigation into Cornelius Gurlitt. Could Nemetz justify holding on to 1,280 artworks for 20 months without having definitively identified a single one as illegally in Cornelius's possession? And what of the tax investigation? Law enforcers had found no evidence Cornelius had violated any tax laws.

Strötz's response was to beef up the investigation by adding manpower and to begin digging out information on Cornelius's art sales to expose possible value-added tax evasion.[10] Nemetz countered accusations that he had acted disproportionately by pointing out that if Hildebrand had purchased art from Jews who were selling under duress, this was an immoral transaction, and therefore legally invalid.[11]

In a Bavarian regional parliament committee meeting, Bausback conceded that mistakes had been made. More provenance researchers should have been assigned at an earlier stage. The research had taken too long. He had himself only found out about Cornelius's trove through the media reports. He defended the prosecutor's decision to keep the find

under wraps for a year and a half, pointing out that this was a criminal investigation and no charges had been pressed, so the individual concerned should be presumed innocent and his privacy protected. The opposition fired back: 'A major fiasco for Bavaria,' said Isabell Zacharias of the Social Democrats.

Bausback also raised questions about the legal situation for heirs and what it says about the national will to confront the crimes of the past. Previously obscure, complex aspects of German civil law relating to statutes of limitations, theft and legal title were subjected to meticulous media scrutiny. Many readers were alarmed to discover that the law protects the owners of Nazi-looted artworks through a thirty-year time-bar on recovering stolen movable goods. If Cornelius had chosen not to negotiate with the heirs, they would have had little legal recourse to force him to relinquish his treasures.

Bausback promised that Bavaria would propose a change to German law to lift the statutes of limitations in cases of Nazi-looted art. 'We cannot and should not allow beneficiaries of the Nazi regime to use the statutes of limitations as a defence against the Jewish owners,' he told the legal committee of the Bavarian parliament. 'Through this defence, they are robbed of their property forever.'[12]

Yet any change in the law would take years and come too late for those trying to recover art from Cornelius's hoard. Separately from the legal steps, Bavaria and the federal government began seeking an agreement with Cornelius on the restitution to families of stolen works in his collection. Once again, they couldn't make contact with him.

In December 2013, a neighbour of Cornelius reported to the local newspaper that a police van, fire engine and ambulance were stationed outside his apartment building with blue lights flashing. The Munich police confirmed that fire officers had broken into Cornelius's Schwabing apartment after a family member had raised concerns about his health and said he wasn't answering the telephone. He had uncharacteristically missed a doctor's appointment. The police found him at home, unwell but alive and deliberately ignoring knocks on the door and the ring of the phone.

Cornelius's brother-in-law Nikolaus Frässle, the widowed husband of Benita, had raised the alarm. Frässle was not close to Cornelius as they had only met a handful of times. Acting mainly out of a sense of duty to the wife he had recently lost to cancer, Frässle found Cornelius a place in a clinic near his home in Ludwigsburg, close to Stuttgart. Breathless and underweight, Cornelius by now urgently needed hospital treatment.

His ill health gave a local court in Munich the opportunity to act. Two days before Christmas, it appointed Christoph Edel, a lawyer specializing in taxes, as Cornelius's custodian to take care of his administrative affairs for the next six months. This is a step German courts sometimes take in cases where a person is no longer able to handle bureaucratic tasks because of old age or illness. The custodian can take financial and legal decisions on behalf of his or her ward and often negotiates contracts on care and accommodation for the elderly.

It's easy to understand why the old and infirm trust Edel with their affairs. Tall and sturdy with a steady gaze, he has a modest, calm manner and exudes dependability. He felt honoured that the court chose him for such a complicated and unusual assignment. He at first underestimated the media interest, and was taken aback by some of the other queries that reached his office – for instance, the phone calls from art dealers and private collectors offering to buy Cornelius's pictures in secret deals.

Edel's first meeting with his ward – whom he found almost childlike in his naivety – was on 27 December 2013. They discussed Cornelius's treatment and the criminal investigation, and Edel assured Cornelius that his primary goal was to ensure the artworks were returned to him. By then in hospital, Cornelius's most pressing desire was to return home to his Schwabing apartment in Munich. He was less than thrilled at the prospect of an outsider interfering in his life and was initially distant and formal. Although he gave Edel the key to his apartment at that first meeting, trust took time to develop.

Cornelius was mistrustful of almost everyone, suspecting people of being part of an elaborate Nazi plot to steal his art collection. In consultations with the psychiatrist Hermann Ebel in Ludwigsburg, he suggested

that the events of the past months – the seizure of his collection, the tax investigation, the appointment of his guardian and his move into hospital – were the fruit of the machinations of a sinister Nazi network. He reminded Ebel that Heinrich Himmler's daughter still lived in Munich. He also accused staff at the clinic of having robbed him of 7,000 euros. He forgot that he had hidden the money in a tissue box, where it was later found.[13]

He underwent a heart bypass operation at the end of January 2014. In February, he was fitted with a pacemaker. Weighing less than 60 kilos, he was often out of breath and needed regular doses of oxygen. Conversations lasting an hour generally exhausted him. Yet he mostly remained courteous, friendly and formal, and even from his sickbed would try to get up to greet visitors. Sometimes he was fit enough to have longer conversations, and his sense of humour, sharp wit and extensive cultural knowledge emerged: Cornelius was a lover of the philosophical writings of Schopenhauer and Hegel as well as of Wagner's music.

He could be imperious, as Edel later recalled: 'On occasion he managed to spur the staff of an entire cardiologic intensive-care ward into action by insisting that he had to make an important phone call immediately.'[14] Mostly, though, Cornelius read books and listened to his beloved CDs. He found the broadsheet *Süddeutsche Zeitung* too demanding, preferring to flick through the tabloid *Abendzeitung*.

Edel appointed three lawyers to handle Cornelius's increasingly complex affairs – Hannes Hartung, Tido Park and Derek Setz, a specialist in criminal law based in Munich. He also enrolled the jovial, sharp-witted 'executive reputation manager' Stephan Holzinger as a spokesman to handle a constant stream of media enquiries. Cornelius was not an executive but his reputation definitely needed managing.

One of the lawyers' first actions was to file suit on 30 January 2014 against unidentified officials who had revealed details of the investigation to journalists, including handing to *Focus* magazine photographs of Cornelius's apartment taken during the search. 'An outrageous violation of official secrecy rules,' Park said.

A month later, they filed suit against the Augsburg prosecutor for seizing the collection on the basis of inadequate evidence that Cornelius had contravened tax laws. They pointed out that even if there were grounds for suspicion, the seizure of the entire collection was disproportionate to the scale of any potential tax evasion.[15]

The action in February shifted to Carl Storch Strasse, a quiet street in an upmarket residential district of Salzburg, away from the bustle and jostle of the tourist-jammed arcades and cobbled alleys of the quaint old town centre. In the sedate suburb of Aigen, such luminaries as the famous German ex-footballer Franz Beckenbauer maintained homes.

It was here that Cornelius had found the solitude he craved for many decades, yet his health had prevented him from returning to this home for several years. The shabby, 1960s-built, two-storey detached house stood out in this manicured environment, alongside the grand villas with sophisticated security systems.

It was neglected, the kind of place children imagine is haunted, with its moss-covered roof, wild, overgrown garden, cracks in the walls and cobwebs over the front door. Its once-white walls were a grimy grey. Rusty latticed bars covered the windows, which were boarded up to shield the interior from prying eyes. Cornelius had even suspended a piece of wood from the ceiling in front of the letter box to thwart anyone who might have been tempted to peer through.

The residents of the street hadn't seen its owner for months. Over the years, he had become the subject of much speculation and rumour. Some were growing vexed at the 'spooky ruin in the middle of this nice area', as Helmut Ludescher, Cornelius's neighbour of fifty years, described the house. Local children were afraid to go and pick up their toys if they landed in his garden.[16]

The house harboured a secret. Not a corpse, as many of the neighbours suspected, but another astonishing cache of art including works by such masters as Monet, Renoir, Gauguin, Liebermann, Toulouse-Lautrec, Courbet, Cézanne, Munch and Manet. They were gathering mildew, dust and cobwebs. Cornelius had told Edel about his second

trove, but insisted he would attend to it himself when he was feeling better.

Events forced faster action. Neighbours had complained to local authorities about structural damage to the house, particularly a large crack in the garage wall. The Salzburg construction authorities wrote to Cornelius demanding access to the entire premises on 17 February for inspection by a team including fire service officials and construction police.

This was the opportunity Edel needed to persuade Cornelius to let him move the paintings out of the abandoned house, where they were at risk from burglars. It was a task the elderly invalid was in no shape to deal with himself, either physically or mentally, nor had he been for many years, as Edel was to find out. Cornelius gave him permission to remove the artworks from the house but asked him not to take the rubbish out as he would deal with that himself when he was fitter.

On a misty, icy Monday in February 2014, Edel, Holzinger, Hartung and an art appraiser from an insurance company parked their cars a little way away and made their way to the house separately on foot, hoping to avoid drawing attention to their operation. After their arrival, two lorries with German number plates parked in the street. The full team included two art restorers and removal men.

They were unprepared for what awaited them. The first challenge was to open the front door. Mountains of rotting refuse in plastic bags barred the way. They pushed it open inch by inch, dislodging the rubbish little by little to create a wide enough space to enter. Once in the hallway, they found the strange contraption Cornelius had built to block the view through the letter box. He had fixed a post to the ceiling and using hooks and string, attached a large piece of plywood that dangled down in front of the door.

Inside the house they were waist-deep in piles of decaying refuse overflowing from plastic carrier bags. The stench was overpowering. Bags of rubbish blocked the stairs and filled every room, interspersed with heaps of books and newspapers. Among the debris lay the precious masterpieces, some of them deliberately hidden. Wading through

the trash was treacherous – it would have been so easy to inadvertently tread on a painting and cause damage worth millions. Locating the artworks scattered all over the house and separating them from the waste was going to be a delicate, risky, dirty and time-consuming business. The task was made even more complicated by Cornelius's express wish that the rubbish should not be removed, only the artworks.

But the men knew that their window to work in peace was limited. Holzinger kept watch in front of the house, trying to keep warm in leather city shoes unsuited to temperatures just a little above zero. He realized it was only a matter of time before the media would cotton on to the activity in the abandoned home. As he was wearing a suit and tie and didn't want to have to face reporters covered in filth, he could not in any case be of much help inside. A neighbour approached him offering to buy the house. He persuaded her to move on.

The first artwork the team discovered was hanging on a wall downstairs, a large-format Gustave Courbet oil portrait of an imposing bearded shepherd striding through a landscape holding a staff and a wide-brimmed hat. Others were harder to locate.

Cornelius had set some old wooden boxes on their sides to serve as bookshelves for his collection of cheap, yellow-jacketed paperback classics produced by the publisher Reclam. Edel spotted what looked like a pile of newspapers behind the improvised shelves. He delved into it and extricated an oil seascape: two sailing boats against a moody grey sky in an extravagant gilded frame. He looked at the signature and showed it to the insurance art appraiser.

'Is this a Monet?' Edel asked.

'No,' the appraiser replied. 'It's a Manet.'

Edel rummaged further to see what else might be lurking behind the bookshelf under the crumpled newspapers. He retrieved an Impressionist view of Waterloo Bridge that was lying on the floor. It may have been painted on a grey and misty London day but it was hard to tell, it was so dusty.

'That's a Monet,' the appraiser said.

Perhaps Cornelius hesitated so long before letting Edel rescue the art because he was embarrassed about the state of the house. Old-fashioned, correct and fastidious as he was about his appearance, it seems contradictory that Cornelius would live in a giant rubbish tip. His reluctance to dispose of anything, even trash, may have been linked to the trauma of his art hoard. Fear of losing his father's treasured legacy dominated his life and overwhelmed his psyche. Edel believes the collection had been a major burden to Cornelius for many years, and he was simply unable to cope with the responsibility of his secret.

The curious neighbours asked Edel questions and construed an image of the scene of devastation the team had encountered inside the house based on the quantities of rubber gloves and surgical masks dumped in the dustbin. Their interest, though, was mostly directed at Cornelius's house. It is not often that a property in this desirable neighbourhood comes onto the market.

As Holzinger had feared, it proved impossible to keep their mission secret in provincial Salzburg. Neighbours alerted both the police and the local press. When the police arrived, Edel showed his identity card and proof that he was Cornelius's custodian and explained what they were doing. Holzinger had prepared a press release in case the media became aware of their mission. The following day, after receiving a call from the Austrian tabloid *Kronen Zeitung*, he sent it out.

Cornelius finally gave permission for Edel to remove the rubbish – a necessary task in order to salvage the rest of the artworks. The team returned later in February. They uncovered further masterpieces in parts of the house that they hadn't previously been able to access because of the mess.[17] A Courbet painting discovered in an upstairs room, a beautiful snowy scene of a forest with rows of cottages in the background, was badly damaged, the paint separating from the canvas and forming bubbles. At the bottom of one pile of old newspapers lurked an inconspicuous folder full of valuable drawings, some of them badly stained.

The final tally was more than 250 pieces, including 41 oil paintings, among them 8 by Cornelius's great-grandfather, the landscape painter

Louis Gurlitt. Many were coated in mould and dust. The artworks were to be stored 'in a safe place', a vault whose location Edel and Holzinger declined to reveal, and would be restored where necessary. The 'Schwabing Art Trove' Task Force would not have access to them. Instead, Cornelius would employ qualified international experts to investigate the provenance of the pictures and publish the results, so that potential claimants could come forward. An initial inspection lent no substance to suspicions that these works were looted, Cornelius's advisers said. It would later transpire that at least one of them was (see page 238).

Cornelius had at first refused to believe that his father could have acquired art stolen from Jews. The only way he could accept it was by acknowledging that Hildebrand may have been deceived. The recluse who had never used the internet had his own website and a professional team. Suddenly, from his hospital bed, Cornelius was leading the restitution debate and setting a moral benchmark.

'If there are grounds to suspect that artworks in the collection were looted, then please give them back to the Jewish owners,' was the message he gave to Edel on one of his visits. Talks were already underway with six claimants, including David Toren and the heirs of Paul Rosenberg, among them Anne Sinclair, a French television journalist. Sinclair is also the ex-wife of Dominique Strauss-Kahn, the former managing director of the International Monetary Fund.

Seizing the initiative and the moral high ground, Hannes Hartung shone an uncomfortable spotlight on other collectors and museums harbouring stolen art who were doing far less than Cornelius to restore it to the rightful owners. 'There are many public and private collections in Germany in which the proportion of potentially looted art is much higher than in the Gurlitt collection,' he said. 'For these collections and the responsible museum directors, however, there are no penalties at the moment.'[18] Hartung should know – he is the lawyer representing the city of Munich in its epic battle to keep Paul Klee's *Swamp Legend* in the Lenbachhaus museum, a painting the Nazis stole from Sophie Lissitzky-Küppers (see pages 164–65).

Cornelius also announced that he was ready to hand the first painting back; Matisse's *Seated Woman* would return to the heirs of Paul Rosenberg. The heirs had reached an unconditional agreement for its restitution. Their London-based lawyer Chris Marinello was on the point of leaving for Munich to sign it when it emerged that Hartung had been fired after disagreements with Holzinger and Edel.

His replacement was quickly announced: Louis-Gabriel Rönsberg, an art-law expert at the firm SLB Klöpper in Munich. The Rosenberg heirs were told it would take a couple of weeks before he would be ready to sign the agreement, but then the government task force contacted Marinello to tell him a second claim had been submitted for the painting, and more documentation was needed to prove the Rosenbergs' claim.

The second claimant was an American, Todd Warren Altschul, who sent poor-quality photocopies of two pictures in the Gurlitt collection: the Matisse and a Courbet painting called *Village Girl with Goat*. Accompanying them was a letter from Altschul claiming that the paintings belonged to his grandmother, Hilde Altschul of Waco, Texas, who left Germany in the 1930s and was prohibited by customs from taking the two paintings with her. He also sent a statement she allegedly made in 1994, naming him as her heir should the paintings ever surface.

A Google search on Todd Warren Altschul quickly revealed that he was sitting in prison in Texas and had been convicted for a variety of crimes. He was serving two sentences, one of which was an eighty-seven-month stint for mail fraud. The photocopies, supposedly of photographs taken before World War II, transpired to be doctored images downloaded from the internet. The task force informed Marinello that the second claim was fraudulent.

Even so, Berggreen-Merkel told Marinello at a meeting in Berlin that the task force needed a few more weeks to check the Rosenbergs' claim. One of Rosenberg's heirs is in her nineties, and her wait would turn out to be much longer than just a few weeks. Marinello called the task force's delay 'a tragedy of ineptitude'.

As the claims flooded in, the German government's response to repair its damaged image was to announce plans for a centrally managed and funded German Centre for Lost Cultural Property, based in Magdeburg with a branch in Berlin. Culture Minister Monika Grütters, appointed in December 2013 after the post had been vacant for months because of her predecessor's illness, promised the new foundation would be up and running within the year: 'Before the Gurlitt case and the national and international reaction it was clear that we have to boost our efforts in provenance research and restitution questions.'[19]

Grütters, who was at the negotiations for the Washington Principles in 1998 (see pages 205–6), conceded that Germany had responded 'too diffidently' in implementing them. She promised to significantly increase the current government funding for provenance research and to unite disparate entities dealing with Nazi-looted art under one roof. Government-funded provenance researchers would also be available for private collectors and independent museums.

Meanwhile, there was a flurry of behind-the-scenes diplomatic activity. Stuart Eizenstat held separate meetings with Berggreen-Merkel and Grütters. While Berggreen-Merkel, a lawyer, emphasized the need to protect Cornelius's privacy, Grütters impressed Eizenstat with her commitment to restitution. 'She is a breath of fresh air,' he said.[20]

Cornelius returned to his Munich apartment after a long spell in hospital on 31 March 2014. Frässle travelled back in the ambulance with him and stayed a few days. Two carers attended to him around the clock. Edel had arranged for the flat to get a much-needed renovation: Cornelius went home to new floors, new kitchen and bathroom fittings and a fresh coat of paint. He was pleased with it.

Days later, Berggreen-Merkel's efforts to reach an agreement with Cornelius finally bore fruit, when an accord with the state of Bavaria and the German government on the fate of the artworks seized in his apartment was announced. On Friday, 4 April 2014, Edel spent some time explaining the agreement to Cornelius, who found the five-page legal text challenging. He studied it over the weekend.

Under the terms of the accord, Cornelius agreed to allow the government task force to continue researching the provenance of his trove even after its release from police custody. The task force would keep hold of art that may have been looted until the end of 2014, in which time it would aim to wrap up its work and would return all the artworks to him.

Cornelius promised to grant the government researchers access to any works whose provenance was still not cleared up by then, and agreed that art believed to be stolen by the Nazis but which remained unclaimed should be published on the website lostart.de. He pledged to seek 'fair and just solutions according to the Washington Principles' in resolving claims, including restitution where appropriate. As stated in the agreement, all parties saw this contract as a way of 'addressing past Nazi crimes independently of the criminal proceedings, the privacy laws and the actual legal conditions'. Cornelius would have the right of access to view pictures 'that were particularly close to his heart' during the research period.[21]

'The entire world is watching to see how we will answer these questions, and this is a good answer,' Bausback announced. Cornelius, he said, 'accepts his moral responsibility, and I respect that'.[22] Ronald Lauder, at the World Jewish Congress, called the accord 'an important and hopeful precedent, one that we urge other private individuals to emulate'.[23]

Cornelius had set a moral benchmark that went far beyond the legal requirement for private individuals harbouring Nazi-looted art. It also exceeded the standards of many museums. In a matter of months, his position had turned around from defensive, secretive obstinacy to actively seeking justice for the victims of crimes committed by the Nazis in their campaign of racial persecution. The impact of public pressure cannot be overstated in the debate over Nazi-looted art.

Two days later, Nemetz agreed to return Cornelius's confiscated treasures to him. Though the prosecutor said he was 'absolutely convinced of the legitimacy of the measure at the time', information had since come to light that required him to re-evaluate the legal situation regarding the seizure, particularly in view of the legal complaint filed

against him by Cornelius's lawyers. The tax investigation into Cornelius was to continue, he said.[24]

Cornelius's last weeks at home were peaceful, spent with his books and CDs when his illness allowed. He seemed to lose interest in his art collection, indifferent by now as to whether it would be returned to him or not. A bald private detective engaged as his personal bodyguard made himself useful in Cornelius's apartment, for example putting green moth papers in the cupboard. Cornelius christened him 'the monk with the green notes'.[25]

Yet his heart surgery and the unwelcome attention of the last six months of his life were clearly more than he could physically cope with. He died at home on 6 May 2014. His doctor and a carer were present.

His funeral, on a beautiful sunny day in Düsseldorf, was a quiet affair with just a dozen people attending. Most of them had either never met Cornelius or only become acquainted with him in the past year. There were no old friends, no lovers, no close family. Among those present were his lawyers, Nikolaus Frässle and cousins Cornelius barely knew, Berggreen-Merkel of the 'Schwabing Art Trove' Task Force, the auctioneer Henrik Hanstein of Lempertz, and Matthias Frehner, the director of the Museum of Fine Arts (Kunstmuseum) in Berne.

Edel, the person who had spent most time with Cornelius as his custodian in the past months, gave a well-judged speech, quoting Schopenhauer: 'Even in the same environment, each of us inhabits a different world.' Cornelius had certainly lived in his own world.

He was buried alongside his mother and father in a family grave at Düsseldorf's Nordfriedhof cemetery. Cousin Ekkeheart, a self-declared 'ageing hippy', threw copies of Cornelius's pictures – including Max Liebermann's *Two Riders on the Beach* – into his open grave. Months later, sitting on a couch in a television studio sporting red glasses, an array of leather pendants, a glittery red scarf and a cap on his greying ponytail, Ekkeheart explained the gesture. 'Cornelius loved his pictures more than anything,' he said. 'I wanted them to accompany him on his journey to Nirvana.'[26]

11 Late Justice

The way people react on finding out that museums and private collectors around the world are still holding on to Nazi-looted art and refusing to speak to the heirs of the original owners varies enormously. Some wonder 'Why do the heirs still care after all these years?' Others exclaim 'That's scandalous! How can that be?!'

The first question is a more straightforward one to answer. Many of those who fled Germany during the Nazi era or survived the Holocaust lost everything – not just their material wealth, confiscated piece by piece in hundreds of racist rulings, but also their families, their professions, their earning ability, their homes, their cultural heritage and, most intangibly, their identities. Art, artefacts, musical instruments, books and furnishings are the only shreds of these lost lives that their descendants can still recover. Rarely, if ever, is their quest to recover such family treasures purely about money. Most heirs looking for lost art simply want to claw back a little piece of late justice and salvage a fragment of family identity.

Martha Hinrichsen is leading her family's effort to recover the Spitzweg drawing of a couple making music that Hildebrand Gurlitt bought from her grandfather three weeks before Henri Hinrichsen fled to Belgium, where he was later arrested and deported to Auschwitz (see pages 88–90). After the war, Helene Gurlitt had said it was burned in the Dresden fire when asked about its fate by the Hinrichsens' lawyer. The family believed her and stopped looking for it in the 1960s. In fact, it had hung in Helene's hallway, as Cornelius revealed in his interview with *Der Spiegel*. 'It gave me a chill when I read that,' Martha Hinrichsen said.

Hinrichsen knows the drawing isn't valuable; at current market prices, it would probably fetch at most about $10,000. Subtract the legal fees and divide the remainder among the forty-five heirs of the Hinrichsen

couple – grandchildren, great-grandchildren, great-great grandchildren and a charity foundation – and it starts to look barely worth the postage to Europe, let alone the trouble involved in filing a claim and providing evidence to the 'Schwabing Art Trove' Task Force.

Yet Hinrichsen has no doubt that her mission is worthwhile. Growing up in New York, Martha knew little about her family history and spoke no German. The Hinrichsens who survived the Holocaust were scattered around the world. Her father Walter Hinrichsen, the second son of Henri Hinrichsen, fled Germany in 1936, long before her birth. After serving in the US Army in Germany, he founded the New York branch of his father's music publishing company, where Martha also worked for almost three decades. She remembers another Spitzweg hanging over the piano when she was growing up, a dark painting of musicians performing by night called *The Serenade*.

'I would love to have the Spitzweg drawing for sentimental reasons,' she said. 'My father loved Spitzweg and that draws me to it. I would buy it if the other heirs agreed. It is about winning back a piece of family identity. For my grandfather it was a part of his home life, of what he loved, and it is really more about him than about the work of art. It cannot be returned to my grandfather and there is no justice for what he suffered in the Holocaust. This little piece of justice can be served to his heirs.'[1]

It is more than seventy-five years since Henri Hinrichsen lost his drawing. The Spitzweg was hidden away in a private collection, guarded jealously by Cornelius Gurlitt until 2012. But what of the art in public museums that remains unrestituted and still hangs on the walls or lurks in the depots? Why has it never been returned? The second question merits a longer response.

Plunder is nothing new, especially in times of war. The looting of the temple of Solomon by the Babylonians is described in the Old Testament. Napoleonic armies stripped treasures from collections across Europe. Yet the scale of the Nazis' looting was unprecedented – and much of it was directed against German citizens before war even broke out.

The Allies were aware of 'the systematic spoliation of occupied or controlled territory' and issued the London Declaration on 5 January 1943. This warned those who traded in the loot, particularly in neutral countries, that the Allies would regard such transactions as invalid after the war, including the purchases of items lost in forced sales. The plunder, it said, 'has taken every sort of form, from open looting to the most cunningly camouflaged financial penetration, and it has extended to every sort of property – from works of art to stocks of commodities, from bullion and banknotes to stocks and shares in business and financial undertakings'.[2]

The US government estimated that the Nazis looted about a quarter of Europe's wartime art stock – booty described by the US prosecutor at Nuremberg, Robert Storey, as exceeding the treasures of the Metropolitan Museum of Art in New York, the British Museum in London, the Paris Louvre and Moscow's Tretyakov Gallery combined.[3]

The Monuments Men handled fifty million artworks in fourteen hundred repositories after the war.[4] Small wonder, understaffed as they were, that they did not trace the owners of every piece of art looted from private Jewish collections – an estimated 600,000 paintings, but also sculpture, works on paper, furniture, porcelain, books, decorative arts, antiques and collectibles. Many of the collectors had been murdered. Most who survived had fled Germany and the countries it occupied, and were not always easy to track down. And much of the art had already been sold or squirrelled away in private collections, so it never came to their notice.

Allied troops returned art looted from the occupied countries that they had amassed at their collecting points to the relevant governments, expecting them to trace the owners and return it to them. France, for example, took back more than 60,000 objects, although it estimates roughly 100,000 were stolen. The French government returned about 45,000 pieces to their owners in the four years after the war. After 1954, there was no effort to trace the missing owners of the remaining items, and some 13,000 artworks for which no heirs had come forward were

sold at auction. The 2,000 works remaining were entrusted to French museums,[5] and it was only in 2013 that the French government said it would begin efforts to trace the owners.

In the Netherlands, some artworks were returned to the pre-war owners in the five years after the war, though responses to restitution claims in that era were 'legalistic, bureaucratic, cold and often even callous', according to a government-commissioned report in 2001.[6] Some unclaimed artworks sent back by the Allies were sold in the 1950s. The Dutch government still holds 3,800 looted artworks returned after the war. As in France, they are spread around the collections of the national museums.

Perhaps we will never find out who really owns the Cézanne self-portrait showing the balding, bearded artist in his painter's smock that hangs in the Musee d'Orsay in Paris. Or the Lucas Cranach painting, *Christ and the Adulteress*, that Hermann Voss purchased for Hitler's Führermuseum and now forms part of the Dutch national collection. It is possible that not only the owners, but also their entire families were killed in the Holocaust. But just maybe, someday, documents will surface – in a gallery's archive or a private attic – and the missing piece of a puzzle will finally allow the heirs to be traced and a decades-long mystery to be solved. Sometimes it takes a very long time for vital clues to come to light in the opaque world of art.

The artworks returned to governments by the Monuments Men are by no means the whole story. How many more dealers and collectors like Hildebrand Gurlitt hid paintings from the Allies or lied about their provenance in order to get them back? The historian Jonathan Petropoulos has written of a 'network, centered in Munich, of art dealers and experts who had once worked for the Nazis' and – largely unpunished for their role in the plunder of the Jews – continued to operate discreetly long after World War II.[7]

Many of those far more heavily implicated in Nazi looting than Hildebrand maintained key positions in the art scene after the war. Even Karl Haberstock, a Nazi Party member, rabid anti-Semite, close

adviser to Hitler and profiteer from the plunder of Paris Jews, managed to rehabilitate himself as a dealer in an elegant apartment overlooking the English Garden in Munich in the 1950s. His widow donated his collection, including paintings by Cranach, Van Dyck, Tiepolo and Veronese, to the city of Augsburg after her death in 1983. Haberstock was honoured by the mayor of Augsburg for his loyalty to his home town. It was only after Petropoulos criticized the way museum officials were dealing with Haberstock's controversial legacy in his 2000 book, *The Faustian Bargain*, that serious provenance research into the collection began.

A conspiracy of silence and secrecy reigned for decades, and some would even argue that it still lives on, perpetuated by a new generation. Among those involved during the Nazi era was Bruno Lohse, a former SS officer who was the deputy director of the looting *Einsatzstab Reichsleiter Rosenberg* (ERR) in Paris, and therefore a key player in the plunder of the French Jews. One of his tasks during the occupation was to select looted artworks stored at the Jeu de Paume for Hermann Göring's private collection. Though Lohse was among the few Nazi art looters to be imprisoned after World War II, he picked up his work again in the 1950s, purchasing art for wealthy private clients. He remained devoted to the memory of Göring into the 1990s and, according to Petropoulos, 'whiled away his days looking at old photos of the Reichsmarschall as well as the ERR art plundering headquarters in Paris that Göring and Lohse had effectively co-opted'.[8]

The fact that Lohse still possessed Nazi-looted art came to light in 2007 – the year he died – when the Swiss prosecutor secured a safe in a Zurich bank vault, registered in the name of a Liechtenstein foundation controlled by Lohse. The safe contained several paintings, including *Le quai Malaquais, printemps* (*Malaquais Quay, Spring*) by Camille Pissarro. The painting had been plundered by the Gestapo from a Jewish publisher's home after the family had fled Vienna. The publisher, and after his death his Zurich-based daughter, had been seeking it for seventy years.[9]

Yet it was not just a question of a handful of dealers swapping Nazi-looted art among themselves. The market in Europe, and particularly in Germany, was awash with plunder in the decades after the war. Sellers fudged provenance and buyers didn't care to enquire – including museums, which also received looted art in bequests and gifts. Sweden's Museum of Modern Art, for instance, purchased an Emil Nolde painting, *Blumengarten* (*Utenwarf*) (*Flower Garden*) at an auction in Switzerland in 1967. It was stolen from Otto Nathan Deutsch, a Jewish collector who fled to Amsterdam. His heirs, two of whom had survived concentration camps, filed a claim in 2002. After seven years of negotiations, they finally reached a settlement with the museum in 2009.[10]

Attitudes to Nazi-looted art remained stuck in the post-war era until the 1990s. After the Monuments Men had concluded their work, not much was done to return plundered works to the owners. Collectors whose art wound up in Eastern European hands had no chance of recovering it during the decades of the Cold War. The policy in communist East Germany was not to restitute at all, and it is only since 1990 that heirs have had the opportunity to reclaim artworks from East German museums. Since the early 1990s, Berlin's state museums have restituted 350 artworks and more than 1,000 books to their rightful owners. Dresden State Art Collections has developed a software system to help analyse more than 1.2 million artworks.

After the fall of the Berlin Wall, Jews who had been expropriated by the Nazis in the territory that later became East Germany – as well as those whose property was confiscated by the East German communist regime – were permitted to reclaim assets, largely businesses and real estate, under the *Vermögensgesetz* (Property Act) of 1990. This development, combined with the 1990s scandals over seized gold, dormant bank accounts and unpaid insurance policies belonging to victims of the Holocaust in Switzerland, raised awareness of Nazi-looted art and opened a new chapter in the restitution debate. In January 1995, a conference called 'The Spoils of War' was the first that brought together American, German and Russian experts to discuss looted art. In 1997,

Stuart Eizenstat, then Undersecretary of State for Economic, Business and Agricultural Affairs under President Bill Clinton, announced plans for the Washington Conference on Holocaust Assets to take place in 1998.

While the conference was still in the planning stages, a girl with auburn hair, a pale complexion and wide blue eyes stole centre stage in the restitution debate – despite the fact that she died of fever as a nurse in Croatia in 1917. Manhattan District Attorney Robert Morgenthau seized Egon Schiele's 1912 portrait of his lover, model and muse, seventeen-year-old Wally Neuzil, three days after the closure of an exhibition at New York's Museum of Modern Art, where it had been on show, on loan from Austria's Leopold Museum. He suspected the painting had been stolen from Lea Bondi, the owner of an art gallery in Vienna who had acquired it sometime before 1925.

The 'Wally' case pitted the US government against Vienna's Leopold Museum, which was founded by the Austrian ophthalmologist and art collector Rudolf Leopold in 1994. Leopold's passion for art outweighed his caution for provenance, and the museum came under heavy pressure over many years to untangle the problematic ownership history of some of his acquisitions.

When German troops occupied Austria in 1938, Bondi's gallery was earmarked as 'non-Aryan' and therefore subject to confiscation. Bondi sold it to an art dealer close to the Nazis called Friedrich Welz, then emigrated to Britain with her husband in 1939. The US government argued in court that *Portrait of Wally* – which hung in her home, not her gallery – was seized from her under duress with no compensation, while the Leopold Museum contended that it was included in the gallery sale and that Welz paid 200 Reichsmarks for it.

After World War II, US occupying forces had detained Welz for two years and seized his property, including art. As was the case with the Netherlands and France, the Monuments Men returned thousands of works to the Austrian government for restitution to the rightful owners, among them *Portrait of Wally*. Yet in a bureaucratic bungle, the precious portrait was restituted to the heirs of another Schiele

collector expropriated by Welz, who then sold the collection to Vienna's Belvedere museum.

In 1949, Bondi regained possession of her gallery, though not of *Portrait of Wally*. She met Rudolf Leopold and sold several works to him in London. She also asked him to help her recover the portrait. Yet Leopold acquired it himself in 1954 through a swap for another Schiele painting with the Belvedere. Bondi died in 1969 without retrieving the painting.

The US seizure of the portrait sent shock waves through American museums, which feared that the scandal would freeze loans from Europe so vital for special exhibitions. In 1999, the State Court of Appeals ruled that the seizure of an artwork lent for exhibition was prohibited under New York State law. The US government then began a civil forfeiture action in New York and the painting was seized again, this time by the Customs Service. Bondi's heirs asserted a claim to the painting and it was agreed that if the case was won, the government would hand *Portrait of Wally* to the heirs.

It took twelve years for the courts to untangle this case. In 2009, eleven years after the District Attorney seized the portrait, Chief Judge Loretta Preska ruled in the federal court in Manhattan that the painting was stolen from Bondi. Finally, in 2010, the Leopold Museum paid $19 million to Bondi's heirs to settle the decades-long dispute.[11]

Portrait of Wally's tortuous journey through the US courts came to symbolize the legal complexities of Nazi-era art restitution claims. Yet the seizure in 1998 had its uses for advocates of a coordinated international effort to return Nazi-looted art by serving as a wake-up call to American museums. If they didn't cooperate, they could risk losing access to international art loans.

Philippe de Montebello, the director of the Metropolitan Museum, promised in a hearing at the US House Banking Committee on Holocaust Assets that the Association of Art Museum Directors, which he headed,

would present a series of principles to address the issue of looted art. These included a pledge that US museums would research the provenance of their collections, publish information so that the heirs could make claims, refuse to take loans or gifts of art shown to be looted and unrestituted, and set up a mediation process for ownership disputes.

As Eizenstat put it later, 'it was clear that the Washington Conference would be no picnic'.[12] Many thought the Russians would boycott it, and there was resistance in Europe to the fact that the Americans were seizing the initiative. Amazingly, however, the four-day conference, starting on 30 November 1998, did result in a set of eleven international principles on provenance research and restitution of cultural property in public collections, endorsed by forty-four countries, including Russia. The goal, according to Eizenstat's concluding remarks, was 'to complete by the end of this century the unfinished business of the middle of the century: the completion of the historical record on Holocaust-era assets and the provision of some measure of justice – however belated – to the victims and survivors of that unparalleled tragedy'.

His timetable was extremely optimistic, as the trove found in Gurlitt's apartment twelve years into the 21st century revealed all too clearly. De Montebello's assessment was far more accurate: 'The genie is out of the bottle.'

Reproduced in full here, since they are succinct and self-explanatory, are the eleven Washington Conference Principles on Nazi-Confiscated Art.

> I. Art that had been confiscated by the Nazis and not subsequently restituted should be identified.

> II. Relevant records and archives should be open and accessible to researchers, in accordance with the guidelines of the International Council on Archives.

> III. Resources and personnel should be made available to facilitate the identification of all art that had been confiscated by the Nazis and not subsequently restituted.

IV. In establishing that a work of art had been confiscated by the Nazis and not subsequently restituted, consideration should be given to unavoidable gaps or ambiguities in the provenance in light of the passage of time and the circumstances of the Holocaust era.

V. Every effort should be made to publicize art that is found to have been confiscated by the Nazis and not subsequently restituted in order to locate its pre-War owners or their heirs.

VI. Efforts should be made to establish a central registry of such information.

VII. Pre-War owners and their heirs should be encouraged to come forward and make known their claims to art that was confiscated by the Nazis and not subsequently restituted.

VIII. If the pre-War owners of art that is found to have been confiscated by the Nazis and not subsequently restituted, or their heirs, can be identified, steps should be taken expeditiously to achieve a just and fair solution, recognizing this may vary according to the facts and circumstances surrounding a specific case.

IX. If the pre-War owners of art that is found to have been confiscated by the Nazis, or their heirs, can not be identified, steps should be taken expeditiously to achieve a just and fair solution.

X. Commissions or other bodies established to identify art that was confiscated by the Nazis and to assist in addressing ownership issues should have a balanced membership.

XI. Nations are encouraged to develop national processes to implement these principles, particularly as they relate to alternative dispute resolution mechanisms for resolving ownership issues.

Unfortunately, the Washington Principles had to be non-binding in order to secure universal agreement, and in some areas, they were simply too vague. The phrase 'just and fair solution' in Principle IX can be interpreted very widely according to who is demanding justice and fairness. Nonetheless, the principles have proven to be useful moral guidelines and initiated many more binding steps on the national level in some countries. Forty-seven countries reaffirmed their commitment to them in the Terezin Declaration in 2009. Even Cornelius Gurlitt agreed to apply them in determining the fate of his own collection. Considering the Washington Principles were not designed for private individuals, that testifies to their success, universality and durability.

One government had already jumped the gun before the Washington Conference. Austria, not generally known for willingness to confront its Nazi past, passed the Federal Law Governing the Return of Cultural Objects from Austrian Federal Museums and Collections in 1998. It created a commission to investigate provenance and a council to judge claims. The resulting system is one of the best in the world.

The new Austrian law triggered a chain of events that would change the restitution landscape permanently. Maria Altmann, niece of the glamorous turn-of-the-century Viennese art patron Adele Bloch-Bauer, promptly filed a claim for five paintings by Gustav Klimt in Vienna's Belvedere museum. The most famous of these and one of the best-known paintings in Austria was *Portrait of Adele Bloch-Bauer 1* (*Golden Adele*), a dazzlingly beautiful oil-and-gold portrait of a bejewelled, ruby-lipped and raven-haired Bloch-Bauer in an ornately patterned evening dress against a thickly textured gold background. Despite her splendour, there is an inescapable sadness about her dark eyes and wanness.

Bloch-Bauer was a friend of Klimt's and purchased the painting from him. On her death in 1925, her husband inherited it along with four other Klimts – another portrait of Adele, *Apple Tree 1*, *Birch Forest*, and *Houses in Unterach on the Attersee*. When he fled to Switzerland shortly

before the Nazis annexed Austria, he left them in Vienna. They were seized by the Gestapo in 1939, as were the rest of his possessions.

The newly appointed Austrian art council decided to reject Altmann's claim in 1999, on the grounds that Bloch-Bauer had bequeathed the painting to the Belvedere's predecessor museum in her will. Maria Altmann couldn't afford to file suit in Austria because she would have had to pay a proportion of the value of the paintings in court fees – about 1.75 million euros – so she filed her complaint in Los Angeles. The case went to the United States Supreme Court in 2004 as Austria contended that a suit in the US violated its sovereign immunity. The Supreme Court upheld Altmann's right to file suit and the following year, Austria and Altmann agreed to settle the case in arbitration.

An Austrian arbitration committee made up of high-ranking lawyers decided in Altmann's favour, arguing that the wish Bloch-Bauer expressed in her will for the paintings to one day belong to a Viennese museum was by no means binding and that Austria had never acquired legal title. Bloch-Bauer had bequeathed them to her husband – her sole heir – and he had undeniably lost them due to Nazi persecution.

Austria considered buying the paintings, but decided they were unaffordable. Ronald Lauder purchased *Golden Adele* for the Neue Galerie, reportedly paying a jaw-dropping $135 million, the highest price ever for a painting at that time. Lauder, former US ambassador to Austria and avid art collector – he acquired his first drawing by Egon Schiele with his bar mitzvah money at the age of thirteen – is the son of Estée Lauder, the founder of the cosmetics company. He opened the Neue Galerie, a museum on New York's Fifth Avenue devoted to Austrian and German 20th-century art, in 2001.

Altmann put the four other Klimts up for auction by Christie's at the Rockefeller Plaza in New York on 8 November 2006, where they fetched $193 million in a sale that went down in history as the biggest ever. Art worth more than half a billion dollars changed hands that night.

Justice was served, and Altmann was rewarded for her admirable persistence and determination to right a past wrong. But a sense of unease

Otto Dix, *Portrait of the Lawyer Dr Fritz Glaser*, 1921.

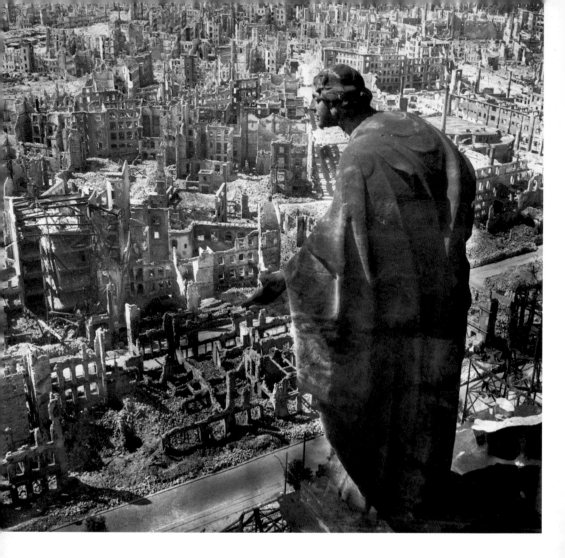

ABOVE The view of Dresden's ruins from the tower of the town hall in 1945, after the Allied bombardment.

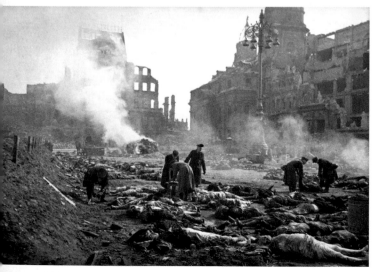

LEFT Burning corpses on the Altmarkt square in Dresden on 25 February 1945, after the devastating Allied air attacks.

RIGHT The portal of Aschbach Castle, where Hildebrand Gurlitt sought refuge with his family after the bombardment of Dresden.

BELOW The dining hall of Aschbach Castle, home to Baron Gerhard von Pölnitz. Hildebrand Gurlitt and Karl Haberstock stored their art collections in the rooms of the castle, where their contents were examined by the Allied Monuments Men after the war.

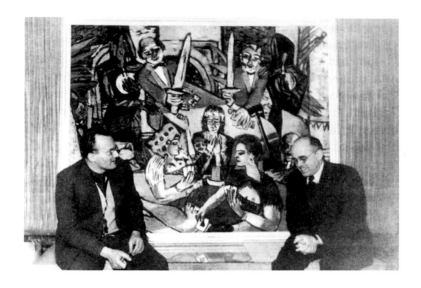

ABOVE Peter Beckmann and Hildebrand Gurlitt
at the opening of the Max Beckmann exhibition in
Düsseldorf in 1950.

RIGHT Hildebrand Gurlitt opening the
'Masterpieces from the Museu de Arte in São
Paulo' exhibition at the Art Association for the
Rhineland and Westphalia in Düsseldorf, 1954.

LEFT A portrait of Hildebrand
Gurlitt taken during his
tenure as director of the Art
Association for the Rhineland
and Westphalia in Düsseldorf,
date unknown.

RIGHT Hildebrand Gurlitt (left) with German President Theodor Heuss and Culture Minister Werner Schütz at the São Paulo exhibition at the Art Association for the Rhineland and Westphalia in Düsseldorf, 1954.

Hildebrand Gurlitt (left) with Thomas Mann (second from left), Viktor Achter, Katia Mann (foreground right) and Lotte Achter at the São Paulo exhibition at the Art Association for the Rhineland and Westphalia in Düsseldorf in 1954.

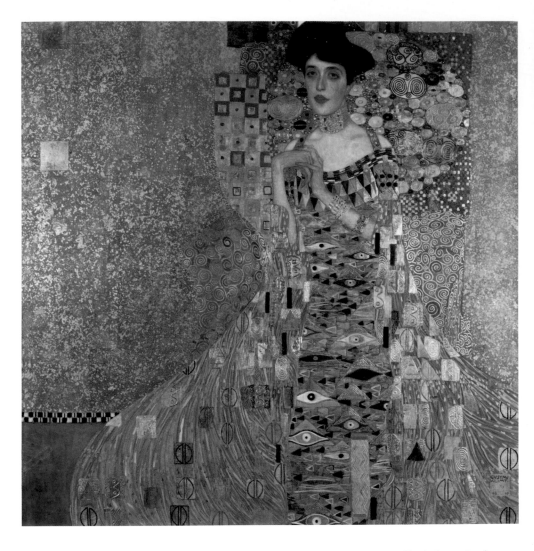

Gustav Klimt's *Portrait of
Adele Bloch-Bauer 1*, 1907,
oil, gold and silver on canvas.
The painting was the subject
of one of the most high-profile
restitution cases ever.

Ernst Ludwig Kirchner's
Berlin Street Scene,
1913–1914, oil on canvas.

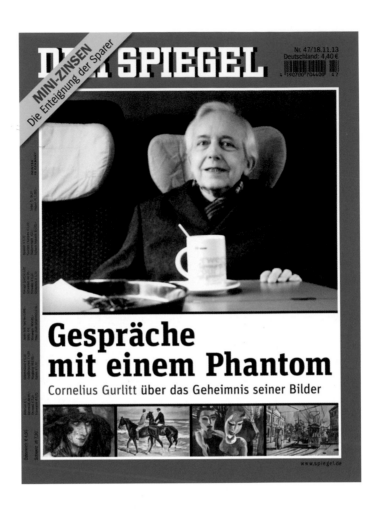

Der Spiegel magazine cover for the issue of 18 November 2013, featuring the only interview that Cornelius Gurlitt ever gave. The headline reads 'Conversations with a Ghost'.

lingered among art lovers. Is this what restitution had to entail? The four Klimts sold at Christie's, once proudly on display as part of Austria's national heritage in the gracious Belvedere, disappeared into private collections. Rumours abounded about the enormous contingency fee her lawyer Randol Schoenberg might have earned – possibly as much as $120 million. (Schoenberg, the grandson of the composer Arnold Schönberg and a family friend of Altmann, said it was less than that and he used a part of his earnings to build a new Museum of the Holocaust in Los Angeles.[13])

Blaming lawyers for earning money from restitution is a little like holding undertakers responsible for the number of dead people in an epidemic. Lawyers are the symptom of an existing problem, not its cause. If there were no dispute about the ownership of Nazi-looted art, there would be no need for heirs to hire lawyers. But what both the *Portrait of Wally* case and Maria Altmann's Klimts proved beyond doubt is that the law courts are not the best arena for resolving restitution claims. After years of legal wrangling, both cases ended up being settled out of court.

Of course, lawyers can make a lot of money out of these complex cases that stretch out over years. Norman Palmer, a London barrister and member of the UK Spoliation Advisory Panel, described Nazi-looted art claims as 'a lawyer's amusement arcade'.[14] It goes without saying that what is entertaining for lawyers can be expensive for their clients, and legal costs can far exceed the value of the items at stake. The problem for the heirs of Jewish victims of Nazi plunder is that they face few alternatives. Many people wonder why valuable restituted works are so often immediately sold at auction – if the heirs care so much about getting the artwork back, why do they immediately sell it? The answer is often that they have reached an agreement whereby the lawyer takes a cut of the artwork's value as his fee should he secure its recovery. The heir is therefore compelled to sell it to pay the lawyer. Few would in any case have the resources to insure a Klimt hanging over the family fireplace. Another factor is that the families of Jews dispossessed and exiled by the Nazis can be scattered around the globe. By the second

or third generation, descendants of one couple can be very numerous, making it impossible to consider sharing. There is no one country they call home, let alone a single place for the painting to hang and for them all to enjoy it.

In the first decade of the 21st century, sales of restituted works invigorated the art market. Most paintings by masters like Klimt have long been in museum collections and it is a momentous occasion when works such as these go on the auction block. They can fetch astronomical prices in a world where the super-rich are increasingly buying art.

The Klimt paintings were only part of the reason that the Christie's sale on 8 November 2006 made history. Another painting in the same auction could have been the show-stopper if it hadn't been for the even more valuable Klimts. It, too, had been restituted to the heir of a Jewish collector, and the bitter outcry over its return surpassed by far the backlash over the restitution of the Klimt paintings to Maria Altmann.

That night, Ronald Lauder paid $38 million for Ernst Ludwig Kirchner's *Berlin Street Scene*, a record for the artist. The 1913 painting, one of the artist's most famous works, had until shortly before the sale hung in Berlin's Brücke Museum, which had housed it since 1980. It depicts two women in seductive feathered hats and furs exchanging fleeting glances with two men in dark hats as they pass close by on a crowded street. The angular, elongated figures and faces and the sexually charged atmosphere are typical of Kirchner's edgy Berlin work at that time.

Before the Christie's auction, the Berlin Senate had restituted *Berlin Street Scene* to the heir of Alfred Hess, who ran a shoe-manufacturing business in the eastern German city of Erfurt before World War II. The family had one of the most comprehensive collections of German Expressionist art at that time, with about four thousand artworks. Hess died in 1931. His son, Hans Hess, lost his job at a publishing company following the rise of Hitler in 1933, and the family was eventually forced to leave Germany. Tekla Hess, Alfred's wife, said the Gestapo used threats to compel her to return the now scattered art collection to Germany. She sold *Berlin Street Scene* to a Cologne-based collector in 1936.

Many did not view this as a case for restitution and accused the Senate of handing back a city treasure too readily. Under the headline 'Amateurs at the Berlin Culture Senate', a statement by three art historians accused the authorities of inflicting 'dramatic damage' on Berlin's public collections by 'acting like dilettantes'. Some of the criticism carried unpleasant anti-Semitic overtones. Bernd Schultz, an expert in 19th- and 20th-century art at Berlin auction house Villa Grisebach and one of the three signatories, railed at 'unscrupulous, slick lawyers in the US', accusing them of 'talking about the Holocaust but meaning money'.[15]

Again, it was the greedy lawyers who took the blame. The auctioneer made no mention of the unscrupulous, slick players in the art market who had profited from an absence of scrutiny for decades by selling art that belonged to victims of Nazi plunder and had never been returned to them.

In Berlin's city parliament, the opposition Christian Democrats, Greens and Free Democrats accused Culture Senator Thomas Flierl of acting too rashly and failing to inform either lawmakers or the public. 'This painting is central to Berlin,' said Alice Ströver, the Green Party's spokeswoman on cultural issues at the time. 'It captures the mood in the city at that time.' Ströver did not go as far as Schultz to question whether the restitution was justified, but she did remonstrate with the Senate for failing to raise money to buy the painting back from the heir before it went to auction. The Senate had in fact tried and failed to raise 15 million euros to buy *Berlin Street Scene*.[16]

The historian and veteran provenance researcher Monika Tatzkow showed conclusively that restitution was morally justified. The owner, Tekla Hess, undoubtedly lost it due to persecution: whether she agreed to its sale or ever got the purchase price is not clear. The Berlin state prosecutor also backed the decision to return it: in a forty-eight-page report he concluded that if Berlin had fought a legal battle to keep the artwork on the grounds that statutes of limitations had expired, it 'would reduce the cultural and historical meaning of the work for the general public, and the ethical and moral value of this cultural treasure'.[17]

Yet the Senate could, and probably should have, exercised due diligence and mitigated the public outcry by submitting the claim to a German government panel set up in 2003 in a delayed response to the Washington Principles (known as the Limbach Commission). Unlike the commissions set up in Austria and the Netherlands, it can only recommend resolutions for disputes if both sides agree. Many museums simply refuse to allow heirs to submit their claims to the commission. Led by the former constitutional court judge Jutta Limbach, it had only resolved one claim by 2006.

The commission's shortcomings became all too clear in its second recommendation. One of the accusations directed at it in the wake of the *Berlin Street Scene* debacle was that its decisions would always favour the heirs. Perhaps the commission members wanted to counter those criticisms. Whatever the motive, the commission made a decision in 2007 to reject Peter Sachs's claim for his father's poster collection.

Hans Sachs, a dentist, was a passionate collector, beginning in his schooldays. One of the first serious poster collectors, he published a magazine called *Das Plakat*, founded a society, held exhibitions and gave lectures. His collection included works by Henri de Toulouse-Lautrec, Ludwig Hohlwein, Lucian Bernhard and Jules Chéret. It encompassed 12,500 posters and was at the time the biggest in the world.

When Gestapo officers seized his collection in 1938, they told Sachs that Propaganda Minister Joseph Goebbels wanted the posters for a new museum wing dedicated to 'business' art. Sachs was arrested on *Kristallnacht* in November 1938 and sent to Sachsenhausen concentration camp. He was freed after three weeks and fled to the United States with his wife and their son Peter, who was then only fourteen months old.

Sachs had smuggled out some Toulouse-Lautrec posters, which he sold to feed his family as they began a new life, but he never saw his collection again. Presuming it hadn't survived the war, he accepted compensation of 225,000 Deutschmarks (about $50,000 at the time) from the West German government in 1961.

When he discovered in 1966 that part of his collection was still intact in East Berlin, Hans Sachs made contact with the communist regime's authorities to try to get the posters loaned abroad for exhibitions, but the East German authorities rebuffed his request. In a letter to the Museum for German History (Museum für Deutsche Geschichte), Sachs said he felt compensated for his loss by the West German authorities and was happy to learn that the surviving posters were housed together in the museum. He added, though, that nothing could take away the sense of emotional loss that 'won't heal for the rest of my life'.

After German reunification in 1990, the posters formed part of the collection of the German Historical Museum (Deutsches Historisches Museum), a stately building on Berlin's Unter den Linden. The museum, now jointly owned by the German government and the state of Berlin, estimated the posters' value at more than 4.5 million euros and was determined to keep them when Peter Sachs made his claim in 2005. It argued that Hans Sachs had never asked for them back. This reasoning overlooked the fact that during the Cold War era, such a request would in any case have been futile given East Germany's policy of non-restitution.

The Limbach Commission rejected Peter Sachs's claim in January 2007, saying his father had accepted compensation and had resigned himself to the status quo. Sachs, a retired airline pilot living in Las Vegas, had offered to pay back the compensation in return for the posters. Again, the heir was left with no option but to go to court.

It was another drawn-out, complex legal wrangle. In keeping with its pledge to adhere to the Washington Principles of 1998, the German government and the museum agreed not to apply statutes of limitations. A Berlin court first ruled in favour of Sachs. The government and German Historical Museum appealed. In an unsatisfactory and puzzling technical decision, the Berlin appeals court ruled that though Hans Sachs had never lost legal title to the posters, his son did not have the right of recovery in a civil proceeding.

The final court of appeal, the Bundesgerichtshof, overturned that decision in March 2012 and ordered the German Historical Museum

to hand over the posters to Sachs. 'The owner of art lost due to Nazi injustices must be able to demand it back from the person who possesses it now, in a case where the work was missing after the war, and therefore couldn't be returned in line with Allied restitution laws,' the court said in its ruling.[18] This may be the only time that a claimant for Nazi-looted art has won his case in a German court, and this was only possible because the government waived its right to invoke the statutes of limitations.

So on strictly legal grounds, Sachs won. In mediation by a panel that was designed to take moral considerations into account, he had previously, unaccountably, lost. The Limbach Commission had unquestionably reached the wrong conclusion in 2007.

Peter Sachs paid back the compensation and finally took possession of the posters. He arranged for some of them to be auctioned, but by the time of the Bundesgerichtshof decision, he was elderly and ill. His case had taken seven years to resolve. He died in September 2013, before he could derive any pleasure from his posters.[19]

The Dutch, Austrian and British mediation panels are more successful. Yet flawed though the German commission is, it does at least exist. In the United States, attempts to create a mediation committee failed, in part because of resistance from those very museums that crafted the original principles on returning Nazi-looted art.

As a result, restitution cases invariably end up in court and museums are vigorous in defence of their collections. Marei von Saher, the heir of Dutch dealer Jacques Goudstikker, has been trying since 2001 to recover two Lucas Cranach paintings of Adam and Eve that hang in the Norton Simon Museum in Pasadena, California. Goudstikker left them in the Netherlands, along with hundreds of other artworks, when he fled the Nazis in 1940. Much of Goudstikker's collection was seized by Göring; the Cranach paintings of Adam and Eve were on display at his country home, Carinhall.

After mediation between the Goudstikker heirs and Norton Simon Museum failed to achieve a settlement, the case went to court in 2007.

The museum denied Saher's claim on the grounds that the statutes of limitations had expired. The United States Court of Appeals for the Ninth Circuit in 2014 ruled that Saher had the right to pursue her claim in a district court – seven years later and counting.

While a few American museums have returned looted art to heirs without the need for expensive lawsuits, others have pre-empted claimants by filing for 'quiet title', or asking courts to declare them the rightful owner of a disputed artwork to bar lawsuits against them. 'This is simply contrary to the whole spirit of the Washington Principles,' according to Eizenstat.

The trouble with leaving heirs at the mercy of museums is that there is an intrinsic conflict. Museum directors view their primary responsibility as preserving and protecting their collections. To give art away runs counter to their mandate. Not all recognize that returning stolen art to the rightful owners is a higher moral priority, even if, in the event of a lawsuit, the museums might be sure of winning on technical grounds. Making museums responsible for the restitution of looted art is a textbook example of putting the fox in charge of the henhouse. The fox may genuinely want to behave responsibly, but instincts almost inevitably prevail and tragedy ensues for all.

Leaving the Hans Sachs debacle aside, independent, government-appointed panels generally fare better in achieving 'just and fair' solutions for the heirs of Nazi-looted art – and sometimes highlight the shortcomings of museums. In a 2014 decision, the UK Spoliation Advisory Panel assessed a claim against the Tate Gallery in London for *Beaching a Boat, Brighton* by John Constable, filed by the heirs of a Hungarian Jewish collector whose possessions were looted by the Nazis. The Tate had contested the claim, arguing that it bought the painting in good faith, that the museum had a 'moral obligation towards the public' to display this national treasure and that the collector may have sold it in his lifetime. The panel ruled that the painting was almost certainly stolen from him by the Nazis, expressed surprise that the Tate had conducted no provenance research given the gaps in the artwork's ownership history and said the

museum had withheld information about the picture from the claimants. It recommended the painting be returned to the heirs.[20] In March 2015, the Tate announced that new information about the provenance had come to light that it wanted the panel to review, delaying the painting's return.

Museums that display willingness to negotiate with the heirs can reap the benefits by keeping artworks. The more efficiently and amicably they respond to a claim, the more inclined an heir may be to reach a financial settlement rather than demand full restitution. The heir of Robert Graetz, a Jewish textiles entrepreneur who was murdered at Auschwitz during World War II, gave a painting by Karl Schmidt-Rottluff on permanent loan to the Wiesbaden Museum in 2012. It had finally been restituted to him after years of negotiations with Berlin's New National Gallery. Graetz was impressed with Wiesbaden's efforts in the area of provenance research and restitution and chose to reward the museum with his loan.

While the Washington Principles committed museums to conducting provenance research, very few completed a thorough investigation of their collections in the subsequent years, often citing rising budget pressures as a reason for their lethargy. Germany has about six thousand museums, many of them small, provincial and operating on a shoestring. Their directors are expected to attract ticket-paying crowds to sensational exhibitions, yet many are happy if they have two curators working for them. Paying for a provenance researcher is, under such straitened conditions, rarely a priority. There is also a lack of qualified experts; in Germany there were only about three hundred provenance researchers in 2014.

To alleviate the problem, in 2008 the German government set up the Office for Provenance Research in Berlin, which allocates financing to museums for specific projects. Its funding increased steadily, and was trebled after the discovery of the Gurlitt trove. Under its auspices, museums and libraries had examined the provenance of over ninety thousand artworks and half a million books by early 2014. Yet of 6,000 museums, only 285 had actually started investigating their collections, and just half of those had begun publishing the results. From 1998 to 2013 about 12,000 objects – including several book collections – were

returned to their rightful owners.[21] What remains to be done exceeds by far the work already completed.

Paintings tend to be unique, and therefore easier to trace than prints, of which there may be several almost identical versions in circulation. With books, the task is still harder. There is no official estimate for how many Nazi-looted books remain in German libraries, but the figure is almost certainly in the millions. Tracing their owners and returning them is a task that librarians say will take decades.

The Berlin Central and Regional Library estimates it has as many as 250,000 books that are potentially looted. It acquired in one single purchase 40,000 books seized from the homes of Jews who were deported or murdered. So far, the library has returned 345 books and bookplates to 29 heirs. It would take one person twenty-five years to look through every book, according to the historian investigating them, and even that would not be enough, because few books carry visible signs of being looted – libraries also need to comb through their acquisition records and other archival sources. The Berlin library is one of a very few that have even started to research the provenance of their collections.

In the case of paintings, lawyers are often willing to work for claimants on contingency – for a percentage of the value of the claim – because the objects involved are worth considerable sums. Yet few individuals or institutions offer assistance in recovering books. The Commission for Looted Art in Europe, which has helped libraries in Bremen, Berlin, Hamburg, Marburg, Weimar and Nuremberg to track heirs, is an exception.

Anne Webber, the co-chair of the London-based organization, tells the story of a German library that restituted three books to a child Holocaust survivor. Though of little material value, the books had been seized by the Nazis along with the rest of the family's possessions. They had belonged to the mother of the survivor and she had written her name on the flyleaves. The daughter, an elderly woman living in Israel, barely remembered her mother, who, along with all her siblings, had been murdered by the Nazis. It was the first time she had seen her mother's handwriting and she was overwhelmed. The books were the only item

salvaged from her entire childhood, her family, her home and her heritage. Their emotional value was immeasurable.

This can also be true of heirlooms and furniture, as Ronald Lauder has pointed out: 'Looted art means not only a Matisse or a Rodin, it also includes a pair of silver candle holders. During the Holocaust not only the wealthy were dispossessed, but also the many more middle-class Jewish families or even the poorer ones, who may have owned something that was passed down from generation to generation and represents not only financial value but great cultural and sentimental value.'[22]

If regaining possession of artworks in Germany and other Western nations is an arduous, lengthy, expensive and sometimes painful business for the heirs of Jewish collectors persecuted by the Nazis, it is impossible in many Eastern European countries. Claims in Poland, Hungary and Russia are still rebuffed. Russian museums hold plenty of Nazi-looted art – when Stalin's 'Trophy Brigades' emptied the east German depots, they not only robbed the public collections, they also took many artworks belonging to Jews who had already been plundered by the Nazis. What would most benefit research is access to Russian archives, which contain reams of documentation that could help track looted art inside and outside Russia.

The Warsaw National Museum holds many magnificent works from the stunning collections of Breslau's Jews, snatched by the grasping Cornelius Müller-Hofstede for the Silesian Museum of Fine Arts (see page 22). Hungarian museums, too, hold artworks looted from Jews. The heirs of Baron Mor Lipot Herzog are seeking the return of more than forty works from Budapest museums, including paintings by El Greco, Camille Corot, Lucas Cranach the Elder, Anthony van Dyck and Gustave Courbet. They are housed at the Museum of Fine Arts, the Hungarian National Gallery and the Museum of Applied Arts. Herzog assembled one of Europe's great private art collections, the largest in Hungary, with more than 2,500 pieces by artists including Velázquez, Renoir and Monet. The art was looted by the Nazi German occupiers and by the Hungarian government of the time. Hungary has refused

to hand back the paintings and the heirs filed suit against the government in the United States District Court for the District of Columbia in January 2010.[23] The case is likely to become another drawn-out, expensive legal battle.

———

In September 2014, the Jewish Claims Conference published an examination of progress made by the nations that endorsed the Washington Principles. It found that only four countries had made 'major progress': Austria, the Czech Republic, the Netherlands and Germany. Most had done little or nothing. Among those that had made no significant progress were Italy and Poland. 'For the most part the "unfinished business of the twentieth century" remains unfinished,' the report's authors concluded.[24]

The discovery of the Gurlitt collection revived interest worldwide in the issue of Nazi-looted art, and the number of international conferences addressing restitution of Holocaust-era assets increased. The Claims Conference called for the founding of an international association of provenance researchers and has taken the first steps towards its establishment. Germany in particular has taken concrete steps: increasing funding for provenance research, debating a change in the law and establishing a new German Centre for Lost Cultural Property to better coordinate efforts in research and restitution. Yet there are still some who fear the response treated the Gurlitt revelations as a public relations disaster rather than a serious unresolved issue, and that the measures taken so far are 'window-dressing' rather than far-reaching steps to change attitudes and practices.

In the case of private owners like Cornelius Gurlitt who keep their collections secret, there is in any case little that the government can do. Who knows how many more families harbour secret troves of Nazi-looted art in their homes? Cornelius's treasures were only exposed in his lifetime because of a chain of random events: a routine search on a train, the seizure of his assets by a zealous – some would argue overzealous – prosecutor

and a leak to the press by a disgruntled investigator. Perhaps there are not many hidden collections of the same dimensions, but as the children of the war generation die and their children inherit, a few more skeletons are likely to emerge from cupboards, attics and cellars across Germany and further afield.

12 Berne's Burden

Less than an hour after learning of Cornelius's death, his guardian Christoph Edel telephoned the Museum of Fine Arts (Kunstmuseum) in Berne to tell the director Matthias Frehner that his ward had bequeathed his entire collection to the museum in his will. Frehner was out of the office – attending a seminar at the Federal Office of Culture focused, of all things, on the progress Swiss museums had made in investigating their collections for Nazi-looted art.[1] Edel left an urgent message with the receptionist asking for a call back to discuss the bequest.

The message reached Ruth Gilgen, head of communications and sponsoring at the museum. She googled Edel to check he was genuine, then she looked up Cornelius Gurlitt's website and found no death announcement, so assumed he was still alive and this strange phone call was not immediately pressing. She tried to reach Frehner, but it was only later that day, as news of Cornelius's death flooded the airwaves, that she grasped the urgency of the matter.[2]

Both Frehner and Christoph Schäublin, the president of the Board of Foundations that oversees the Museum of Fine Arts, initially suspected a hoax. After Edel sent Cornelius's will as an email attachment, the truth sank in. They were astonished. No one at the museum had ever met Cornelius or had any contact with him.

A handful of media enquiries followed. 'We knew an avalanche was about to engulf us,' Schäublin said.[3] The day after Cornelius's death, the museum issued a statement drafted by Schäublin saying its trustees and directors were 'surprised and delighted, but at the same time do not wish to conceal the fact that this magnificent bequest brings with it a considerable burden of responsibility and a wealth of questions of the most difficult and sensitive kind'.[4]

Why did this mysterious old man decide to leave his treasured collection to the Berne museum? Perhaps in part as a snub to his native country, which he felt had betrayed him – he could not understand why he was treated like a criminal and hounded in his own home. Perhaps, also, because of his long-held belief that he was being shadowed by a network of old Nazis in Munich that, he imagined, was trying to snatch his collection. He was in any case suspicious of all government authorities. The Berne Museum of Fine Arts is run by a private foundation and therefore, unlike most German museums, is not a state-managed institution. Cornelius expressly stipulated in his will that his heir was the private-law foundation of the Berne museum.

Cornelius knew Switzerland not only from his business dealings, but also from his childhood holidays in Ticino with Hildebrand's friend Karl Ballmer. He visited his Uncle Wilibald in Berne in his youth. He mentioned Berne when he was searched by customs officials on the train: many years earlier, he had sold artworks at Galerie Kornfeld in the Swiss capital.

The Munich district court charged with carrying out Cornelius Gurlitt's will gave the museum six months to decide whether it would accept this heavy legacy, and the museum said it would need most of that time to reach its decision. If it were to reject the bequest, the collection would revert to Cornelius's two surviving first cousins, Wilibald's children, Dietrich Gurlitt and his younger sister Uta Werner.

The German government made no secret of its preference that Berne should inherit. If the bequest stayed in Germany, the collection would remain a German problem, a political and diplomatic liability that the government would have little control over. It was not clear how far Cornelius's commitment to return looted art was binding for his heirs. In the case of the Gurlitts, cousins who barely knew Cornelius, there was no way to be certain they would honour his promises.

The Gurlitts at first put forward a united front, saying they hoped Berne would accept the bequest. Dietrich Gurlitt, Uta Werner, Cornelius's brother-in-law Nikolaus Frässle, Dietrich's son Christoph

Gurlitt and daughter Anne-Clära Gurlitt made rare media contact to clarify their position: 'We wholly welcome the will of Cornelius Gurlitt in which he appoints the Berne Museum of Fine Arts as the sole heir of his valuable collection and support this fully. We hope that the Berne Museum of Fine Arts will accept this bequest. We want and intend to contribute to the unhindered implementation of the deceased's last will and testament.'⁵ This unity would not last for the six months that Berne took to decide.

By the end of 2014, the 'Schwabing Art Trove' Task Force had received more than three hundred claims of varying credibility. Some arrived with documentation proving ownership of specific artworks. Others were general enquiries from heirs asking whether art owned by their grand-parents was in the collection.⁶ At least one claim was fraudulent.

After a year of research, the task force had ascertained that three of the artworks were looted and should be restituted: the Matisse painting of the seated woman with a fan should be returned to the Rosenbergs; the Liebermann painting of the riders on the beach belonged by rights to David Toren; and Henri Hinrichsen's Spitzweg drawing of a couple making music should be given back to his family.

While the Museum of Fine Arts deliberated, the collection was in legal limbo and the heirs of Jewish collectors who had filed claims were left with no option but to wait patiently – having already waited more than seventy years. The Jewish community was critical of the task force's progress. Greg Schneider, executive vice-president of the Jewish Claims Conference, was 'disappointed that the work of the task force has been veiled in secrecy' and surprised that it was taking so long.⁷

More artworks surfaced. The officials responsible for executing Cornelius's will uncovered some in his apartment that the customs officers had overlooked when they seized his collection in 2012. Edel had found them and set them aside in a box in the sitting room while workmen were renovating the apartment. A Degas sculpture, a Rodin marble and some Roman, Greek, Egyptian and Asian antiquities were added to the trove under investigation.

Cornelius had taken a suitcase with him to hospital. Frässle moved it to his own home after the heart patient was discharged. It was opened four months after Cornelius's death by the administrator of his estate, who found an early Monet pastel of an evening landscape.[8] There was something oddly touching about Cornelius's need to have a precious artwork with him in hospital, almost as a kind of security blanket. He was perhaps worried about the cost of his treatment and wanted to ensure he still had the means to pay it, even if the artworks in Salzburg were seized, too.

None of this made the decision any easier for the Museum of Fine Arts. The matter was complex and sensitive. Switzerland took decades to acknowledge its complicity with the Nazis, and the exposure, when it came, was painful, challenging the traditional self-image of a neutral, plucky little country at the centre of warring Europe. A less flattering picture began to emerge in 1996, when a debate erupted over Nazi gold and dormant accounts belonging to Holocaust victims in Swiss banks. Switzerland was suddenly cast as Hitler's banker and a profiteer of the persecution of the Jews. Under the pressure of US class-action lawsuits filed by Holocaust survivors, the World Jewish Congress and the US government, Swiss banks eventually paid $1.25 billion in 1999 to settle the claims. The Swiss government commissioned a vast study of the nation's activities during the Third Reich, including its dealings with Nazi-looted art.[9]

The report found that Switzerland had served as a trading hub for Nazi-looted art during and after the war, as well as for cultural property that Jewish families had managed to smuggle into the country to protect it from Nazi plundering. Many artworks of dubious provenance had found their way into Swiss museums via donations and bequests from wealthy collectors. As one of the countries to endorse the Washington Principles of 1998 (see Chapter 11), Switzerland committed to return Nazi-looted art in public collections. Yet a 2011 government report found that 'a large majority of museums have not fully processed the provenance of works of art' in their collections.[10]

So did Berne's Museum of Fine Arts want to add to the burden by taking on Cornelius Gurlitt's collection and reminding the world of Switzerland's shame? Ironically, in the summer of 1945, the museum served as a Central Collecting Point for Nazi-looted art that had found its way into Switzerland, where a determined British Monuments Man, the art historian Douglas Cooper, tracked it down and attempted to return it to the owners with the help of the Berne museum director at the time, Max Huggler. Most of it was stolen by the Nazis from French collectors, including the dealer Paul Rosenberg.

Would the Gurlitt collection turn the museum into a repository for Nazi plunder all over again?

Frehner and Schäublin were above all concerned about the museum's reputation, they explained in an airy conference room reached through an inconspicuous door in a hall full of medieval religious paintings. Frehner said a colleague in the Swiss museum world warned him that 'if you take it, you are then on the wrong side, you are stigmatized as an owner of Nazi-looted art and that is highly problematic. You will always be identified with it.'[11] Frehner, a former arts journalist for the *Neue Zürcher Zeitung* (*New Zurich Newspaper*) who contributed to and edited a book about Nazi-looted art in Switzerland in 1998,[12] was particularly sensitive to that risk.

The Museum of Fine Arts, a handsome 19th-century stone building located between the station and the Aare River in the centre of the cosy Swiss capital, houses one of the country's most significant collections, with masterpieces by Cézanne, Picasso, Van Gogh, Chagall, Manet and Kirchner as well as Swiss artists such as Ferdinand Hodler, Cuno Amiet and, of course, Paul Klee, who was born nearby and grew up in Berne. *Ad Parnassum*, one of Klee's most important paintings, is among its treasures.

Since the museum was built it has undergone two extensions, and the foundation that manages it is currently raising funds to extend it further to house contemporary art. Yet with about 100,000 visitors a year, the 135-year-old house of art is not among Switzerland's biggest museum

attractions: the Beyeler Foundation in Basle and the Zurich Museum of Art each draw three times as many visitors. As a private foundation, the Museum of Fine Arts is reliant on sponsors including Credit Suisse, a number of private local donors and subsidies from the canton and city of Berne.[13]

It does not have endless resources at its disposal for expensive court cases, and this was one of Schäublin's major concerns: that fighting claimants in court would prove costly. Ronald Lauder, the president of the World Jewish Congress, touched a nerve when he warned in a *Der Spiegel* magazine interview that Berne 'would be crazy to accept this legacy'. Taking Hildebrand Gurlitt's dubious acquisitions into the museum's own collection would 'open a Pandora's box and spark an avalanche of lawsuits', he said.[14] Coming from him, this sounded like no idle threat – after all, it was the World Jewish Congress that led class-action suits against Swiss banks in the 1990s.

The liabilities for its budget and reputation almost prompted the museum to reject Gurlitt's tainted legacy, but apprehensiveness and caution proved to be a good negotiating strategy. German Culture Minister Monika Grütters met Schäublin and Frehner at the Chancellery in Berlin on 27 June 2014 and gave assurances that the German government didn't want to leave Berne alone with this responsibility. That was the turning point in the museum's decision-making and the parties began to work on an agreement under which the German government would shoulder most of the burden, relieving Berne's museum of much of the risk.

Just weeks before the museum's six months were up, Cornelius's relatives – his cousins and second cousins – stated via their lawyer Wolfgang Seybold that if Berne declined the bequest, they would return any art that was looted to the heirs of the original collectors, publish pictures of the collection and Hildebrand's business correspondence, and would keep together the Expressionist works Hildebrand had obtained from the 'degenerate art' seizures and exhibit them permanently in a German museum. The Gurlitts – all descendants of Wilibald, Hildebrand's

brother, and his Jewish wife Gertrud – also reminded the public that they themselves were 'subject to severe persecution by the Nazis'.[15]

Yet days after this joint statement, a rift in the family surfaced. Uta Werner, supported by her two children and her nephew Ekkeheart Gurlitt, had commissioned a report from a forensic psychiatrist who had never met Cornelius. Working with letters and documents, Helmut Hausner diagnosed Cornelius as suffering from 'mild dementia, schizoid personality disorder and a delusional disorder'. His paranoia about a Nazi plot against him was his motive for bequeathing his collection to the Berne museum, Hausner concluded. 'He wanted to keep his collection permanently safe from the clutches of these supposed Nazi persecutors after his own death.' This persecution delusion, he concluded, meant that Cornelius was not of sound enough mind to make a will.[16]

Werner saw this as sufficient grounds to contest the testament. At quarter past seven on a Friday evening before the Monday on which the Berne Museum of Fine Arts was due to announce its decision, her fax arrived at the probate court in Munich – an application for a certificate of inheritance that would entitle her to half of Cornelius's legacy.[17] If her application were successful, the other half would automatically go to Dietrich Gurlitt, who wanted no part in the challenge to the will. 'I have nothing to do with the attempts by some relatives to raise doubts over Cornelius's mental state,' he wrote in a letter to Frehner, adding that he still hoped the museum would accept the bequest.

Ekkeheart Gurlitt was refreshingly honest about why he was hoping for at least a couple of the artworks for himself. 'I want one to hang in my apartment to remind me of this incredible, once-in-a-century story,' he said. 'And one to provide a welfare safety net. I am an old hippy and I haven't paid all that much into my pension plan.' He envisaged himself guiding visitors through the halls as curator of an exhibition of the entire collection at the new Berlin airport, whose opening has been delayed by years because of catastrophic construction planning and execution. He didn't want the collection to go to provincial Berne because, he contended, no one would make a special effort to go and visit it there.[18]

On 24 November 2014, the Museum of Fine Arts announced that it was willing to accept Cornelius's legacy. At a press event in Berlin, Schäublin said the surprise bequest 'did not engender a sense of triumph. That would have been completely inappropriate given the history that weighs on this collection.'

Germany shouldered much of the weight of that history. Under the terms of the agreement, the German task force would continue investigating the origins of Gurlitt's collection, including artworks found in his Salzburg home, working with reinforcements in the form of provenance researchers chosen by Berne. Germany would fund any legal costs arising from claims and restitutions. Berne would only take possession of artworks that were 'proven not to be looted or with high probability were not looted'.

Any artworks looted from Jewish collectors would be returned to the heirs 'with no ifs and buts', promised German Culture Minister Monika Grütters. She said the three artworks identified as Nazi loot would be restituted to the families of Rosenberg, Hinrichsen and Friedmann as quickly as possible. For Germany, Grütters said, it is important 'to live up to our special responsibility toward the victims of the Nazi dictatorship, not just legally but also morally'.

Artworks with dubious provenance would not even touch Swiss soil, Schäublin stressed, leaving the impression he would prefer a container of radioactive waste to be delivered to the museum's doorstep than a crate of Nazi-looted art. The artworks were to remain in Germany while the complex, time-consuming work of combing archives and catalogues to piece together their history was carried out. The timetable was ambitious – the task force aimed to complete its provenance research by the end of 2015.

At this point it was impossible to guess how many looted works were in the collection. Grütters indicated about five hundred artworks in the Munich hoard could not be ruled out as Nazi plunder, a figure that did not include the Salzburg trove. Under the terms of the agreement between Germany and Berne's Museum of Fine Arts, any pieces

suspected of being looted but for which no claimants could be found were to be exhibited in Germany together with known details about the provenance and the original owners in the hope that their heirs would come forward. Experts fear it may be impossible to identify the original owners of many of the artworks, especially the prints, which are unlikely to be unique.

The task force pledged to publish provenance reports and the business correspondence and records of Hildebrand Gurlitt. These are important not only because of the artworks in the collection, but also because they may help heirs to track lost art that Hildebrand sold on to other buyers decades ago. Hildebrand's business books were made readable online at the end of 2014, although they have been heavily redacted to eliminate names because of German privacy concerns.

For its part, the Berne Museum of Fine Arts agreed to give the German, Austrian and Polish museums from which artworks were seized by Joseph Goebbels in his virulent campaign against 'degenerate art' first priority for loans of those works. A Berne donor who wished to remain anonymous pledged at least 1 million Swiss francs to the museum to conduct provenance research, so the museum announced it would set up its own research facility in Berne dedicated to assisting the German task force in investigating the origins of the Gurlitt works.

The agreement was widely welcomed. Lauder was placated: 'It is the right decision by Berne to refuse the toxic part of this collection. Germany has been the country where the looting took place and it rightly should be the place of resolution.' He took the opportunity to urge German and Swiss museums to do a better job of investigating their collections and restituting looted art. 'Instead of legal nitpicking, we need moral clarity and a commitment to right past wrong-doing.'[19]

The Jewish Claims Conference and the World Jewish Congress called for any unclaimed artworks known to have been looted to be auctioned for the benefit of Holocaust survivors. As Berggreen-Merkel pointed out, the problem with such sales in the past has been that claimants can emerge later, when it is too late to help them.

For the first time, a full list of the artworks in the collection appeared online on the museum's website. The trove that had collected dust and mildew in Cornelius's abandoned Salzburg home was spectacular – fine oils by Cézanne, Corot, Courbet, Gauguin, Manet, Monet, Renoir, Toulouse-Lautrec and Signac, as well as pastels by Degas and Liebermann, a Max Ernst collage, some important Grosz drawings and lithographs, watercolours by Kandinsky, Picasso, Heckel, Kirchner, Nolde, Klee and Marc, and prints by Beckmann and Munch.

One painting on the Salzburg list, a view of Paris from the Pont-Neuf by Camille Pissarro, was quickly identified as stolen. Looted from the Heilbronn family collection in Paris by the *Einsatzstab Reichsleiter Rosenberg* (ERR), it was among the artworks that the art dealer Gustav Rochlitz had acquired in his swaps of 'degenerate art' for approved art at the Jeu de Paume during the occupation of France in World War II.

Much remains unresolved at the time of writing. A cloud of uncertainty hangs over Uta Werner's challenge to the will. The administrator of the estate in Munich retains custody until the probate court has established the heirs to Cornelius's legacy. That may take time; however, Werner has said she doesn't want to hinder the return of art known to have been looted by the Nazis to the rightful heirs and signed a document giving her approval for restitutions to go ahead.

Despite the delays, bungles and missteps along the way, the Gurlitt case has served many useful purposes. 'This case was a catalyst in the realization that Germany has not done nearly enough to properly address the problem of looted art,' Lauder said. 'It is important that the law would reflect the contemporary public opinion and consensus that even a private possessor must seek out the rightful owners and right the original injustice.'[20]

The case has without doubt laid bare deficits in the legal conditions for claimants. It has exposed a rift between what most Germans consider morally correct and what is currently possible in court. No one has argued that Toren, the Rosenbergs or the Hinrichsens should not get their families' artworks back. Yet under the law as it currently

stands, they would have little chance of recovering their property from Cornelius Gurlitt or his heir in court. Where the law and public policy do not concur, there is a duty to change the law.

This is still under discussion. In February 2014, Bavarian Justice Minister Winfried Bausback presented to the Bundesrat, Germany's upper house of parliament, a draft law that would prevent 'bad faith' buyers of stolen objects from invoking the statutes of limitations in legal claims against them.[21] The Bundesrat, in March, conceded that 'the current legal situation is publicly perceived as a perpetuation of Nazi injustices'.[22] Yet Bundesrat members and government officials criticized the Bavarian proposal for being too narrowly applicable and said it would not go far enough in helping heirs to recover Nazi-looted art.[23] A vote was postponed, and the Bundesrat instead asked the German government to examine broader legal solutions to the moral problems posed by the Gurlitt case.

In June 2014, Bausback again pleaded for swift approval of the Bavarian bill, arguing that the task the Bundesrat had given the government was akin to squaring the circle given the constitutional difficulties and that it would be better to quickly implement the Bavarian law change than have no change at all.[24] The Bundesrat demurred. Christian Lange, a parliamentary undersecretary in the Justice Ministry, warned against 'giving stones instead of bread' to potential claimants. Given the probability that more art looted from Jews and believed lost will come onto the market in the coming years as a new generation inherits, he argued that 'the state has to find a convincing answer'.[25]

In February 2015, lawyers at the Justice Ministry were still puzzling over a legal formula that wouldn't be rejected by the constitutional court. As a rule, laws that have a retroactive effect are deemed to contravene the German constitution. Some experts have said a solution is impossible; the Bundesrat already examined the legal framework in 2001 and decided that despite the obvious hurdles for claimants, there was no easy way to make the necessary alleviations. After the Gurlitt case, the will for change to improve the rights of claimants seems to be genuinely present on all

sides. Green Party MPs added to the pressure by pushing for changes to the law to boost provenance research and increase claimants' chances of winning back Nazi-looted art in civil cases. With a cross-party consensus and some of Germany's best legal minds on the case, there is every reason to hope the long-awaited change in the law will finally materialize.

The government has taken steps to improve access to provenance research for museums. The German Centre for Lost Cultural Property began operating in January 2015 with an increased staff of twenty. It has united existing institutions under one roof in Magdeburg: the Limbach Commission, the Berlin-based Office for Provenance Research and the Magdeburg Coordination Centre for Lost Art. For the first time, government funding has been offered to private owners and museums to investigate the provenance of their collections. The federal budget for provenance research trebled to 6 million euros in 2015, with the states adding funding of 608,000 euros.

For Grütters, it is 'simply intolerable that almost seventy years after the victory over Nazi terror there is still Nazi-looted art in German museums'.[26] The pressure to return these stolen treasures will increase.

The most joyful outcome of the Gurlitt case is the rediscovery of the art, these jewels of Europe's heritage that many believed were lost forever in the Nazis' brutal assault on our civilization. The 1897 Cézanne painting of Mont Sainte-Victoire is listed in the artist's catalogue raisonné, but had not been seen since World War II. The jagged, asymmetrical peak near the artist's birthplace, Aix-en-Provence, was a subject he returned to many times in his career.

The Monet painting of Waterloo Bridge that Edel retrieved from behind a makeshift bookshelf in Cornelius's Salzburg house is one in a series the artist produced during and after a 1901 visit to London. He painted the same view at different times of day and in varying weather conditions, often in fog and cloud. He aimed to capture the 'atmosphere', literally the air between himself and the bridge. It is one of the most valuable paintings in the collection; another misty Monet rendering of the same scene sold at auction in 2007 for more than $35 million.

Regardless of ownership and financial value, the art has been recovered for humanity and for scholarship. It is not only the works by the big names that promise to delight art lovers. Another revelation, for instance, is the work of an unknown but talented woman who died in tragic circumstances in 1919. Until now the whereabouts of only a handful of Cornelia Gurlitt's artworks was known, mainly pieces she had given to friends. Hildebrand kept about 130 and left them to his son, who hoarded them in his Munich apartment alongside the Matisse, the Munchs and Monets. These are completely free of suspicion as Nazi loot, so they are likely to be among the first works to enter the Museum of Fine Arts in Berne. Frehner considers Cornelia to be a significant artist and plans to exhibit her work.[27]

Less tangibly, the Gurlitt case has changed the tone of the public debate. With some humility, Grütters highlighted the need for more sensitivity a year after the sensational find in Cornelius's apartment was made public. 'We must develop a more acute moral awareness and be quicker to show empathy' to the heirs of those robbed by the Nazis, she said in a magazine interview. 'It is not always just about material compensation. That can be settled. We need more understanding for the biographies of these people and for the continuing suffering of the victims. That is the most important foundation for our coexistence. History cannot simply be settled.'[28]

These are good words, reflecting the need to continue investing meaning into the task of *Aufarbeitung* (see page 179) on an individual basis as well as at official occasions. Expressions of national responsibility and remembrance of the Holocaust, while demonstrating commitment, can sometimes sound abstract because they lack the individual empathy that Grütters is seeking. The victims, who almost all either emigrated decades ago or were killed in the Holocaust, no longer have a significant voice in the German national debate. Their descendants are often not German-speakers and the desired empathy is harder to generate and communicate when it has to transcend linguistic and cultural barriers.

Above all, the Gurlitt case has served as a reminder that for Germany, the task of addressing the crimes of the Nazis will never be finished and

there is no room for complacency or fatigue in the *Aufarbeitung* of the Third Reich. Germany suffered a kind of collective amnesia after the war, where everyone – as amply demonstrated by Hildebrand Gurlitt – was suddenly a victim and no one was a perpetrator. The generation who came of age in the 1960s lashed out at their parents, sometimes violently, in anger at their failure to acknowledge responsibility for the crimes of the Nazis. Decades of guilt, recriminations, self-accusations and soul-searching attempts to come to terms with genocide and war followed.

The plunder of Jewish art collections is inextricably linked with the atrocities of the Holocaust. The stolen paintings in museum depots, private attics or hanging over fireplaces each have a story to tell – an individual tale of betrayal, persecution and loss. But they are also silent witnesses to lingering moral obligations and to a great European tragedy. They reflect a vacuum in society, a bereavement whose pain lives on.

Sometimes it even seems the day of mourning for a vanished people is only just dawning. From 1996 to 2014, more than 45,000 so-called *Stolpersteine* – brass-covered stones bearing inscriptions commemorating individuals either forced into exile or murdered by the Nazis – were set in the pavements outside their last freely chosen homes. On the streets of Berlin it is not unusual to encounter a group of relatives and locals watching thoughtfully as a plaque is hammered into the cobbles.

Like the stories of thousands of artworks, these tiny memorials underfoot are a bright, poignant reminder of what was irrevocably destroyed: a loyal, integrated Jewish community that contributed enormously to the cultural life and diversity of continental Europe, and in whose absence it is immeasurably poorer than it might otherwise have been.

Epilogue

David Toren was beginning to give up hope as his ninetieth birthday approached. Seventy-seven years had passed since he had last seen Max Liebermann's *Two Riders on the Beach* hanging in his great-uncle's house in Breslau on the morning after *Kristallnacht*. More than three years had gone by since the painting was discovered in Cornelius Gurlitt's apartment, and it was almost a year since the 'Schwabing Art Trove' Task Force had acknowledged that it was unequivocally the property of David Friedmann's heirs. Yet he still didn't have it.

'I hope to be able to show the painting at my 100th birthday party,' he wrote, with typically acerbic humour, in an email on 29 April 2015, the day before his ninetieth. The bureaucratic delays had been endless. He celebrated his birthday with a party in his Madison Avenue apartment. Sixty guests came, and there were caterers and a big cake. But no painting.

Two weeks later, he wrote again, this time triumphantly: 'The painting is on its way.' The Munich probate court finally released both the Liebermann and Matisse's *Seated Woman* for restitution on 12 May.

Ten blocks down from Toren on Manhattan's Upper East Side, Elaine Rosenberg, the 93-year-old daughter-in-law of Paul Rosenberg, also had a reason to celebrate. Chris Marinello, the family's lawyer, travelled to Munich to pick up the Matisse on 15 May. The Hinrichsens were still assembling the last documents for the Spitzweg drawing to be released.

Both the Rosenbergs and Toren said recovering their property had taken far too long. 'It was a roller-coaster ride,' Marinello said. 'It really is outrageous,' said Toren.

Did Toren at least feel a sense of closure now he had recovered the painting?

'No!' he answered. 'We are looking for more important paintings. We are trying to find Liebermann's *Basket Weavers*, for example, and pictures by Courbet and Pissarro. I have to keep busy.'

And so the quest continues.

Gurlitt Family Tree*

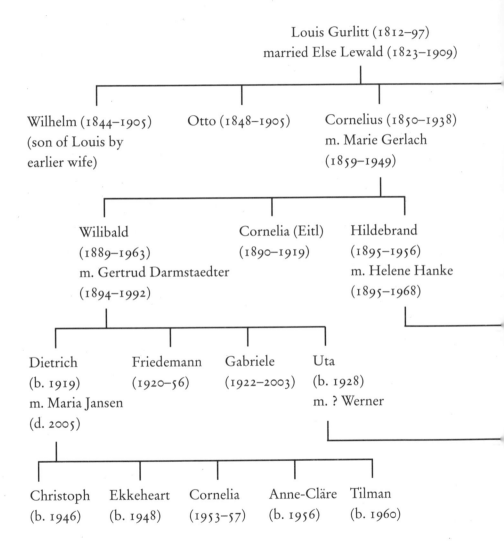

Louis Gurlitt (1812–97)
married Else Lewald (1823–1909)

Wilhelm (1844–1905)
(son of Louis by
earlier wife)

Otto (1848–1905)

Cornelius (1850–1938)
m. Marie Gerlach
(1859–1949)

Wilibald
(1889–1963)
m. Gertrud Darmstaedter
(1894–1992)

Cornelia (Eitl)
(1890–1919)

Hildebrand
(1895–1956)
m. Helene Hanke
(1895–1968)

Dietrich
(b. 1919)
m. Maria Jansen
(d. 2005)

Friedemann
(1920–56)

Gabriele
(1922–2003)

Uta
(b. 1928)
m. ? Werner

Christoph
(b. 1946)

Ekkeheart
(b. 1948)

Cornelia
(1953–57)

Anne-Cläre
(b. 1956)

Tilman
(b. 1960)

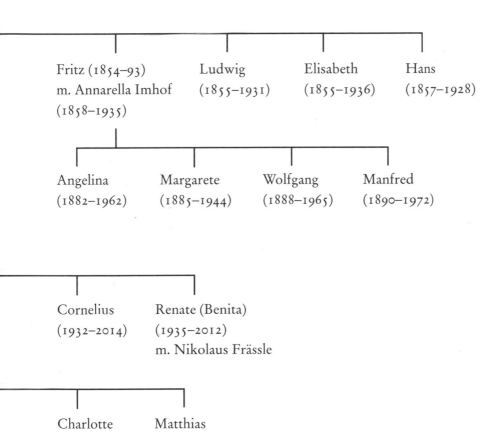

Fritz (1854–93)
m. Annarella Imhof
(1858–1935)

Ludwig
(1855–1931)

Elisabeth
(1855–1936)

Hans
(1857–1928)

Angelina
(1882–1962)

Margarete
(1885–1944)

Wolfgang
(1888–1965)

Manfred
(1890–1972)

Cornelius
(1932–2014)

Renate (Benita)
(1935–2012)
m. Nikolaus Frässle

Charlotte

Matthias

* This family tree is not complete but intended as a guide to the people who feature
in this book. Sources: Cornelius Gurlitt literary remains (Nachlass Gurlitt), Technical
University Dresden; Dietrich Gurlitt, 'Erlebte Grenzen'; Jürgen Paul, Cornelius Gurlitt;
and documents provided by Elizabeth Baars.

Notes

Chapter 1 (pp. 9–25)

1 Hickley, 'Nazi Trove Surprises Family', *Bloomberg News*, 7 November 2013
2 Toren's biography details in this chapter from interview with author, 3 July 2014 and subsequent emails, unless otherwise cited
3 Winzeler, 'Jüdische Sammler und Mäzene in Breslau', in Baresel-Brand and Müller (eds), *Sammeln, Stiften, Fördern*, 2008, p. 131
4 Ascher, *A Community Under Siege*, 2007, p. 3
5 Winzeler, 'Jüdische Sammler und Mäzene in Breslau', in *Sammeln, Stiften, Fördern*, 2008, pp. 132–5
6 Ascher, *A Community Under Siege*, 2007, pp. 41–3
7 David Toren, email to author, 16 July 2014
8 Lasker-Wallfisch, *Inherit the Truth*, 1996; the memoir tells her remarkable survival story
9 Lasker-Wallfisch, email to author, 4 August 2014
10 Silesian Art Collections project at http://www.silesiancollections.eu/
11 Karl Scheffler, 1923, quoted in Winzeler, 'Jüdische Sammler und Mäzene in Breslau', in *Sammeln, Stiften, Fördern*, 2008, p. 139
12 Gronau, *Max Liebermann*, 2001, p. 269
13 Kershaw, *Hitler*, 2010, p. 202
14 Loeser, *Sag nie, Du gehst den letzten Weg*, 1986, pp. 20–21
15 Ascher, *A Community Under Siege*, 2007, pp. 270–71
16 *Ibid.*, pp. 183–7
17 *Ibid.*, p. 183
18 Breitman and Lichtman, *FDR and the Jews*, 2012, pp. 147–51
19 Ascher, *A Community Under Siege*, 2007, pp. 188, 239
20 Winzeler, 'Jüdische Sammler und Mäzene in Breslau', in *Sammeln, Stiften, Fördern*, 2008, p. 145

21 *Ibid.*, p. 147
22 Letter, court documents in case *David Toren v. Federal Republic of Germany and Free State of Bavaria*, filed 5 March 2014
23 Quoted in Ascher, *A Community Under Siege*, 2007, p. 217
24 Ascher, *A Community Under Siege*, 2007, pp. 230, 238
25 Court documents in case *David Toren v. Federal Republic of Germany and Free State of Bavaria*, filed 5 March 2014
26 'Schwabing Art Trove' Task Force, provenance report on Max Liebermann's *Riders on the Beach/Two Riders on the Beach*, 25 July 2014
27 Ascher, *A Community Under Siege*, 2007, p. 239

Chapter 2 (pp. 26–42)

1 Hildebrand Gurlitt, unpublished preface for catalogue GWDP, SArch Düsseldorf
2 *Ibid.*
3 Paul, *Cornelius Gurlitt*, 2003, p. 46
4 Gurlitt family correspondence, Nachlass Gurlitt, TUD. Unless otherwise cited, details from family letters in this chapter are from this source
5 Hildebrand Gurlitt, unpublished preface for catalogue GWDP, SArch Düsseldorf
6 Renn, *Anstöße in meinem Leben*, 1982, pp. 307–8
7 Gurlitt family correspondence, Nachlass Gurlitt, TUD
8 Hildebrand Gurlitt, unpublished preface for catalogue GWDP, SArch Düsseldorf
9 Renn, *Anstöße in meinem Leben*, 1982, pp. 344–5
10 Paul, *Cornelius Gurlitt*, 2003, p. 46
11 Letter Hildebrand Gurlitt to Paul Fechter, 8 August 1919, Nachlass Paul Fechter, DLA Marbach
12 Gurlitt family correspondence, Nachlass Gurlitt, TUD
13 Dietrich Gurlitt, interview with author, 14 January 2014

14 Paul, *Cornelius Gurlitt*, 2003, p. 51
15 Undated letter Hildebrand Gurlitt to
Paul Fechter, Nachlass Paul Fechter,
DLA Marbach
16 Reidemeister, memorial speech,
24 January 1957, SArch Düsseldorf
17 Löffler, *Hildebrand Gurlitt*, 1995, p. 10
18 Hildebrand Gurlitt, unpublished preface
for catalogue GWDP, SArch Düsseldorf
19 Reidemeister, memorial speech,
24 January 1957, SArch Düsseldorf
20 Löffler, *Hildebrand Gurlitt*, 1995, p. 19
21 Congratulatory letters for Hildebrand
Gurlitt's sixtieth birthday, SArch
Düsseldorf
22 Quoted in Kracht, 'Im Einsatz für die
deutsche Kunst', in Steinkamp and Haug
(eds), *Werke und Werte*, 2010, p. 42
23 Löffler, *Hildebrand Gurlitt*, 1995, p. 32
24 Letters Hildebrand Gurlitt to Paul
Fechter, Nachlass Paul Fechter, DLA
Marbach
25 Löffler, *Hildebrand Gurlitt*, 1995, p. 32
26 Quoted in Voigt, *Kunsthändler und
Sammler*, 2007, p. 134
27 Löffler, *Hildebrand Gurlitt*, 1995,
pp. 20–22, 25
28 *Ibid.*, p. 28
29 Letter Hildebrand Gurlitt to Max
Sauerlandt, 8 March 1929, HSUL, NSa:
1b: 92–5
30 Hildebrand Gurlitt, unpublished preface
for catalogue GWDP, SArch Düsseldorf
31 Griebel, *Ich war ein Mann der Strasse*,
1986, p. 268
32 Quoted in HG DNZ, SArch Coburg,
Spk BA Land G 251_035
33 Kracht, 'Im Einsatz für die deutsche
Kunst', in *Werke und Werte*, 2010, p. 46
34 Sworn statement Hildebrand Gurlitt to
First Lt Dwight Mackay, 10 June 1945,
NARA
35 Bruhns, *Kunst in der Krise*, 2001, p. 25
36 Reidemeister, memorial speech,
24 January 1957, SArch Düsseldorf
37 *Neue Englische Kunst* catalogue,
26 June–31 July 1932, HSUL, A/462528
38 Voigt, *Kunsthändler und Sammler*, 2007,
p. 139

39 Kracht, 'Im Einsatz für die deutsche
Kunst', in *Werke und Werte*, 2010, p. 49
40 Bruhns, 'Ausgegrenzte Avantgarde', in
Giesing *et al.* (eds), *Das Raubauge in der
Stadt*, 2007, p. 94
41 Tent, *In the Shadow of the Holocaust*,
2003, p. 62
42 Hildebrand Gurlitt, unpublished preface
for catalogue GWDP, SArch Düsseldorf

Chapter 3 (pp. 43–59)
1 Hildebrand Gurlitt, unpublished preface
for catalogue GWDP, SArch Düsseldorf
2 Statement Dr Walter Clemens, 7 January
1946, SArch Coburg, Spk BA Land G
251_032
3 Quadflieg, *Beckett Was Here*, 2014,
p. 115
4 *Ibid.*, p. 121
5 Nixon, *Samuel Beckett's German
Diaries*, 2011, p. 139
6 Wismer, *Karl Ballmer, Der Maler*, 1990,
p. 26
7 Quadflieg, *Beckett Was Here*, 2014,
p. 170
8 Wismer, *Karl Ballmer, Der Maler*, 1990,
p. 61
9 Bruhns, *Kunst in der Krise*, 2001, p. 225
10 Nicholas, *The Rape of Europa*, 1994,
p. 12
11 Hildebrand Gurlitt, unpublished preface
for catalogue GWDP, SArch Düsseldorf
12 Quadflieg, *Beckett Was Here*, 2014,
p. 100
13 Hildebrand Gurlitt, unpublished preface
for catalogue GWDP, SArch Düsseldorf
14 Mercedes Gurlitt, 'Begegnungen',
provided by Elizabeth Baars
15 Hildebrand Gurlitt, unpublished preface
for catalogue GWDP, SArch Düsseldorf
16 Statement Otto Blumenfeld 9 October
1946, HG DNZ, SArch Coburg, Spk BA
Land G 251_029
17 Statement Hildebrand Gurlitt to
Bamberg prosecutor, HG DNZ, SArch
Coburg, Spk BA Land G 251_029
18 Statement Hildebrand Gurlitt to
Wiesbaden CCP, 13 December 1950,
NARA

19 Jasper Wolffson, email to author, 10 September 2014
20 Wiedergutmachungsakte Ernst Julius Wolffson, HSArch, 351-11, 14485
21 Bruhns, *Kunst in der Krise*, 2001, p. 225
22 Copy of catalogue provided by Elizabeth Baars
23 Speer, *Erinnerungen*, 1996, pp. 40–41
24 Löhr, *Das Braune Haus der Kunst*, 2005, p. 15
25 Goebbels diary entry, quoted in Karsten Müller, 'Violent Vomiting Over Me', in Peters (ed.), *Degenerate Art*, 2014, p. 176
26 Quoted in Kracht, 'Im Einsatz für die deutsche Kunst', in Steinkamp and Haug (eds), *Werke und Werte*, 2010, p. 53
27 *Ibid.*, p. 54
28 Forschungsstelle 'Entartete Kunst' database, Free University of Berlin
29 Petropoulos, 'From Lucerne to Washington, DC', in *Degenerate Art*, 2014, p. 285
30 Hüneke, 'Depot für "Entartete Kunst"', in Hagemann *et al.* (eds), *Schönhausen*, 2009, pp. 58–60
31 Peters, 'Genesis, Conception, and Consequences', in *Degenerate Art*, 2014, p. 119
32 Buomberger, *Raubkunst Kunstraub*, 1998, p. 59
33 Letter Hildebrand Gurlitt to Rolf Hetsch, 28 October 1938, BArch Berlin, R55/21012
34 Correspondence Hildebrand Gurlitt with Rolf Hetsch, 1938–39, BArch Berlin, R55/21012
35 Letter Hildebrand Gurlitt to Werner Kloos, 2 July 1940, HKArch, HAIIK 32-2239 (Sammlung 18)
36 Buomberger, *Raubkunst Kunstraub*, 1998, p. 59
37 Letter Hildebrand Gurlitt to Rolf Hetsch, 17 October 1940, BArch Berlin, R55/21012
38 Hoffmann, 'Zwischen Ideologie und politischem Kalkül', lecture in Berlin, 23 January 2014
39 Letter Hildebrand Gurlitt to Georg Schmidt, 31 May 1939, quoted in Kreis, *'Entartete' Kunst für Basel*, 1990, p. 52

40 Kreis, *'Entartete' Kunst für Basel*, 1990, p. 53
41 *Ibid.*
42 Postcard Hildebrand Gurlitt to Rolf Hetsch, 16 May 1939, BArch Berlin, R55/21012
43 Hildebrand Gurlitt, unpublished preface for catalogue GWDP, SArch Düsseldorf
44 Meike Hoffmann, interview with author, 25 August 2014
45 Letter Hildebrand Gurlitt to Propaganda Ministry, 29 March 1940, BArch Berlin, R55/21012
46 Letter Hildebrand Gurlitt to Rolf Hetsch, 22 June 1940, BArch Berlin, R55/21012
47 Bruhns, *Kunst in der Krise*, 2001, p. 225
48 Quoted in Voigt, *Kunsthändler und Sammler*, 2007, p. 144
49 *Ibid.*, p. 146
50 Hildebrand Gurlitt, unpublished preface for catalogue GWDP, SArch Düsseldorf
51 Letter from Hamburg Museum of Art to city authorities, 1941, HKArch, HAHK 32-2239 (Sammlung 18)
52 Hildebrand Gurlitt, unpublished preface for catalogue GWDP, SArch Düsseldorf
53 *Ibid.*

Chapter 4 (pp. 60–94)
1 Löhr, *Das Braune Haus der Kunst*, 2005, p. 10
2 Schwarz, *Auf Befehl des Führers*, 2014, p. 22
3 Löhr, *Das Braune Haus der Kunst*, 2005, pp. 11, 12
4 Speer, *Erinnerungen*, 1996, p. 57
5 Löhr, *Das Braune Haus der Kunst*, 2005, p. 13
6 Speer, *Erinnerungen*, 1996, p. 42
7 Nicholas, *The Rape of Europa*, 1994, pp. 38–9
8 Consolidated Interrogation Report 'Linz: Hitler's Museum and Library', ALIU, NARA
9 Christa Schroeder's memoirs, quoted in Schwarz, *Auf Befehl des Führers*, 2014, p. 227
10 Deutsches Historisches Museum database of Linz collection, www.dhm.de

11 Consolidated Interrogation Report 'Linz: Hitler's Museum and Library', ALIU, NARA

12 Consolidated Interrogation Report on the activity of the ERR in France, 15 August 1945, ALIU, NARA

13 Sinclair, *21 Rue la Boétie*, 2012, pp. 52–60

14 *Ibid.*, p. 51

15 *Ibid.*, pp. 59–60

16 Feliciano, *The Lost Museum*, 1997, pp. 71–4

17 ERR Project, www.errproject.org

18 Nicholas, *Rape of Europa*, 1994, p. 167

19 'Schwabing Art Trove' Task Force, provenance report on Henri Matisse's *Seated Woman/Woman Seated in an Armchair*, 7 July 2014

20 'Schwabing Art Trove' Task Force press release, 11 June 2014

21 Detailed Interrogation Report, Hermann Voss, ALIU, NARA

22 Consolidated Interrogation Report 'Linz: Hitler's Museum and Library', ALIU, NARA

23 Bamberger Verlagshaus Report 'Profit and Asset Growth Among Stamp Dealers, Antique Book Sellers, Art and Antiquities Dealers in the War Years', 17 February 1947, HG DNZ, SArch Coburg, Spk BA Land G 251_038,

24 Terlau, 'Hildebrand Gurlitt and the Art Trade', in *Vitalizing Memory*, 2005, p. 165

25 Otto Förster, 'Extending the Wallraf Richartz Museum in Cologne from 1933 to 1944', ALIU, NARA

26 Declaration Gurlitt to Breitenbach at MFAA, 3 October 1946, French trans. at NARA

27 Detailed Interrogation Report, Ernst Buchner, ALIU, NARA

28 Nicholas, *The Rape of Europa*, 1994, p. 154

29 Declaration Gurlitt to Breitenbach at MFAA, 3 October 1946, NARA

30 Michel Martin report on Hildebrand Gurlitt, 1946, FMFA, Carton 385, dossier P 19

31 Immatriculation certificate for Marc Chauvet, Schweizerisches Bundesarchiv

32 Letter Hildebrand Gurlitt to Hans Posse, 10 December 1940, BArch Koblenz, B323-134

33 Letter Hans Posse to Hildebrand Gurlitt, 12 December 1940, BArch Koblenz, B323-134

34 *Ibid.*, 21 March 1941, BArch Koblenz, B323-134

35 Detailed Interrogation Report No. 12, Hermann Voss, ALIU, NARA

36 Iselt, *'Sonderbeauftragter des Führers'*, 2010, pp. 153–4

37 'Acquisitions and Exchanges during the Voss Era 1938–1939', Museum Wiesbaden Archiv

38 *Ibid.*

39 Iselt, *'Sonderbeauftragter des Führers'*, 2010, p. 114

40 *Ibid.*, p. 122

41 Consolidated Interrogation Report 'Linz: Hitler's Museum and Library', ALIU, NARA

42 Sworn statement Hildebrand Gurlitt to First Lt Dwight Mckay, 10 June 1945, NARA

43 Bill Kunstkabinett Dr H. Gurlitt to Linz Special Commission, 25 August 1943, BArch Koblenz, B323-134

44 Letter Hans Gerlach to Dr Robert Oertel, 8 December 1943, BArch Koblenz, B323-133

45 Letter Robert Oertel to Reich Chamber of Fine Arts currency department, 9 March 1944, BArch Koblenz, B323-123

46 Detailed Interrogation Report, Hermann Voss, ALIU, NARA

47 Voss statement to Roberts Commission, NARA

48 Terlau, 'Hildebrand Gurlitt and the Art Trade', in *Vitalizing Memory*, 2005, p. 169

49 Telegraph Hermann Voss to Reichsstelle Papier, 1 July 1944, BArch Koblenz, B323-134

50 Bill Kunstkabinett Dr H. Gurlitt to Linz Special Commission, 26 June 1944, BArch Koblenz, B323-134

51 Nicholas, *The Rape of Europa*, 1994, p. 156

52 Michel Martin report on Hildebrand Gurlitt, 1946, FMFA, Carton 385, dossier P 19

53 Declaration Gurlitt to Breitenbach at MFAA, 3 October 1946, NARA

54 Interrogation Report, Gustav Rochlitz, ALIU, NARA

55 Letter Gustav Rochlitz to Hermann Voss, February 1944, BArch Koblenz, B323-147

56 Iselt, 'Sonderbeauftragter des Führers', 2010, pp. 232–5

57 Letter Hermann Voss to Helmut von Hummel, 7 July 1944, BArch Koblenz, B323-147

58 Michel Martin report on Hildebrand Gurlitt, 1946, FMFA, Carton 385, dossier P 19

59 Letter Hildebrand Gurlitt to Hermann Voss, 4 September 1944, BArch Koblenz, B323-146

60 Benson, 'The Importance of Provenance', LACMA blog, 5 February 2014

61 Rossmann, 'Private Geschäfte', Frankfurter Allgemeine Zeitung, 1 February 2014

62 Ibid.

63 Letter Beckmann to Gurlitt, 6 August 1946, Städel Museum Archiv

64 Löhr, Das Braune Haus der Kunst, 2005, p. 117

65 Michel Martin report on Hildebrand Gurlitt, 1946, FMFA, Carton 385, dossier P 19

66 Sworn statement Hildebrand Gurlitt to First Lt Dwight McKay, 10 June 1945, NARA

67 Paul, Cornelius Gurlitt, 2003, pp. 59–60

68 Tent, In the Shadow of the Holocaust, 2003, pp. 145–6, 148

69 Schwarz, 'Hitler's Museum', in Vitalizing Memory, 2005, p. 52

70 Letter Linz Special Commission to Reich Ministry for Science and Education, 8 May 1943, BArch Koblenz, B323-123

71 Michel Martin report on Hildebrand Gurlitt, 1946, FMFA, Carton 385, dossier P 19

72 Sworn statement Hildebrand Gurlitt to First Lt Dwight McKay, 10 June 1945, NARA

73 Michel Martin report on Hildebrand Gurlitt, 1946, FMFA, Carton 385, dossier P 19

74 Lawford-Hinrichsen, Five Hundred Years to Auschwitz, 2008, pp. 129–30

75 Lawford-Hinrichsen, Music Publishing and Patronage, 2000, pp. 287–9

76 Letter Hildebrand Gurlitt to Henri Hinrichsen, 7 January 1940, copy provided by Irene Lawford-Hinrichsen

77 Letter Hans-Joachim Hinrichsen to Hildebrand Gurlitt, 11 January 1940, provided by Martha Hinrichsen

78 Thibaut, 'Der lange Weg zum Spitzweg', Die Zeit, 19 November 2013

79 Bill Hildebrand Gurlitt to Linz Special Commission, 4 April 1944, BArch Koblenz, B323-134

80 Gezer, 'Die Liebe seines Lebens', Der Spiegel, 18 November 2013

81 Lawford-Hinrichsen, Five Hundred Years to Auschwitz, 2008, p. 167

82 Museums Hildebrand Gurlitt wrote to include the Hamburg Museum of Art, the Museum for Arts and Crafts in Halle and the Landesmuseum Oldenburg

83 Tatzkow, 'Max Silberberg', in Melissa Müller and Tatzkow, Verlorene Bilder, verlorene Leben, 2009, pp. 124–5

84 Letter Cornelius Müller-Hofstede to Hildebrand Gurlitt, 28 August 1942, provided by Lothar Fremy

85 Hildebrand Gurlitt, unpublished preface for catalogue GWDP, SArch Düsseldorf

86 Feliciano, The Lost Museum, 1997, p. 133

87 ALIU Final Report, 1 May 1946, NARA

88 Petropoulos, The Faustian Bargain, 2000, p. 157

89 Detailed Interrogation Report, Hermann Voss, ALIU, NARA

90 Iselt, 'Sonderbeauftragter des Führers', 2010, pp. 420–23

91 Michel Martin report on Hildebrand Gurlitt, 1946, FMFA, Carton 385, dossier P 19

92 Sworn statement Hildebrand Gurlitt to First Lt Dwight McKay, 10 June 1945, NARA

93 Finanzamt Bamberg, statement 25 August 1947, HG DNZ, SArch Coburg, Spk BA Land G 251_071

94 Eva-Maria Gurlitt, 'The Arbitrary Treatment of "Jüdisch-versippte" Professors', essay, 1997

95 Dietrich Gurlitt, interview with author, 14 January 2014

Chapter 5 (pp. 95–112)

1 Taylor, *Dresden*, 2004, pp. 277–362

2 Neutzner (ed.), *Abschlussbericht der Historikerkommission zu den Luftangriffen auf Dresden*, 17 March 2010

3 Hildebrand Gurlitt, unpublished preface for catalogue GWDP, SArch Düsseldorf

4 Paul, *Cornelius Gurlitt*, 2003, p. 31

5 Dietrich Gurlitt, interview with author, 14 January 2014

6 Hildebrand Gurlitt, unpublished preface for catalogue GWDP, SArch Düsseldorf

7 Gezer, 'Die Liebe seines Lebens', *Der Spiegel*, 18 November 2013

8 Iselt, *'Sonderbeauftragter des Führers'*, 2010, p. 342

9 Declaration Gurlitt to Breitenbach at MFAA, 3 October 1946, NARA

10 Iselt, *'Sonderbeauftragter des Führers'*, 2010, p. 426

11 Hildebrand Gurlitt, unpublished preface for catalogue GWDP, SArch Düsseldorf

12 Taylor, *Dresden*, 2004, pp. 296–7

13 Rudolph, 'Die Auflösung der Sammlung des Rechtsanwalts Dr Fritz Salo Glaser', *Kur*, vol. 6, 2006

14 Biedermann, 'Die Sammlung Fritz Glaser', in *Von Monet bis Mondrian*, 2006

15 Correspondence Glaser-Gurlitt, February–April 1929, Kunstsammlungen Zwickau Archiv

16 Biedermann, 'Die Sammlung Fritz Glaser', in *Von Monet bis Mondrian*, 2006

17 Griebel, *Ich war ein Mann der Strasse*, 1986, p. 220

18 Biedermann, 'Die Sammlung Fritz Glaser', in *Von Monet bis Mondrian*, 2006

19 Griebel, *Ich war ein Mann der Strasse*, 1986, pp. 263–4

20 Rudolph, 'Die Auflösung der Sammlung des Rechtsanwalts Dr Fritz Salo Glaser', *Kur*, vol. 6, 2006

21 Klemperer, *I Will Bear Witness*, 1999, p. 514

22 Sworn statement Hildebrand Gurlitt to First Lt Dwight McKay, 10 June 1945, NARA

23 *Ibid.*

24 Hildebrand Gurlitt statement to MFAA, 4 March 1947, NARA

25 Sworn statement Hildebrand Gurlitt to First Lt Dwight McKay, 10 June 1945, NARA

26 Detailed Interrogation Report, Ernst Buchner, ALIU, NARA

27 Hildebrand Gurlitt, unpublished preface for catalogue GWDP, SArch Düsseldorf

28 Bohr *et al.*, 'Art Dealer to the Führer', *Der Spiegel*, 21 December 2013

29 Edsel, *The Monuments Men*, 2009, cast of characters in foreword

30 MFAA annual report, October 1945–June 1946, NARA

31 Edsel, *The Monuments Men*, 2009, p. 260

32 Third US Army Reports on MFAA, June 1945–July 1945, NARA

33 Quoted in Petropoulos, 'The Gurlitt Cache', 2013

34 Sworn statement Hildebrand Gurlitt to First Lt Dwight McKay, 10 June 1945, NARA

35 DNB broadcast, 17 March 1945, from Stout memo to ComNavEu, quoted in Nicholas, *The Rape of Europa*, 1994, p. 328

36 Nicholas, *The Rape of Europa*, 1994, p. 385

37 Quoted in Bernsau, *Die Besatzer als Kuratoren?*, 2013, p. 226

38 Bernsau, *Die Besatzer als Kuratoren?*, 2013, pp. 235–45

39 Nicholas, *The Rape of Europa*, 1994, p. 323

40 Quoted in Petropoulos, 'From Lucerne to Washington, DC', in Peters (ed.), *Degenerate Art*, 2014, p. 289

41 Sworn statements M. Pahl Rügenstein and Dr Erich Krause, 13 December 1950, NARA

42 Sworn statement Hildebrand Gurlitt to First Lt Dwight Mckay, 10 June 1945, NARA

43 Statement Hildebrand Gurlitt, 13 December 1950, NARA

44 Summary of interrogation Wolfgang Freiherr v. Pölnitz, report on looting and destruction at Aschbach Castle, NARA

45 First Lt Klyver to MFAA Officer at Office of Military Government for Upper and Central Franconia, 17 October 1945, NARA

46 Eugen Leitherer, interview with author, 1 September 2014

47 Statement Wolfgang von Pölnitz, 18 February 1946, NARA

48 Hildebrand Gurlitt statement to MFAA, 4 March 1947, NARA

49 Consolidated Interrogation Report 'Linz: Hitler's Museum and Library', ALIU, NARA

50 Breitenbach report on interrogation of Wolfgang von Pölnitz, 19 February 1946, NARA

51 Declaration of Property Removed From an Area Occupied by German Forces, 29 April 1946, Office of Military Government of Bavaria, NARA

52 Memorandum, Capt. J. Vlug, ALIU, to Captain Edwin C. Rae, AC, NARA

53 Hildebrand Gurlitt statement to MFAA, 4 March 1947, NARA

54 Letter Breitenbach to Edwin Rae, 8 March 1947, NARA

55 Letter Hildebrand Gurlitt to Ernst Holzinger, 11 April 1947, Städel Museum Archiv

56 Hildebrand Gurlitt, unpublished preface for catalogue GWDP, SArch Düsseldorf

Chapter 6 (pp. 113–131)

1 ALIU Final Report, 1 May 1946, NARA

2 Memorandum Rose Valland 'Collection Hitler du Musee de Linz', 13 September 1946, NARA

3 Rose Valland report on interrogation of Hildebrand Gurlitt, October 1946, NARA

4 Letter Hildebrand Gurlitt to Rose Valland, 1 October 1946, NARA

5 Information from Stephan Klingen, Central Institute for Art History, Munich. In 2014, the Institute began a research project into this theft, with funding from the German government's provenance research centre

6 Breitenbach, 'Historical Survey of the Activities of the Intelligence Department', *College Art Journal*, Winter 1949/1950

7 Information from Stephan Klingen, Central Institute for Art History, Munich

8 Roethel testified to the Bamberg civilian tribunal that he had often seen Hildebrand socially in the years 1938–41. Statement Dr H. K. Roethel, 24 February 1947, HG DNZ, SArch Coburg, Spk BA Land G 251_056

9 Armin Zweite, memorial speech for Hans Konrad Roethel at the Lenbachhaus, 22 March 1982

10 Letter Hildebrand Gurlitt to Dr Roethel, 20 April 1947, NARA

11 *Ibid.*, 19 September 1947, NARA

12 Wiesbaden Administrative Records, Collection Gurlitt, NARA

13 Nicholas, *The Rape of Europa*, 1994, pp. 432, 434

14 Monthly report, Wiesbaden CCP, October–December 1950, NARA

15 Ballmer Bescheinigung for Hildebrand Gurlitt, 31 December 1950, NARA

16 Saure and Gawel, 'Bild löst das Rätsel', *Bild-Zeitung*, 11 December 2013

17 Hildebrand Gurlitt, unpublished preface for catalogue GWDP, SArch Düsseldorf

18 Taylor, *Exorcising Hitler*, 2011, p. 222

19 Letter Hildebrand Gurlitt to Ernst Holzinger, 7 July 1947, Städel Museum Archiv

20 Letter Hildebrand Gurlitt to Fritz

Schumacher, 24 July 1946, HSUL, NSch: XI: B 03: 5-6

21 Letter Carl Georg Heise to Hildebrand Gurlitt, 26 November 1945, HKArch, HAHK 32-2239 (Sammlung 18)

22 Letter Hildebrand Gurlitt to Carl Georg Heise, 4 November 1945, HKArch, HAHK 32-2239 (Sammlung 18)

23 *Ibid.*, 29 December 1945, HKArch, HAHK 32-2239 (Sammlung 18)

24 Letter Carl Georg Heise to Hildebrand Gurlitt, 9 January 1946, HKArch, HAHK 32-2239 (Sammlung 18)

25 Letter Karl Haberstock to Carl Schellenberg, 27 December 1949, Haberstock Archiv, HA/VI/172

26 Letter Carl Georg Heise to Hildebrand Gurlitt, 10 January 1951, Letter Hildebrand Gurlitt to Carl Georg Heise, 12 January 1951, HKArch, HAHK 32-2239 (Sammlung 18)

27 Quoted in Taylor, *Exorcising Hitler*, 2011, p. 270

28 *Ibid.*, p. 285

29 HG DNZ, SArch Coburg, Spk BA Land G251_01

30 Declaration Maya Gotthelf, 3 June 1946, HG DNZ, SArch Coburg, Spk BA Land G 251_016

31 Letter Hildebrand Gurlitt to Jacques Jaujard, 10 February 1947, FMFA

32 Letter A. S. Henraux to Jacques Jaujard, 2 April 1947, FMFA

33 Letter Oberstadtdirektor Entnazifizierungsausschuss Stadtkreis Düsseldorf to Bamberg tribunal prosecutor, 13 August 1947, HG DNZ, SArch Coburg

34 Letter Hildebrand Gurlitt to Ludwig Renn, 12 December 1946, Ludwig Renn Archiv

35 Letter Hildebrand Gurlitt to Fritz Schumacher, 24 July 1946, HSUL, NSch: XI: B 03: 5-6

36 Letter Hildebrand Gurlitt to Herr Rüffer, 16 April 1947, HG DNZ, SArch Coburg, Spk BA Land G 251_057

37 *Ibid.*, 27 May 1947, HG DNZ, SArch Coburg, Spk BA Land G 251_069

38 Letter Bamberg civilian tribunal prosecutor, 18 June 1947, HG DNZ, SArch Coburg, Spk BA Land G 251_067

39 Police statement Ingeborg Hertmann, 27 November 1947, HG DNZ, SArch Coburg, Spk BA Land G 251_087

40 Excerpts from Ingeborg Hertmann's letters to Hildebrand Gurlitt, presented by Gurlitt to the Bamberg civilian tribunal, 9 January 1948, HG DNZ, SArch Coburg, Spk BA Land G 251_109,

41 *Ibid.*, 27 December 1948, HG DNZ, SArch Coburg, Spk BA Land G 251_115

42 Letter Hildebrand Gurlitt to Bamberg civilian tribunal prosecutor, 8 December 1947, HG DNZ, SArch Coburg, Spk BA Land G 251_113

43 *Ibid.*, 8 January 1948, HG DNZ, SArch Coburg, Spk BA Land G 251_110

44 Ferdinand Möller Archiv, BG – GFM MF 5314

45 Bamberg civilian tribunal prosecutor statement, 12 January 1948, HG DNZ, SArch Coburg, Spk BA Land G 251_107

46 Letter Hildebrand Gurlitt to Arnold Zweig, 13 March 1948, Arnold Zweig Archiv, Akademie der Künste

47 Correspondence for Chagall exhibition, Kunstverein files, SArch Düsseldorf

48 Otten (ed.), *Von Dada bis Beuys*, 1998

49 *Ibid.*

50 *Ibid.*

51 Letter Hildebrand Gurlitt to Manfred Gurlitt, 3 March 1941, HSUL, GN: B 9: 45-46

52 Voss, 'Erben ohne Chancen', *Frankfurter Allgemeine Zeitung*, 15 November 2014

53 Hildebrand Gurlitt, unpublished preface for catalogue GWDP, SArch Düsseldorf

54 Catalogue excerpt provided by Wolfgang Henze, Galerie Henze & Ketterer, Switzerland

55 Hildebrand Gurlitt, unpublished preface for catalogue GWDP, SArch Düsseldorf

56 American Federation of Arts, *German Watercolors, Drawings and Prints*, 1956

57 Correspondence in Kunstverein files, SArch Düsseldorf

58 Letter Hermann Albrecht (Wolffson's lawyer) to Amt für Wiedergutmachung, 17 November 1960, HSArch

59 Letter Wirtz, Hengeler and Frenz to Hermann Albrecht, 18 October 1955, provided by Jasper Wolffson

60 Jasper Wolffson, email to author, 5 September 2014

61 Otten (ed.), *Von Dada bis Beuys*, 1998

62 Letter Viktor Achter to Herr Grote, SArch Düsseldorf

63 Terlau, 'Hildebrand Gurlitt and the Art Trade', in *Vitalizing Memory*, 2005, p. 170

64 Reidemeister, memorial speech, 24 January 1957, SArch Düsseldorf

65 Letter General Director, Dresden State Art Collections, to Karl-Heinz Hering, Berthold Glauerdt, Art Association for Rhineland and Westphalia, 15 December 1956, SArch Düsseldorf

Chapter 7 (pp. 132–151)

1 Nachlass Gurlitt, TUD

2 Gezer, 'Die Liebe seines Lebens', *Der Spiegel*, 18 November 2013

3 *Ibid.*

4 Cornelius von Heyl, interview with author, 16 September 2014

5 Interview with Lotte Herdegen, 'Gurlitt und der Jahrhundertschatz', *ZDF Zoom*, 12 February 2014

6 Fritz Schumacher to Hildebrand Gurlitt, 16 July 1946, HSUL, NSch: XI: B 03: 5-6

7 Letter Hildebrand Gurlitt to Fritz Schumacher, 24 July 1946, HSUL, NSch: XI: B 03: 7

8 Letter Hildebrand Gurlitt to Ludwig Renn, 12 December 1946, Ludwig Renn Archiv

9 Häntzschel and Lorch, 'Verwirrtes Erbe', *Süddeutsche Zeitung*, 18 November 2014

10 Cornelius von Heyl, interview with author, 16 September 2014. Unless otherwise cited, boarding school details in this chapter are from this source

11 Letter Minna Specht to Anna Beyer, 5 May 1946, quoted in Alphei and Scheigkofler, *Minna Specht*, 1993, p. 79

12 *Ibid.*, 26 November 1946, p. 80

13 Alphei and Scheigkofler, *Minna Specht*, 1993, p. 31

14 Volkhard Simons, 'Hurra Frau Dr. Specht ist da!', in Alphei and Scheigkofler, *Minna Specht*, 1993, p. 109

15 Franziska Engelking, interview with author, 4 September 2014

16 Edel, speech at Cornelius Gurlitt's funeral, 19 May 2014

17 Gezer, 'Die Liebe seines Lebens', *Der Spiegel*, 18 November 2013

18 Helmut Hausner report on Cornelius Gurlitt's ability to make a will, 17 November 2014

19 Gezer, 'Die Liebe seines Lebens', *Der Spiegel* 18 November 2013

20 Helmut Hausner report on Cornelius Gurlitt's ability to make a will, 17 November 2014

21 'Schwabing Art Trove' Task Force, provenance report on Carl Spitzweg's *Das Klavierspiel*, 3 October 2014

22 Letter Benita Gurlitt to Manfred Gurlitt, 1 July 1962, HSUL, GN: B9: 31-33

23 Letter Helene Gurlitt to Ludwig Renn, 6 January 1967, Ludwig Renn Archiv

24 Gezer, 'Die Liebe seines Lebens', *Der Spiegel*, 18 November 2013

25 Cornelius von Heyl, interview with author, 16 September 2014

26 Franziska Engelking, interview with author, 4 September 2014

27 Gilbert and Willeke, 'Der nette Herr Gurlitt', *Die Zeit*, 10 April 2014

28 Salzburg neighbourhood reporting by Josie Leblond

29 Gezer, 'Die Liebe seines Lebens', *Der Spiegel*, 18 November 2013

30 *Ibid.*

31 Catalogue excerpts provided by Wolfgang Henze, Galerie Henze & Ketterer, Switzerland

32 Wolfgang Henze, email to author, 28 October 2014

33 Siegfried Gohr, interview with author, 5 August 2014

Chapter 8 (pp. 152–167)

1 Gilbert and Willeke, 'Der nette Herr Gurlitt', *Die Zeit*, 10 April 2014
2 Gezer, 'Die Liebe seines Lebens', *Der Spiegel*, 18 November 2013
3 Gilbert and Willeke, 'Der nette Herr Gurlitt', *Die Zeit*, 10 April 2014
4 Higgins and Bennhold, 'For Son of a Nazi-Era Dealer', *New York Times*, 17 November 2013
5 Frank Meyer interview with Karl-Sax Feddersen, Deutschlandradio Kultur, 4 November 2013
6 Eberhard Kornfeld, email to author, 7 April 2014
7 Lorch, 'Sein Mann in der Schweiz', *Süddeutsche Zeitung*, 6 February 2015
8 Krause, 'Villa Grisebach: Mein lieber Mann!', *Tagesspiegel*, 2 June 2000
9 Information from Toren's lawyer Lothar Fremy
10 David Toren, interview with author, 3 July 2014
11 James Ratcliffe, interview with author, 28 March 2014
12 Hickley, 'Heirs Win Back Nazi-Looted Art', *Bloomberg News*, 28 October 2013
13 Digitized catalogue entries, www.lostart.de
14 Hickley, 'US Seizes Old Master', *Bloomberg News*, 24 April 2009
15 Hickley, 'Dealer Returns Painting', *Bloomberg News*, 6 May 2009
16 Landgericht Köln, Urteil 2O 266/12, 24 April 2013
17 Melissa Müller, 'Sophie Lissitzky-Küppers', in Melissa Müller and Tatzkow, *Verlorene Bilder, verlorene Leben*, 2009, p. 111
18 Ackermann, 'Die schmutzigen Geschäfte des Kunsthandels', *Die Welt*, 11 November 2013. He reported that Bernd Schultz said the seller was not Cornelius Gurlitt but declined to reveal his or her identity
19 Petropoulos, 'From Lucerne to Washington, DC', in Peters (ed.), *Degenerate Art*, 2014, p. 290
20 *Ibid.*, p. 295
21 *Ibid.*, p. 290
22 Wiegelmann and Delin, 'Deutsche Museen greifen nach Gurlitts Erbe', *Die Welt*, 15 May 2014

Chapter 9 (pp. 168–176)

1 Gilbert and Willeke, 'Der nette Herr Gurlitt', *Die Zeit*, 10 April 2014
2 Bosley, 'Germans Hide Cash in Diapers', *Bloomberg News*, 4 September 2013
3 Gilbert and Willeke, 'Der nette Herr Gurlitt', *Die Zeit*, 10 April 2014
4 Gezer, 'Die Liebe seines Lebens', *Der Spiegel*, 18 November 2013
5 Augsburg prosecutor's press conference, 5 November 2014
6 Gilbert and Willeke, 'Der nette Herr Gurlitt', *Die Zeit*, 10 April 2014
7 Vanessa Voigt, interview with author, 10 November 2014
8 Petropoulos, 'The Gurlitt Cache', 2013
9 Vanessa Voigt, interview with author, 10 November 2014
10 Gezer, 'Die Liebe seines Lebens', *Der Spiegel*, 18 November 2013
11 Sibylle Ehringhaus, interview with author, 26 September 2014
12 www.geschkult.fu-berlin.de
13 Meike Hoffmann, interview with author, 12 December 2014
14 *Ibid.*, 25 August 2014
15 www.errproject.org
16 Reinhard Nemetz interview in the documentary *Der seltsame Herr Gurlitt*, 19 March 2014
17 Markus Krischer, interview with author, 1 September 2014

Chapter 10 (pp. 177–196)

1 Jewish Claims Conference press release, 5 November 2013
2 Walters and Kelly, 'Can the Weirdo… Solve the Mystery?' *Daily Mail*, 6 November 2013
3 Guido Westerwelle interview with DPA, 11 November 2013
4 Eizenstat, speech, Tel Aviv, 24 June 2014
5 Ingeborg Berggreen-Merkel, email to author, 12 December 2014

6 Joint press statement Bavarian Justice Ministry, Bavarian Education and Art Ministry, the Federal Ministry of Finance and the Federal Minister of Culture, 11 November 2013

7 World Jewish Congress press release, 20 November 2013

8 Denis Trierweiler interview in the documentary *Der seltsame Herr Gurlitt*, 19 March 2014

9 Häntzschel, 'Rechthaberei hilft hier nicht weiter', *Süddeutsche Zeitung*, 17 November 2013

10 Krischer, Röll and Spilcker, 'Gurlitts Höhle', *Focus*, 29 January 2014

11 Statement Augsburg prosecutor, 4 December 2013

12 Bavarian Parliamentary Committee for Constitutional, Legal and Parliamentary Questions press release, 28 November 2013

13 Helmut Hausner report on Cornelius Gurlitt's ability to make a will, 17 November 2014

14 Edel, speech at Cornelius Gurlitt's funeral, 19 May 2014

15 Cornelius Gurlitt press release, 19 February 2014

16 Salzburg neighbourhood reporting by Josie Leblond

17 Cornelius Gurlitt press release, 26 March 2014

18 *Ibid.*, 17 February 2014

19 Monika Grütters interview, *Spiegel Online*, 27 March 2014

20 Eizenstat, speech, Tel Aviv, 24 June 2014

21 Agreement between the Free State of Bavaria, the Federal Government and Cornelius Gurlitt, 7 April 2014

22 Press release announcing the above agreement, 7 April 2014

23 World Jewish Congress press release, 7 April 2014

24 Augsburg prosecutor press release, 9 April 2014

25 Edel, speech at Cornelius Gurlitt's funeral, 19 May 2014

26 Ekkeheart Gurlitt interview, *Kulturzeit*, 24 November 2014

Chapter 11 (pp. 197–228)

1 Martha Hinrichsen, interview with author, 2 June 2014

2 Inter-Allied Declaration Against Acts of Dispossession Committed in Territories Under Enemy Occupation and Control, 5 January 1943.

3 Cited in Schwarz, *Auf Befehl des Führers*, 2014, p. 11

4 Eizenstat, speech, Tel Aviv, 24 June 2014

5 www.lootedart.com

6 Ekkart Committee Recommendations

7 Petropoulos, 'Inside the Secret Market for Nazi-Looted Art', *Art News*, 19 January 2014

8 *Ibid.*

9 Hickley, 'Nazi-Looted Pissarro in Zurich Bank', *Bloomberg News*, 6 June 2007

10 Hickley, 'Jewish Heirs, Sweden Settle 7-Year Feud', *Bloomberg News*, 9 September 2009

11 Hickley and Schneeweiss, 'Vienna's Leopold Pays $19 Million', *Bloomberg News*, 21 July 2010

12 Eizenstat, speech, Tel Aviv, 24 June 2014

13 Morrison, interview with E. Randol Schoenberg, *Los Angeles Times*, 17 March 2012

14 Hickley, 'Nazi-Loot Panel Hopes Fade in US', *Bloomberg News*, 29 November 2012

15 Schultz, 'Man sagt Holocaust und meint Geld', *Frankfurter Allgemeine Zeitung*, 10 January 2007

16 Hickley and Sandler, 'Battle Rages Over Kirchner Picture', *Bloomberg News*, 28 August 2006

17 Schnabel and Tatzkow, *The Story of Street Scene*, 2008, p. 129

18 Hickley, 'Nazi-Looted Posters Must Return to Sachs Heir', *Bloomberg News*, 16 March 2012

19 Suzanne Glass, grand-daughter of Hans Sachs, interview with author, 29 July 2014

20 *Report of the Spoliation Advisory Panel in Respect of an Oil Painting by John Constable*, 26 March 2014

21 Kulturstiftung der Länder statistics, 10 April 2014

22 Ronald Lauder, email to author, 19 September 2014

23 Hickley, 'Herzog Heirs Say Closer to Recovering Nazi-Looted Art', *Bloomberg News*, 25 April 2013

24 Fischer and Weinberger, *Holocaust-Era Looted Art*, 10 September 2014

Chapter 12 (pp. 229–242)

1 Matthias Frehner, interview with author, 10 December 2014

2 Ruth Gilgen, interview with author, 28 November 2014

3 Christoph Schäublin and Matthias Frehner, interview with author, 28 November 2014

4 Statement Berne Museum of Fine Arts, 7 May 2014

5 Statement emailed to author by Christoph Gurlitt, 28 May 2014

6 Ingeborg Berggreen-Merkel, public panel discussion in Berlin, 26 November 2014

7 Greg Schneider, interview with author, 4 December 2014

8 'Schwabing Art Trove' Task Force press release, 5 September 2014

9 Tisa Francini *et al.*, *Fluchtgut–Raubgut*, 2001

10 Report of the Federal Department of Home Affairs and the Federal Department of Foreign Affairs on the Status of Work in the Area of Nazi-Looted Art, Especially in the Area of Provenance Research, 17 January 2011

11 Christoph Schäublin and Matthias Frehner, interview with author, 28 November 2014

12 Frehner (ed.), *Das Geschäft mit der Raubkunst*, 1998

13 Kunstmuseum Berne, Annual Report, 2013

14 Gorris and Knöfel, 'Deutsches Erbgut', *Der Spiegel*, 3 November 2014

15 Statement Wolfgang Seybold, 11 November 2014

16 Summary of Helmut Hausner's report, 17 November 2014

17 Munich probate court press statement, 24 November 2014

18 Ekkeheart Gurlitt interview, *Kulturzeit*, 24 November 2014

19 World Jewish Congress press statement, 24 November 2014

20 Ronald Lauder, email to author, 19 September 2014

21 German Bundesrat, Kultur-Rückgewähr-Gesetz, KRG

22 Entschließung des Bundesrates zum Verlust von Kulturgut in der NS-Zeit, Drucksache 94/14, 14 March 2014

23 Bundesrat meeting, 13 January 2014

24 *Ibid.*

25 *Ibid.*

26 Joint press statement, Culture Minister Monika Grütters and the 16 state and municipal authority culture ministers, 10 October 2014

27 Christoph Schäublin and Matthias Frehner, interview with author, 28 November 2014

28 Gorris and Knöfel, 'Deutsches Erbgut', *Der Spiegel*, 3 November 2014

Bibliography

Archives

Akademie Der Künste Archiv, Berlin
 Academy of Fine Arts Archive
Arnold Zweig Archiv
Bundesarchiv, Berlin and Koblenz (BArch
 Berlin/Koblenz) German Federal Archive
Deutsches Literaturarchiv, Marbach (DLA
 Marbach) German Literature Archive
Paul Fechter literary remains (Nachlass Paul
 Fechter)
Ferdinand Möller Archiv,
 Berlinische Galerie, Berlin
Haberstock Archiv, Augsburg
Hamburger Kunsthalle Archiv (HKArch)
 Hamburg Museum of Art Archive
Kunstsammlungen Zwickau Archiv
 Zwickau Art Collections Archive
Ludwig Renn Archiv, Berlin
Ministère des Affaires Étrangères, Archives,
 La Courneuve, France (FMFA), French
 Ministry of Foreign Affairs Archives
Museum Wiesbaden Archiv
National Archives and Records
 Administration, Washington, US
 (NARA)
Office of Strategic Services (OSS) Art
 Looting Investigation Unit (ALIU)
 Reports
Monuments, Fine Arts and Archives
 (MFAA) Section Documents
Schweizerisches Bundesarchiv, Berne,
 Switzerland Swiss Federal Archive
Staatsarchiv Hamburg (HSArch)
 Hamburg State Archive
Staats- Und Universitätsbibliothek,
 Hamburg (HSUL) Hamburg State and
 University Library
Städel Museum Archiv, Frankfurt
Stadtarchiv Coburg (SArch Coburg)
 Coburg Town Archive
Hildebrand Gurlitt Denazification File
 (Hg Dnz)
Stadtarchiv Düsseldorf (SArch Düsseldorf)
 Düsseldorf City Archive
Gurlitt, Hildebrand, unpublished preface
 for the Exhibition Catalogue German

Watercolors, Drawings And Prints
 (GWDP)
Reidemeister, Prof. Dr Leopold, Memorial
 Speech 'In Memoriam Dr Hildebrand
 Gurlitt', Düsseldorf, 24 January 1957
Universitätsarchiv, Technische Universität
 Dresden (TUD) University Archive,
 Technical University Dresden
Cornelius Gurlitt Literary Remains
 (Nachlass Gurlitt)
Zentralinstitut Für Kunstgeschichte,
 Munich Central Institute for Art History

The following also shared documents from
their personal archives:
Elizabeth Baars
Dietrich Gurlitt, including Gurlitt, Eva-
 Maria, 'The Arbitrary Treatment of
 "Jüdisch-versippte" Professors at the
 University of Freiburg in the Third
 Reich', history essay, Red Cross Nordic
 United World College, 1997
Wolfgang Henze
Martha Hinrichsen
Irene Lawford-Hinrichsen
Jonathan Petropoulos, 'The Gurlitt Cache:
 Scenes from a Movie', unpublished, 2013
Jasper Wolffson

Legal documents

Austrian Government, Bundesgesetz über
 Rückgabe von Kunstgegenständen aus
 den Österreichischen Bundesmuseen
 und Sammlungen [Federal Law
 Governing the Return of Cultural
 Objects from Austrian Federal
 Museums and Collections], pub. 4
 December 1998
German Bundesrat, Kultur-Rückgewähr-
 Gesetz [Law for Return of Cultural
 Goods].
Inter-Allied Declaration Against Acts of
 Dispossession Committed in Territories
 Under Enemy Occupation and Control,
 5 January 1943
United States District Court for the District

of Columbia, court documents in case *David Toren v. Federal Republic of Germany and Free State of Bavaria*, filed 5 March 2014, Case 1:14-cv-00359-ABJ

Official reports

Conference of Jewish Material Claims Against Germany and World Jewish Restitution Organization: Fisher, Wesley A., and Weinberger, Ruth, *Holocaust-Era Looted Art: A Current World-Wide Overview*, 10 September 2014

Dresden Historical Commission: Neutzner, Matthias (ed.), with Schönherr, Nicole, Plato, Alexander von, and Schnatz, Helmut, *Abschlussbericht der Historiker-kommission zu den Luftangriffen auf Dresden zwischen den 13ten und 15ten Februar 1945* [Final Report on the Aerial Attacks on Dresden from 13 February to 15 February 1945], 17 March 2010

Kunstmuseum Berne, Annual Report, 2013

'Schwabing Art Trove' Task Force, reports on the provenance of artworks in the Gurlitt collection at http://www.lostart.de/Webs/DE/Datenbank/KunstfundMuenchen.html

Swiss government, *Bericht EDI/EDA über den Stand der Arbeiten im NS-Raubkunstbereich, insbesondere im Bereich Provenienzforschung* [Report of the Federal Department of Home Affairs and the Federal Department of Foreign Affairs on the Status of Work in the Area of Nazi-Looted Art, especially in the area of Provenance Research], 17 January 2011

UK Spoliation Advisory Panel, *Report of the Spoliation Advisory Panel in Respect of an Oil Painting by John Constable, 'Beaching a Boat, Brighton', now in the Possession of the Tate Gallery*, 26 March 2014

Interviews with the author

Berggreen-Merkel, Ingeborg, email response to written questions, 12 December 2014

Edel, Christoph, Munich, 27 May 2014, and subsequently by telephone

Ehringhaus, Sibylle, Berlin, 26 September 2014

Engelking, Franziska, by telephone, 4 September 2014

Frehner, Matthias, Berne, 28 November 2014, and subsequently by telephone

Gilgen, Ruth, Berne, 28 November 2014

Glass, Suzanne, Berlin, 29 July 2014

Gohr, Siegfried, by telephone, 5 August 2014

Gurlitt, Dietrich, Überlingen, Germany, 14 January 2014

Heyl, Cornelius von, by telephone, 16 September 2014

Hinrichsen, Martha, by telephone, 2 June 2014

Hoffmann, Meike, Berlin, 25 August 2014, and subsequently by telephone

Krischer, Markus, by telephone, 1 September 2014

Lauder, Ronald, email response to written questions, 19 September 2014

Leitherer, Eugen, by telephone, 1 September 2014

Ratcliffe, James, London, 28 March 2014

Schäublin, Christoph, Berne, 28 November 2014

Schneider, Greg, by telephone, 4 December 2014

Toren, David, New York, 3 July 2014, and subsequent emails

Voigt, Vanessa-Maria, by telephone, 10 November 2014

Other interviews and broadcasts

Der seltsame Herr Gurlitt [Gurlitt and the Secret of the Nazi Treasure], Maurice Philip Remy, dir., Broadview TV, 19 March 2014

Ekkeheart Gurlitt interview, *Kulturzeit*, 3Sat, 24 November 2014. Frank Meyer interview with Karl-Sax Feddersen, Deutschlandradio Kultur, 4 November 2013

Guido Westerwelle interview, Deutsche Presse-Agentur (DPA), 11 November 2013

'Gurlitt und der Jahrhundertschatz' [Gurlitt and the Treasure of the Century], *ZDF Zoom*, 12 February 2014

Speeches and lectures

Edel, Christoph, speech at Cornelius
Gurlitt's funeral, Düsseldorf,
19 May 2014
Eizenstat, Stuart, speech, International
Forum on Holocaust Era Cultural Assets,
Tel Aviv, 24 June 2014
Hoffmann, Meike, 'Zwischen Ideologie und
politischem Kalkül: Das Schicksal von
Werken von Edvard Munch im Dritten
Reich' [Between Ideology and Political
Calculation: The Fate of the Works of
Edvard Munch in the Third Reich],
lecture in Berlin, 23 January 2014

Online databases

Commission for Looted Art in Europe,
contains official documents on
Nazi-looted art, a press archive and
comprehensive database at www.
lootedart.com
Deutsches Historisches Museum (German
Historical Museum), database of the
Linz collection at http://www.dhm.de/
datenbank/linzdb
Dutch government, database of looted,
unclaimed artworks in the Netherlands at
http://www.herkomstgezocht.nl/eng
ERR Project, database of art stolen by the
Einsatzstab Reichsleiter Rosenberg at
http://www.errproject.org/jeudepaume
Forschungsstelle 'Entartete Kunst',
database of 'degenerate art' seized from
German museums compiled by the Free
University of Berlin at http://www.
geschkult.fu-berlin.de/e/db_entart_
kunst/index.html
French government, database of unclaimed,
looted artworks in France's possession
at http://www.culture.gouv.fr/
documentation/mnr/MnR-pres.htm
Lost Art, Koordinierungsstelle Magdeburg,
database of art missing or found and
believed to have been expropriated in the
Third Reich at www.lostart.de
Silesian Art Collections project at http://
www.silesiancollections.eu/

Articles

Ackermann, Tim, 'Die schmutzigen
Geschäfte des Kunsthandels' [The
Dirty Deals of the Art Trade], Die Welt,
11 November 2013
Benson, Timothy, 'The Importance of
Provenance', Los Angeles County
Museum of Art (LACMA) blog,
5 February 2014
Bohr, Felix, Gorris, Lothar, Knöfel, Ulrike,
Röbel, Sven, and Sontheimer, Michael,
'Art Dealer to the Führer', Der Spiegel,
21 December 2013
Bosley, Catherine, 'Germans Hide Cash
in Diapers as Swiss Secrecy Crumbles',
Bloomberg News, 4 September 2013
Breitenbach, Edgar, 'Historical Survey
of the Activities of the Intelligence
Department, MFA&A Section, 1946–
1949', College Art Journal, Winter
1949/1950
Gezer, Özlem, 'Die Liebe seines Lebens'
[The Love of His Life], Der Spiegel,
18 November 2013 [interview with
Cornelius Gurlitt]
Gilbert, Cathrin, and Willeke, Stefan, 'Der
nette Herr Gurlitt' [Nice Mr Gurlitt],
Die Zeit, 10 April 2014
Gorris, Lothar, and Knöfel, Ulrike,
'Deutsches Erbgut' [A German Legacy],
Der Spiegel, 3 November 2014
Häntzschel, Jörg, 'Rechthaberei hilft hier
nicht weiter' [Dogmatism Doesn't Help
Us Here], Süddeutsche Zeitung, 17
November 2013 [interview with Sabine
Leutheusser-Schnarrenberger]
— and Lorch, Catrin, 'Verwirrtes Erbe'
[Confused Legacy], Süddeutsche Zeitung,
18 November 2014
Hickley, Catherine, 'Dealer Returns
Painting Lost in Nazi-Era Forced Sale',
Bloomberg News, 6 May 2009
— 'Heirs Win Back Nazi-Looted Art, Lose
Others at Auction', Bloomberg News,
28 October 2013
— 'Herzog Heirs Say Closer to Recovering
Nazi-Looted Art', Bloomberg News,
25 April 2013
— 'Jewish Heirs, Sweden Settle 7-Year Feud

Over Nazi-Looted Nolde', *Bloomberg News*, 9 September 2009
— 'Nazi-Loot Panel Hopes Fade in US, Forcing Court Action', *Bloomberg News*, 29 November 2012
— 'Nazi-Looted Pissarro in Zurich Bank Pits Heiress Against Dealer', *Bloomberg News*, 6 June 2007
— 'Nazi-Looted Posters Must Return to Sachs Heir, Court Rules', *Bloomberg News*, 16 March 2012
— 'Nazi Trove Surprises Family Searching for 70 Years', *Bloomberg News*, 7 November 2013
— 'US Seizes Old Master Lost in Nazi-Era Forced Sale', *Bloomberg News*, 24 April 2009
— and Sandler, Linda, 'Battle Rages Over Kirchner Picture Returned to Heir', *Bloomberg News*, 28 August 2006
— and Schneeweiss, Zoe, 'Vienna's Leopold Pays $19 Million to Keep Schiele's "Wally"', *Bloomberg News*, 21 July 2010
Higgins, Andrew, and Bennhold, Katrin, 'For Son of a Nazi-Era Dealer, a Private Life Amid a Tainted Trove of Art', *New York Times*, 17 November 2013
Krause, Markus, 'Villa Grisebach: Mein lieber Mann!' [Villa Grisebach: My Dear Man!], *Tagesspiegel*, 2 June 2000
Krischer, Markus, Röll, Thomas, and Spilcker, Axel, 'Gurlitts Höhle' [Gurlitt's Cave], *Focus* magazine, 29 January 2014
Lorch, Catrin, 'Sein Mann in der Schweiz' [His Man in Switzerland], *Süddeutsche Zeitung*, 6 February 2015
Morrison, Patt, interview with E. Randol Schoenberg, *Los Angeles Times*, 17 March 2012
Petropoulos, Jonathan, 'Inside the Secret Market for Nazi-Looted Art', *Art News*, 19 January 2014
Prantl, Heribert, and Vahland, Kia, 'Limbach empfiehlt Rückgabe "entartete Kunst"' [Limbach Recommends Return of 'Degenerate Art'], *Süddeutsche Zeitung*, 19 November 2014
Rossmann, Andreas, 'Private Geschäfte' [Private Deals], *Frankfurter Allgemeine Zeitung*, 1 February 2014

Rudolph, Sabine, 'Die Auflösung der Sammlung des Rechtsanwalts Dr Fritz Salo Glaser' [The Dissolution of the Lawyer Dr Fritz Salo Glaser's Collection], *Kur* magazine, vol. 6, 2006
Saure, H.-W., and Gawel, Ralf, 'Bild löst das Rätsel des gestohlenen Chagalls' [Bild Solves the Riddle of the Stolen Chagall], *Bild-Zeitung*, 11 December 2013
Schultz, Bernd, 'Man sagt Holocaust und meint Geld' [They Say Holocaust and Mean Money], *Frankfurter Allgemeine Zeitung*, 10 January 2007
Thibaut, Matthias, 'Der lange Weg zum Spitzweg' [The Long Path to the Spitzweg], *Die Zeit*, 19 November 2013
Voss, Julia, 'Erben ohne Chancen' [Heirs Without Hope], *Frankfurter Allgemeine Zeitung*, 15 November 2014
Walters, Guy, and Kelly, Tom, 'Can the Weirdo Who Hid $1 Billion of Nazi Art Solve the Mystery of the Tsar's Lost Treasure Trove?', *Daily Mail*, 6 November 2013
Wiegelmann, Lucas, and Delin, Sally-Charell, 'Deutsche Museen greifen nach Gurlitts Erbe' [German Museums Grasp for Gurlitt's Inheritance], *Die Welt*, 15 May 2014

Books and exhibition catalogues

Alphei, Hartmut, and Scheigkofler, Barbara, *Minna Specht. Berichte aus der Odenwaldschule* [Minna Specht: Reports from the Odenwaldschule], Heppenheim, Germany: Odenwaldschule, 1993
American Federation of Arts, *German Watercolors, Drawings and Prints, 1905–1955: A Mid-Century Review*, New York: American Federation of Arts, 1956 [exhibition catalogue]
Ascher, Abraham, *A Community Under Siege: The Jews of Breslau Under Nazism*, Stanford: Stanford University Press, 2007
Bernsau, Tanja, *Die Besatzer als Kuratoren? Der Central Collecting Point Wiesbaden als Drehscheibe für einen Wiederaufbau der Museumslandschaft nach 1945* [Occupiers as Curators? The Central Collecting Point Wiesbaden as a Hub for

the Rebuilding of a Museum Scene after 1945], Berlin: Lit Verlag Dr W. Hopf, 2013

Biedermann, Heike: 'Die Sammlung Fritz Glaser' [Fritz Glaser's Collection], in Heike Beidermann, Ulrich Bischoff and Mathias Wagner (eds), *Von Monet bis Mondrian: Meisterwerke der Moderne aus Dresdener Privatsammlungen der ersten Hälfte des 20. Jahrhunderts* [From Monet to Mondrian: Masterpieces of Modern Art in Dresden Collections in the First Half of the 20th Century], Berlin: Deutscher Kunstverlag, 2006 [exhibition catalogue]

Breitman, Richard, and Lichtman, Allan J., *FDR and the Jews*, Cambridge, USA: Harvard University Press, 2012

Bruhns, Maike, *Kunst in der Krise* [Art in Crisis], Munich: Dölling und Galitz Verlag, 2001

— 'Ausgegrenzte Avantgarde' [Ostracized Avantgarde], in Michaela Giesing, Gaby Hartel and Carola Veit (eds), *Das Raubauge in der Stadt: Beckett liest Hamburg* [The Eye in the City: Beckett Interprets Hamburg], Göttingen: Wallstein Verlag, 2007

Buomberger, Thomas, *Raubkunst Kunstraub, Die Schweiz und der Handel mit gestohlenen Kulturgütern zur Zeit des Zweiten Weltkriegs* [Stolen Art, Art Theft: Switzerland and the Trade in Stolen Cultural Property in World War II], Zurich: Orell Füssli, 1998

Edsel, Robert, *The Monuments Men*, New York: Center Street, 2009

Feliciano, Hector, *The Lost Museum: The Nazi Conspiracy to Steal the World's Greatest Works of Art*, New York: Basic Books, 1997

Frehner, Matthias (ed.), *Das Geschäft mit der Raubkunst* [The Trade in Looted Art], Zurich: Verlag Neue Zürcher Zeitung, 1998

Griebel, Otto, *Ich war ein Mann der Strasse* [I was a Man of the Street], Leipzig: Mitteldeutscher Verlag Halle, 1986

Gronau, Dietrich, *Max Liebermann, eine Biographie* [Max Liebermann,

a Biography], Frankfurt am Main: Fischer Taschenbuch Verlag, 2001

Hüneke, Andreas, 'Depot für "Entartete Kunst"' [Depot for 'Degenerate Art'], in Alfred P. Hagemann, Detlef Fuchs and Alexandra Schmöger (eds), *Schönhausen: Rokoko und Kalter Krieg: die bewegte Geschichte eines Schlosses und seines Gartens* [Schönhausen: Rococo and Cold War: The Eventful History of a Palace and its Park], Berlin: Jaron Verlag, 2009

Iselt, Kathrin, *'Sonderbeauftragter des Führers': Der Kunsthistoriker und Museumsmann Hermann Voss* ['The Führer's Special Commissioner': The Art Historian and Museum Man Hermann Voss], Cologne: Böhlau Verlag, 2010

Kershaw, Ian, *Hitler*, London: Penguin Books, 2010

Klemperer, Victor, *I Will Bear Witness: A Diary of the Nazi Years, 1942–1945*, New York: Random House, 1999

Kracht, Isgard, 'Im Einsatz für die deutsche Kunst, Hildebrand Gurlitt und Ernst Barlach' [In the Service of German Art: Hildebrand Gurlitt and Ernst Barlach], in Maike Steinkamp and Ute Haug (eds), *Werke und Werte* [Artworks and Values], Berlin: Akademie Verlag, 2010

Kreis, Georg, *'Entartete' Kunst für Basel* ['Degenerate' Art for Basle], Basle: Wiese Verlag, 1990

Lasker-Wallfisch, Anita, *Inherit the Truth 1939–1945*, London: Giles de la Mare, 1996

Lawford-Hinrichsen, Irene, *Five Hundred Years to Auschwitz*, Harrow, UK: Edition Press, 2008

— *Music Publishing and Patronage*, Kenton, UK: Edition Press, 2000

Loeser, Franz, *Sag nie, Du gehst den letzten Weg: Ein deutsches Leben* [Never Say Die: A German Life], Cologne: Bund-Verlag, 1986

Löffler, Michael, *Hildebrand Gurlitt*, Zwickau: Städtisches Museum Zwickau, 1995 [Städtisches Museum Zwickau catalogue for exhibition 27 August–29 October 1995]

Löhr, Hanns Christian, *Das Braune Haus der Kunst, Hitler und der 'Sonderauftrag Linz'* [The Nazi House of Art: Hitler and the 'Linz Special Commission'], Berlin: Akademie Verlag, 2005

Müller, Karsten, 'Violent Vomiting Over Me: Ernst Barlach and National Socialist Cultural Policy', in Olaf Peters (ed.), *Degenerate Art: The Attack on Modern Art in Nazi Germany 1937*, New York: Prestel, 2014 [Neue Galerie exhibition catalogue]

Müller, Melissa, and Tatzkow, Monika, *Verlorene Bilder, verlorene Leben: Jüdische Sammler und was aus ihren Kunstwerken wurde*, Munich: Elisabeth Sandmann Verlag, 2009 English trans. *Lost Lives, Lost Art: Jewish Art Collectors, Nazi Art Theft and the Quest for Justice*, New York: Vendome Press, 2010

Nicholas, Lynn, *The Rape of Europa*, New York: Vintage Books, 1994

Nixon, Mark, *Samuel Beckett's German Diaries 1936–1937*, London: Bloomsbury Publishing, 2011

Otten, Marie-Luise (ed.), *Von Dada bis Beuys: 30 Jahre Kunstverein für die Rheinlande und Westfalen mit Karl-Heinz Hering* [From Dada to Beuys: 30 Years of the Art Association for the Rhineland and Westphalia with Karl-Heinz Hering], Ratingen: Schwarzbach Presse, 1998 [exhibition catalogue]

Paul, Jürgen, *Cornelius Gurlitt*, Dresden: Hellerau-Verlag, 2003

Peters, Olaf, 'Genesis, Conception, and Consequences', in Olaf Peters (ed.), *Degenerate Art: The Attack on Modern Art in Nazi Germany 1937*, New York: Prestel, 2014 [Neue Galerie exhibition catalogue]

Petropoulos, Jonathan, *The Faustian Bargain: The Art World in Nazi Germany*, New York: Oxford University Press, 2000
— 'From Lucerne to Washington, DC: "Degenerate" Art and the Question of Restitution', in Olaf Peters (ed.),

Degenerate Art: The Attack on Modern Art in Nazi Germany 1937, New York: Prestel, 2014 [Neue Galerie exhibition catalogue]

Quadflieg, Roswitha, *Beckett Was Here: Hamburg im Tagebuch Samuel Becketts von 1936*, [Beckett Was Here: Hamburg in Samuel Beckett's 1936 Diary], Leipzig: Amazon Distribution, 2014

Renn, Ludwig, *Anstöße in meinem Leben* [Inspirations in My Life], Berlin: Aufbau-Verlag, 1982

Schnabel, Gunnar, and Tatzkow, Monika, *The Story of Street Scene*, Berlin: Proprietas Verlag, 2008

Schwarz, Birgit, *Auf Befehl des Führers: Hitler und der NS-Kunstraub* [On the Führer's Orders: Hitler and Nazi Art-Looting], Darmstadt: Theiss Verlag, 2014
— 'Hitler's Museum', in American Association of Museums, *Vitalizing Memory: International Perspectives on Provenance Research*, Washington, USA: American Association of Museums, 2005

Sinclair, Anne, *21 Rue la Boétie*, Paris: Éditions Grasset & Fasquelle, 2012

Speer, Albert, *Erinnerungen* [Memories], Frankfurt am Main: Ullstein Verlag, 1996

Taylor, Frederick, *Dresden*, London: Bloomsbury Publishing, 2004
— *Exorcising Hitler: The Occupation and Denazification of Germany*, London: Bloomsbury Publishing, 2011

Tent, James F., *In the Shadow of the Holocaust*, Lawrence, Kansas, USA: University Press of Kansas, 2003

Terlau, Katja, 'Hildebrand Gurlitt and the Art Trade During the Nazi Period', in American Association of Museums, *Vitalizing Memory: International Perspectives on Provenance Research*, Washington, USA: American Association of Museums, 2005

Tisa Francini, Esther, Heuss, Anja, and Kreis, Georg, *Fluchtgut – Raubgut: Der Transfer von Kulturgütern in und über die Schweiz 1933–1945 und die Frage der Restitution* [Property Sold in Flight, Property Stolen: The Transfer of Cultural

Goods in Switzerland 1933–1945 and the Question of Restitution], Zurich: Chronos Verlag, 2001

Voigt, Vanessa-Maria, *Kunsthändler und Sammler der Moderne im Nationalsozialismus: Die Sammlung Sprengel 1934 bis 1945* [Art Dealers and Collectors of Modern Art in the Nazi Era: The Sprengel Collection 1934 to 1945], Berlin: Dietrich Reimer Verlag, 2007

Winzeler, Marius, 'Jüdische Sammler und Mäzene in Breslau' [Jewish Collectors and Sponsors in Breslau], in Andrea Baresel-Brand and Peter Müller (eds), *Sammeln, Stiften, Fördern, Jüdische Mäzene in der deutschen Gesellschaft* [Collecting, Donating, Sponsoring: Jewish Patrons in German Society], Magdeburg: Koordinierungsstelle für Kulturgutverluste, 2008

Wismer, Beat, *Karl Ballmer, Der Maler* [Karl Ballmer the Painter], Switzerland, Aarau: Aargauer Kunsthaus, 1990 [exhibition catalogue]

Sources of Illustrations

a = above; b = below; l = left; r = right

65a Private collection. 65b Photo Catherine Hickley. 66a, 66b, 67 Archive of the Technische Universität Dresden (Technical University of Dresden). 68a Kunstsammlungen Zwickau, Max Pechstein Museum. Photo Fritz Alter. 68b, 69 Archive of the Technische Universität Dresden (Technical University of Dresden). 70, 71a Kunsthaus Desiree/Knecht Verlag. 71b Photo courtesy Lost Art Koordinierungsstelle Magdeburg via Getty Images. 72a Archive of the Technische Universität Dresden (Technical University of Dresden). 72b Courtesy the Gurlitt family. 137a Kunstmuseum Basel. Photo akg-images. 137b bpk/Zentralarchiv, Staatliche Museen zu Berlin. 138a, 138b Photo Scherl, SZ Photo. 139a, 139b bpk. 140a, 140b Bayerische Staatsbibliothek München/Bildarchiv. 141a, 141b Archive of the French Ministry of Foreign Affairs, Récupération artistique, carton 991, droits reserves. 142a Galerie Neue Meister, Staatliche Kunstsammlungen Dresden. Photo Elke Estel. 142b Irene Lawford-Hinrichsen. 143 ©VG Bild-Kunst, Bonn 2015. 144 Zentralinstitut für Kunstgeschichte, Munich. © Succession H. Matisse/VG Bild-Kunst, Bonn 2015. 209 Private collection, courtesy Neue Galerie, New York. ©VG Bild-Kunst, Bonn 2015. 210a SLUB Dresden/Deutsche Fotothek Photo Richard Peter. 210b SLUB Dresden/Deutsche Fotothek Photo Walter Hahn. 211a Zentralinstitut für Kunstgeschichte, Munich. Photo Beyerlein. 211b Zentralinstitut für Kunstgeschichte, Munich. 212a LACMA. Courtesy Piper 1993. Max Beckmann © VG Bild-Kunst, Bonn 2015. 212br Courtesy Kunstverein für die Rheinlande und Westfalen, Dusseldorf. 212bl Courtesy Dietrich Gurlitt. 213a, 213b Courtesy Kunstverein für die Rheinlande und Westfalen, Dusseldorf. 214 Neue Galerie, New York. This acquisition was made available in part through the generosity of the heirs of the Estates of Ferdinand and Adele Bloch-Bauer. 215 Private collection, courtesy Neue Galerie, New York. 216 *Der Spiegel*, 18 November 2013.

Acknowledgments

I owe a great debt of gratitude to two gentlemen with very long memories who were willing to take the time to speak to me at length, and whom it was a privilege to meet. The first is David Toren, whose recollections supplied most of Chapter 1, and the second is Dietrich Gurlitt, the nephew and godson of Hildebrand Gurlitt.

Christoph Edel, Cornelius von Heyl, Stephan Klingen, Martha Hinrichsen, Irene Lawford-Hinrichsen, Louis Rönsberg, Meike Hoffmann, Vanessa Voigt, Greg Schneider and Sibylle Ehringhaus also contributed crucial insights and information for which I am very grateful, as I am to all the interview partners listed in the bibliography.

Jonathan Petropoulos was generous enough to give me one of his own unpublished articles. The young and talented Josie Leblond contributed some excellent reporting from Salzburg. Hubert Portz shared his extensive research on Cornelia Gurlitt. Ulf Bischof read and revised the German law passages and Anne Webber read and commented on other parts of the text.

Anne and Ulf are among the people I want to thank for their help over many years in my reporting for *Bloomberg News* on Nazi-looted art, along with Willi Korte, Agnes Peresztegi, David Rowland, Monika Tatzkow, Sabine Rudolph, Christoph von Berg, Sophie Lillie, Thomas Buomberger and too many more to mention. I would also like to thank Bloomberg editors Reto Gregori and Heather Harris for their unswerving support during my seventeen years at the company, and Matt Winkler for first requesting that the arts desk report on Nazi-looted art and restitution. It was a very good idea.

Some existing sources that I have quoted frequently deserve a special mention, in particular Özlem Gezer's interview with Cornelius Gurlitt in *Der Spiegel*. Without her exact and empathetic reporting, we would know significantly less about Cornelius than we do. I would also draw attention to Lynn Nicholas's authoritative book *The Rape of Europa* and Kathrin Iselt's admirable and exhaustive biography of Hermann Voss, which perhaps has not so far received the international acclaim it deserves.

Stefi Grundner helped craft my trickier email requests in German and Sebastian Engelmann volunteered his services in deciphering Sütterlin script. Vanessa Fuhrmans and Troy McMullen saved me a fortune by giving me a bed for a week in New York, Georg Jochum put me up on the shores of Lake Constance, and Dale and Regula Bechtel treated me to their hospitality in Spiez, Switzerland. All were also wonderful company and made a business trip feel a whole lot less businessy. Elizabeth Baars gave me as friendly a welcome in Hamburg as Christian Fuhrmeister did in Munich. Thanks to all.

My brother-in-law David Clarkson was the first non-professional reader and made some key suggestions after zipping through the text in two days over Christmas. Early readers and former *Bloomberg* colleagues Alan Crawford and Tony Czuczka, both authors themselves, also gave helpful advice. Many Berlin friends gave warm encouragement when I first decided to embark on this project, among them Hannah Cleaver, Derek Scally, Astrid Williams, Shirley Apthorp, Birgit Jennen, Kate Millar, Chad Thomas and Allan Hall. My parents, brother and sister, to whom this book is dedicated, have contributed valuable moral and emotional support – actually for as long as I can remember.

My agent Maggie Hanbury has been a tower of strength and I am eternally grateful to Nicholas Jacobs for introducing us. I would like also to thank Jamie Camplin and Amanda Vinnicombe for their commitment to the story. My editor Jo Murray is impressively meticulous and it is greatly reassuring to have someone comb the manuscript so carefully after months of being alone with it. Any errors are of course my own.

Catherine Hickley
Berlin, 7 February 2015

Index